WHITE ABORIGINES
Identity Politics in Australian Art

White Aborigines is an investigation of how identities have been constructed in Australian art from 1788 to the present. Beginning with a discussion of the ways in which Australia was imagined by Europeans before colonisation, Ian McLean traces the representation of indigenity—both Aboriginal and non-Aboriginal— through the history of Australian art. In doing so, he tells the story of the invention of an Australian subjectivity. He argues that the colonising culture invested far more in indigenous aspects of the country and its inhabitants than it has been willing to admit. McLean considers artists and their work within a cultural context and also provides a contemporary theoretical and critical context for his claims. He proposes strikingly original readings of the practices of several Aboriginal and non-Aboriginal artists, concluding with a detailed discussion of the work of Gordon Bennett.

Ian McLean is a senior lecturer in art history and theory at the School of Art, University of Tasmania. He is the author of *The Art of Gordon Bennett* (with Gordon Bennett, 1996), and his articles have appeared in journals including *Third Text, Thesis Eleven, Art and Australia, Agenda* and the *Australian Journal of Art*.

All ruling strata claim to be the
oldest settlers, autochthonous.
Theodor Adorno
Minima Moralia, *p. 155*

For Sumai

WHITE ABORIGINES
Identity Politics in Australian Art

IAN McLEAN

CAMBRIDGE
UNIVERSITY PRESS

PUBLISHED BY THE PRESS SYNDICATE OF THE UNIVERSITY OF CAMBRIDGE
The Pitt Building, Trumpington Street, Cambridge, United Kingdom

CAMBRIDGE UNIVERSITY PRESS
The Edinburgh Building, Cambridge CB2 2RU, UK http://www.cup.cam.ac.uk
40 West 20th Street, New York, NY 10011–4211, USA http://www.cup.org
10 Stamford Road, Oakleigh, Melbourne 3166, Australia

First published 1998

Printed in Australia by Brown Prior Anderson

Typeset in New Baskerville 10/12 pt

National Library of Australia Cataloguing in Publication data
McLean, Ian, 1952– .
White Aborigines: identity politics in Australian art.
Bibliography.
Includes index.
ISBN 0 521 58416 7.
1. Painting, Australian. 2. Aborigines, Australian, in art.
3. Aborigines, Australian–Painting, I. Title.
759.94

Library of Congress Cataloguing in Publication data
McLean, Ian. 1952– .
White Aborigines: identity politics in Australian art/Ian McLean.
p. cm.
Includes bibliographical references and index.
ISBN 0 521 58416 7 (hardcover: alk. paper)
1. Australian aborigines in art. 2. Painting, Australian.
3. Identity (Psychology) in art. I. Title.
ND1460.A89M36 1998
759.994–dc21 97–30210

A catalogue record for this book is available from the British Library

Contents

Illustrations

Preface

This book discusses how the relationships between Aboriginal and non-Aboriginal 'Australia' were imagined in Australian painting over the previous two hundred years. My aim is to do more than trace a particular theme in the history of Australian painting; it is to tell a story of the invention of an Australian subjectivity.

The purpose of my interpretative history is to test an argument, not provide a comprehensive account of Australian painting. My analysis of paintings and, at times, other forms of expression, is presented as evidence that, in Australia, the colonising culture invested far more in indigenous aspects of the place than they have been willing to admit. The relevations of Elizabeth Durack's and Leon Carmen's Aboriginalised alter egos are only the most recent examples of the desire by the colonising culture to be white Aborigines. This desire, sanctioned by the doctrine of *terra nullius*, forms a disturbing and even obsessive undercurrent in Australian mythologies of identity. It is an unresolved social issue and shows every sign of remaining so for a long time.

The tracking of the representation of indigenity in Australian painting involves more than investigating those paintings which include images of Aborigines – particularly since the relations between Aborigines and non-Aborigines have been, and still are, primarily governed by issues of land ownership. Further, the psychology of representation and its stagings in allegory and other symbolic forms, along with an understanding of the concepts which inform Western thinking about identity, are important to my discussion. Implicit in my argument is the persistence of age-old Western meta-narratives of identity which continue to stage our politics of identity, and which are constituted as much by the constructions of forgetting as by memory.

The first three chapters discuss and place in historical context the

ideas and ideologies which staged the initial imagining, exploration, invasion and settlement of Australia by Europeans – ideologies which galvanised around concepts of the Antipodes, utopia, melancholy and redemption. The remaining chapters, which are loosely linked in chronological order to suggest an historical narrative, trace the picturings of identities in Australian painting during the nineteenth and twentieth centuries, and conclude with a discussion of the contemporary urban Aboriginal artist, Gordon Bennett. Finally, I have written a postscript that directly engages with the theoretical concerns that drive my argument.

My argument owes a considerable debt to the large number of excellent and insightful studies of colonial cultures, and in particular, of Australian culture, that have been published in the last decade. However, Bernard Smith's *European Vision and the South Pacific*, published nearly thirty years ago, remains the starting point of any study of Australian culture from the perspective of cultural interactions between indigenous and colonising peoples. Of the many recent studies, Robert Dixon's *The Course of Empire and Neo-Classical Culture in New South Wales, 1788–1860* is a much-valued book which I often returned to for guidance. Ian Burn's and Paul Carter's writings, as different as they are from each other, have always been an inspiration, especially in their attention to the aesthetic dimensions of pictures and texts. Ross Gibson was another early inspiration, and it was probably his film, *Camera Natura*, which first set me thinking seriously about notions of Australian identity.

I have been particularly fortunate to have received the considerable input of Bernard Smith, who supervised the PhD thesis from which this book is drawn. I wish to especially thank him for the generosity of his time and ideas, and for his continued support.

I also must thank Sneja Gunew and Terry Smith who, in their reports on my thesis, provided invaluable suggestions for its working into a book; Paul Carter, Nikos Papastergiadis and Kay Schaffer, for their intelligent comments on various aspects of my argument; Gordon and Leanne Bennett for patiently and thoroughly answering my many questions during the research for chapter 8; and to the many colleagues who responded to my published essays and conferences and seminar papers – many of which were the starting points of the chapters in this book. Finally, this book would not have been as elegant without the patient editors at Cambridge University Press – Phillipa McGuinness and Jane Farago, the readings of Sue Rowley, and the excellent editorial work of Lee White.

No matter how fine one's sources and colleagues, in the end the writer must claim responsibility for what is written, especially since all histories, and especially interpretative histories such as this, are highly selective accounts. At this point, as I write the last words before returning the

edited manuscript to the publisher, I realise that I can do nothing more about the many omissions and generalisations which my overly ideological reading of paintings and texts produced, and, with some relief, leave it for others to judge me on these counts.

IAN MCLEAN

Acknowledgments

Earlier versions of parts of the following chapters have been published previously: chapter 1 – Ian McLean, 'Europe's Antipodean others', *Thesis Eleven*, 48, 1997, pp. 69–90; chapter 2 – Ian McLean, 'Reclaiming Australia: the Port Jackson School and its exile', *Art and Australia*, 33, 1, Spring 1995, pp. 94–103; Ian McLean. 'Colonials kill artfully', *Perspectives on Academic Art*, ed. Paul Duro, Art Association of Australia, Canberra, 1991, pp. 56–71; chapters 3 and 4 – Ian McLean, 'Your own land is the best: the limits of redemption in Australian colonial art', *Australian Journal of Art*, XII, 1994–5, pp. 124–45.; chapter 4 – Ian McLean, 'White Aborigines', *Third Text*, 21, Spring 1993, pp. 17–26; chapter 8 – Ian McLean and Gordon Bennett, *The Art of Gordon Bennett*, Craftsman House, Sydney, 1996; Ian McLean, *Mirror Mirror: The Narcissism of Coloniality: Gordon Bennett*, Canberra School of Art Gallery, Canberra, 1996; Ian McLean, 'Psycho(d)rama mirror line: reading Gordon Bennett's installation *Mirrorama*', *Third Text*, 25, Winter 1993–4, pp. 77–80; Postscript – Ian McLean, 'Imagining "Australia": Paul Carter's migrantology', *Crossing Lines: Formations of Australian Culture*, eds C. Guerin, P. Butterss and A. Nettlebeck, Association for the Study of Australian Literature, Adelaide, 1996, pp. 19–25; Ian McLean, 'The metaphors of (post)colonial redemption: the writings of Paul Carter', *Third Text* (forthcoming).

In 1993 the University of Tasmania funded twelve months study leave for research at the Department of Fine Arts, University of Melbourne, as part of my PhD work on the representation of Aborigines in Australian painting. I particularly appreciated the help of Professor Margaret Manion and Dr Roger Benjamin in looking after my needs there, and Chris Wallace-Crabbe, who allowed me to use the facilities of the Centre for Australian Studies.

CHAPTER 1

Ocean and the Antipodes

Like other settler colonies, Australia has a cultural ethos and national mythology which *appears* indifferent to its indigenous inhabitants, because their origins seem elsewhere and fantastic, even fabulous. However, non-Aboriginal Australian culture also brushes up against the fabulous. Living on the 'other' side of the world during a Eurocentric age, all Australians contain the trace of what ancient Aegean geographers called 'Ocean' (*Okeanos*), 'the vast "river" thought to surround the landmass formed by Europe, Africa and Asia'.[1]

James Romm described Ocean as 'a vivid symbol of the gateway or barrier between inner and outer worlds'.[2] On the inner side, Ocean is the threshold of all that is solid and everyday; on the other outer side, it melts into the primal airy chaos *(apeiron)* of the beyond. While stories of limitless waters west of the Pillars of Heracles (Gibraltar) provided an actual basis for the ancient Greek idea of Ocean, its function was to conceptually secure an identity, a sense of self and place. For this reason some ancient writers, such as the much travelled and world-wise Herodotus, doubted its actual existence. However, the idea remained integral to classical geography, for it provided the symbolic means of imagining identity by making place an emblem of the self. It is, for example, evident in Ptolemy's maps, which depict the known world surrounded by ocean. If, after Plato,[3] Ptolemy imagined a large land mass on the other side of Ocean, it was an emblem of the unknown, of the non-identical. Thus Ptolemy named it *terra incognita*, a theoretical land which, at least since late Roman times, has also been called the Antipodes.

According to Yuri Lotman, 'every culture' divides 'the world into "its own" internal space and "their" external space' – it is 'one of the human cultural universals'. Lotman's boundaries are for crossing, they are

fertile luxuriant sites, a hybrid zone of multiple translations in which
'new information ... snowballs'.[4] However, in its original conception,
Ocean could not be crossed. It was the ultimate border that fenced off
an absolute other that was untranslatable. If, as Romm says, in Ocean's
watery substance land and air 'break down' into 'a murky undifferenti-
ated welter of elements',[5] it is not a hybrid zone, not a middle dialogical
space in which differences are preserved and reconstituted. Rather,
Ocean circulates at the ends of the earth where all the old antinomies
are washed around until, at the outer edge, they break down into a
primeval ether without difference. Ocean as threshold is a premonition
of what Luce Irigaray called 'the immemorial inauterine abode', of what
Jacques Derrida described as the 'radical trembling [that] can only
come from the *outside*',[6] and of what Freud called the uncanny. Ocean is
the gateway to the imaginary, to the (pre-) origin and limit of identity
where, 'submerged in ... astonishment, wonder, and sometimes terror
before that which surrounds it', we are 'returned to the evanescence of
subject and object', 'to the lifting of all schemas by which the other is
defined' (Irigaray).[7]

In its original conception, Ocean was a fearful place to be avoided.
Even though the experiences of Greek colonialism eventually resulted
in speculation about either a utopia or dystopia across this watery divide,
Ocean remained a site of anxiety. However, within its terror was
glimpsed the possibility of salvation. Following the ambitious expansions
of Hellenistic and Roman times, Ocean was even made the site of
sublime emotions.[8] In the fifteenth century this ancient figure of
fabulousness was revived by Portuguese and Spanish powers. Columbus
believed that the Atlantic might, like the Aegean Sea, also be a 'watery
divide between Europe and Asia'.[9] Soon the Pacific and the possibility of
a fabulous Antipodes, or *terra incognita*, also figured in this yearning.
Reporting in 1503 on his third voyage to South America, Amerigo
Vespucci asserted: 'I found myself in the Antipodes ... often I believe
myself to be in paradise'.[10] Over the next few centuries, the Antipodes,
terra Australis and Magallanica, as it was variously called by Europeans,
was envisaged as a huge antarctic continent which almost touched the
southern points of America and Asia (at Java). 'Never before', said
Romm, 'had ancient geography seemed so potent, nor had fictional
literature seemed so pregnant with truth'.[11]

No matter how imaginary its origins, during the colonial period
Ocean was objectified as a real ocean across which real people sailed.
This mixing of reality with the imaginary was a potent alchemic brew
which, for many, promised salvation and gold. In Oceania, Europeans
fervently hoped, was a great austral land with untold riches. However,
they discovered death, not gold. Ocean prevailed.

When, on 15 (or 27) September 1513, Vasco Nunez de Balboa ascended the heights of the isthmus of Darien in the New World and gazed westwards, he was the first European to spy the Pacific ocean. Believing he had discovered the fabled South Seas, no doubt he followed the custom of his times and looked skywards to ask for God's blessing and providence. But instead a curse descended upon him and those who repeated his gaze. Dying a few years later at the hands of a jealous rival, he did not live to hear of the incredible voyage by Ferdinand Magellan, and of its terrible fate. Magellan entered the South Seas after violently suppressing mutineers who baulked at travelling any further from home. Perhaps their cries were a warning. He may have named this vast watery expanse the 'Pacific', but the peace he found there was not what he had imagined. Its inhabitants murdered him. Along with nearly all his crew, Magellan never made it home.

However, the lure of Oceania stilled all fears. The Portuguese came from the east and the Spanish from the west. In 1521, the year Magellan was killed, the Portuguese Cristóvao de Mendonça disappeared while searching for the austral 'Isles of Gold'. In 1537 Cortés dispatched two ships from Mexico to find the 'Isles of Gold' and *terra Australis*. After mutiny the ships were lost off New Guinea. If, over two hundred years later, French and English sea captains continued to pursue what Lancelot Voisin had called in 1583 'the third world', 'a situation wonderful in its pleasures, richesses and other commodities of life',[12] the Pacific paradise reflected in their dreaming eyes was a fatal shore.

Death, after all, lurks in the garden. William Hodges knew this. In his paintings of Tahiti, the centre of the Enlightenment's utopian longing, paradise is already lost in its picturing. The serene, golden light and lazy ambience of Hodges' Tahitian sketches are suffused with a languorous melancholy that evokes a sense of loss and portent. This is also the principal theme of his larger, more traditionally composed paintings, done afterwards to commemorate the ethical scope of Cook's second voyage to the Pacific. *Monuments of Easter Island* (*c.* 1775), with its skull and bones in the foreground of menacing shadows, is a prophetic vision of Cook's own fate. In the Pacific, Bernard Smith persuasively argued, the European pastoral tradition first entered the dark night of romanticism.[13]

And the sun still has not risen. The non-European world is still a place upon which Westerners, including many who live in the Americas, Australia and the Pacific, project their desires and fears. Ocean has not ebbed. For example, the French poststructuralist, Jean Baudrillard, construes the 'original situation' of the USA as one which fundamentally lacks originality. 'America' has 'no origins', 'no past and no founding truth', but 'lives in perpetual simulation'. 'From the outset, from the

very dawn of their history', the USA was like Ocean: 'a culture of mix-
ing, of national and racial mix, of rivalry and heterogeneity', its 'soft-
mobile' 'networks and soft technologies' exhausting themselves 'in
surfaces'. Consequently, 'America has no identity problem'. Like Japan,
'which to a certain extent has pulled off this trick better than the US
itself', it too transforms 'the power of territorials' into that of
'deterritoriality and weightlessness'. If Baudrillard envies the USA its
'spatial, mobile' freedom set loose from the 'historical centrality' of
Europe, this freedom is a witless, naive, mindless place, an endless space
of collapsed binaries, a 'sublime form that banishes all sociality, all
sentimentality, all sexuality'[14] – in Baudrillard's word, a 'desert'. Here
America is, like Ocean, a metaphor of absence used by Baudrillard to
write about the presence of being European. Such metaphors still
resound in Australian art criticism. For example, Edward Colless, who
for some time has been enamoured by his melancholic abode in
Hobart, wrote in 1993 that here 'art depends on a response to Tasmania
as an antipodal limit where one's world borders on something unformed,
illegible and intractable; an isolated outpost, if not frontier'.[15] It is a
view which has resonated in the ideas about 'Australia' for over 2000
years. The wild currents of river Ocean brought Englishmen to 'Botany
Bay' over 200 years ago, but the myth of Ocean has not diminished.

If 'Botany Bay' sounds like another Pacific paradise, Joseph Banks
recommended its golden meadows and fish-filled waters to the English
government as an ideal site for a prison. Not that Banks envisaged
Botany Bay as a place where the melancholic souls of criminals could be
soothed in bucolic surroundings. Rather, it was a site where they might
subsist without undue burden to Britain. More importantly, the English
wanted an ocean and more between the fair fields of England and
'Botany Bay'. And this they got. To get there, the First Fleet sailed across
all the oceans, the Atlantic, the Indian, the Southern, and then, on the
final leg, into the Pacific. Robert Hughes quipped that if the Pacific was
the cradle of eighteenth-century European utopianism, in Australia
there was 'not Utopia, but Dystopia; not Rousseau's natural man moving
in moral grace amid free social contracts, but man coerced, exiled,
deracinated, in chains'.[16] However, I will argue that the difference
between utopia and dystopia is not what it seems. Certainly the English
were uncertain which they had created. If Botany Bay was envisaged by
its planners as a dystopia, as early as 1786 Alexander Dalrymple
suggested that transportation to 'Botany Bay' might be a salubrious
environment for the convict. He was not thinking of penal reform, but
fearing that it 'will *incite* [English] men to become *Convicts*'.[17]

The irony that a land of thieves might be a place where the con-
demned could grow rich and free, a sort of Cockaigne (or antipodean)

utopia where traditional values were upturned, was a popular theme in nineteenth-century English literature – and indeed, entertained the popular imagination from the time the plan to make a prison in 'Botany Bay' was first announced.[18] Such ideas were increasingly popularised in the nineteenth century. In 1827 Peter Cunningham reported that the children of convicts grew up in Australia 'tall and slender', 'little tainted with the vices so prominent among their parents'.[19] Cunningham's point was that the 'tyranny of distance' is also a freedom. The oceans which guarantee both have always stood between Australia and its imperial genealogy, as if the ocean, not England, was Australia's origin. And when Britain no longer ruled the waves, Australia quickly switched allegiance to those who now did.

If Ocean is no place, in practice it is a threshold between landfalls. Even Aphrodite, the goddess born of the Ocean after being nurtured in the foam of Uranus's castrated testicles flung to the sea, is washed back to the beach. Yet, if Australia, like Aphrodite, was born of salt and foam, and if most Australians obsessively hug the sandy coastline and play amongst its waves, the beach appears rarely in their dominant mythologies of pioneer settlement and bush. In Adam Lindsay Gordon's poetry, the first to be considered distinctly Australian, the ocean is a melancholy place, with the beach conjuring memories of shipwrecks and death – as was the fashion during the colonial era. If, contrary to this, Australia's golden beaches have for the last 100 years been figured as an austral Eden, deadly sharks and stingers still patrol its waters, and lifesavers its sands. Ocean is a figure of the unconscious; it is displaced in the littoral flotsam which constitute the icons of Australian pleasures; it is condensed as an emblem of the tyranny of distance which marks the odyssey of Australian identity; and it is interiorised in the Australian psyche as the mythological inland sea, now the red Centre which waters the Australian imagination. The ocean may figure little in Australia's formative myths of nationhood, but these myths run over with an oceanic feeling: stories of death and loss, in which the land is more like an ocean to be sailed than a soil in which things take root or a rock on which homes are built. As explorers headed inland on their camels, horses and mules they carried boats. What is repressed here?

Australia's oceanic origins do not literally return us to the sea, but to a repressed genealogy which has taken refuge in the unconsciousness of a nation. Freud described the 'oceanic' feeling as a sublime emotion – a 'sensation of "eternity" … of something limitless, unbounded',[20] and argued that as common as it might be in the religious longings of humankind, it was fundamentally pathological in nature. Oceanic feelings are defensive mechanisms that, in the wake of a weakened or traumatised symbolic order, revive memories of the mother's nurturing

body which, in Elizabeth Grosz's words, is etched like a '"watermark" ...
on the child's body'.[21]

The non-Aboriginal Australian subject is launched upon a sea of
repressions. Its origins are not the physical hardship of sea travel, but
the psychological trauma of leaving home. While initially lost in the
diaspora of Ocean, once in Australia the immigrant is overtaken by the
desire for indigenity. But the desire is not easily satisfied. The migrants'
yearnings barely escaped their oceanic fate. There were no European or
pilgrim fathers here, no ready-made oedipal triangle, only convicts,
Aborigines and what seemed an unforgiving land. Captain Arthur
Phillip sensed this even prior to arriving in New South Wales. 'I would
not wish', he wrote, 'convicts to lay the foundation of an empire'. 'There
can be no slavery in a free land, and consequently no slaves.'[22] In 1836
Charles Darwin confirmed Phillip's fears, diagnosing a topsy-turvy
politics of identity which made convicts 'outwardly honest', 'converting
vagabonds, most useless in one hemisphere into active citizens of
another, and thus giving birth to a new and splendid country – a grand
centre of civilisation'. Darwin's point was that this sham redemption
only condemned Australians to exile, to a vagabond and oceanic
descent. In other words, Darwin pronounced it an Antipodes. He
judged the new colony's prosperity a facade, and 'any real sense of
reform' there a failure, with the possibility of 'any moral reform' being
'quite out of the question'.[23]

Australia's antipodality is a sign of its oceanic origins. Like Ocean, the
Antipodean never *becomes*, never *is*, but is condemned to a perpetual
becoming,[24] a constitutional rootlessness and mobility, an 'in-between-
ness'. But Australians are ordinary people. Most of them do not seek
oceans to traverse, or fabulous quests, but only a destination, a place.
Like all on the advent of subjectivity, Australians yearn to escape their
watery origins and simply *be.* They want to arrive, to possess their own
subjectivity, their own wealth, their own home.

While all the evidence suggests that Australia is a nation long-divided
on the question of origin and identity, one must be careful not to
mythologise this restless ambivalence as a unique mark of Australian-
ness. The anxiety which supposedly characterises Australians is a mani-
festation of a more general anxiety of being – an anxiety which, said
Derrida, will never be expelled. The moment of one's birth, of one's
'nameable identity' is never recoverable because, says Derrida, culture
arranges it this way. 'Identification is a difference to itself, a difference
with/of itself.' For Derrida, a male of Jewish heritage, this difference is
symbolised by circumcision – the 'signature' of an 'other' forever
written on his penis. His scarred penis is his ticket into a community or
social identity. The scar witnesses an 'ineffaceable alliance: birth of the
subject ... rather than biological birth'.[25]

The scar Australians bear is antipodality, of having an identity founded in negativity rather than positivity, in migration rather than indigenity. However, the anxiety of being antipodean is Western. Like Australians, Europeans also are not simply 'the accretion of indigenous material';[26] they, too, bristle with historical differences, both in terms of their many homelands (Irish, Basques, Serbs), and the postcolonial traffic of large-scale migrations that continue today. Second, the very homelessness which characterises the Australian (and colonial) condition is also the defining historical experience of Europeanity – or what Europeans call 'modernity'. Thus, while it has been usual to regard European modernity as the author of colonialism, the tropes of modernism and colonialism as they were played out in Australia during the last 200 years are difficult to disentangle. Both exhibit the same epistemological characteristics: nomadism, alienation and obsessive concern with their own historicity, origin and purity. What Michel Foucault said of European modernity was first expressed in colonialist art and writing: even 'words ceased to intersect with representations and to provide a spontaneous grid for the knowledge of things', 'the being of language itself became, as it were, fragmented', so that there was a 'dispersion of language', and a 'disappearance of discourse'.[27] Ocean is in their blood.

Australia in particular was a site of such disappearance, a vanguard of fragmentation. What is the modernist *flâneur* if not a type of exile, someone who seeks redemption in the oceania of alienation? In this respect Australia is an ideal site for modernists seeking subversive and liberatory texts. Perhaps, in being cast to the ocean, the ideological cement of the Old World was loosened and the very structures and semiological basis of identity were glimpsed. Lotman, whose work on the function of boundaries shows 'the processes whereby the periphery of culture moves into the centre', argues that 'in the frontier areas semiotic processes are intensified because here there are constant invasions from outside'. It 'is a place of incessant dialogue ... there is a constant exchange, a search for a common language, a *kione*, and of creolised semiotic systems'.[28] Perhaps the history of non-Aboriginal Australian painting exposes, in its upturning and reinvention of a Western identity in the antipodes, the very structures of semiological exchange which stage identity. However, if in deconstructing Australia we do uncover the semiological differences which define European identity, I argue that this deconstruction is also an affirmation which repeats European projections of identity and alterity. This was evident from day one. Paul Carter observed that as soon as the First Fleet dropped anchor in Botany Bay, it had to move on in order to maintain an Antipodes in the Antipodes. 'It was', argued Carter, 'precisely by removing from Botany Bay that [Captain Arthur] Phillip constituted

Botany Bay as a place, the first "other" place in the colony. It was in terms of, and in contrast with, this other place that Sydney Cove (and the authority of Phillip) was now, for the first time, defined.'[29] That is, Phillip constituted Sydney Cove as an English place by keeping Botany Bay as the site of the other – as an anti-site. Between Botany Bay and Sydney was an ocean – or as Watkin Tench ironically called it in his early narrative of the penal colony, a 'road'. There is, says Carter, a certain pathos in Tench's road. If he longed for roads which, 'like the highway of reason', would order this antipodean space, the road to Botany Bay was more like the ocean, a palimpsest of rough watery tracks, 'all thick, low woods or shrubberies, barren heaths, and swamps', and it would only be navigable by intimates of its ways.

If the road to Botany Bay seemed to the newly arrived colonists like Ocean, there was an actual road consisting of Aboriginal tracks. 'The road to Botany Bay' said Carter, 'leads back not only to the world of the convicts but also to Australia's first inhabitants, the Aborigines'.[30] Botany Bay, which, according to Tench, comprised an Aboriginal settlement of perhaps sixty people, and was the meeting place of hundreds of Aborigines, was also the first other of Australia. To this day, Botany Bay remains a colloquial term for the penal colony as opposed to the free colony of Sydney, as if these two colonies in one had to be symbolically cleaved. Thus, Sydney quickly built its own penal colony at Norfolk Island, and then in Tasmania which, in turn, built its infamous hell on the west coast of the island, now the site of a Green Arcadia. And the creation of oceans was not stopped, as if once having successfully crossed Ocean, the European invaders had to preserve a space of absolute otherness within the continent. We see it in their conceptions of the inland sea, of an Empty Land and the Dead Heart of the Centre. In 1941, after 450 years of unparalleled global conquest by Europe, Charles Barrett, the Australian frontier journalist, could not see how civilisation, or history, would ever reach into the 'wildest corners of the Untamed Territory': 'white men have ventured, alone, into Arnhem Land, and never been heard of again'.[31] In this respect, Australian culture constructs within its very centre an absolute alterity that stubbornly refuses Lotman's idealised border exchanges as redemptive spaces. In their refusal, in their stubborn antipodality, Australians preserve their origins as European. To be an Antipodean in Australia is to be a European.

Being Antipodean in Australia

Australian subjectivity is founded on age-old Western figures of otherness – the most significant being the notions of the Antipodes and an

austral utopia. This gives Australians a perverse claim to being European. Indeed, a common strategy of Australians who fear their perverse origins is to read the metaphors of an Antipodes and a southern utopia back into classical texts as evidence of an early Greek interest in Australia, as if this guarantees a golden genealogy. According to Arnold Wood (1922), the discovery of Australia 'may begin in a Greek Utopia written by an author named Theopompous about 350 BC', who envisaged a 'Utopia of the South':

> 'certain islands named Europia, Asia, and Libia, which the Ocean sea circumscribeth and compasseth round about; and that without this world there is a continent or parcel of dry land which in greatness is infinite and immeasurable'; and he told of its 'green meadows and pasture plots', its 'big and mighty beasts', its gigantic men, ... its 'many and divers cities, its laws and ordinances clean contrary to ours'.[32]

Sixty years later, J. W. Johnson suggested that the origins of 'Australia' (as an idea) could be traced to classical sources:

> It is strikingly apparent that from Homer on, writers most often turned toward the south to seek the sweet golden climes ... We can find in both the Iliad and Odyssey the precarious balance between the Doric Greek nostalgia for the harsh, demanding life of the past in the north and a yearning for a promising future life in the south ... Homer himself succumbed to the appeal of a remote southern land where perfection might well exist. The land, of course, was Ethiopia, a country geographically real but sufficiently fabled to qualify it as a true utopia.[33]

In this way, Australia is no longer an ocean but is rooted in an heroic classical descent which mitigates, even exonerates the banality and horrors of its colonial origins.

The supposed classical descent of Australia, a mythology which pays scant attention to the actual aspirations of ancient Greeks, is the work of imperial historians who *forget* that neo-classicism was marshalled during the colonial era in the context of the imperatives and ambitions of the epoch of European colonialism (that is, since 1500), not antiquity. Like most genealogies, it is retrospective and fictitious. The Europeans who came to Australia may have imbued the Australian landscape with their education in the classics; but it was an appropriated classicism framed within an Enlightenment epistemology, not the classicism of antiquity. Indeed, the 'austral' trope did not enter Western discourses until the Renaissance period, its supposed privileged place in the classical imagination being wishful thinking on the part of Australian imperial historians. If the ancient Greek imagination located

fabulous and paradisial communities over the horizon, it showed no preference for southern regions. Hesoid's Golden Age and the Blessed Isles were located nowhere in particular. Odyssey journeyed to both paradisial and hellish places in a westerly direction, and Plato's fabled *Atlantis* was also situated in the west. Some of the oldest Greek accounts locate paradisial places to the north.[34] The south was not absent from the early Greek imagination which, in its original Homeric form, envisaged the inner known world as a circular disc divided into northern (Europe) and southern (Asia and Africa) regions of equal sizes, with the south being the site of most fabulous creatures, including those with inverted feet. However, neither Asia or Africa were *terra incognita*, that mythical outer continent beyond the encircling ocean from whence *terra Australis* derives.

If the idea of a distant paradise was a significant concept in antiquity, that of a marvellous southern land was not. Theopompous's story (related by Wood above) is just one of what Frank and Fritzie Manuel called a 'large body of Hellenistic novel utopias'[35] whose sources are ancient myths of paradise and the Golden Age. Theopompous followed an age-old tradition that imagined a nether-continent beyond the seas which fenced the world of islands; just as Plato spoke of that 'opposite continent, which encircles the true outer Ocean' and to which, he said, seafarers from Atlantis could make 'their way' (*Timeaus* 24e–25a). This 'opposite continent' was antipodal, not southern. It lay 'without this world'. Being over the horizon it encircled 'the Ocean sea [which] circumscribeth and compasseth round about the globe'; an outer periphery of a centred cosmos 'which in greatness is infinite and immeasurable' (Theopompous). Even when Aristotle's speculation of a southern inaccessible hemisphere antipodal to the northern hemisphere entered general geographical discourse, antipodality rather than southernness was the main interest.[36] The Roman geographer, Ptolemy, called it *terra incognita*, and in his maps it wrapped around the outer edge of the globe. Hence, this opposite continent was, in all respects, a geographical *frame* for a classical politics of identity. Being an absence it could not be discovered, only imagined.

The great sea voyages of the Renaissance sailors left only one place for this great unknown land, the largely unexplored southern ocean. In Renaissance Ptolemaic maps *terra incognita* is named *terra Australis nondum cognita*, or simply *terra Australis*, an undiscovered land mass whose existence was not dispelled until Cook's second voyage of 1772. Such Renaissance formulations which were in the minds of European explorers who first sought Australia, can not be read back into Theopompous or Ptolemy in order to classicise 'Australia', or to australise the Antipodes.

While the idea of the Antipodes has a long genealogy which has played an important role in the conceptualising of Europe and Australia over the centuries, it is not an unchanging ahistorical concept. Rather, the idea of the Antipodes acquired radically different meanings during the different epochs of Western civilisation. Hence, in tracing the genealogy of antipodality the critic of Australian identity must focus on its historical meanings and specific uses in the period during which Australia was discovered, invaded and settled, and not apply it as an abstract concept.

The idea of the Antipodes has a complex genealogy, in part due to its manifold origins: fabulous creatures dating from Homeric folk lore, including some with inverted feet, though none were named Antipodes;[37] classical Pythagorean geometry; a theological monstrous Antipodes invented during the early medieval period; and a neo-classical Antipodes which was a concept of inversion widely used during the epoch of European colonialism. While these various Antipodes tend to be conflated because they are all Western discourses of otherness, their mechanisms of antipodality constitute separate epistemological fields. For example, the classical concept of antipodality, first glimpsed in Pythagorean cosmography in which 'another body named *antichthon* is the opposite or counterpoise of the world',[38] is quite distinct from the fabulous places and creatures of Homeric mythology – the tales of 'blameless Ethiopians', 'fortunate Hyperboreans', 'righteous Scythians', and fabulous creatures which Romm identified as forms of 'ethno-centric inversion'.[39] Equally, classical notions of antipodality are distinct from medieval and Renaissance concepts.

Since the time of Pythagoras it was accepted by most classical scholars that the earth was spherical. The geometry of spheres provided the theoretical basis of classical concepts of antipodality. Etymologically, a geometer measures the earth, mapping its logical (mathematical) rather than geographical or mythical attributes. As such, geometry was an expression of dialectical and logical thought processes which the philosophers distinguished from mythological narratives. Thus, when the geographer Eratosthenes (b. 276 BC) wrote that 'five encircling zones were girt around' the earth, his conclusion, that 'in them dwelt men antipodal to each other',[40] was the logical outcome of there being a spherical earth. Likewise, when Pliny (b. AD 23) wrote that human beings 'all round the earth ... stand with their feet pointing towards each other' (*Natural History*, II, 65, 161), he was describing the geometry of a spherical earth, not fabulous creatures with inverted feet. He was arguing that the symmetries of geometry annulled difference, that life on the other side of the world was the *same* as here, that the sky was still above one's head, and there was no sensation of being upside-down.

While classical geometry contributed to modern European antipodal metaphors, it was only one influence. Equally important were Christian tropes which, after the shift of the Roman Empire east, quickly undermined age-old classical ideas – including those of geometry. The early Christian rhetorician Lactantius (born sometime before AD 250), who initiated the Christian attack on classical philosophy, is probably responsible for inventing the term Antipodes: 'How is it with those who imagine that there are antipodes opposite to our footsteps?'[41] The term was further popularised by Augustine, Macrobius and Martianus, all of whom were writing in the early fifth century.

If Macrobius and Martianus were largely responsible for transmitting classical geometric notions of antipodality and a spherical earth to the Middle Ages, the early medieval period mainly felt the influence of Augustine, who followed Lactantius by pouring scorn on the idea, mainly because it was contrary to 'Scripture' (*City of God*, 16, 8). However, the Antipodes did reappear in another form countenanced by Augustine. Rejected was classical geometry; invented was the monstrous Antipodes, who were located by Christian theologians in Asia and Africa, not the opposite side of the world. The idea of the monstrous Antipodes, says Rudolf Wittkower, is the invention of Isidore, the Bishop of Seville.[42] In his influential *Etymologies* (c. 630), Isidore followed Augustine in dismissing the existence of 'those who are called Antipodes, because they are believed to be opposite to our feet, so that, being as it were placed beneath the earth, they tread in footsteps that are opposite to our feet' (*Etymologies*, IX, 2, 133). However, while he rejected a geometric Antipodes, Isidore affirmed the existence of the monstrous 'Antipodes in Libya [who] have feet turned backward and eight toes on each foot' (*Etymologies*, X, 3, 24). This is consistent with the thinking of Augustine, who entertained the idea of monstrous races,[43] not as Homeric or classical emblems of ethnocentric difference, but as signs of God's wonder.

When classical antipodal concepts began to infiltrate the late medieval and early Renaissance period, a hybrid classical/Christian cosmology developed in which the Antipodes again became a place on the other side of the world, but a place which was inhabited by wild humans rather than a people who, in accord with the classical notion of a geographic Antipodes, were essentially the same as those in the northern hemisphere.[44] This Wild Man was not imagined according to Christian precepts of wondrousness or Homeric notions of fabulousness, but according to distinct antipodal tropes which were characteristic of modern neo-classical thinking. During Renaissance times, argued Hayden White, 'the Wild Man' became 'endowed with two distinct personalities' that were structured by the same antipodal

opposition (inversion) to the European norm: one of benign innocence, untrammelled desire and an Edenic nature, the other a malign place of punishment and exile, which was more Judaic than Augustinian in tone. No longer 'monstrous', the other becomes 'savage', be it noble or ignoble, and henceforth enters an abstract dialectical relationship with everything European. 'Significantly', writes White, 'during the transitional period between the medieval and the modern ages, many thinkers took a more ambivalent position, on both the desirability of idealising the Wild Man and the possibility of escaping civilisation'; and he cites Montaigne and Shakespeare as classic examples.[45] He could also have named the motives of both colonisation and the transportation of convicts.

No one surpassed Shakespeare in making neo-classical antipodality a mode of thought by which knowledge was organised. He developed a dramatic chiaroscuro in which inversion itself constituted meaning – to an extent that nothing can be taken at face value. In his art things are always pregnant with their contrary. His characters are invariably double-sided – a condition of which Shakespeare takes full advantage in his most visual chiaroscuro, his use of black characters making their way in a white world.[46] With the development of the slave trade, the sexual relations between blacks and whites provided an obvious subject for Shakespeare and other Elizabethan poets to develop antipodal themes. While Africans had always been part of the European consciousness, not until the late sixteenth century, when European colonialism and its attendant slave trade were set in train, was their blackness exploited as a structural chiaroscuro. One of the first examples is Shakespeare's early play, *Titus Andronicus* (*c.* 1590). The centre and tragedy of both *Titus Andronicus* and *Othello* derive from the love between a black man and a white woman, with the very visible passion between Othello and Desdemona transgressing, or at least exceeding, the racial antipodality which structured the ethical order of 'Europe'. So successful is Shakespeare that Othello remains to this day the most ambivalent of Shakespeare's characters; critics unable to decide if he is the 'noble Moor', 'a hero' in the mould of the ancients who acts from 'inner necessity', a 'self-made man', the archetypal 'stranger',[47] or an 'erring barbarian', a 'credulous fool', an 'undeveloped mind', the 'savage Othello', a 'primitive type'.[48] Whether Othello is savage or civilised, or savage and civilised, the plot is so full of contraries to the day that it can only be an Antipodes, a world upside-down: a 'Christian African is pitted against a diabolical white [Iago] who lusts after his [Othello's] wife ... [and] an honourable and self-restrained African of modest sexual inclinations and ability is yoked to a youthful, white female who publicly reveals a bold sexual appetite'.[49]

The (imaginative) sexual relations between white- and black-skinned people was only a minor example of the widespread use of antipodal metaphors in the Renaissance and its aftermath. Writing about the English Renaissance, Ian Donaldson commented that 'the feeling of Saturnalia is abroad'. He observed that in the sixteenth and seventeenth centuries '*to act the antipodes* had become a proverbial expression'. He cited an 'anonymous writer lamenting the upheavals of the [English] civil war': 'But now the world is turned upside downe, and all are acting the antipodes, young boys commande old Souldiers, wise men stand cap in hand to fine fools, maidens woe widows, married women rule their husbands'.[50] The same desire to act the antipodes provided the moral terms for a type of punishment never before seen in the world. Transportation, as it was called, constituted a legally sanctioned salvation in which the condemned were exiled to the Antipodes – at first Virginia and then New South Wales.

Transportation was the invention of the modern period. While during the Middle Ages 'persons could be forced to abjure the realm', it was a rare event mainly used for political expediency against noblemen.[51] If medieval courts had frequently banished 'non-resident troublemakers' to the next county,[52] it was not, like transportation, a form of exile and bondage.[53] The social change most pertinent to the development of transportation was, besides the demand for cheap labour in the colonies, the criminalising of the poor during the Renaissance period. Medieval attitudes to the poor had been tolerant, and played an important role in notions of Christian piety and charity. However, after 1500 attitudes changed. The poor, the idle and the vagrant – all signs of a social melancholy – were forced into work houses, and on to galleys and colonial plantations.[54] This shift in criminology included a 'dramatic increase in the number of statutes' and 'the regular appearance of all sorts of corporeal punishment'. The majority of the new statutes concerned vagrancy and its punishment by various forms of enforced confinement. Vagabondage, which like the ocean was an unreasonable fluidity, became 'a major crime'.[55] By the mid-sixteenth century vagabonds constituted the largest body of criminals yet to inhabit Europe. In 1530 Henry VIII instituted the 'Whipping Act', which directed that vagrants were to be 'tied to the end of a cart naked, and beaten with whips throughout the market town, or other place, till the body shall be bloody by reason of such whipping' – after which they had to take an oath to return to their previous residence, or to their native place. Whipping posts were erected throughout England alongside the stocks. In 1547 an Act was passed which 'allowed any person offering them [vagrants] work which they refused, was authorised to brand them on the breast with a V, hold them in slavery for two years,

feed them on bread and water, and hire them out to others'.[56] It was followed in 1555 by building houses of correction. In 1598 parliament instituted transportation. In the seventeenth and eighteenth centuries 'contractors carried away the troublesome and the unwanted without cost to the Government and sold their services to the planters',[57] just as they did slaves from Africa. 'More than half the persons transported were in their twenties and four-fifths were male.'[58]

Transportation might seem a poetic reward for vagabondage. However, it was not meant to mimic vagrancy, but to invert it through a form of slavery in which the condemned endured forced labour in open-air prisons. By 1755, wrote A. G. L. Shaw, it was 'a major ingredient of English criminal law'. 'As the century progressed', wrote Pieter Spierenburg, 'more and more received sentences of transportation, so that by 1772 three-fifths of male convicts were transported (women were transported less often during every period). Imprisonment, meanwhile, was statistically insignificant during the first half of the century'.[59]

If transportation is the invention of the seventeenth and eighteenth centuries, the prison is the invention of the nineteenth century. While the development of prisons can be traced to early Babylonian times, and while the number of prisons and imprisonable offences increased in Europe after the Middle Ages, their uses were very different to the modern prison. For example, Newgate, built in London during the late twelfth century, was primarily for holding debtors and those waiting trial or sentencing; but it was not a place of punishment. In England, which developed prisons relatively late, punishment was either the gallows or transportation. Thus, Newgate was a threshold, a border zone, Ocean. Within its walls, argued John Bender, the world was turned upside-down, all the 'customary categories' were confused, 'sites at once of misery and hilarity, punishment and immorality, death and generation'. It was a type of Antipodes within England: 'There he that yesterday was great, today is mean; he that was well-fed abroad, there starves: he that was richly clad, is stark naked; he that commanded, obeys'.[60]

This is how Moll Flanders describes her entry into Newgate before transportation to the colony of Virginia:

> 'tis impossible to describe the terror of my mind, when I was first brought in, and when I looked around on all the horrors of that dismal place, I looked on myself as lost, and that I had nothing to think of but of going out of the world . . . the hellish noise, the roaring, swearing, and clamour, the stench and nastiness, and all the dreadful crowd of afflicting things that I saw there, joined together to make the place seem an emblem of hell itself, and a kind of entrance into it.
> . . . These things poured themselves in upon my thoughts in a confused manner, and left me overwhelmed with melancholy and despair.[61]

Daniel Defoe's *Moll Flanders* (1722) is an exemplary tale of the nexus between Enlightenment, criminology, colonialism and redemption: a criminal born in Newgate prison, transported to Virginia where, after a life of transgression, she eventually makes good as a wealthy plantation owner, and retires to England fabulously wealthy. Defoe called his novel a 'history' because it is cast as a narrative that has 'virtuous and religious uses'. Moll's eventual virtue is measured by the radical inversion of her initial melancholy. Defoe explained: 'to give the history of a wicked life repented of, necessarily requires that the wicked part should be made as wicked as the real history of it will bear, to illustrate and give a beauty to the penitent part'.[62]

This, too, was the narrative structure of 'Botany Bay' which, like Newgate, was blessed with a name that delineated its redemptive mission as much as it belied the horror of the place. If colonial Australia is largely a creation of the nineteenth century, it was imagined in the seventeenth and eighteenth centuries. In this respect Botany Bay was the last and penultimate Newgate planned during a period of penal reform which aimed to replace transportation with modern prisons. However, due to the unacceptable expenses and difficulties of building a modern penitentiary, convicts were sent to New South Wales.

Botany Bay was a type of prison never seen before – and one with unexpected, and for some, unacceptable results. While the transporting of convicts to the colonies was a long-established practice by 1788, John Hirst points out that Australia is the only place where convicts were 'sent to found the society in which they were to endure their punishment'. 'New South Wales started as a colony peopled by convicts and ex-convicts.' The police force, overseers and even some magistrates were drawn from the convict and ex-convict population. Convicts were even awarded the right to give evidence in court and to sue, and enjoyed rights enforced by the government – including safe passage to Australia. It was safer, said Hirst, to be transported to New South Wales than to migrate to the United States. Private punishment by masters to whom convicts were assigned was forbidden – whereas in 'America masters had beaten convicts, and in Britain corporal punishment was still a central part of household discipline'.[63] Thus, to many, New South Wales was not a place of punishment but a Cockaigne land where even servants might dine at the master's table. Even worse, argued Jeremy Bentham in his pamphlet 'Panopticon versus New South Wales' (1802), it was a site of disorder where all modern practices of reason and moral values were inverted. But whatever the reasons were for and against transporting convicts to Botany Bay, the decision had the sanction of a whole way of thinking, for Australia had always been, to Europeans, an antipodal place.

CHAPTER 2

Artful Killings

While those drawing up the plan for a penal colony at Botany Bay could refer to the experience of over two hundred years of Western colonisation, the idea of a penal colony as opposed to a colony of free settlers was new and untried. Perhaps this is one reason why the colony's quick transformation into a settler colony was inevitable. However, the main reason was a psychological imperative to find redemption in the Antipodes. This meant that, in its very discovery, the place had to be remade as ocean, as *terra nullius*, as a site of invasion and utopia. The colony's limited penal purpose was quickly foreclosed. At the end of 1791 Arthur Phillip advised that New South Wales would only survive if it was a traditional colony of free settlers using convicts as slave labour, and recommended that land be granted to members of the New South Wales Corps to ensure this change. The next year the British government 'was converted to Phillip's views'. 'Such', wrote Hughes, 'was the germ of the assignment system, the modified form of slavery on which Australia's early economy would be built'.[1] John Black argues that the officers of the New South Wales Corps provided the capital for the colony's economy at a time when such practices were an accepted part of army culture. They 'were the first entrepreneurs of Australia of whom the Kerry Packers, Michael Edwards and Rupert Murdochs are descendants'.[2] Within a few years, the New South Wales Corps had lit the fuse for the prison's rapid explosion into a settler colony. With it the mantle of otherness passed from the convicts to the Aborigines, signalling the transformation of a prison into settlement, and a politics of exile to one of invasion. It was then, with the penal colony now also a settler colony, that the invasion started in earnest, and Aborigines were slaughtered without remorse. The colony never looked back. In 1844 William Charles Wentworth, the native-born son of an emancipist, zealot for a 'free' Australia, and

advocate of squattocracy, put plainly what has been the policy of all settler societies during the epoch of colonialism: 'the civilised people had come in and the savage must go back ... it was not the policy of a wise government to attempt the perpetuation of the aboriginal race ... They must give way before the arms, aye! even the diseases of civilised nations'.[3]

Even those who hoped that Aborigines could be civilised, such as the 'saviour' of the Tasmanian Aborigines, George Augustus Robinson, believed that the civilised people had come in and the savage must go back. For Robinson, the savage could be exorcised from the Aborigine through a rigid religious education and the rigorous enforcement of English social habits. This transfiguration by civilisation was an aesthetic means of killing Aborigines. To kill by art destroys, more than anything else, a way of life. The organising trope of this ethnocide is melancholy.

Melancholy and the Colonial Imagination

Because melancholy is a fundamental trait of the colonial imagination I am considering melancholy as a 'linguistic mode' 'that is more tropical than logical',[4] and not as a particular ailment. This might seem empirically inadmissible to those who usually study melancholia. Julia Kristeva, for whom melancholia is a specific medical condition, defines it as a *'noncommunicable* grief' (my emphasis) caused by a 'phylogenetic inheritance' that originates in the realm of the 'presign', 'prelanguage' or 'asymbolia'. Yet Kristeva's very explanation (figuring) of melancholia is forged in a linguistic trope that joins language and biology in a difference that is typical of what I call the melancholy trope. She assigns semiology (language) to love and joy, and the imagination to melancholy, animality and sadness.[5]

Even when artists and writers are afflicted with the blues, my concern is the way melancholy is used in their texts as a tropic formation or poetic closure for expressing social and ideological positions that exceed their own personal angst. Bernard Smith did exactly this when he argued that Old World values persisted in framing the conception of Australia: 'Australia is once again a land of monstrous prodigies and antipodal inversions'; and, he concluded, even amongst the 'native-born', 'the virgin Australian landscape ... still inspired melancholy feelings'.[6]

Since its initial conception in Hippocratic medicine, melancholy has been one element of a tetradic system in which the body was conceived as a dynamic balance of four parts, or humours as they were called – blood, yellow bile, black bile and phlegm. The humours were the basic building blocks of life in all its forms, and their relations matched the four basic temperaments, the four ages of mankind, the four seasons,

the four basic elements and, according to Michele Savonarola, four animals: blood (sanguine youth, spring, air, ape); yellow bile (choleric prime, summer, fire, lion); black bile (melancholic decline, autumn, earth, swine); phlegm (phlegmatic old age, winter, water, lamb).[7] The same tetradic scheme is used by Giambattista Vico to argue that 'there were four principal tropes from which all figures of speech are derived', each corresponding to 'the cycles through which consciousness' and 'civilisation' 'passed': 'metaphor (the age of gods), metonymy (the age of heroes), synecdoche (the age of men), and irony (the age of decadence)'.[8] In *The Course of Empire* (1833–6) series of paintings, Thomas Cole imagined the progress of empire according to a similar scheme: *The Arcadian or Pastoral State, The Consummation of Empire, Destruction* and *Desolation*.[9]

Of the four humours, melancholy attracted the most attention amongst humanists because at its heart was a paradox which put the power of redemption into the human sphere. Unlike the other humours, melancholy was characterised by mental changes which marked a threshold between insanity and genius, utter loss and salvation. The idea is fundamental to understanding Western post-Renaissance culture. Aristotle's notion of melancholy being the realm in which the extremes of genius and madness are held in a dialectical balance is pivotal to Renaissance humanist philosophy, and the reason for the ascendancy of the melancholy trope in its aesthetic practices. 'Why is it', wrote Aristotle, 'that all those who have become eminent in philosophy or politics or the arts are clearly melancholics, and some of them to an extent to be affected by the disease caused by black bile?' (Problem XXX).

While this paradox was not important in medieval times when melancholy was believed to be unequivocally Satan's sign, it became a central characteristic of the Renaissance. Then the relationship which Aristotle drew between melancholy and genius was at the core of human-ist ideology and its redemptive vision of creative genius overcoming a morbid constitution.[10] For example, the redeeming vision of Italy's triumphant baroque churches decorated in South American gold emanates from their endless images of sad Madonnas and tortured Christs. 'Despite all its beauty and moderation', Friedrich Nietzsche wrote, the classical mind 'rested on a hidden substratum of suffering' which impels us 'to realise the redeeming vision'. Thus, the 'beauty' of civilisation 'is by no means a simple condition that comes into being naturally'. It is not 'like a terrestrial paradise ... found at the gate of every culture', but is 'rooted in some deficiency, privation, melancholy, pain'.[11]

The exemplary Renaissance representation of melancholy is Albrecht Dürer's engraving, *Melencolia 1*. Dürer alerts us to Aristotle's paradox in the dialectic he established between the conventional medieval attributes

of melancholy – avarice (the keys and purse), lethargy, a dark, brooding mood (the black, staring face) – and classical humanist emblems of genius – namely, depicting Melancholy as a geometer, scholar and craftswoman.[12] For Dürer, melancholia is not Satan's sign but the promise of redemption. He pictures this in the strange events occurring in the distant sky, in which the *horizon* is crowned with a blazing portentous comet and the arc of a rainbow. The rainbow is usually associated with images of redemption – it forms the throne of Christ the Judge, and God set a rainbow in the sky after the Flood. In Greek mythology, the goddess Iris descended on a rainbow to the melancholy palace of Sleep in order to waken the God of slumber and his power of dreaming. Within this scheme, Dürer pictures Iris as the nocturnal animal (the bat) sent to waken the figure of Melancholy, in order to greet the dawning age from over the horizon.

Melencolia 1 was drawn in 1514, in the midst of groundbreaking European voyages that had for the first time opened up the Atlantic and Pacific oceans to European adventurers. Dürer seems to allude to these portentous events in the very perspective of the picture – the whole space of the engraving being structured around a severe perspective that takes our eye straight to the ocean's horizon, straight to utopia. He depicts Melancholy as a utopian; she gazes into the heavens, her tools lying about her as she contemplates the ideal geometry of the polyhedron and sphere. In one sense she is a visionary dreaming of a new order – though it is her very dreaming which signifies her immobility and melancholia. The modern melancholic discovers an immortality in the oceans of his or her mind, and often, in the ocean itself. An oceanic history became the stage of transcendence. The sea, long the emblem of death, the infinite, the passage to the other, also became in the Renaissance the domain of salvation. Columbus's discovery, Jack Lindsay observed, 'was to start off the writing of Utopias . . . [Thomas More's] narrator was a "sea traveller met in Antwerp". In Campanella's *City of the Sun* [1602] . . . a Genoese sea-captain [just returned from the far East] tells the story; and [Francis] Bacon's *New Atlantis* [1626] began, "We sailed from Peru"'.[13] James Harrington named his utopia *Oceana* (1659), and Defoe set his utopia, *Robinson Crusoe* (1719), on an island off the coast of South America. In all of these the ocean does not map the limits or edge of the world, but signifies the sort of limitless transcendence found in baroque paintings, where the eye is always disappearing over the horizon. However, this disappearing is not an escape from the real, but a means of incorporating the other into the real. Utopias and their development in travel narratives, says Louis Martin, bring the new world into the old, the infinite into the finite, Oceania into the home. Consequently, argued Martin, utopias are thresholds, liminal in-between places, neutral zones in which dif-

ferences might be reconciled.[14] Here the Aristotelian balance might be restored. That is, utopias offer imagined cures for contemporary social ills. In the seventeenth and eighteenth centuries colonialism put this imagination into practice.

The most influential writer on melancholy in the seventeenth century was the astrologer Richard Burton who, feeling 'offended' by 'my Mistres Melancholy', undertook his study of melancholia to 'make an Antidote out of that which was the prime cause of my disease'.[15] His book, in the main a compilation of symptoms, is framed by a utopia which outlines the tropic purpose of his discourse. Here he also suggests that colonialism is the political means by which melancholy is purged from the social body and its balance restored. Britons, he wrote, were 'once as uncivill as they are in Virginia, yet by the planting of Colonies and good laws [by the Romans], they became from barbarous outlaws to be full of rich and populous Cities'. 'Even so', he continued, 'might *Virginia*, and those wild *Irish* have been civilized long since, if that order had beene heretofore taken, which now begins of planting Colonies'. Colonialism cured melancholy by surgically removing its main symptoms – idleness and vagabondage: 'Idle drones ... Rogues, Beggars, Egyptian Vagabonds' need to be 'purged from a Common-wealth, as a bad humour from the body, that are like so many Ulcers and Boiles, and must be cured before the Melancholy body can be eased'. It may, said Burton, 'be in *Terra Australis Incognita*, there is roome enough ... or else one of those floating islands in the *Mare del Zur* ... There is roome enough in the inner parts of *America* and the Northerne coasts of *Asia*'.[16]

Burton is well aware that his utopia, which he describes in some detail, is a literary conceit, in effect, a satire – and indeed, a satire on utopias. In this respect, his utopia is a type of Elizabethan comedy. It bears comparison with the contemporaneous comedies of Richard Brome, whose comic formulas of inversion ('the World's turn'd prodigall', 'turn'd/ Quite upside downe')[17] were the means of orchestrating a redemptive psychic journey. This is particularly evident in Brome's play, *The Antipodes*, in which the central character, Peregrine Joyless who, as his name suggests, is afflicted with the contradictory emotions of 'travelling thoughts' and lethargy, is cured by an imaginary sojourn in the Antipodes.

Burton's and Brome's writings are prophetic documents which reflect the penal reform of their times. In 1598 the English Parliament had followed the examples of Portugal, Spain and France by ruling that criminals and vagrants could be used as colonisers. Transportation began to Virginia in 1607, but it did not begin in earnest until the latter half of the century. This is the social context of Burton's claim that we need 'Citties of correction', not 'Houses of correction', and his praise of Spain, which deported criminals, mainly vagabonds, to work the mines of South

America.[18] Thus, it is not surprising that for the next 200 years melancholy was a meta-trope of colonialism: melancholy was the diagnosis, colonialism the medicine, utopia the body redeemed.

If Burton and Brome mobilise the same symmetrical inversions, whose body was redeemed remained an open question. While Burton makes the colonies a hell so that the social body of England can be a heaven, Brome makes the Antipodes a utopia so that Peregine Joyless's individual melancholy can be saved. The same contradictory attitude towards the colonies prevailed throughout the eighteenth century. For example, in 1756 Charles de Brosses reiterated Burton's scheme when he suggested the establishment of a French penal colony in New Britain: 'the political body, like the human body, has vicious humours which should often be evacuated'.[19] So did the *London Chronicle* in January 1788, when it wrote that Botany Bay is 'a drain for its [Britain's] more degraded inhabitants'.[20] On the other hand, Botany Bay was also imagined as a type of utopia in which one might, like Peregine Joyless, make good. However, for those who migrated or were transported to the Australian colonies it didn't really matter whether Australia was a utopia or dystopia – either way they were at a primary site of melancholy.

Melancholy in Australian Colonial Art

When the exploration and settlement of Australia got fully underway after the 1830s, the aesthetic conventions for the art of exploration and colonial settlements were well established. Mainly derived from the *plein-air* and landscape art of the eighteenth and early nineteenth centuries, they included a medley of styles ranging from neo-classicism to romanticism, all of which functioned under the sign of Saturn (or melancholy). Bernard Smith would also want to add the empirical demands of the topographical arts as a convention in its own right.

According to Smith, the scientific imperatives of eighteenth century Pacific explorers wrested art from the religious and neo-classical values of the art academies, transforming it into a scientific discourse that presaged romanticism and modernism.[21] However, if the art of eighteenth century exploration is the handmaiden of science, it nevertheless employs the aesthetic conventions of the day. Indeed, the very success of these conventions in posing as scientific topographical surveys is directly proportional to their success as myth. Take the example of the exemplary British explorer artist, William Hodges, who accompanied Cook on his second voyage. According to Smith, Hodges' paintings are 'fearless attempts to break with neo-classical formulas and to paint with a natural vision'.[22] While there is no doubt that Hodges developed the *plein-air* practices he had learnt from Richard Wilson into a naturalistic

vision, like Wilson he put his empirical observations in the service of a higher god, lending to his pictures a psychic temper and moralism typical of the day. If Hodges' *View of the Cape of Good Hope, taken on the spot, from on board the* Resolution (1772) is, as Smith claims, a faithful and naturalistic account of the typical weather conditions prevailing during the expedition's stay at the Cape,[23] it is only half the story. The painting also expresses the anxieties of the artist about to embark on a long journey towards the south pole – especially considering that Hodges' previous experience had only included painting trips to popular picturesque sites in Europe. Like Claude and Wilson before him, Hodges exceeds the naturalism of the genre to make landscape a type of history painting capable of transmitting moral values – here, ones which ex-pressed both his own anxieties and the heroic and sublime temper of exploration to exotic places. The main figurative means used to transmit moral values in the late eighteenth and early nineteenth centuries were the beautiful and its opposite aesthetic concepts: the sublime, the picturesque and the grotesque. These three oppositional metaphors are essential to colonial cultures, for each is centred on the idea of wilder-ness which, from its etymological root 'wilder', means the condition of wandering.[24] Not only were their practitioners, like Hodges, generally great wanderers, but their art advocated the wandering line as against the straight lines of beauty and reason.

While elements of the sublime, the picturesque and the grotesque are, due to their common parentage, often applied to a similar land-scape, and indeed, are used in confusing ways, in colonial spaces they each served specific ideological purposes. The sublime is the principal aesthetic trope of exploration, the grotesque of invasion and the pic-turesque of settlement. The sublime pacifies the unknown or newly discovered by making it an empty, silent ahistorical space, a virgin stage ready to be occupied. However, the sublime cannot be improved; it is outside of history and so immune to progress. Its purpose is the *suspension* of terror and strangeness. When this spell is broken by colonisation, the silent, still bush and its inhabitants enter history, ready for picturesque improvement and progress. For example, recounting his tour of the United States' 'wilderness' during the early 1830s, the Frenchman Alexis de Tocqueville applied a sublime aesthetic to produce an ethical defence of colonialism: 'I came back to the banks of the stream and could not forbear stopping a few minutes in admiration of the sublime horror of the scene ... No other sound, no breath of life, broke the silence of this solitude'. But later, 'we were woken from our reverie by a gun shot that suddenly echoed through the woods ... It might have been the long, fearsome war cry of civilisation on the march ... In but a few years these impenetrable forests will have fallen'. If 'this

consciousness of destruction … gives … such a touching beauty to the
solitudes of America', it was, continued de Tocqueville, 'a melancholy
pleasure', because 'thoughts of the savage, natural splendour that is
going to come to an end become mingled with splendid anticipation of
the triumphant march of civilisation'.[25]

Hodges pictures the Pacific in a similar way. In *Waterfall in Dusky Bay,
New Zealand* (1773 or 1776), awe-inspiring cliffs tower over a primeval
inlet. Whatever Hodges' scientific motives in painting *Waterfall in Dusky
Bay*, Smith acknowledges that 'its dreamy evocation of the romantic
scenery anticipates in several ways the mood of early romantic painting
and poetry, of Turner, Wordsworth and Shelley'.[26] Indeed, Hodges dis-
covered in Tahiti ethereal scenes of a pure sublimity which more than
matched its bucolic reputation. However, the larger paintings completed
at the end of the voyage strike a sombre note. In *Tahiti Revisited* (1776),
the voluptuous Tahitian bathers offer no Arcadian dream: The 'image
of a pagan god (*tii*)' towers over them, and behind them is 'an ele-
vated platform (*tupapau*) with a shrouded corpse'.[27] Paradise inevitably
becomes a Paradise Lost. Tahiti, a figure of Paradise, 'also quickly took
on vanitas associations and was from the beginning evoked by poets
and artists as a "tainted paradise" whose rewards, "physical, fitful, and
transient", signified the ephemerality of earthly pleasures' (Varnedoe).[28]
No matter how empirical Hodges' paintings may be, they are consistent
with the ethic of colonialism which, in imagining a Paradise, saw a
Paradise lost, and so one for the taking.

While the ahistorical metaphors of silence and stillness that constitute
the sublime aesthetic are well suited to the art of exploration, they are
inappropriate to the art of invasion and settlement. The march of civil-
isation is a noisy grotesque affair which plunges the place into history,
and the coloniser and colonised into a perpetual war. In Australia the fall
happened on the first day of landing at Sydney Cove, described here by
David Collins, the first Judge Advocate of New South Wales:

> The spot chosen … was at the head of the cove, near the run of fresh water,
> which stole silently along through a very thick wood, the stillness of which had
> then, for the first time since the creation, been interrupted by the rude sound
> of the labourer's axe, and the downfall of its ancient inhabitants; – a stillness
> and tranquillity which from that day were to give place to the voice of labour,
> the confusion of camps and towns.[29]

The landing at Sydney Cove resulted in an epistemic shift more rapid
and profound than any imagined by Michel Foucault. The art of
exploration gave way to that of invasion; and with it, the sublime made
way for the grotesque.

The grotesque, the most extreme expression of melancholy, belongs to that great parade of legend, fable and phantasmagoria which, down the ages, have been the icons of absolute otherness. Like a decorative fringe, the grotesque marks the boundary of Western reason, the outermost margin where reason begins to break up into disparate idiosyncrasies and aberrations. However, this margin also haunts the centre of reason and Enlightenment as the non-identical which erupts within language and symbol. The grotesque both excludes unwanted elements and provides the ground for a redemptive ideology which, in accord with the melancholy trope, dialectically overcomes the horror of the scene.

The grotesque is the dominant aesthetic used in the first years of the colony. This is not surprising. The colonists' tasks, after all, were daunting: to make a prison on an inhospitable tract of land at the other end of the world with the most precarious line of supply and communication, and in the company of a large body of criminals and at times hostile natives. The apprehension of Midshipman George Raper is obvious enough in his watercolour *The Melancholy Loss of His Majesty's Ship Sirius ...* (1790), in which the tangled masts of the lifeline to home collapse into the weird snakelike waves. Raper experiences the same unease when he ventured close to the cliffs of Port Jackson. And once on shore, the English artists showed a grotesque, deformed race comically strutting in a strange land. By contrast, a few years later French artists with Baudin's exploration party made sympathetic studies of Aborigines and their environs which showed a proud, dignified stoic people.

While Baudin's professionally trained artists were better equipped than their English counterparts to ennoble their subjects, the most important difference, I contend, was not the relative merits and skills of the French and English artists, but the moral frame of their expeditions. Baudin was an explorer serving science. The neo-classical style of his artists both precisely delineated their subjects, and produced an effect akin to the sublime, transforming them into a stoic silent people. The First Fleet, however, was comprised of convicts, marines and naval men, colonists who had the unenviable task of establishing a prison in the Antipodes. If, as Bernard Smith argues, these works generally meet the empirical demands of science, they are tarnished by a gothic sensibility which mark them as grotesque texts. The imaginative purposes of the artists are unmistakable.

The bulk of paintings made in the first years of the colony are by the convict artist Thomas Watling, and an unknown painter (or painters) whom Bernard Smith called the 'Port Jackson Painter'. The gothic qualities of their works bear witness to the antipodal and grotesque characteristics which, it was believed, were typical of the place. It constitutes, wrote Watling, 'an inversion in nature as is hitherto unknown'.

Such perceptions are particularly stark in the compelling portraits of Balloderee and Gna.na.gna.na. by the Port Jackson Painter, which seem deliberately intent on conveying the perceived fierceness, horror and exoticism of Aborigines. Watling described the 'barbarian New Hollander' in these terms: 'Irascibility, ferocity, cunning, treachery, revenge, filth, and immodesty, are strikingly their dark characteristics – their virtues are so far from conspicuous, that I have not, as yet, been able to discern them'.[30]

The same exaggerated grotesquerie is applied to the occasional views of the harbour, such as *Grotto Point in the entrance of Port Jackson*. For Watling, it seemed, the shadow of Saturn was so dark that redemption seemed impossible. In his words:

> When this gloom ['of melancholy's sombre shadow louring over my soul'] frowns dreadful over the vista of my being, I but too much indulge the dreary prospect – exploring the wide domain of adversity terminated only by impending darkness; – hence it is, that whatever flows from my pen, or is laboured by my pencil, affects, in some degree, the tone of mind that possess [sic] me.[31]

It was, suggested Ross Gibson, 'the earliest attempt ... to write an Australian aesthetics'. Its subject, the psychology of exile, and its two principal motifs, landscape and Aborigines, set the pattern for the dominant themes of Australian art to this day. In Gibson's words, it is 'the first chapter in a long autobiography of a bastard nation'.[32]

Watling was unable to reinscribe Port Jackson as familiar. Trained in the picturesque aesthetic, he attempted to employ its subtle codes to create moral landscapes. However, he explained, 'the landscape painter, may in vain seek here [in Port Jackson] for that beauty which arises from happy-opposed offscapes'. In the Antipodes nature itself seemed rebellious. The failure of Watling to impose his aesthetic on the landscape, to make from it an unambiguous and convincing moral order or ideology, as John Constable did of the English landscape, is Watling's most original contribution to Australian art.

While it might be tempting to explain the failure of the picturesque in early Australian colonial art to Watling's melancholy predicament, his experience seems to have been shared by all the Europeans of the colony, or at least the educated ones whose textual records are readily available. Watling's melancholic sensibility proclaims his education as much as it does his fate. He writes in the tradition of Enlightenment in which educated men peppered their observation with allusions to the fashionable idea of paradise lost. In this, his assessment is little different to that of the free men in the colony. Like them, Watling was alert to the extrinsic differences (how different it was from home) but unable to see

its internal order: 'though there are a variety of objects to exercise the imagination, yet such a sameness runs through the whole of the animal and vegetable creation of *New South Wales*'.[33]

Watling's conclusion was a familiar one: 'the face of the country is deceitful'.[34] David Collins' attitude was much the same. On first arriving he saw the 'most noble and capacious harbour, equal if not superior to any yet known in the world'. However, when a year later he was contemplating the bushy interior of its peninsulas, he was 'struck with horror at the bare idea of being lost in them': 'It is certain, that if destroyed by no other means, insanity would accelerate the miserable end that must ensue'.[35] Even the sensitive Watkin Tench, who knew and loved the bushy environs of Port Jackson better than any other European at the time, warns the reader:

> The first impressions made on a stranger is certainly favourable. He sees gently rolling hills, connected by vales which possess every beauty that verdure of trees, and form, simply considered in itself, can produce; but he looks in vain for those murmuring rills and refreshing springs, which fructify and embellish more happy lands.[36]

It was inevitable that this small colony of Western people, educated according to the tropes of the colonial epoch, would, when establishing a bridgehead of Western civilisation on an isolated alien shore, 'other' the indigenous environment and its inhabitants, and in doing so, picture them in grotesque terms. However laudable Phillip's anthropological and botanical aspirations, they could not resist the imperatives of invasion. In less than three years his benign attitudes to Aborigines had transformed into a conquistador's campaign of terror. By December 1790 he had become frustrated at the increasingly violent resistance by the Aborigines. Quoting Phillip, Tench reported the launching of an official campaign 'to infuse an universal terror' amongst the Aborigines 'in order, at once to convince them of our superiority' and 'strike a decisive blow'. This remained common practice on the frontiers of settlement as they slowly advanced across the continent – an advance which continued well into the twentieth century.

Terror is an artful game in the grotesque genre. Its purpose is primarily psychological. At its best, terror mixes a macabre humour with theatrical effect. Take the example of the Aborigine lynched for stealing corn. He was hanged by the neck from a tree with a corn cob stuck in his mouth, and the body left to rot as a mock-scarecrow.[37] The grotesque theatre extended to the shooting of Aborigines as pests, as sport, for target practice and for dog food. In the mid-nineteenth century the historian John West reported from Launceston, Tasmania:

> The smoke of a fire was the signal for a black hunt. The sportsmen having taken up their positions, perhaps on a precipitous hill, would first discharge their guns, then rush towards the fires, and sweep away the whole party. The wounded were brained; and the infants cast into the flames; the musket was driven into the quivering flesh; and the social fire, around which the natives gathered to slumber, became, before morning, their funeral pile.[38]

Such atrocities were not just designed to kill Aborigines, but to cast them into hell. This aim was entirely predictable, for it had been the pattern of European colonialism since the sixteenth century. Las Casas had first observed it in 1542: 'the indigenous peoples' of South America, 'naturally so gentle, so peace-loving, so humble and so docile', were not just conquered, but dealt the most grotesque hand, resulting in 'excesses' and 'enormous loss of life'.[39] West witnessed this same narrative repeat itself 300 years later: at first the colonists

> are charmed by their [the natives] simplicity; they sleep among them without fear; but these notes soon change; and passing from censure to hatred, they speak of them as improvident, importunate, and intrusive; as rapacious and mischievous; then as treacherous and blood thirsty – finally, as devils, and beasts of prey ... a detested incubus.[39]

So herded into creek beds and driven over cliffs, Aborigines were run down in revengeful fits by Europeans who then named these sites as if to commemorate their grotesque acts: 'Slaughterhouse Creek', 'Graves-end', 'Murdering Island', 'Skull Camp'.[40]

The grotesque aesthetic effectively made Aborigines taboo, their very existence a transgressive moment in the European legend. This is why so much effort was expended by Europeans in arguing over the ways in which a people, already presumed fossilised, were to die. Aborigines had to die in especially grotesque ways that marked their race anachronistic, and their anachronism had to be impressed upon their remaining life. Dead or alive, they were branded a race cast aside by history. Even to hang an Aborigine as if a European did not acknowledge symbolically the differences which defined civilisation, and even civilised warfare.

The grotesque is seemingly beyond redemption. During the counter-Reformation it had been sanctioned for the allegorical depiction of 'the hideous face of Hell and the tortures of the damned'.[42] Thus, the grotesque 'acquired a pejorative implication as something monstrous, unnatural, ridiculous'.[43] If the sheer horror of the grotesque makes it a close relation of the sublime, the sublime is the first step towards redemption from the depths of the grotesque. When the sublime became fashionable in the eighteenth century, places previously considered grotesque, such as mountain peaks, became exemplary sites of the sublime. However, if the grotesque conjures up an evil beyond redemption, the

meta-trope of melancholy garners it into a redemptive scheme as the other or non-identical of goodness.[44] Geoffrey Harpham points out that without the moral and rational order of Enlightenment, the key components of the grotesque are ineffective.[45] This is clear in Peter Cunningham's intentionally comic description (in 1827) of Aborigines, their 'abject state', placing 'them at the very zero of civilisation':

> some of the old women only seem to require a tail to complete the identity; . . . The quick and hurried movements and gestures of many of our natives, seem indeed closely allied to those of wild animals of the forest; the sudden bobbing-twist they give their heads, and comical ape-like mode of raising their hands as eye-screens, when looking upwards at the sun . . . resemble more the motion of some of our wild four-legged, than those of our civilised two-legged animals.[46]

For all its cruel horror, Cunningham's description of Aborigines is intentionally comic, his joke being 'an attempt to invoke and subdue the demonic aspects of the world'[47] – what Wolfgang Kayser and Mikhail Bakhtin regarded as the quintessential purpose of the grotesque. The psychological function of the grotesque joke is redemptive – the 'defeat of fear'. 'All that was terrifying', said Bakhtin, 'became grotesque'; 'the awesome became a "comic monster"':

> it is impossible to determine where the defeat of fear will end and where joyous recreation will begin. Carnival's [monstrous] hell represents the earth which swallows up and gives birth, it is often transformed into a cornucopia; the monster, death, becomes pregnant . . . Hell has burst and has poured forth abundance.[48]

Indeed, the colonial grotesque received widespread pictorial application in depictions of the Aboriginal carnival, the corroboree, in which Aborigines dance wildly and demonically under large skeletal trees and a full moon – as in James Wallis?/Joseph Lycett, *Corroboree at Newcastle* (c. 1820). The painting, wrote Candice Bruce and Anita Callaway, 'seems to derive from' an engraving made after drawings '"taken on the spot" by Wallis, whose accompanying text describes "the grotesque and singular appearance of the savages, and their wild notes of festivity, [which] all form a strange and interesting contrast to anything ever witnessed in civilised society"'.[49]

However grotesquely so-called 'wild' Aborigines were depicted, those who attempted to adopt European manners were singled out for the most grotesque treatment. Bennelong appeared grotesque to the British because his imitation of civilised life was, by European definition, un(Ab)original: unnatural, fantastic, bizarre, monstrous, hybrid and comical. No matter how skilfully and ironically Aborigines imitated

Europeans, their humorous parodies were deftly turned against them as a sign of their grotesquerie. The court jester failed to entrap the king; the colonisers did not see that they were the butt of a joke, even when they virtually described it as such. Cunningham described a ball at Sydney town:

> Never was this personification of bodkin chivalry seen in a higher pitch of pride and glee than in the eventful night, when skimming round and round in the magic mazes of the waltz with one of our pretty currency *belles*; his head twirling awry, now this way, now that, in languishing dandy perfection, and his body bent stiffly forward into that twisted lumbago-like stoop, unattainable except by *exquisites* of the highest caste ... when to his inexpressible horror, what should present itself at his very elbow but a sort of goblin *facsimile* of his own person, in every particular except that of a white face, skimming round and round in exact imitative concord with his own manner and movements? This was no other than the facetious Bidjee.[50]

To the colonists the very modernism of dandyism made its Aboriginal variety absurd, grotesque, comic. This is implicit in Cunningham's observations: 'it is amusing to see the consequential swagger of some of these dingy dandies, as they pace lordly up our streets, with a waddie twirling in their black paws. No Bond street exquisite could ape the great man better, for none are better mimicks of their superiors'.[51]

The grotesque folly of Bidjee, Bennelong and more famously, Bungaree,[52] only confirmed the moral legitimation that Cunningham sought. It is for this sort of reason that Jean-Paul Sartre concluded: 'there is nothing more consistent than a racist humanism since the European has only been able to become a man through creating slaves and monsters'.[53] This is the real lesson of an education in the classics. The deathly waltz which danced across Australia was a calculated art practised by normal law-abiding members of the European community. It was commonplace and condoned by both the middle classes and the most respected voices of the day. Populist opinion was derogatory and racist, and shared the pragmatism and realism of an age which made Charles Dickens the most popular writer in Australia and England. Dickens, along with like-minded authors such as Anthony Trollope, held a dim view of the Aborigines. Likewise, the middle-class visitors to the colonies, whose first-hand reports appeared in popular travel journals and books aimed at the new middle-class market, were invariably scathing in their detailed grotesque descriptions of Aborigines. In 1833 Mrs Augusta Prinsep reported that Tasmanian Aborigines:

> are undoubtedly in the lowest scale of human nature, both in form and intellect. They have small hollow eyes, broad short noses, with nostrils widely distended, uncommonly large mouths, jaws elongated like the Ourang

Outang, and figures scarcely more symmetrical. They are dark, short in
stature, with disproportionately thin limbs and shapeless bodies entirely
naked.[54]

Forty years later Anthony Trollope, whose son was a settler and failed
grazier, reported contemptuously that, to his eyes, 'the deportment of
the dignified aboriginal is that of a sapient monkey imitating the gait
and manners of a do-nothing white dandy'. In Australia, said Trollope
approvingly, there was almost universal contempt for 'negro-
philanthropy':

> There is a strong sect of men in England – a sect with whom I fully sympathise
> in their aspirations, though I have sometimes found myself compelled to
> doubt their information – who think the English settler abroad is not to be
> trusted, except under severe control, with the fate of the poor creatures of
> inferior races with whom he comes in contact on the distant shores to which
> his search for wealth may lead him. The settler, as a matter of course, is in
> quest of fortune, and is one who, living among rough things, is apt to become
> rough and less scrupulous than his dainty brother at home.

Trollope was convinced that the Aborigines were and would always
be 'savages of the lowest kind'. 'Of the Australian black man we may
certainly say that he has to go.' Trollope added the compromise position
which in the end prevailed: 'that he should perish without unnecessary
suffering should be the aim of all who are concerned in the matter'.[55]

Trollope was well aware that the Aborigines were not without their
European supporters, including some of the most respected and in-
fluential members of the community. These supporters had been
instrumental in the writing of a Select Committee report accepted by the
House of Commons in 1837, which asserted:

> It might be presumed that the native inhabitants of any land have an
> incontrovertible right to their own soil; a plain and sacred right, however,
> which seems not to have been understood. Europeans have entered upon
> their borders uninvited and, when there, have not only acted as if they were
> undoubted lords of the soil but have punished the natives as aggressors if they
> have evinced a disposition to live in their own country. If they have been
> found upon their own property they have been treated as thieves and robbers.
> They are driven back into the interior as if they were dogs or kangaroos.[56]

However, even the most high-minded men who protested against the
grotesque treatment of Aborigines could not escape the meta-trope of
melancholy. In Australia, such men were generally most influential at
official levels. In Tasmania they included Lieutenant-Governor Sir John
Franklin, the Reverend John West, the educator, James Bonwick, the
Aboriginal Protector, George A. Robinson, and the painter, John Glover.

When exposed to the reality of frontier life in Australia such men were moved by the melancholy of the noble savage fallen before civilisation. If their views of Aborigines seemed at complete odds with the general settler, grotesquerie was strangely interlaced with their melancholic discourses on the fate of the noble savage. For example, West evoked the slaughter of Aborigines in grotesque terms – even if his intention, like that of Las Casas before him, was to highlight an evil side of European civilisation. Another example is Robinson, the 'saviour of the last Tasmanians', and the first Chief Protector of Aborigines in New South Wales. He was in the habit of decapitating his Aboriginal charges when they died and boiling their heads for preservation. Yet Robinson was, in his time, the most sympathetic European in Australia to the plight of Aborigines, the man who knew the languages and customs of the Palawa (Tasmanian Aborigines) better than any other European, and was about the only European that the Palawa felt they could trust. Little wonder Truganini, the loyal friend of Robinson, feared the mutilation of her own body, a fate abhorrent to Aborigines, as it is to most people.

Robinson no doubt believed that his grotesque collections served some higher good – just as the squatters believed that their grotesque massacres of Aborigines also served some higher good. In fact, it was the same higher good: Western civilisation. 'Savages' were a tragic/comic backdrop designed to better silhouette the main European players in the Western dialectic of spiritual triumph. In this respect, the Aborigine singled out for the most grotesque (and so aesthetic) treatment, was Mosquito, a Kuringgai from Broken Bay near Sydney, born some time before the British invasion. In his classic moral history written in 1870, *The Last Tasmanians*, James Bonwick, an admirer of Robinson and West, immortalised Mosquito with the following metaphors: 'the extraordinary sagacity of Mosquito enabled him to elude several snares for his capture', but finally 'the human tiger's lair' was discovered.[57]

Mosquito most likely fought in alliance with Pemulwuy in the Sydney–Hawkesbury area. At the time the British colonists represented the actions of the Aborigines as 'diabolic and outrageous offences'. Pemulwuy's son, Tedbury, had from his father's 'horrible tuition and example imbibed propensities of the most diabolical complexion'.[58] Supposed 'primitive' rites provided chiaroscuro for the white conscience, the favourite theme being tales of barbaric offences against women. Pemulwuy and his companions kidnapped a woman from another tribe and 'dragged her into the woods, where they fatigued themselves with exercising acts of cruelty and lust upon her'.[59] Mosquito's origins are clouded in similar legend. Taken prisoner in 1805, along with another Aborigine whom the British named 'Bulldog', Mosquito was transported without trial to Norfolk Island, and eventually to Tasmania in 1813. Many

of his supposed crimes, such as rape and murder, are, whatever their actual basis, selectively clothed in such exaggerated grotesque metaphors that their origins are probably as much in the Eurocentric imagination as in fact. According to Bonwick: 'These two Blacks (Mosquito and Bulldog) waylaid a woman, ill-used, and then murdered her. To gratify their horrible propensities, they ripped open the body of the poor creature, and destroyed the infant she carried.' Bonwick also reported that 'once the terrible monster cut off the breast of one of his gins, because she would persist, against his orders, in suckling her child'.[60]

Bonwick was writing in the 1870s, well after the Palawa had been defeated. By 1870 Tasmania had become what it is now, a picturesque tourist destination. So why did he need to lampoon Mosquito? Bonwick's aim was to secure the redeeming vision. Mosquito not only served as a convenient chiaroscuro for Bonwick's eulogy to Truganini, the so-called 'last Tasmanian', more importantly, he signified the savagery which, in Tasmania, had been defeated.

If the representation of Mosquito and Truganini in *The Last Tasmanians* is typical of the post-Renaissance ambivalence towards 'savages' (as either noble or ignoble), the imperatives of the frontier and its grotesque tropes became the rule of Australian cultural expression throughout the nineteenth century – and in becoming the rule, signified the failure of the melancholy trope. For if the grotesque prevails, redemption falters. However, it seemed to many that in Tasmania the frontier did pass during the 1830s. Consequently, here the melancholy trope did triumph, and the idea of the noble savage was again possible. At a time when Aborigines in the other Australian colonies were being killed and lampooned as never before, across the strait in Tasmania Truganini became world-famous as the melancholy queen of a lost race. According to Bonwick, 'her mind was of no ordinary kind. Fertile in expedient, sagacious in council, courageous in difficulty, she had the wisdom and fascination of the serpent, the intrepidity and nobility of the royal ruler of the desert'.[61] Never before had the untrammelled desires for genocide on the part of the colonisers so quickly transformed into the elegant ceremonies of ritualistic sacrifice. Is this why the iconic presence of Truganini deAboriginalised the surviving Palawa at a time when their compatriots on the mainland continued to die comically, grotesquely? If, in colonial discourses, mainland Aborigines retained the savagery of Mosquito, on the 'apple isle' they assumed a noble melancholy – a clear signal that the Tasmanian colonists believed redemption was just around the corner.

CHAPTER 3

The Art of Settlement

Utopia is across ocean, in the Antipodes. If the invasion of Australia initially had need of a grotesque aesthetic, its ultimate aim was redemption. This became clear as the frontier moved further inland. The first architect of this redeeming vision was Lachlan Macquarie – though John Macarthur had already sketched the outlines of a colony grown rich on the back of sheep. Macquarie, who arrived in 1810 to take up his appointment as Governor, created the civic apparatus and leadership necessary to transform the colony from a frontier outpost into a significant settlement. He even gathered 'about him a circle of poets, painters and architects who would turn Sydney into "a second Rome, rising at the antipodes"'.[1] It is not that the killing stopped; in fact, it increased. But with the battle further away, Sydney and its environs began to take on the trappings of Western civilisation. However, if the frontier was out of sight, it was not out of mind.

Following the end of the Napoleonic wars in 1815, when large numbers of convicts were transported, policies were put in place to attract free settlers, as if from slavery and genocide could be born prosperity. Yet even before the full effects of these changes were felt, the colony prospered of its own accord. The wealth of the few gentleman migrants who held large estates 'was more than matched by that of the ex-convict merchants and tradesmen'[2] – whom Macquarie encouraged. If it was difficult to convince many Englishmen that a penal colony could be a salubrious abode, utopian hopes of a pastoral redemption in the Antipodes entertained many a settler's mind, and provided the first outlines of a nationalist mythology that was sustained well into the twentieth century. William Charles Wentworth, for example, urged the revival of a quasi-medieval pre-industrial agrarian aristocracy. According to Carol Lansbury, Wentworth fashioned his vision of a redeemed

Australia from 'the Arcadianism of the Romantic movement – the belief that only by a return to the land could men find contentment of spirit and a tranquil and prosperous life'.[3] For most of the nineteenth century this redeeming vision was imagined by painters in terms of the picturesque.

The prevalence of the picturesque in Australian art during the early colonial period is usually considered evidence of a colonial and European vision. This is because the origins of the picturesque are invariably traced to developments in English politics and taste. Nigel Everet, for example, called picturesque improvement 'the Tory view of landscape'.[4] Jurgis Baltrusaitis, more interested in taste than politics, includes Milton's descriptions of untamed paradise in *Paradise Lost* (1674) and the fashion for Chinese and Italianate landscapes, as the sources of the picturesque.[5] However, while the picturesque is part of a reaction against neo-classical virtues, in particular the mathematical gardens popular in the seventeenth century, in *European Vision and the South Pacific*, Bernard Smith argued that the eighteenth-century reaction against the neo-classical was propelled and led by the colonial imperatives of exploration and settlement in exotic places. Indeed, picturesque gardens were conceived as exotic rather than indigenous places. They are inspired by thoughts of empire, not home. 'The gothic north', wrote Baltrusaitis, 'could very well coexist between China and Egypt. The Greco-Roman Occident could spring up anywhere in the world. Pyramid and crenellated castle stood side by side. Landscapes were created helter-skelter in the garden, like the oddities piled into the shelves of a curio cabinet'.[6] Such historical oddities are due to an excess rather than absence of an historical consciousness. Indeed, the most important difference between picturesque and sublime landscapes is that the picturesque is inhabited and cultivated; it represents an historical landscape.

Picturesque artists did not seek the absolute ahistorical wildness of the sublime, nor the clean symmetry of civilisation. Rather, they sought a space between the two. Thus, the European picturesque landscape habitually shows a cultivated and so civilised nature spreading back into the middle distance through the frame of a wilder nature in the foreground. In such hybrid in-between places differences were garnered into a new synthetic space, where nature and a classical past were entwined in a perpetual union. The hybrid space of the picturesque is thus, also the space of colonialism – or the space which colonialists desired. Because the picturesque created a synthesis of nature and culture, it was the ideal aesthetic for representing the redemptive scene sought by colonialism. The picturesque confirms the mission of Western empire. The favourite picturesque subjects were the frontiers of civilisation where history was in the making; not the clean lines of the city, a post-historical space where

history had long reigned, or the wilderness where history is not yet. The picturesque artists preferred a landscape in which the ordered farms and estates bordered on wilderness, a synthetic space where nature and culture were always in dialogue – places such as Snowdonia in Wales, and the Lakes District in Cumbria.

The picturesque is at home in frontier spaces, but it did not find an easy home in the colony of New South Wales. Australia proved a testing subject for the picturesque, because here a dialectic between nature and culture was not easily achieved. Here nature was too wild and capricious. This perhaps explains the overt and exaggerated neo-classicism of Taylor's panorama of Sydney (an aquatint triptych published in London in 1823). The picturesque dialectic (of nature and culture) is so forced that the scene is unbelievable; it declares its utopianism. Gordon Bull points out that the panorama was constructed by the same formula of order and absolute visibility which, according to Jeremy Bentham (in *Panopticon versus New South Wales* (1802–3)), was absent from New South Wales. If the work is, as Bull emphasises, 'extraordinary' for the time,[7] what makes it extraordinary is not its aesthetic which, despite its neo-classical bent, follows the principles of the picturesque, but its unsustainable redemptive vision.

In Australian painting utopian hopes were, as a rule, compromised. Instead of synthetic compositions that effortlessly transfigured the 'wild' into the picturesque, early Australian colonial art is characterised by a fractured aesthetic. Typically, early pictures of colonial life in Australia show a rugged, wild dark foreground, often with Aborigines, and the enlightened order of European settlement in the middle-ground, each foreign to the other. A synthesis is not achieved. It occurs in Thomas Watling's views of Sydney (*c.* 1795) and, observes Robert Dixon, in the 'most widely reproduced' images of the new colony, 'John Eyre's two views of Sydney Cove' (1810), its foreground embellishments of 'blasted trees', 'massive angular rocks', 'barrenness' and 'darkness' being associated with 'solitude and melancholy'.[8]

The hinterland also failed to provide satisfactory vistas. In Earle's *A Bivouac of Travellers in Australia in a cabbage-tree Forest, Day Break* (*c.* 1838), and *Bougainville Falls, Prince Regent's Glen, Blue Mountains,* (*c.* 1838), the environment remains weird and unhomed. Dixon argues that, unlike the United States experience, 'the geography of New South Wales persistently failed to conform to' English landscape conventions. 'In direct contrast to the American experience, the myth and reality did not coincide.'[9] John Oxley, appointed by Macquarie in 1817 to explore the course of the Lachlan River, failed to discover the picturesque vistas of Macquarie's dreams. Here, Oxley penned in his journal, 'everything seems to run counter to the ordinary course of nature in other countries'.[10]

However, the desire for redemption is a strong tonic. One explorer determined to discover the picturesque and the sublime in Australia was Thomas Mitchell. He arrived in Sydney in 1827 to be Deputy Surveyor under Oxley, and then soon replaced him. In his report the aesthetic conventions of the day (neo-classical, picturesque and sublime) combine as a scientific survey to produce a myth equal to the redemptive demands of colonialism. In accord with these conventions, Mitchell figures Aborigines as 'Neptune or Jupiter', or 'ancient druids' or 'the witches of Macbeth'. The leader of one hostile Aboriginal group was described as a 'very remarkable personage, his features decidedly Jewish, having a thin aquiline nose, and very piercing eye, as intent on mischief, as it had belonged to Satan himself'.[11]

Mitchell depicted *Talambe – a young native of the Bogan Tribe* 'more sympathetically in the classical pose of a recumbent river god', before 'the "sylvan" scenery of the river over which he presides',[12] so as to evoke a melancholy emotion that 'no reflecting man' could help but feel before an ancient people. The Aborigines, wrote Mitchell, 'cannot be so obtuse as not to anticipate in the advance of such a powerful race [as the English], the expiration of their own'.[13] This emotion, expressed in sublime rather than picturesque terms, is particularly evident in such sketches by Mitchell as the *Tombs of a Tribe* and the *Valley of the Grose*,[14] which depict a haunting landscape that still carries the signs of

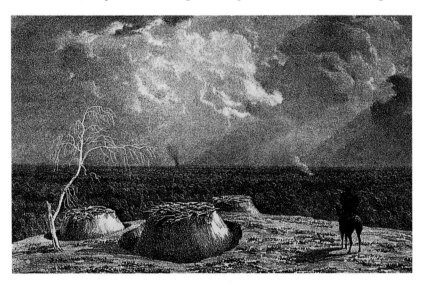

Thomas Mitchell, *Tombs of a Tribe*. Lithograph by G. Barnard after drawing by Thomas Mitchell. T. L. Mitchell, *Three Expeditions into the Interior of Eastern Australia*, vol. 1, T. & W. Boone, London, 1893, p. 262.

its Aboriginal inhabitants. However, the primary moral purpose of
Mitchell's art was to fashion a space ready for colonisation. Thus, in
accord with European explorers at the vanguard of colonialism at least
since the time of Columbus, he announced the discovery of Paradise, a
country 'in the same state as when it was formed by its Maker':[15]

> We had at length discovered a country ready for the immediate reception
> of civilised man ... Unencumbered with too much wood, yet possessing
> enough for all purposes; with an exuberant soil under a temperate climate;
> bound by the sea-coast, and watered abundantly by streams from lofty
> mountains: this highly interesting region lay before me with all its features
> new and untouched as they fell from the hand of the creator! Of this Eden
> it seemed that I was the only Adam: and it was indeed a sort of paradise
> to me.[16]

Mitchell discovered a sublime landscape equal to any in Europe – and
his pictures bear this out, especially the most reproduced image, *View of
Nundawar Range*, and his favourite, *Mitre Rock and Lake, From Mount
Arapiles*. However, it was not Mitchell but the settlers who followed in his
wake who had to test the picturesque virtues of 'Australia Felix'. Indeed,
while Mitchell was exploring the hinterland north of Bass Strait, to its
south an Englishman with the same ambition as Mitchell to discover
Claude in the Antipodes, was testing the picturesque to an extent not
repeated anywhere else in Australia.

Whereas Mitchell could, in quickly passing through the country, live
more securely in his imagination and dreams, John Glover had made a
home in a particular spot which he painted again and again in the hope
of fashioning a redeeming vision. Further, if Mitchell surveyed the
vanguard of the frontier prior to invasion, in Tasmania Glover settled in
the wake of invasion. Arriving at the end of the Tasmanian Black War, on
his sixty-third birthday, 18 February 1831, he witnessed the last round-up
of the Palawa people and the securing of the place for the historical
project of Western civilisation. He even saw the final anti-climax of
the war: Robinson escorting the last group of Aborigines to their new
abode. They camped near Glover's property at Patterdale, where he
sketched them.[17]

By the time Glover settled in Tasmania, artists such as Joseph Lycett
had already employed picturesque conventions to depict Aborigines.
Lycett's Aborigines work the land in a similar fashion to rural labourers
in British paintings – as if they are a natural part of the place. They
inhabit rather than own the land. If Glover also follows this convention
his purpose is quite different. While based on eye-witness accounts, and
on his own observations of both the Palawa and other Aborigines
brought down from New South Wales, Glover places his Aborigines in a

precolonial scene. In his paintings the Palawa become mythical antecedents cast back into an indefinite past, as if the Druids of Van Diemen's Land. Glover had a strong motive; he actually owned the land he painted and, like the English aristocracy, wanted to picture a genealogy of power and kinship, not conquest. His was a Tory view of the landscape which sought not to displace the Aborigines but to inherit their birthright.

Glover brought with him Uvedale Price's treatise on the picturesque,[18] as well as a considerable reputation and fortune made as an English painter of the picturesque. However, conventional wisdom follows Bernard Smith's claim that Glover's Australian work:

> depended less upon the picturesqueness and literary associations which mark so much of his English work, and relied upon a clear perception of the characteristic features of the Australian scene. Consequently, what his work loses in elegance is more than compensated for by the surprising emergence, late in life, of a fresh, unaffected, and essentially empirical vision.[19]

In my opinion there are no substantial stylistic differences between Glover's English and Tasmanian work. Indeed, many of his so-called 'English' paintings (such as *Castles in Italy near Otricoli: a Brown Friar and a thief being taken to prison* (1841) and *Royal Naval Hospital, Greenwich,* (*c.* 1838)) were painted in Tasmania from sketches he had brought with him.[20] Glover's Australian oeuvre divides into three genres: depictions of Aborigines before colonisation; depictions of the contemporary Tasmanian landscape, mainly the area around where he lived; and depictions of European landscapes worked up from his sketchbooks. As different as these three genres are, the studies for them can be seen side by side in the same sketchbooks – Glover having brought with him many partly filled sketchbooks of European scenery which he subsequently filled with sketches of Tasmanian scenes. Throughout his career he made numerous *plein-air* studies from nature, which he then used in the manufacture of studio paintings. The same practice continued in Tasmania, except that here the additional challenge of drawing a new landscape, and a supposedly 'wild' one full of recent catastrophic memories, lent a new life to the moral lessons he sought to tell in his paintings. Smith (and after him, John McPhee) is correct when he points out that Glover did *see* and paint the details of Australian scenery with an empirical accuracy. This was his training. However, as in his English paintings, the detail also delineated a moral purpose consistent with the picturesque aesthetic that framed Glover's art.

Despite Smith and McPhee seeing in Glover's Tasmanian art the triumph of an empirical vision over a picturesque mind-set, Glover consciously aspired towards a picturesque style. He even exhibited his

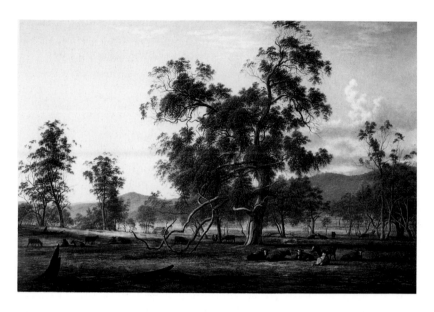

John Glover, *Australian Landscape with Cattle, The Artist's Property Patterdale,*
c. 1835. Oil on canvas. 75.5 by 112.5 cm. Rex Nan Kivell Collection, National
Gallery of Australia, Canberra. T339 NK803.

Australian landscapes in England (in 1835) with two works by Claude
serving as a benchmark. Hughes sensibly observed that 'Claude's tran-
quil prospects and serene skies gave him [Glover] a schema for his own
image of Tasmania' – Claude's transcendent schema being 'a friendly
world in which the European settler can move without strain'.[21] Tim
Bonyhady (also sensibly) concluded that Glover 'obviously continues to
regard the Roman artist as the paragon of landscape painters', and that
'Claude's idealised Italian landscapes probably appeared to Glover as the
paradigm for the pastoral arcadia he perceived in Tasmania'.[22]

Glover's Tasmanian paintings are typical of early colonial art in
that they depict a fractured space. However, Glover smooths over this
fractured space by creating a doubled discourse in which the binary
structure of the semiology is split into two different sets of pictures,
rather than being represented in the same picture. One group depicted
Aborigines before invasion, the other showed the pastoral wealth of a
settled land without Aborigines – what Bonyhady dubbed Aboriginal and
Pastoral Arcadias.

In his Pastoral Arcadias Glover is closer to the landscape, as if living
in it, or at least wanting to know it intimately. For example, *Australian
Landscape with Cattle, The Artist's Property Patterdale* (*c.* 1835), a typical
example of his Pastoral Arcadia, tends towards realism rather than the

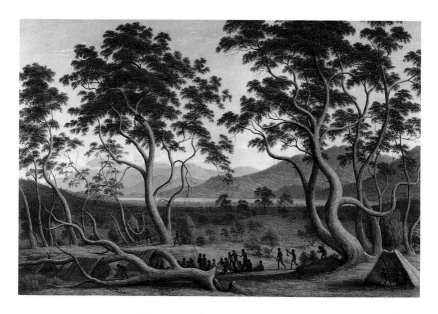

John Glover, *The Last Muster of the Aborigines at Risdon*, 1836. Oil on canvas. 121.5 by 182.5 cm. Queen Victoria Museum and Art Gallery, Launceston, Tasmania.

picturesque, and prefigures the work of Louis Buvelot. By contrast, Glover's Aboriginal Arcadias are more distant, picturesque, allegorical and dreamlike. Together, the Aboriginal and Pastoral Arcadias articulate a distinct semiology or aesthetic structure. In *Australian Landscape with Cattle* a majestic gum tree confirms Glover's accomplishments as a colonialist land owner. When Aborigines are present, nature writes in a more medieval script. For example, in *The Last Muster of the Aborigines at Risdon* (1836), the trees beneath which the Palawa people crouch and dance assume a distinct gothic character, as if possessed by a primitive spirit. Generally, the closer an Aborigine is to a tree, the more snakelike its limbs. A closer reading of *Australian Landscape with Cattle* might interpret its giant tree, whose twisted limbs have a realism lacking in the mannered gothic lines of *The Last Muster of the Aborigines at Risdon*, as an emblem of an Aboriginal Tasmania, for the painting pictures a recently colonised space in which this tree seems the last reminder of precolonial days. The tree assumes a genealogical significance: it serves as a symbol of Glover's inheritance; it marks the grandeur of the place which is now his.

The juxtaposition of English culture (cows, buildings) with gum trees gave them an oaklike grandeur, but Aborigines lent the same gum trees a grotesque appearance. Both, then, are important signs in a frontier

semiology, each dependent on the other for its full meaning. This allegorical use of trees is typical of the time. In this respect, the realism of Glover's depiction of gum trees in his Pastoral Arcadias has to be considered against the grotesqueries he employed in his Aboriginal Arcadias, thus confirming Baltrusaitis' observations that 'it was nature's theatrics, its dispositions in accordance with the emotions it inspired, that were returned to with the greatest persistence' in the eighteenth century.[23]

If Glover's sinuous curvilinear trees cannot be dismissed as distracting mannerisms but have a distinct moral and allegorical intent,[24] are the Aboriginal Arcadias as benign as Bonyhady supposes? Smith, for example, described the Aborigines depicted in *The Western View of Mountains* (1833) (a typical Glover Aboriginal Arcadia) as 'small, dark, naked, and unattractive little people who dance and leap with quick angular movements and grotesque gesticulations; he represents them, we might say, as the little black devils to be removed from his southern paradise'.[25]

Hughes concurred, describing the Aborigines in Glover's paintings as 'nasty little cacodemons'.[26] Certainly *The Last Muster of the Tasmanian Aborigines at Risdon* depicts the Aborigines termite-like teeming around the looming serpentine limbs of the gum trees; and in one of his last paintings, a small watercolour of a corroboree in the moonlight, the Aborigines appear like devils or witches prancing beneath the full moon. Even Bonyhady, who coined the term Aboriginal Arcadia, believed that such 'decidedly ape-like' images are meant to be the 'epitome of savagery'.[27] However, if some of Glover's paintings of Aborigines employ the grotesque conventions of the day, on the whole his paintings of Aborigines cannot be so easily categorised as grotesques. Bonyhady's characterisation of Glover's grotesquerie as Arcadian is not entirely unwarranted. Taken together, Glover's work exhibits an ambivalent attitude to Aborigines. His sketches of Aborigines are, like his sketches of nature, naturalistic and empathetic. Moreover, most of his paintings place them in a wild romantic Eden, a type of redemptive wilderness which had always attracted him. In *The Bath of Diana, Van Diemen's Land* (1837) Glover shows an idyllic Eden of bathing Aboriginal women, while on the far bank, unseen by them, under a massive tree whose grotesque limbs slither in the air, stands a black Acteon gesticulating with his spear, as if forewarning the imminent expulsion. What is the allegory?

We must be careful not to interpret Glover's depictions of Aborigines in the Darwinian terms to which we have become accustomed, but according to the conventions of his time. Like his depictions of trees, Glover's portrayal of Aborigines with distinct orangutan features follows the associationist principles of the day. The product of age-old ideas

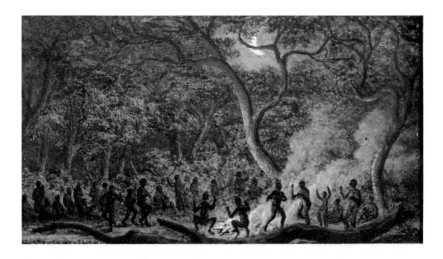

John Glover, *Corrobory*, 1846. Watercolour. 9.5 by 17 cm. Tasmanian Museum and Art Gallery, Hobart.

about the symbolism of physiognomy in which the body was understood in semiological terms, it received its most influential expression in Charles Le Brun's studies (1671) of the correspondence between facial features and the emotions. Benjamin Duterrau applied them in his painting of George Robinson and a group of Tasmanian Aborigines, *The Conciliation* (1836), and probably also drew on more recent work by Petrus Camper (1791), which measured intellectual development by the facial angle. In giving the skull of the Aborigine with whom Robinson shakes hands a facial angle of 90 degrees, Duterrau confirms Robinson's belief that the Tasmanian Aborigines were as intellectually developed as Englishmen. If Glover's depictions of Aborigines sometimes seem closer to Johann Lavater's studies of the physiognomy of animals and humans (the four volumes of *Physiognomische Fragmente* 1775–8), and Dr Gall's phrenology, which 'discerned the aptitudes of men and animals from the configuration of their skulls',[28] his allegorising of the Aboriginal occupation of Tasmania through the myth of Diana not only classicises his own land, but classicises the Aborigines. Significantly, Diana and her nymphs are emblems of Arcadia and purity. The ominous introduction of Acteon taints the Arcadian attributes of the scene in an ambiguous way which is difficult to interpret. Is Acteon an emblem of the white invaders, or is he a type of Mosquito, an ignoble savage disturbing the noble Diana at bath?

In contrast to his Aboriginal pictures, Glover painted his improvements of the same land in a more redemptive light. Most notable, in this respect, are *My Harvest Home* (1835) and *A View of the Artist's House and*

Garden, Mills Plains (1835). However, while Glover did here discover a personal redemption in the Australian bush, he did not repeat these exaggeratedly transcendent visions in later works. If the above two Claudian-type paintings are fashioned as a paradise regained, in most of the landscapes which depict his new home (that is, Tasmania) there stirs the *unhomely* (uncanny) – Glover is unable to forget the Aboriginal presence which shadows his paradise.

The uncanny presence of Aborigines, even in Glover's Pastoral Arcadias, means that here redemption falters. Rather than transcending the Palawa claims on the land, his paintings of Patterdale are haunted by their Aboriginal doubles. They are dreaming pictures. As he gazes over his land he sees Aboriginal ghosts in the landscape, an ethereal presence that now haunts rather than owns and works the place. The haunting is at its most palpable in the melancholy solitude of the wooded ranges that frame his scenes like a looming amphitheatre that watches over him with all the sublime terror of an absolute unbounded other. Here the space of the picture resists any imposed order, and Glover must paint blind in the hope of finding an order from inside his own consciousness – or in this most modernist of strategies, let the space compose itself. In *A View of the Artist's Home* this disorder pictured in the bush on the hill behind his garden is ordered by the iconic pyramid shape that he has given the hill – such a hill not actually existing behind his garden. However, in *Mt Wellington with the Orphan Asylum, Van Diemen's Land* (1837), the solitude of this chaos is cast like a great stain across the painting. The rainbow, a traditional emblem of redemption, ironically taunts the orphan asylum which, like the new colony, precariously inhabits a strange land with all the disjointed logic of a dream. These are symbolic not allegorical pictures, and are forerunners of Australian landscape art in the second half of the nineteenth and the twentieth centuries.

What distinguishes Glover's English and Tasmanian pictures is that in Tasmania his Claudian vision was unfulfilled. In Australia the 'magisterial gaze' (Boime) of Empire was unrewarded. Compare Glover's paintings to those of his near contemporary in the United States, Thomas Cole – such as his celebrated *The Oxbow*, painted in 1836 – in which illuminated vistas offered a spectacle of what he called 'futurity and progress'. Cole summed up his purpose when, in 1836, he wrote: 'looking over the yet uncultivated scene, the mind's eye may see far into futurity. Where the wolf roams, the plough shall glisten; on the grey crag shall rise temple and tower – mighty deeds shall be done in the new pathless wilderness; and poets unborn shall sanctify the soil'.[29]

Like Glover, Cole was an English migrant inspired by English and Italian landscapes, and had come under the influence of the neo-classical painter Claude and the theories of Price. In Massachusetts he was able

to realise the picturesque vision. However, Massachusetts, free from its colonial attachments, was a very different place to Tasmania. The failure of Glover to picture a fully redemptive vision in Tasmania may well be due to his closeness to the frontier, to his living on the cusp of two worlds. At Mount Holyoke, from which Cole painted *The Oxbow*, that moment had long since passed. If Cole were standing at the same point as the explorer and settler had before him, by Cole's time it had become the viewpoint of the tourist trail, not the frontiersman – though the tourist, in following the footsteps as the explorer and settler, reinscribes the original invasion. Cole's picturesque is an ideology by which the coloniser maintains power through sightseeing. 'It was', wrote Stephen Daniels, 'nothing less than a national duty for Americans to admire the river and its scenery and to show it off to visiting Europeans'.[30] In Australia, however, even tourism – and the impressionists are perhaps the first real artists–tourists of Australia – failed to cement the invasion.

Even in picturesque Tasmania the picturesque failed. The other Australian colonies fared even worse. Mitchell's report of a small corner of good land in south-east Australia was soon overshadowed by Sturt's discovery of a barren centre, which only confirmed Oxley's earlier findings. At the point where Sturt finally turned back in defeat, he gazed over a never-ending desert upon which 'there was not a blade of grass or a drop of water'. His assistant, Mr. Browne, 'absolutely made an involuntary exclamation of horror'.[31] This is a sublime rather than picturesque moment – though the sublimity exceeds its own moral purpose to become a fully symbolic landscape that carries its meaning within, rather than wears it as signs to be read. Ludwig Becker, appointed as artist on the ill-fated Burke and Wills expedition, pictured this symbolic landscape. In *Border of the Mud Desert near Desolation Camp* (1861), painted shortly before he fatally succumbed to the heat and terror of the place, he prophetically depicted the men on camels like mythological ghosts heading towards their destiny into the golden light cast down from the heavens and shimmering like a mirage on the horizon.

The suspicion that the Australian landscape was not going to surrender itself to its new owners haunts much mid nineteenth-century Australian art of settlement. The bush refused to articulate the desires of Englishmen, except perhaps in the most settled areas. Eugène von Guérard and Nicholas Chevalier transformed the Victorian hinterland into picturesque vistas, with Buvelot even depicting intimate Victorian rural scenes as evocative as their European counterparts. Conrad Martens also produced picturesque views of the Sydney area, as in *The Cottage, Rose Bay* (1857). However Martens' paintings also contain an anxious Turneresque element which disturbs the peace and naturalism of the scene. Equally, many of von Guérard's and Chevalier's paintings

verge on the sublime. This failure of the picturesque was an international phenomenon that can be traced to the triumph of the romantic imagination, and to a new relationship to the world in which the other inhabited the very centre of one's being and culture. Those hybrid spaces on the outskirts of the kingdom, so loved by the picturesque artist, were suddenly not scenes to be enjoyed from afar or on a tour of the country, but were always within one, a primitivism in the very heart of one's being, and even in the heart of empire, in London itself. Gail Ching-Liang Low points to the practice of mid to late nineteenth-century English writing which produced 'a literature of documentary, discovery, exploration, and adventure' within the slums and backstreets of London that made contact with English men and women 'as lawless as the Arab and the Kaffir'.[32]

This new paradigm of otherness, characteristic of the second half of the century, culminated in the so-called ripping yarn – those masculinist adventure romances that were popular at the end of the century, such as Robert Louis Stevenson's *Treasure Island* (1882), H. Rider Haggard's *King Solomon's Mines* (1885) and Rudyard Kipling's *Kim* (1901). Here the exotic is no longer the site of picturesque improvement, but an emblem of redemption in which the other is an object of narcissistic desire. The native is no longer a grotesque sign in an allegory of semiological difference, but a symbolic locus of repressed identity that often takes on apocalyptic overtones.

This new paradigm of the other was first consciously pictured by Thomas Baines, a mid nineteenth-century explorer artist who worked in Africa and northern Australia (in the Gregory expedition). Baines left England during a period of mass migrations by Europeans to other parts of the world; however, he was not a migrant. Despite his poverty he did not take an assisted passage to America or Australia, but went to Africa, a place where the British government was not encouraging migration. Baines was an adventurer, not a migrant; his is the art of adventure not of settlement. He pictures, in an exemplary fashion, the symbolic purpose of empire art during the latter half of the nineteenth century, when the picturesque had lost its credibility as a redemptive vision.

While Baines, like many settlers, travelled in the hope of overcoming hardships in the home country, he was driven less by proletarian poverty and more by that existential loneliness felt by adventurers and modernists alike, who sought solace in the other rather than the same, who thought not of home and origin, but of transcending both on whatever frontiers they could find. In his journal, Baines 'dismisses the topics of parentage and birthplace, never to revert to them' (Wallis), and describes his home town of King's Lynn not as a hearth, but as 'the portal through which I entered this vale of tears'. Such a metaphor is not out of

place, for King's Lynn was a busy port. Baines came from a family of mariners not farmers. 'The sea', wrote John Wallis, 'was in his blood'.[33]

Although Baines does paint sublime scenes, and even Turneresque landscapes which will never be tamed or civilised, he is too much a man of action, an adventurer, to be defeated by philosophical contemplation on the futility of empire and human endeavour before the vastness of nature. In *Dr Livingstone's Paddle Steamer* (1858, watercolour), which depicts the sublime wilderness into which he is about to embark, he is too intent on creating an historical space to give his painting entirely over to the sublime. The paddle steamer is pictured like a white angel whose penetration of the virgin space of central Africa transfigures it into a new historical scene – thus breaking the spell which had long hung over Africa, being, in the words of Hegel, 'no historical part of the World', 'the land of childhood' 'shut up' from the 'rest of the World'. In short, Baines renders the sublime picturesque, and thus provides a pictorial apology for Livingstone's expedition.

Dr Livingstone's Paddle Steamer pictures a synthetic space that has many hallmarks of the picturesque. However, it also represents a new attitude to the space of the other characteristic of the ripping yarn. This new attitude, which is typical of both modernism and the empire aesthetic, expressed an ideology of identity that found redemption in the other, in difference and alienation. For Hegel, one reason why Africa was unhistorical is that 'the Negro ... exhibits the natural man in his completely wild and untamed state'.[34] By the late nineteenth century such abject places were increasingly looked upon as sites where British 'men can be freed from the constraints of Victorian morality ... and explore their secret selves in an archaic space which can safely be called the "primitive"' (Showalter).[35]

Baines is one of the first European artists who proposes, in a characteristic modernist fashion, that the other, the primitive, the savage, might offer a perspective on redemption. While the noble savage had been, in the eighteenth century, both an ironic foil and an emblem of paradise lost for Europeans to assess their own culture, Baines performs the modernist primitivist manoeuvre: he invests in the exotic in order to know the boundaries of his own self, identity and truth. Here the other or exotic becomes a substitute of the self. 'I don't want to gush over it', wrote Kipling, 'but I do want you to understand ... that immediately outside our English life is the dark and crooked and fantastic; and wicked: and awe-inspiring life of the native ... I have done my best to penetrate it'.[36]

When artists of the picturesque and the sublime contemplate the other for their own moral edification, they keep a respectful distance which never transgresses their own ethical standards. Indeed, picturesque artists

draw the other into the realm of civilisation, the synthetic space of their pictures being a means to pacificy the other, not transgress their own morality. Terence Ranger has shown how the same values worked during the late nineteenth and early twentieth centuries to establish a system of colonial governance that penetrated the minds of the colonisers and colonised alike. This 'invented tradition', as he called it, reproduced the rigid straight lines of neo-classical virtue – what he named the 'drill-square mentality' – upon the colonies as hierarchical boundaries of race that were not to be crossed. However, there were also many highly educated champions of empire opposed to the 'drill-square' regime. Ranger cites Baron Robert Baden-Powell, who drew on 'Matabele scouting abilities so as to provide white youth with a flexible training, richly situated in Kiplingesque myths of the jungle'. Thus, 'the paradox of young (black) Africans being trained into regimental rigidities and young whites being trained in bush-craft'.[37] It is this alternative but equally invented tradition of empire which Baines contributes to.

Previously the Aborigine had served as an emblem of otherness against which the European coloniser measured his or her civility. If Europeans are depicted with Aborigines as, for example, in the paintings of corroborees in which European onlookers gaze at Aborigines dancing wildly in the night, it was to establish a Manichaean scene in which the civilised European was contrasted against the demonic theatre that they were witnessing.[38] In contrast to this, Baines places himself, other whites and the Union Jack, into the middle of native life. In a watercolour of his house at Wankies on the Zambezi (1863), Baines pictures himself under the Union Jack in the middle of the composition, standing beside his grass hut surrounded with wild exotic plants, grotesque skeletons of animals and what he called the 'joyful occasion' of several Damar tribesman killing an ox. In another watercolour of the same place, Baines shows himself lowering the flag, and, in the middle of the picture, the African trader, Mr Synman, in European dress, directing operations. When the scene is the more violent confrontation between the 'races' which the art and novels of adventure preferred, Baines actually takes the perspective of the native. In an oil sketch of himself coming under attack from Aborigines in the Gulf of Carpentaria (1856), his perspective is from a canoe alongside that of the attackers who are throwing spears at Baines and the men under his command. A similar scene is repeated in the oil sketch of himself and his companions under threat from Aboriginal warriors. Likewise, in *Kaffirs attacking infantry in Keiskamma Gorge* (1850), he sketches an attack of the Kaffirs on British troops as if he were fighting with the Kaffirs. During this so-called Kaffir War (1850–3), Baines belonged to a special unit, the Cape Mounted Rifles, which consisted of Hottentot fighters led by colonial-bred officers.

Baines mixes categories and crosses boundaries which, at the time, were rigidly policed. Low referred to such mixing during the imperial period as a 'hybrid fantasy' – yet Baines lent it a photographic-type realism which, if it has its formal origins in the wandering line and hybrid space of the picturesque, exceeded its ethical purpose. His journalistic cinematic style is a precursor to the action illustrations which accompanied the ripping yarns and, to this day, the countless Hollywood re-stagings of imperial adventures. Such images became, in the twentieth century, the basis of a modern identity – a populist modernist primitivism derived from imperial fantasies of masculinist romance. Dixon described it as a 'narcissistic displacement'[39] by white males on the black naked body in order to revitalise their own subjectivity.

Baines' frontier adventurism, along with his primitivism and its narcissistic politics of identity and difference, might seem far removed from art of the more settled regions of Australia. However, if the pictures of settlement lack Baines' direct engagement with the indigenous other, they represent, albeit in a repressed fashion, the same narcissistic scene. For example, Marcus Clarke, at the request of von Guérard, interpreted the landscapes of Buvelot and Chevalier as ghostly sites of the other in which the Aborigine is an intimate part of a landscape that mirrors the narcissistic desires of non-Aboriginal Australians. The monument to this narcissistic landscape is Henry James Johnstone's *Evening Shadows* (1880), in which Aborigines, camped by a stream under old mournful gums, make one of their last visible appearances in the 'high' art of the nineteenth century. Their presence is not erased but sublimated into the melancholy of the bush, where it is the sign of an other at the centre of both the bush and colonial identity.

The haunted landscape prevails in mid to late nineteenth-century Australian art and literature, especially in the literature. Indeed, Johnstone's paintings are a visual translation of Marcus Clarke's contention that 'the sight of aged trees must necessarily evoke some thoughts of the vanished past which saw them bud and blossom'.[40] For Charles Harpur and Henry Kendall the bush is simultaneously an emblem of non-Aboriginal Australian identity and Aboriginality. In Harpur's 'Ned Connor', a stockman is driven mad by the ghost of an Aborigine whom he had wantonly murdered; and in Kendall's best-known poem, 'The Last of His Tribe' (1864), the bush is haunted with an Aboriginal presence that penetrates the psyche of the stockman:

> He crouches, and buries his face on his knees,
> And hides in the dark of his hair;
> For he cannot look up to the storm-smitten trees,
> Or think of the loneliness there:
> Of the loss and the loneliness there.

Like many non-Aboriginal Australians of his time, Kendall subscribed
to Social Darwinism. He is well known for his grotesque racist parodies
which he wrote late in his life – such as 'Peter the Piccaninny' (1880):

> I never loved a nigger belle –
> My tastes are too aesthetic!
> The perfume from a gin is – well,
> A rather strong emetic.

However, if these comic poems are contemptuous, unlike the comic
grotesquerie of Cunningham, they do not disavow Aborigines. In the
'darker melancholy' and brooding terror 'of Kendall's *black* nature
poems' (Smith)[41] such as 'Cooranbean' (1879), the haunting presence
of an Aboriginal ghost is all-pervasive:

> The brand of black devil is there – an evil wind moaneth wround –
> There is doom, there is death in the air: a curse groweth up from the ground!
> No noise of the axe or the paw in that Hollow is heard:
> No fall of the hoof or the paw – no whirr of the wing of the bird;

Clarke realised that the absence of Aborigines was registered in the
heightened melancholy of the art and literature of the time, where their
memory lingered as if ghosts forever haunting the psyche of the nation.
A melancholy landscape is an historical landscape, haunted with
memories. The once dreary featureless bush now teemed with spirits and
history, making this *new* country the most *ancient* land, and giving its new
owners a new indigenous identity. This symbolist aesthetic proved far
more effective than the picturesque in taking possession of the country.
For example, this is how Clarke described Buvelot's *Waterpool Near
Coleraine* (1869):

> The time-worn gums shadowing the melancholy water tinged with the light of
> fast-dying day seem fit emblems of the departed grandeur of the wilderness,
> and appear to poetic fancy to uprear in the still evening a monument of the
> glories of that barbaric empire [of the Aborigines] upon whose ruins the ever-
> restless European has founded his new kingdom. [42]

The predilection for the ghostly presence of primitive forces found,
for example, in the writing of Harpur, Kendall and Clarke, is typical of
the interest in the occult which accompanied the symbolism and
adventurism of late nineteenth-century art and literature, and provided
a potent arena for imperial novels well into the twentieth century. Joan
Kirkby, for example, argued that novels such as E. M. Forster's *A Passage
to India* (1924) and Joan Lindsay's *Picnic at Hanging Rock* (1967) repre-
sent the 'British intrusion into an unfamiliar land' as 'an outbreak of

inexplicable phenomena and preter natural experiences'. 'It as though the earth refuses to be confined by an order of culture unnatural, even inimical, to it; and forces seem to be unleashed by the earth itself in resistance to such schematisation.'[43] Unlike neo-classical and picturesque schemas, in late nineteenth-century symbolism the grotesque, occult and primitive became the locus rather than antipole of both colonial and modern identity. When, in his criticism of Buvelot, Clarke wrote that 'the animal life which exists in the glooms of these frowning hills is either grotesque or ghostly . . . their solitude is desolation', his purpose was not to warn good Englishmen away, but something far more metaphysical: to make a memory from loss, and a history from its perceived absence. Clarke knew that the picturesque failed in Australia. In Europe 'every rood of ground is hallowed in legend and in song',[44] but 'this our native or adopted land has no past, no story. No poet speaks to us'. His solution, to write a poetic history, attempted to access a primal language which made Australia a 'Land of the Dawning', and hence a type of modernity, a newness, that claimed its place in Western civilisation. While 'some see no beauty in our trees', Clarke believed that:

> the dweller in wilderness acknowledges the subtle charm of this fantastic land of monstrosities. He becomes familiar with the beauty of loneliness. Whispered to by the myriad tongues of the wilderness, he learns the language of the barren and uncouth, and can read the hieroglyphs of haggard gum trees blown into odd shapes . . . The phantasmagoria of that wild dreamland called the Bush interprets itself, and he begins to understand why free Esau loved his heritage of desert-land better than all the bountiful richness of Egypt.[45]

No matter how much those who followed Clarke disavowed his aesthetic, they did not escape his ideological closures. This is particularly true of the impressionists, and it is their blindness that produces the contradictions in an art which, for the first time, claimed a national purpose, as if redemption had finally been achieved.

CHAPTER 4

The Bad Conscience of Impressionism

The difficulties in appreciating the contradictions and ambiguities of Australian impressionism are due primarily to their close association with nationalist aspirations. Impressionism, it is said, threw off the shackles of colonialism and its picturesque and grotesque aesthetics, to produce a radical new vision of landscape suited to an independent modern Australia. This view was originally the marketing propaganda of the impressionists themselves. In 1916 Frederick McCubbin argued that Australian artists before the impressionists 'were all imbued with the spirit of Europe.' Their art:

> belonged to lands of humid skies, of deciduous trees and low toned landscapes; countries so vitally different from our land of strident sunshine, clear skies and dry atmosphere.
>
> All these pioneer pictures leave us cold, they inspire us with no love and with very little interest, beyond the spectacular. They might belong to any country, so little are they Australian.

McCubbin selected Arthur Streeton's *The Purple Noon's Transparent Might* (1896) as the exemplary Australian painting:

> In this picture the glorious brilliancy of the noonday sun flooding the landscape with its white light, seems to bleach the local colour with its dominating strength ...
>
> One cannot imagine anything more typically Australian than this poem of light and heat. It brings home to us forcibly such a sense of boundless regions of pastures flecked with sheep and cattle, of the long rolling planes of the Never-Never, the bush-crowned hills, the purple seas of our continent.
>
> You could almost take this picture as a National Symbol.[1]

Fifty years later the same view prevailed. This is how Robert Hughes put it:

No country in the West during the nineteenth century, with the possible exception of Patagonia, was less endowed with talent ... There is little in the history of Australian art between 1788 and 1885 that would interest a historian ... But events after 1880 were more interesting. Within a decade, four young Melbourne painters were to give Australian art a direction, and form the first identifiable national school.[2]

The privileged position that impressionism enjoys in the myth of Australian nationhood is due to its congruence with the nativist sentiments of journals such as the *Boomerang* and the *Bulletin* – the latter's mast-head being 'Australia for Australians'. 'The *Bulletin* saw itself as nurse and guardian of national literature', publishing writing and pictures that were, 'for the first time, consciously of, by and for the Australian people'.[3]

However impressionism was no less or more internationalist than its predecessors. First, the realism and symbolism of impressionism were typical of global art styles at the time, realism being associated with nationalist political struggles around the world, and symbolism with an empire ethic that found redemption in the exotic and the primitive. Second, impressionism was part of an ideology which, in Australia, gained its political impetus from the immense social changes wrought by the large influx of migrants from different locations who were attracted by gold – the increased wealth and population engendering a new-found sense of prosperity and confidence in the future of the place. For these reasons, Leigh Astbury links the emergence of Australian impressionism not to local aspirations, but to the influence of 'immigrant painters' who introduced 'a ferment of new ideas', exposing local artists 'to a range of recent European styles' and contrary fashions, from *plein air* naturalism to symbolism and art for art's sake.[4] The impressionists were bohemians and Japonists before they were bushmen, and as much the product of *fin de siècle* symbolism and Whistleresque aestheticism as they were of realism. Streeton may have convinced Bernard Hall, the director of the National Gallery of Victoria, that *The Purple Noon's Transparent Might* 'is most characteristically Australian in the way of pictorial sentiment',[5] but Streeton had named his paean of national symbolism and Australian heat after lines from Shelley's 'Stanzas Written in Dejection, near Naples' (1818):

> Blue isles and snowy mountains wear
> The purple noon's transparent might

Arguably, the Australian impressionists looked to the local bush for inspiration, not because they were, or even aspired to be, bushmen and women, but because they were partial to the pastoral ideal commonly

found amongst city-dwellers. The impressionists' motives, Tom Griffiths pointed out, were the same as those of other intellectuals of the day, such as the writer Charles Barrett, who set up a bush hut called 'Walden' at Olinda in the Dandenongs.[6] This recurring ideal of a direct communication with nature and locality (place) was largely responsible for the numerous artists' camps on the outskirts of Australian cities in the late nineteenth century – as it was throughout Europe.

The impressionists, in accord with their European cousins, sought an uncommonly intimate communion with nature. While the picturesque painters of previous decades preferred a prospect and distance which imposed a certain order on the place, the impressionists wanted to be in the landscape, as if this would enable them to imbibe its essential identity. Streeton wrote: 'I love the thought of walking into . . . the great gold plains, and all the beautiful inland Australia . . . I fancy large canvasses all glowing and moving in the happy light and other bright decorative and chalky and expressive of the hot trying winds and the slow immense summer'.[7]

This desire might be partly explained by the city-dweller's nostalgia, evident amongst the picturesque painters, to be in and part of nature. However, added to this was an empire ethic which sought identity in the other, and a new-found nationalism which sought an indigenous identity. The Australian Natives Association was formed in Melbourne in 1871. As well, naturalist clubs, such as the Field Naturalists Club of Victoria formed in 1880, championed the widespread interest in indigenous flora and fauna, and prominent journalists such as Donald Macdonald contributed articles on Australian nature to several journals and newspapers. The colonisers even claimed the sun as their very own, because it seemed such an important natural feature of the place. Bernard Smith noted that the impressionists' 'great love of the sun did not spring simply from a desire to state visual facts truthfully', rather 'the image of the sun came to be used increasingly . . . as a symbol of Australia itself. The sun, that is, came to occupy a key place in the mystique of Australian nationalism, and, when, in 1915 the Anzacs stormed the Dardanelles, they wore it emblazoned upon their slouch hats'.[8]

Seeing this sunnier disposition as the sign of an independent national consciousness, Smith argued that the impressionists turned away from colonialist associations of Marcus Clarke's more grotesque vision of the place. And there is plenty of evidence. Macdonald, for example, dismissed Clarke's melancholy as 'unreal', and saw the Australian landscape as a redeemed place that seemingly ignored the hardships of colonisation.[9] While very aware that the colonisation of Australia had decimated Aboriginal populations, he believed it was due to the hand of destiny rather than malevolence and conquest: the Australian 'plains have been

propagated with a ploughshare only, and no roaring cannon shot has ever burst the glebe'.[10] It is exactly this quiet of a virgin dawn which Streeton, in particular, immortalised in his paintings. He, too, sought a transcendence which completely forgot the slaughter, destruction and melancholy of colonial history. For the same reason, Tom Roberts was pleased to note in his presidential address at the close of the first Society of Artists exhibition in 1895:

> It would probably be noticed that there was not in this exhibition that note of melancholy which was supposed to be characteristic of the Australian bush. Marcus Clarke and Adam Lindsay Gordon started that note, but he was glad there was not a single trace of it left in the work that was now being done by artists. There was something bright and fresh and hopeful in this exhibition, and that … was … the mark of a young country that was going to be a great nation.[11]

The repudiation of colonialist melancholy for a postcolonial redemption was not as straightforward as Roberts suggests. The desire for indigenity was inextricably bound up with the empire ethic of identity in otherness. Likewise, the sunnier disposition of nativism and impressionism was not as alien to Clarke's melancholy aesthetic as it might first seem. This is particularly evident in the life and writings of Henry Lawson which, Xavier Pons argues, is full of 'contradictions and paradoxes'.[12] Lawson, who was a more strident and fierce nationalist than any of the painters, and who for a short time actually adopted the life of a rural worker in his search for a redemption that he only found in the bottle, was contemptuous of idyllic images of the bush. In his poem 'Up the Country', Lawson attacked Banjo Paterson's 'Clancy of the Over-flow' for 'its idyllic vision of the bush, suggesting that, in fact, it fell nothing short of a hell on earth'. Indeed, Lawson's 'In a Wet Season' describes the bush in ways that recall Clarke – 'Sky like a wet, grey blanket; plains like dead seas, dismal – everything damp, dark and unspeakably dreary'[13] – except that Lawson's mode is realist rather than allegorical. If Roberts' picturing of mateship in his two most praised hymns of the bush, *Shearing the Rams* (1880–90) and *Break Away!* (1891), accords with the masculinist heroism of Lawson's poems, his characterisation, like Paterson's, lacks the lonely melancholy which lend Lawson's subjects their existential weight:

> not quiet with the resentful or snobbish reserve of the educated Englishman, but with a sad or subdued sort of quietness that has force in it – as if they fully realised that their intelligence is much higher than the average, that they have suffered more trouble and heartbreak than the majority of their mates … [and yet] intensely sympathetic in their loneliness and sensitive reserve.[14]

However, the sunnier dispositions of Streeton and Roberts were imagined within a symbolist frame that was not adverse to melancholic and poetic pretensions. Many early impressionist paintings, such as Roberts' *Evening, when the Quiet East Flushes Faintly, the Sun's Last Look* (1887–8) and Arthur Streeton's *Twilight Pastoral* (1889) and *Still Glides the Stream, and Shall Forever Glide* (1890), carry unmistakable traces of Clarke's 'poetic fancy' aesthetic in their damp purple light, and the lonely skeletal gums presiding over a developing land – even if their melancholy was less strident and more akin to the Whistleresque aestheticism of the time. Even Streeton's and Roberts' most sun-filled and characteristically Australian work, such as Roberts' *Break Away!* and Streeton's *Golden Summer, Eaglemont* (1889), painted during one of the worst droughts ever recorded, were arguably concerned with 'heightened poetic feelings' which transcended the harshness of the drought for a resplendent vision of, in Streeton's words, 'copper and gold ... light, glory and quivering brightness'.[15] Astbury wrote that *Golden Summer, Eaglemont* 'has been consciously idealised' in the manner 'of the pastoral idyll'[16] and its melancholy associations. For these reasons, Bernard Smith suggests that in *Golden Summer, Eaglemont* 'the romantic light of the afterglow and moonrise ... is closer to Claude ... than to the French impressionists'.[17] It is also close to Adam Lindsay Gordon's poems, immensely popular at the time, and praised by Clarke. Indeed, a good twenty years before Streeton, Gordon discovered the expressive potential of the characteristic impressionist colours of golds and silver greys. In his melancholy poem 'De Te' he writes:

> A Burning glass of burnish'd brass,
> The calm sea caught the noontide rays,
> And sunny slopes of golden grass
> And wastes of weed-flower seem to blaze.
> Beyond the shades of denser bloom,
> The skyline girt with glowing haze
> The farthest faintest forest gloom,
> And the everlasting hills that loom.

The metaphors of light and gold in both Gordon and the impressionists is not the idealised Claudian vision which inspired Glover, but a symbolist evocation of redemption which was not so much sunny as other-worldly, and as in Gordon, melancholy. 'Even in Sydney', wrote Ruth Zurbans, 'where the image of a sunny South cast a stronger spell', '*fin de siècle* symbolist trends came to dominate'.[18] 'By the mid-nineties', wrote Astbury, Australian critics were claiming 'the "sad tone" of such poetic landscapes as typical and representative of Australian scenery and experience'.[19] One critic wrote in 1895: 'the presence of so many "grey

days", "misty mornings", "summer evenings", etc ... can be measured out by the square yard ... There are few "hot days", thank heavens!'[20]

If the high-keyed naturalism of Streeton's and Roberts' paintings of the 1890s have come to represent a sunny optimistic disposition, 'it is', argued Ian Burn, 'part of the retrospective reading of the Heidelberg era'. 'The point to be stressed', he continued, is that low-keyed paintings 'existed alongside those "more Australian" high-keyed pictures',[21] and each should be considered in terms of the symbolism of the day. Charles Condor's *Mirage* (1888) and *Yarding Sheep* (1890), and John Ford Paterson's *Fernshaw: a Bush Symphony* (1900), despite being high-keyed, are each decidedly symbolist. Paterson's pinks and mauves, wrote Burn, create a sense of 'solitude' and 'poetic silence',[22] as if commemorative of some tragic event. What are the meanings of Australian Parisian paintings, such as Aby Alston's sun-drenched symbolist painting *The Golden Age* (c. 1893) and E. Phillips Fox's *Summer* (c. 1912)? Each depicts the bright light of the sun falling across the skin of youthful female bodies. And how are we to distinguish them from Streeton's studies of golden summers, or from his *The Spirit of the Drought* (c. 1895)?

No matter how poetic Australian painting was in the 1890s, there was a conscious attempt by a number of painters to distance themselves from Clarke's melancholy – as if its poetic conventions were not adequate to the task. The first to do this was Roberts. The subject of his painting *Sunny South* (c. 1887), wrote Astbury, is 'the attraction of brilliant sunshine'.[23] Others also broke with the melancholy disposition of nineteenth-century Australian art. Condor's *Spring-time* (1888) and Streeton's *Butterflies and Blossoms* (1890) are amongst the most cheerful images ever painted of the Australian landscape. If, observed Tim Bonyhady, such cheer was realised by eschewing the Australian bush,[24] Streeton did invent a type of composition and viewpoint that pictured a redemptive vision of the landscape – though invention might be too strong a word, for he returned to the elevation of the neo-classical prospect preferred by picturesque artists. However, in the context of the time, the return was an original move which successfully introduced a way of painting a transcendent landscape.

The colonial art of Glover, Martens, von Guérard and Chevalier had, in the picturesque tradition, kept a distance from the landscape, and indeed, were often painted from an elevated position. Clarke, however, drew his readers into the undergrowth and crannies of the bush, just as Buvelot, H. J. Johnstone and other realists did in their paintings. In the early work of McCubbin and Roberts this new found intimacy is evoked to an unprecedented extent,[25] their viewers being, in Michael Fried's sense, *absorbed* into the landscape.[26] Such paintings offer a self-containing and fully subjective vision which at the same time makes one

feel part of the landscape. Just as Constable's own private subjective vision[27] came to embody for Englishmen the essence of their national identity and indigenity, so McCubbin and Roberts made the Australian landscape seem continuous with one's identity. However, Constable's absorption in the landscape spoke of his indigenity, whereas in the paintings of Johnstone, McCubbin and Roberts the same desire evoked an unease with a landscape to which these artists were only visitors. If Streeton's more elevated position gave him a commanding perspective, it also witnessed his estrangement from a landscape which, no matter how much he wanted to be absorbed into it, was not fully his. In this respect, his pictures unconsciously witness an occupied rather than indigenous land. Indeed, the panoramic technique, which in the late eighteenth century had proved so useful to tourists wanting to quickly master the landscape in the ubiquitous picturesque style, was invented by Thomas Sandby as a means to show the lie of the land for military purposes.[28] The relationship between the panoramic view, ideology and power has been so often commented on that I do not need to revisit it here,[29] except to point out that the panoramic or prospect aesthetic implies that the viewer/artist is estranged from the landscape, yet at the same time offers a pictorial means of transcending this alienation.

Streeton's paintings unconsciously witness his estrangement from the landscape, and consciously evoke his sense of place in it. Streeton had always shown an interest in painting the expanse of landscape afforded by the panoramic technique, and by the early 1890s was using it to good effect – as in *Still Glides the Stream, and Shall Forever Glide* (1890), *The Valley of the Nepean* (1891) and *The Valley of the Mittagong* (1892). It became such a characteristic trademark of his later work that J. S. MacDonald declared Streeton a 'master of distances'.[30] Further, Streeton's transcendent effects did, to an extent, overcome the unease implied in his desire to master distance. Burn accurately described it as the plotting of a 'rapprochement between people and place'.[31] Hence, Streeton's return to the elevation of the earlier colonial artist was a return to the opposite effect. While the vast realm of impenetrable bush in Glover's *Mount Wellington with Orphan Asylum, Van Diemen's Land* (1837) presents an alien melancholy land yet to be tamed, in Streeton's *Golden Summer, Eaglemont* 'the "veil" of thick bush has been lifted and the distance depicted without it appearing as an enormous expanse which is both mysterious and vaguely threatening, a vast unknown'.[32] Expressed as a transcendent rather than melancholy effect, it became emblematic of the spiritual reintegration and national identity of modern Australia. Streeton's 'Arcadian metaphor', observed Deborah Edwards, 'conveniently cancelled the stigma of a convict past',[33] and created a national style which was adopted by later landscape painters such as Elioth Gruner

and W. B. McInnes. Burn perceptively observed that in the 1890s the sense of a homely landscape was 'still tentative', whereas in the later post-war work of Streeton and his followers, it 'is presupposed – the artist, and thus the viewer, appearing in full possession of the landscape'.[34]

Whatever the ambivalence of impressionism it provided a transcendent discourse which, for many at least, redeemed the melancholy and grotesque beginnings of the place. According to Burn the signs of impressionism's redemptive ideology were many: a transcendent light, an 'Arcadian evocation' which, in Streeton, is even 'sustained' to the horizon, and the use of slender young gum saplings which 'carry a heavy ideological load' of youth, optimism, the new.[35] At a populist level, Streeton's redemptive vision still prevails. However, a number of people, especially more radical artists and intellectuals, have remained sceptical. Events in the new century quickly undid the work of impressionism. Its transcendent vision, like the hopes of earlier generations of Australian artists, also failed; and it failed at the very time that Streeton achieved his greatest public recognition – after the First World War. This failure of redemption suggests that impressionism remained primarily a discourse of repression rather than one of transcendence. While it may be argued, as Adorno did, that all transcendence is built on repression, in the case of Australian impressionism this repression was never foreclosed and so the transcendence never complete.

If the impressionists forget Clarke's 'fit emblems of the departed grandeur of the wilderness' and monuments 'of the glories of that barbaric empire', the forgetting was a discourse of repression, a nativist discourse without Aborigines. Bernard Smith was the first to sense this. He explained it as a classic case of Freudian blindness, seeing a portent in a politics of identity which erased Aboriginality, as if it was 'a nightmare to be thrust out of mind'. Between the 1880s and 1920s, when 'Australian cultural life was dominated by the ethos of the pastoral life and social Darwinism' and the White Australia policy was formulated, Aborigines are rarely depicted in Australian paintings. During these times, wrote Smith: 'with the Aborigines banished to hidden reserves and the old melancholy of the bush absent, Australian nature could at last be approached in a radiantly happy mood ... The Heidelberg painters and their successors were now able to consolidate the pastoralist dream of a sun-kissed Arcadia'.[36] The most famous appearance of Aborigines in art during this period is in that neglected painting of empire, *The Landing of Captain Cook at Botany Bay 1770* (1902). Commissioned to commemorate Federation, and painted in Britain by the expatriate artist E. Phillips Fox, it graphically and consciously illustrates the role of Aborigines in the Australian imagination at this time.

Fox chose to depict the moment when Cook ordered a third shot fired at two Aborigines protesting the landing. Compositionally, the viewer is made to identify with the landing party. The figures of Cook and Joseph Banks, under a large unfurled Union Jack, are ennobled through references to the antique sculpture *Apollo Belvedere*,[37] while the pictorial space comes forward to meet the viewer and locate him or her behind the three marines preparing to fire at the two Aborigines who are silhouetted, in classic noble savage pose, in the distance. From here, the viewer's sight-line to the Aborigines is the same as that of the marine who aims his gun at them. It is a graphic demonstration of a painting which, in a most didactic manner, puts Aborigines in the firing line. And opposite the Aborigines, symbolically waiting to take their place, is the *Endeavour* anchored in the bay.

It is unusual for the Federation of Australia to be celebrated, let alone pictured in terms of such a stark conquest. Fox seems to deliberately draw our attention to the consequences of colonisation for the indigenous populations, here disappearing in the distance as indeed they seemed to be to most observers at the time. A review of the painting in the Melbourne *Herald* read: 'It is not well for young Australians to look upon Cook's landing as a shooting down of helpless Aboriginals'.[38] The reviewer, who would have preferred the artists to depict the exchange of trinkets and blankets, may have been thinking of Blamire Young's *Buckley Acting as Interpreter at Indented Head* (1901), another painting of Federation times which depicted Aborigines.

John Longstaff's painting of Burke, Wills and King forlornly contemplating their fate under the river gums of Cooper's Creek (*The Arrival of Burke, Wills and King at the Deserted Camp at Cooper's Creek* (1902–7)), also commissioned to commemorate Federation,[39] is more typical of the time. If, according to Bernard Smith, it 'represents a curious survival into the twentieth century of that melancholy interpretation of Australian life and nature',[40] Aborigines are absent, and the drama of colonialism is depicted as one of empire, not indigenity. Except for Fox's painting, and a few other studies,[41] Aborigines disappear from non-Aboriginal Australian art, not to appear again until the time of the Second World War.

How are we to explain the simultaneous disappearance of Aborigines and Clarke's melancholy aesthetic from Australian painting? According to Freud, when the memories of formative experiences appear to disappear, they have not been erased but repressed in the unconscious, from where they are articulated in art, wit and dreaming through mechanisms of displacement, reversal and indirect expression. Colonial genocide had made Aborigines figures of the coloniser's unconscious, from where they are reified in various substitute and necessarily

ambivalent images. The ambivalence was rarely addressed in a conscious fashion – though one rare example is Barbara Baynton's allegory of Australian bush mythology, 'Squeaker's Mate',[42] first published in 1902.

Baynton portrays Australia as a Cockaigne (antipodean) land where the ideological differences of race and sex are dangerously mixed – especially given the exaggerated masculinist and racist virtues of the time. Not only are gender roles reversed, but Squeaker, as his name suggests, is a figure of castration: 'The woman carried the bag with the axe and maul and wedges; the man the billy and clean tucker bags'. 'From the bag she took the axe, and ring-barked a preparatory circle, while he looked for a shady spot for the billy and tucker bags.' Second, Squeaker's mate was like an Aborigine: 'her grey eyes were as keen as a Blacks', and the land had seemingly deserted her. The tree with which she was to make the fences for her run was rotten:

> Long and steadily and in secret the worm had been busy in the heart. Suddenly the axe blade sank softly, the tree's wounded edges closed on it like a vice. There was a 'settling' quiver on its top branches which the woman heard and understood . . . a thick worm-eaten branch snapped at a joint and silently she went down under it.

Crippled, she is replaced by Squeaker with another mate, but she gets her revenge, as swiftly and terrifyingly as a 'wounded, robbed tigress'.

While Lawson also depicts the bush as an unyielding harsh place, he uses it as a foil to celebrate the indomitable spirit of its inhabitants, and so reinforce the myths of mateship that he espoused. It is these very myths which Baynton deconstructs. 'Squeaker's Mate' is an ironic undoing of the masculinist ideal of mateship – which is why Australian critics have generally found it and other stories by Baynton perplexing. A. A. Phillips called her a 'dissident' because, Kay Schaffer pointed out, her stories 'defy the mood of cheery optimism which the Democratic Nationalists assert as central to the Australian tradition'.[43] If the impressionist painters generally avoid such perplexing ambivalence in their supposed sunny pictures, they do not evade it in the symbolism of their imagery. In place of Baynton's revenging trees or Clarke's ghostly gums, the impressionists depict either slender young saplings, or old trees triumphantly felled like trophies on the ground – as in Streeton's *The Selector's Hut: Whelan on the Log* (1890) and Condor's *Under a Southern Sky* (1890). However, the saplings are still native trees, symbols of the new nation that bear the imprint of a repressed Aboriginality. It did not take long for the saplings to grow into monumental emblems of a new nation. Indeed, between 1890 and 1910 these gums grew with their characteristic rapidity into what Burn called the 'regal gum-tree' of Hans Heysen – an

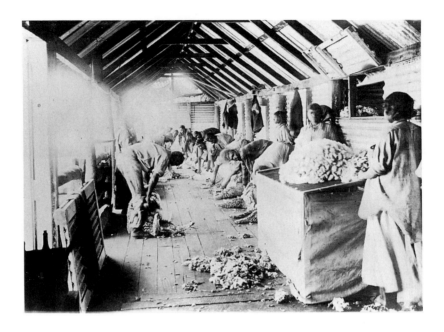

Family photograph, Corruna Downs Station – old Drake Brockman property,
WA, *c.* 1906.

'anthropomorphic' vision of 'giant gum trees frozen in self-conscious,
melodramatic poses'.[44]

If gum trees can be considered emblems of Aboriginality, the bushie
and itinerant rural worker on the wallaby track are exemplary substitute
figures of the Aborigine in the mould of the frontier ethic advanced by
Frederick Jackson Turner, in which the white frontiersman takes on the
qualities of the Indian. However, the crossovers occurred in ways which
Turner never imagined. For example, when Roberts painted *Shearing the
Rams* (1890), his icon of Australian identity and 'strong masculine
labour'[45] on the frontiers of empire, such labour was being performed
on the new Australian frontiers in the north by Aborigines – male and
female. In 1881 over 2000 Aborigines were 'employed' in the pastoral
industry, with the figure rising to 4000 in 1905 – though 'employed' is
here a euphemism for slavery.[46] In a photograph of the shearing shed at
Corruna Downs Station in Western Australia (*c.* 1905),[47] the home of
Sally Morgan's grandmother (in *My Place*), male and female Aborigines
perform labour in an environment almost identical to that shown in
Robert's *Shearing the Rams* and *The Golden Fleece* (1894). The image of
Aboriginal shearers was too transgressive to be considered an icon of the
nation at the time of Federation. Even today, the unintentional reappro-

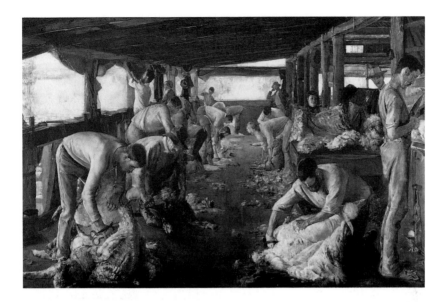

Tom Roberts, *The Golden Fleece – Shearing at Newstead*, 1894. Oil on canvas. 104 by 158.7 cm. Art Gallery of New South Wales, Sydney.

priation of such an iconic image pictured in this photograph deconstructs the myth which Roberts laboured to produce in *Shearing the Rams*.

The impressionist nude paintings can also be considered pictures of repression. Astbury pointed out the extent of the Australian impressionists' ambition to paint the figure.[48] The ambition reflects more than their training, which Astbury construed to be one of academic conservatism. Their nudes also continue a long pastoral tradition which accompanied the utopian impulse of the colonial era, and one which was then reasserting itself amongst European modernists. While the impressionist nude is *plein air*, and seems a natural part of the life and ethic of the bohemian camps around Sydney and Melbourne at the time, it has often been pointed out that there is nothing particularly Australian about these artists' camps.[49] Bernard Smith, for example, saw them as part of an international 'neo-pagan interest in nudity, sex and sun-cults'.[50] The Australian impressionists were not just embracing the Australian sun but a Nietzschean cult which their European counterparts also followed. A host of avant-garde European painters headed south, even to Africa, to revitalise their vision. If, in this sense, Australian impressionists merely emulated their European origins, in Australia they had a different history to contend with.

'Roberts' charming little *Sunny South* must be', wrote Bernard Smith, 'one of the first, if not the first, studies of the nude in a *plein air* setting painted in Australia'.[51] However, Smith forgets that for the previous 100 years there had been plenty of *plein air* nudes in Australian art – all of them depicting Aborigines. With impressionism the nude changed colour. Instead of Aborigines enjoying their lost paradise, as in Glover's paintings, there are the white native-born in their new austral Eden. Most of the impressionists seemed to have tried their hand at the genre. Besides Roberts' *Sunny South*, there is Condor's *The Yarra, Heidelberg* (1890), Streeton's *Boys Bathing, Heidelberg* (1891), Sydney Long's *By Tranquil Waters,* (1890), McCubbin's *Afterglow,* (1912), and many more.

In one sense, the appearance of the white Australian nude is directly linked to the nationalism of the period, for it depicts the uninhibited freedom of the sunny south, in contrast to English life. Perhaps, in this respect, these images of naked white Australians are meant as an affront to English Victorian prudery. This, no doubt, contributed to the ironic effect of the cover drawing for the *Boomerang*'s Christmas issue of 1888, titled 'Christmas Here and There', in which Australia is, in anticipation of Norman Lindsay's iconography, represented by a half-naked Grecian maiden enjoying a Mediterranean pagan luxury, while rugged up English people freeze in a bleak winter.

It is not just a conscious Nietzscheism or nationalism but also a repressed Aboriginality which makes an appearance in the artists' camps at Mosman on the north shore of Sydney Harbour in the 1890s, transforming the wilderness that Collins had so dreaded into a summer arcadia. Something of what Collins feared is still retained in the depiction of the heavy bush in Roberts' *The Camp, Sirius Cove* (1899), which spills into the deep waters of the bay. Camped within in its folds these bush bohemians seemed to participate in its mysterious interior. Here, in the company of such *Bulletin* aficionados as Livingstone Hopkins, the impressionists adopted what they considered to be the bohemian virtues which, once seen as signs of Aboriginal laziness, are now emblems of a sophisticated avant-gardism. It is fitting that the bohemians moved to Mosman while the sole surviving Aborigine of the area, a Cammeragal 'known as "Tarpot"', spent the last years of his life 'in a cave near the ferry wharf'.[52]

Anthropology, Modernism and Aboriginality

While the particular content of the repressions and exclusions in impressionist paintings are the result of their local Australian context, their form and structure is common to the modernist aesthetic which they consciously espoused. The artists' camps were amongst the vanguard

No. 58. SATURDAY, DECEMBER 22, 1888. Price, 3d.

Monty Scott, 'Christmas Here and There', *Boomerang*, 22 December 1888, front page.

of modernism in Australia. Modernism, especially its avant-gardist forms, celebrates the triumphant frontier as the spawning ground for rejuvenating a European civilisation, a Nietzschean-type ideology forged from 'the return to primitive conditions on a continually advancing frontier line'.[53] Seeing themselves as the vanguard or frontiersmen, modernists regularly plunged into the transgressive and primitive in order to revitalise both the project of modernity and their own subjectivity. Here the primitive is in a diachronic rather than synchronic frame, the frontier being imagined as a line demarcating ancient and modern Australia. Unlike colonial painters, the impressionists did not include Aborigines and non-Aborigines in the same pictorial space, unless, as in Fox, it was to consciously allegorise a diachronic relationship. The paradigm was not confined to aesthetic modernism but structured other modernist disciplines, in particular anthropology.

Modern anthropology, as distinct from earlier ethnographic studies, understood indigenous peoples according to a diachronic formula of alterity – no longer *savage*, but *native, primitive, pre-historic, aboriginal.* Savagery, once excluded semiologically through grotesque tropes as the antipode of civilisation, was now dispersed temporally by Darwinian tropes as the *earlier, embryonic, original, native* form of the *contemporary, adult* society of modernity. Freud accomplished much the same temporal disappearance in his field, believing that the 'psychic life' of 'the so-called savage ... races' is 'a well-preserved, early stage of our own development'. He thus singled out for his study 'the most backward and wretched' of tribes: 'the aborigines of the youngest continent, namely Australia, whose fauna has also preserved for us so much that is archaic and no longer to be found elsewhere'.[54] One of Freud's primary sources was the Australian anthropologist Baldwin Spencer, of the same generation as F. J. Turner and Freud. When Spencer travelled to the Centre, which in Australia is the Western Desert, his camels were time-machines which took him back to the origins of mankind. Thus, he declared Aborigines to be 'a relic of the early childhood of mankind left stranded'.[55] In this telling metaphor we sense why Spencer was a primary reference for Freud, and why of all aboriginal people, the Australians have been blessed with the title 'Aborigine', as if their culture is the first of all cultures.

The frontier sciences of anthropology and psychoanalysis effectively made Aborigines the unconscious of modernity. The absence of Aborigines in Australian impressionism is of the same order as their presence in anthropology and psychoanalysis. This is most evident in the work of Spencer. Appointed Professor of Zoology at Melbourne University in 1887, he became the most influential anthropologist of his day, remaining active in the field until his death in 1929. Not only was he

working at the same time that (European) impressionism made its mark in Australia, but he was the most important private collector of Australian impressionist paintings, one of Streeton's close friends and a sketcher of some talent.[56] His home was at the frontiers of modernity, be it the frontiers of art, anthropology or empire.

Spencer was in the vanguard of a science which hoped to confirm its theories of cultural evolutionism by proving that Aborigines were a living anachronism occupying the lowest rung of the ladder, and whose 'time' was thus 'rapidly drawing to a close'.[57] Aborigines, already consigned to oblivion by the politics of frontier life, were buried all over again by an anthropology in which they were the other of history, progress and culture. In the tropes of evolution, (ab)'original' signified less-developed primitive forms. To Spencer, Aboriginal societies were like living fossils, their 'rudimentary customs' the original forms of contemporary European culture.[58] His teacher and colleague, Edward B. Tylor, Professor of Anthropology at Oxford University, wrote of the Tasmanian Aborigines:

> They stand before us as a branch of the Negroid race illustrating the condition of man near his lowest known level of culture ... Many tribes in the late Stone Age have lasted on into modern times, but it appears that the aborigines of Tasmania, whose last survivors have just died out, ... represented the condition of Palaeolithic Man.[59]

The ideological purpose of such historicism is and was then, clear: 'to look at a savage of the Brazilian forests, a barbarous New Zealander or Dahoman, and a civilised European, may be the student's best guide to understanding the progress of civilisation'.[60] Hence, while Spencer documented the sophistication of Aboriginal cultural patterns, he warned his readers not to be misled by the complex ritual of the Aborigines:

> To a certain extent it is without doubt elaborate, but at the same time it is eminently crude and savage in all essential respects. It must be remembered that these ceremonies are performed by naked, howling savages, who have no idea of permanent abodes, no clothing ... no belief in anything like a supreme being.[61]

More than anyone else at the time, Spencer gave scientific credibility to the frontier ethos. His ideas even penetrated the popular imagination. Well into the twentieth century it was widely believed that Aboriginal art consisted, at best, of no more than 'some crude ideas ... [which] found expression in the adornment of war weapons'. Sir Frank Fox (the inaugural editor of the *Lone Hand*) who made this valuation in 1927, summarised the current scientific opinion: 'the Australian aboriginal was a very poor type ... a quaint relic from the prehistoric times when the

ichthyosaurus was a living reality ... there was really no "language" at all, only a small collection of words expressing common needs and primitive ideas'. There was only one possible ending: 'But the race is dying ... it is possible to calculate with almost certainty a date on which "the last post" will be sounded over the Australian, as it has been over the Tasmanian, aboriginal race'.[62]

Spencer's job was not to silence Aborigines; this had been done already. Much of the anthropological work of Spencer and others at the time was motivated by the perceived near-extinction of Aborigines. As with the impressionists, Spencer's larger mission was a redemptive one: from the disappearance of Aborigines he would fashion a transcendent ideology for the new nation – just as E. Phillips Fox did, if somewhat uncomfortably for some viewers, in his depiction of the landing of Cook at Botany Bay. Australia's presence was founded on an absent Aboriginality. Yet, ironically, the principal legacy of Spencer's work is that he made Aboriginality visible to an extent never seen before. He amassed a huge collection of Aboriginal art, helped create an Aboriginal art movement and genre (of bark paintings) to meet the demands of his collecting,[63] made photographs, films and sound recordings, wrote books and presented popular public lectures on Aborigines and their culture.[64] However, all of this evidence was seen as proof of the Aborigines' innate primitiveness and their immanent extinction. Spencer did his best to advertise their anachronism, confirming a mythology in which an inexorable logic was at work: the more Australia modernised, the more Aborigines had to disappear.

If Spencer amassed a huge collection of Aboriginal art, it was to document its non-artness. What Aboriginal art signified to Spencer is evident in his display of Aboriginal products according to an evolutionist style developed by General Pitt Rivers in the 1870s – it had the effect of reducing Aboriginal art to artefacts from bygone days, rather than as sophisticated aesthetic objects of contemporary use. In the catalogue for the exhibition of Aboriginal art held in 1929 at the National Museum of Victoria, and displayed according to the principles that Spencer had established as its director, A. S. Kenyon urged the viewer to 'divest his mind of all civilised conceptions and mentality and assume those of prehistoric man – of the infant of the present day'.[65] Such evolutionism was evident in the first recorded exhibition of Aboriginal art in the late 1880s in Adelaide, called 'Dawn of Art'. Likewise, journals in the intervening years, such as the *Centennial Magazine* and the *Lone Hand* published sympathetic articles on Aboriginal art that paternalistically discussed Aborigines as if they were children. A. W. Grieg believed that Aboriginal art exhibited a 'beauty that is childish, but by no means

despicable', and represented the 'tentative beginnings of the art and crafts of our own humanity'.[66]

Aboriginality, Repression and Identity

In making Aboriginality the origin and unconscious of modernity, Spencer and Freud also made it the centre of modernity. The dead father, said Freud, lives on in the unconscious. Repression, then, is the means of fashioning a descent. When the dead father is an Aboriginal one, his repression signifies an unconscious identity by non-Aboriginal Australians with Aborigines. If this is difficult to see in impressionist paintings except by a sophisticated psychoanalysis of its figures of repression, it is very apparent in the racist jibes and tropes of Australia's radical republican rags with which the impressionists were closely associated, such as the *Bulletin* and the *Boomerang*. For example, the conflation of Aborigines and a free white Australia is self-evident in the logo of the socialist paper, the *Boomerang*, which frequently allegorised itself as an Aborigine with boomerang in hand or flight.[67] This suggests that the nationalism of the time, and its twin legacy of a white Australia and a tolerant society based on mateship, is deeply ambivalent. Indeed, the ambivalence still haunts Australian society 100 years later, as evident in the Howard–Hanson débâcle of 1996–7, in which nationalism, mateship and racism combined in a divisive debate about multi-culturalism, Aboriginality and national identity that drew global attention.

Because of his pre-eminence Henry Lawson testifies admirably to the ambivalence at the heart of the (non-Aboriginal) Australian myth. The patron saint of Australian mateship, he 'found Japanese and American blacks quite acceptable – it was all a matter of being civilised enough rather than white enough' – though, Pons points out, he later changed his mind, expressing 'no sympathy whatever' for Afro-Americans or Japanese. Pons also notes the contradiction between apocryphal claims about Lawson's 'soft spot for the blacks [Aborigines]' and his own assertion that he had 'been suckled on a black breast', and the descriptions in his poems of Aborigines according to the racist 'stereotypes of the day'. The contradiction is mirrored in the ambivalence which Lawson felt towards England, resenting 'British condescension towards the colonies' yet, despite his 'red republicanism', becoming, after the death of Queen Victoria, an enthusiastic servant of empire and King, and a mouthpiece of the xenophobia and militarism that characterises Australian national identity, and indeed, most modern nationalisms around the world. Pons diagnosed in Lawson an arrested Oedipal development due to an unstable family environment: an absent father,

'inadequate mothering', a peripatetic childhood, resulting in a femi-
nised character with latent 'homosexual tendencies', doubts concerning
his own masculinity, and fascist leanings.

However, Pons argument that Lawson's racism and nationalism was a
sublimation of his own 'narcissistic wound into a political cause',[68] is too
narrowly focused. Whatever the personal reasons for Lawson's poetry,
the authority he won as the national poet suggests a collective malaise
and ambivalence. The racism of Australian nationalism cannot be
blamed on the sexual repression of its protagonists caused by poor
upbringing, but represents a collective repression – a collective Oedipal
trauma. Evidence for this is in the *Boomerang*'s personification of the new,
independent, red republican Australian as an Aborigine, even though it
advocated a white Australia. The conflation between the new white
Australia and black Aborigine was then so transgressive that it could only
be sustained by the comic form. Freud observed that wit and dreams
'discover similarities in dissimilarities ... "wit is the disguised priest who
... likes best to unite those couples whose marriage the relatives refuse to
sanction"'.[69] One such marriage was the city–bushman, sanctioned in the
Boomerang's allegory of the federation of labour closing ranks against
British capital.[70] Another clandestine liaison is evident in the Australian
penchant for appropriating their former names for Aborigines, such as
'Australians', 'Tasmanians' and 'native'.

The irony that the unconscious identification by non-Aboriginal
Australians with Aborigines occurred as the colonists became confident
of their own transformation into an independent *centre* of Western
civilisation did not go unnoticed at the time – especially by cartoonists.
Civilisation in the Antipodes was, after all, the joke. For example, the
cover page of the *Bulletin*, 18 March 1909, carried a witty cartoon by
Livingstone Hopkins which linked imperialism and Aboriginality
by depicting evolution, as then understood, in reverse, where 'John
Bull' becomes 'aboriginal Bull'.[71] The manifest meaning is clear –
Aboriginalism will lead to degeneration of the race and empire. How-
ever, at a repressed or latent level, John Bull and Aborigines share more
than they imagine. The same unconscious transference occurred in
Norman Lindsay's cartoon of Australia's role in the First World War,[72]
where Australia was cast as the evolutionary heir to the Aborigine.

A new non-European derived identity was also foreshadowed in some
products and advertisements of the time, for example, Boomerang
Brandy and Lionel Lindsay's long running serialised cartoon advertise-
ments in the *Bulletin* for Cobra boot polish featuring Chunder Loo of
Akim Foo.[73] Such populist cartoons and advertisements had a double
meaning: a conscious racism framed within the nationalist assumptions
of white Australia; and an unconscious Aboriginalism that articulated the

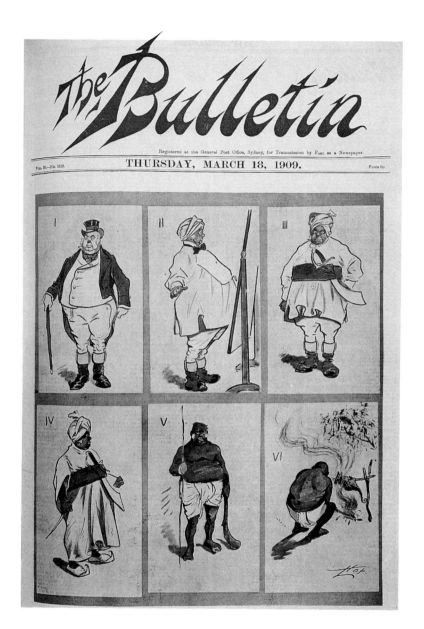

The Bulletin

Registered at the General Post Office, Sydney, for Transmission by Post as a Newspaper.

Vol. 30.—No. 1518. THURSDAY, MARCH 18, 1909. PRICE 6D

Livingstone Hopkins, 'The Gradual Development of Bull'. The caption read: 'J. Bull has annexed another 15,000 square miles filled with niggers. (1) There was a white Bull once. (2) Then he became light brown, and bought a turban. (3) He grew still more brown, acquired a big sash and a curved sword. (4) His brownness increased and he acquired petticoats and funny shoes. (5) Gradually he became so brown that he was practically black, and he undressed himself again and wore a loin-cloth. (6) And in the end he will annex so many niggers that he will be quite black, and the last scene will be an aboriginal Bull roasting his 'possum over a small fire.' *Bulletin*, 18 March 1909, front page.

'repressed fears' of many Australians. Exemplary in this regard were the tourist artefacts of the time, especially the photographs and postcards of Aborigines popular at the turn of the century. In Tasmania, for example, images of Truganini and Tasmanian Aboriginal shell necklaces became the standard symbols of a place notorious around the world for its genocidal activities against these Aborigines.[74]

Impressionism and its related ideologies so encapsulated the Australian myth that even those who found impressionism too limited were unable to exceed its imperatives. For example, Sydney Long, who in 1905 applauded the impressionists' discovery of the sun and colour of Australia, regretted that they had only painted the 'fringe of coast line ... bits of seascape and scraps of orchards and blossoms' 'where the typical Australian is not'. He called for 'an imaginative school' which would discern the 'feeling' of Australia. The problem, he said, is that artists have not found a way to evoke the history of Australia, to 'express the lonely and primitive feeling of this country'; and urged that artists 'bid the Aboriginal blossom out in all the graceful proportions of manly vigour; when sufficient time has intervened to allow us to forget his failings'.[75] He obviously believed that this time had arrived. A year earlier in his painting *The Music Lesson*, Long had substituted a nude Aboriginal maiden for the Caucasian nymphs which, in the fashion of Streeton, had formerly wafted through his landscapes. Long's Aboriginalism used a similar pastoralist aesthetic to impressionism. According to Deborah Edwards:

> Long explored the concept of Australia as pastoralist Arcadia in *Midday* 1896 and produced a fully developed image of the environment as an idyllic fantasy world in *Spirit of the Plains* 1897, which paralleled Streeton's *Spirit of the Drought* c. 1895 in its desire to capture the 'essential' Australia through female personification of the landscape.[76]

If the impressionists displaced Aboriginality in substitute figures, Long did it allegorically, successfully relegating them to a mythical spirit world. Either way, Aborigines were out of the present picture.

The impressionist pastoral arcadia was built on a xenophobic white Australia and a virulent racism. The transcendence orchestrated by the modernist ideologies of art, literature and anthropology belied the failure of Australians to claim their own place and identity. It was less a disappearance than a repression, an exile to the unconscious. Here settlers and Aborigines are bound to a common fate. The 'Antipodes', the first name that Europeans gave to the flora, fauna, and Aborigines of Australia, also became the name of the new Australians. This convergent destiny of Aboriginal and non-Aboriginal Australians was secured by the psychological imperatives of colonialism. When, after the First World

War, Australian impressionist paintings achieved their greatest popularity and became emblems of a nation, non-Aboriginal Australians began to consciously assert a white Aboriginality, and the mantle for the redemptive vision passed, as if by natural descent, from Streeton through Hans Heysen to the Aboriginal painter, Albert Namatjira. And in this passing Australian art, for the first time, self-consciously rather than unconsciously conceived its aesthetic purpose and nationalism in terms of place rather than just one of type or race. If the contradictions of Australian nationalism did not unravel, they at least became more transparent. Far from being diminished, the Antipodes was ever present.

CHAPTER 5

Aboriginalism and Australian Nationalism

Australia became a fundamentally different place after the First World War. It might seem that the bushie merely became the Anzac digger, but in becoming so, he was transformed from a largely literary emblem of national type into an institutionalised symbol of nationhood. Only after the war did the late nineteenth-century interest in place, nativism and local heritage values transform into a nationalist agenda. Suddenly national monuments sprung up in every country town, the most ubiquitous being to the Anzac digger. 'Most Australians', wrote Geoffrey Serle (in disbelief), 'firmly believed Australia actually became a nation at Gallipoli'.[1]

The war irredeemably altered Australia's relations with Europe. 'The truth is', wrote Russel Ward, 'that the war had shown the mother country to be so much less omnipotent than the men of the early Commonwealth had believed her to be ... Australia ... [was now] much more important in her own right than before'.[2] Its importance was not just moral. 'On the basis of its contribution to the war effort', wrote Ian Burn:

> Australia first gained equal and permanent representation at the War Cabinet in Britain, thus obtaining recognition as a nation within Empire, and separate representation at the Peace conference at Versailles in 1919 and on the Assembly of the League of Nations. Political autonomy was thus assured and it was widely held that Australia's separate national status had been secured.

Further, wrote Burn, the war was particularly influential on Australian art. 'No other nation so meticulously documented its participation', and as a consequence provided a 'more accepted and respectable place in Australian society' for artists.[3] Art became a self-conscious vehicle for picturing the nation, with several contesting discourses of nationhood

being developed in the inter-war years, ranging from a conservative Eurocentric pastoralism to radical forms of modernisms. These discourses are the subject of this chapter. However, before discussing them, two qualifications are necessary.

First, while it makes sense to discuss the art of this period in terms of its different discourses of nationhood, their relationships are often ambiguous. Moreover, while a few artists and critics sometimes adhered to extreme positions, either advocating an anti-modernist conservatism or an anti-conservative modernism, most usually fell somewhere in the middle. Pastoralism and modernism were not necessarily antagonistic – and indeed Burn argues that Australian art of this period can only be understood in terms of a *rapprochement* between modernism and pastoralism.

Second, Robert Dixon warns that we should not 'underestimate the capacity of ... [imperial discourses] to renew themselves in the twentieth century'.[4] Australian nationalist discourses were still constructed within the frame of an imperial ideology which defined identity according to late nineteenth-century notions of racial difference, even if this ideology did, after the First World War, begin to unravel. Indeed, it is arguable that imperial ideology increased its hold on Australians in the first decades of the twentieth century. The empire's faltering before the Boers, the defeat of Russia by Japan, combined with the jingoism of the First World War, increased both the anxiety of Australians and their loyalty to empire. Indeed, it was rare for any nineteenth-century nativist to imagine Australia outside of the British empire; a point which the Australian historian Keith Hancock reflected upon in 1930. 'A country', he wrote, 'is a jealous mistress and patriotism is commonly an exclusive passion; but it is not impossible for Australians, nourished by a glorious [English] literature and haunted by old memories [British history], to be in love with two soils'. Hancock uncritically applauded the ability of Australians to be simultaneously imperial and nativist: 'if such a creature as the average Briton exists anywhere upon this earth, he will be found in Australia'. Without blinking, Hancock called this 'average Briton' 'the Australian type', and discussed 'him' in a chapter titled 'Independent Australian Britons'. Hancock's point was that for most Anglo-Celtic Australians the choice between nationalist and imperialist identities was never very pressing, for it amounted to the same thing. For them 'pride of race counted for more than love of country':

> They exulted in the crimson thread of kinship that ran through them all ...
> Defining themselves as 'independent Australian Britons' they believed each
> word essential and exact, but laid most stress upon the last. The *Bulletin*, which
> for fifty years has been the most popular and influential mouthpiece of

Australia's literary, economic and political nationalism, has constantly boasted that the British race is better represented in Australia than in 'cosmopolitan and nigger-infested England'.[5]

Even after the Second World War it was commonplace to read the following type of introduction – here Arthur Mee's introduction to Daisy Bates' *The Passing of the Aborigines* (1947). He described Bates as 'one of the most romantic figures in the British Empire' who spent her life as 'the solitary spectator of a vanishing race', watching over them 'for the sake of the Flag'. Mee's praise of Bates is framed not by the love of place but by the conceit of race and arrogance of empire:

> On the fringe of the vast island continent of Australia live a few millions of white people; in the vast desert regions far from the coast live a few thousands of black people, the remnant of the first inhabitants of Australia.
> The race on the fringe of the continent has been there for about one hundred years, and stands for Civilisation; the race in the interior has been there no man knows how long, and stands for Barbarism.[6]

Australian may have become a fundamentally different place between the wars but it also remained the same. The Antipodes prevailed.

Pastoralism and European Vision

If, after the First World War, the empire collapsed at the centre, Australian advocates of pastoralism hoped that it might be revived at the periphery. In this respect, pastoralists conceived their nationalism within the frame of empire. Despite the cynicism of a few dissidents, and the real desolation of the war, faith in the empire was, for many, undiminished. After all, its institutions, laws and armies were still in place. For several generations those of British descent had been weaned on what Dennis Judd called 'imperial Darwinism': 'the certainty that the British were a superior people endowed by God and destiny to rule over an ever-increasing proportion of the world's surface for the good of its inhabitants'. In the early years of the twentieth century, wrote Judd, 'The empire was increasingly celebrated in schoolroom, shop and factory, and from pulpit and political platform; there was Empire Day, a series of colonial and Imperial conferences ... and the widely accepted concept of an "empire upon which the sun never set"'. Moreover, the 'British empire emerged victorious from the war, its borders considerably extended', with imperial business being carried on as usual. A great Empire Exhibition was held in London in 1924, there was an Empire Marketing Board, and even an Imperial Airways.[7] No wonder, then, that Ginger Mick, that great Australian literary hero and macho larrikin lout

invented by C. J. Dennis in 1916, had his revelation and found his destiny 'on Egyp's sandy shore' at the empire's behest. Mick may not have been 'keen to fight so toffs kin dine/On pickled olives', he may have cursed 'the flamin' war' and declared 'I ain't got nothin' worth the fightin' for', but it was because of empire, 'becos a crook done in a prince, an' narked an Emperor', that 'Pride o Race lay 'olt of 'im, an' Mick shoves out 'is chest', and felt so 'grand to be Australian, an' to say it good an' loud/ When yeh bump a forrin country wiv such fellers as our crowd'. Here he learnt racial pride:

> An' I never knoo wot men me cobbers were:
> Never knoo that toffs wus white men till I met 'em over 'ere –
> Blokes an' coves I sort o' snouted over there[8]

Mick might have felt grand to be Australian, but he could not conceive being Australian outside of the British empire. Indeed, this had long been the complaint of Australia's more radical thinkers. In 1901 A. G. Stephens, a supporter of the impressionists who had worked as a sub-editor for the *Boomerang* and the *Bulletin*, wrote:

> The literary work which is Australian in spirit ... is only beginning to be written. The formal establishment of the Commonwealth has not yet crystallised the floating elements of natural life ... Our children bow instinctively to the fetishes of their fathers ... Australia's nationality is like an alchemist's crucible just before the gold-birth, with red fumes rising, and strange odours, and a dazzling gleam caught by moments through the bubble and seethe.[9]

Likewise, Vance Palmer's call in 1905 for artists and writers to be 'ardent nationalists' was not intended to defend but to create a national culture that did not yet exist. He deplored the fact that 'we are content to read English books', 'to imitate the customs of old degenerate nations, and to let our individuality be obscured by the detestable word "colonial"'. Thus, he complained, 'the majority of Australians too often look on their country with foreign eyes, and measure it by foreign standards of beauty' which mark Australia as 'a desolate country devoid of every element of beauty'. 'There must', he proclaimed, 'be no seeing through English spectacles. Our art must be original as our own fauna and flora are original'.[10] Palmer, perceptively in my opinion, later looked upon the 1890s as a mythical golden age, a legendary period of intense personal visions rather than a community of ideas, calling it the nation's 'dream-time' rather than the birth of nation.[11]

Despite the post-centenary (post-1888) upsurge in nativism (especially amongst the circles in which the impressionists mixed), Roberts and Streeton, along with many other Australian artists, migrated to England

in the late 1890s, not to return until after the First World War. So many
artists migrated that Bernard Smith (after William Moore) called the two
decades after 1900 'Exodus'.[12] Indeed, the migration was experienced by
these artists as a return to the homeland because Australians understood
their identity in terms of race and empire. At this time, observed Russel
Ward, 'practically every white-skinned person [world-wide] ... believed
passionately in the "natural", divinely ordained superiority of the "White
Race"'.[13] This is why nineteenth-century nativism created an 'upsurge of
imperial' rather than national 'sentiment';[14] and why conservative critics
could, after the First World War, so easily make the art of 1890s nativism
serve an agenda which, in Europe, was called fascist. In 1919 Lionel
Lindsay wrote:

> We in Australia waited long for our national painter, whilst he was among us
> we failed to recognise this aspect of his genius. Twenty-five years have given
> us, however, a sense of perspective, and today we can see in the landscapes of
> Arthur Streeton, as in the poetry of Henry Kendall ... a quality of race, the
> inspired vision of the native born.[15]

Twelve years later he eulogised Streeton as 'the great painter who fixed
for all times the image of [the Australian] country' – and it wasn't the
bohemian one of sun and sex of the 1890s. Streeton, said Lindsay, 'made
the Hawkesbury the "Holy Land" of Australia'.[16] According to J. S.
MacDonald, Streeton's paintings struck 'the national chord': 'they point
to the way life should be lived in Australia, with the maximum of flocks
and the minimum of factories ... we can yet be the elect of the world, the
last of the pastoralists, the true thoroughbred Aryans in all their
nobility'.[17]

There was nothing new in such calls. For at least 100 years this had
been the strategy of a frontier-type nativism advocated by the likes of
W. C. Wentworth, who wanted to restore the lost pre-industrial England
and the yeoman farmer 'in the wide lands of Australia'.[18] No matter how
much Australians 'were surrounded by the drought-stricken, burnt
present of the real bush', wrote Carol Lansbury, 'Australians of the
nineties unconsciously lived in the imagined Arcadian past of England
furnished for them in books'[19] – as if Europe could be regained on
Australia's broad plains. This sentiment remained unchanged for
conservative critics such as MacDonald and Lindsay, their nationalism
being fanned by a nostalgia for the old empire days which, before the
war, was never in doubt. If, in retrospect, Streeton's grim frosty depiction
of Nelson's column in Trafalgar Square, *The Centre of Empire* (1902) seems
to cast an ironic mournful and even prophetic note in its purple
shadows, and while Streeton was at the time suffering from poverty, a
harsh English winter, loneliness and homesickness,[20] there is no evidence

that the painting was meant to be an allegory of loss. To the contrary, Streeton waxed about the beauty of London winters: 'those foggy days are dreams of colour, with sun struggling to appear making the ever changing river like a beautiful opal; somewhere the light appears the palest pink of a delicate rose, another time of the most evanescent yellow'.[21]

Far from creating disillusion with Europe, for many the war only increased their nostalgia for old Europe. Lindsay, who spent much of his time in Europe after the war, wrote to Hans Heysen:

> I see that the attempts of our generation to build up some sort of an Aus-
> tralian civilisation has foundered. The present Australians are a sordid race as
> inhabit the earth, having for gods the motor car and electrified toys ... You
> can I think imagine how I feel after living in civilised countries where, in spite
> of war and poverty, the things of intelligence are valued.

In Australia, he said, the 'small elite suffers, and it is from a small elite that a civilisation is built'.[22] Viewed in this context, Deborah Edwards rightly concluded that Mervyn Napier Waller's nationalist mural, *The Pastoral Pursuits of Australia* (1927), sought to secure Australia's European pedigree by conflating 'the Australian and the Classical to a point ... [which] simultaneously conveys the existence of Antiquity in Australia and Australia thrown back to Antiquity',[23] thus aesthetically affirming MacDonald's hope for the rescue of the European pastoral tradition in Australia.

However, such hopes only affirmed the gravity of the situation. When MacDonald described Streeton's paintings as 'melodious and Grecian'[24] he confirmed the melancholy of the time. Streeton's *The Purple Noon's Transparent Might* (1896) is perhaps the closest that any Australian painting came to picturing a redeeming vision of Australia, but even its autumn colours and shrouded purple ranges evoke a landscape unable to overcome the weariness and lethargy of its age. The noon heat sits heavily and lazily on the place. This ambiguity increased after the war in the paintings done by Streeton and his followers – such as Elioth Gruner, Murray Griffin, Robert Johnson, W. D. Knox, W. B. McInnes and Lloyd Rees. While the increased 'simplification and reduction to essentials'[25] of their paintings produced a more symbolic, ideal and iconic landscape, they were strangely detached and deserted evocations of an austral paradise. If this land of the golden fleece belongs to the true thorough-bred Aryans in all their nobility, the languor of the landscape and the absence of any last pastoralists is disquieting. While apparently picturesque in their sentiment they are devoid of humans, and return Australia to a limitless silent space reminiscent of the sublime. Abandoned to their own grandeur, these bare landscapes seem their own

masters, as if haunted by heroes of an ancient Dreamtime. Burn suggested that they embody the 'grief and national emotion associated with the war', and drew strong parallels between Streeton's *The Land of Golden Fleece* (1926) and Will Longstaff's *Menin Gate at Midnight* (1927), with its legions of ghostly soldiers, 'forever restless in foreign soil', massing before 'the eerie pale moonlit gateway'. Both, Burn argued, were throughout the mid-twentieth century popular 'moralistic' and 'sacred' icons of the nation.[26]

While the war may not have induced a sense of loss in Streeton, upon returning to Australia he was overcome by a feeling of regret for the destruction of the indigenous landscape. His environmentalism led him to produce a very different vision to the heroic pastoralism proclaimed by MacDonald. Two years after painting *The Land of Golden Fleece*, Streeton completed *Last of the Messmates* (1928). Although the reviewer for the *Sydney Morning Herald* declared it 'a capital rural scene, endowed with strength',[27] there is little doubt that Streeton did not intend a hymn to pioneer heroism in the battle against the mighty forests, but to commemorate the sacrifice of Australia's indigenous forests. Streeton's starkest memorial is his late painting, *Silvan Dam and Donna Buang, A.D. 2000* (1940), painted during the Second World War, in which he offers a prophetic vision of Australia in sixty years' time. Ironically, Streeton's depiction of a 'barren and scarified desert'[28] pictured the type of landscape that had already become the new icon of Australia: the desert which, like the ocean, is a principal site of melancholy. The question which remains unanswered is to what extent was Streeton's environmentalism a substitute for more repressed regrets about his own identity? Did the war trigger memories of a long colonial war that was never spoken about, except unconsciously? Streeton's *The Somme Valley near Corbie: the second phase of the Australian attack on the south of the Somme on the morning of August 8th, 1918* (1919), commissioned while he was a war artist, can be read in these terms. A sombre stretch of land with simplified forms rolls out below the viewer. It could be mistaken for an Australian pastoral landscape, for it is a hymn of repression, with only the barely distinguishable background of 'rolling smoke', like low clouds in an Australian haze, registering the disquieting facts of war on the horizon of this otherwise idyllic scene. One admiring reviewer wrote that Streeton's war paintings reminds us 'that there were blue skies and sunshine even at the front. He avoids the more ugly horrors of war ... Here [in *The Somme Valley near Corbie*] is a wide stretch of peaceful countryside, with trees and a winding river, flecked with sunlight and shadow, in the foreground'.[29]

The reviewer could have been describing any Australian impressionist landscape. George Lambert, at least, seemed aware of this ambivalence

in Australian painting when, returning to Australia after working as an official war painter, he observed: 'Australia was not nearly so pretty as they had made it. It was a hard land, a stern land, with something cruel in it, a land of greys, a land of drawing and patterns. [Whereas] the renderings he had seen suggested honeymoons'.[30]

Lambert's comments are tempered by his recent experiences as a war artist in Palestine and the commission he was currently working on – a monumental painting of the landing at Anzac Cove in which he juxtaposed the Australian-type hero with a desert-like landscape. Lambert 'openly acknowledged the nostalgia surrounding his experiences as a war artist in Palestine: "to live again among . . . Australian horses in open spaces, in a clear atmosphere of bright sunlight, gave the illusion that I was back on the plains in New South Wales"'.[31] Such sentiments were common at the time. Mary Eagle observed:

> Not only artists but the community at large took note of Lambert's war paintings ... The war paintings which had a public following were huge images of khaki-clad battalions fighting and dying in the embrace of a rocky landscape like that of inland Australia. Into this landscape their bodies merge as if being metamorphosed into clay.[32]

If the war shaped the pastoral landscapes of Streeton and his followers, it also created a new landscape icon which, since the 1930s, has dominated the Australian imagination – the desert. Burn, like critics before him, also points to the impact of modernism on post-war Australian landscape art, and, like Bernard Smith, argues that this was especially the case with the new desert iconography, first developed by Heysen, and later by Russell Drysdale and other artists such as Sidney Nolan. Thus, Burn describes the new desert iconography as 'challenging the status of the pastoral symbolism', its images of 'a parched, harsh inland, the antithesis of pastoral prosperity'. However, he also admits that many continuities exist between the two visions:

> Like the pastoral vision it [the desert landscape] remained, until the 1940s, a land without people or visible signs of the twentieth century, thus retaining the feeling of purity of the landscape. In terms of pictorial organisation it resembles the pastoral image with its shallow space, its unified and specific structure.[33]

Indeed, the practitioners and critical supporters of a desert iconography were generally amongst the most ardent admirers of impressionism – so much so that the advocates of a desert iconography framed their vision in pastoralist terms.

Whatever the continuities between impressionism and desert pastoralism, the shift brought with it a populist Aboriginalism which saw in the

desert, its Aboriginal inhabitants and their culture, unique emblems of Australian-ness. The irony is that a colony which had brought its Aboriginal population to the brink of extinction now began to lionise Aboriginal culture as an emblem of nationhood. This may have represented a significant victory for Aborigines, but it was, in every respect, a symbolic one – for the Aboriginalisation of Australian identity was a type of appropriation which paralleled in its aims and methods the assimilation policy of the Australian government.

From Desert Pastoralism to Aboriginalism

During the 1930s the central Australian desert usurped the bush as the exemplary national metaphor in modernist art and literature, and in the popular press. Hans Heysen's paintings of the Flinders Ranges, which were invariably described as 'views from central Australia',[34] became icons of the nation.

Heysen, who 'visited the War Museum three times to see Lambert's Palestine landscapes',[35] did most to indelibly fix the subliminal associations in Lambert's paintings between the desert and Australian identity. He had his revelation during his first trip into the Flinders Rangers in 1926, a few years after Lambert's war pictures went on public display. Six months later Heysen described the Flinders Ranges to Lionel Lindsay as 'rugged and full of primitive character'.[36] In 1932 he remembered that 'it was in the Flinders Ranges that I was made curiously conscious of a very old land where the primitive forces of Nature were constantly evident';[37] and for the next two decades he regularly returned, believing fervently that he had discovered 'a painter's country' which, he confessed, 'holds me fast ... for seldomly a day passes but that my mind does not dwell there'. 'There is', he continued, 'a lot to be done in this far back land with its strange forms ... and although more artists have gone since my first trip, none that I know of have brought the country back with them'.[38]

In the previous twenty years Heysen had earned a considerable reputation with his pastoral landscapes which featured gum trees cast as heroic substitutes for the absence of a human history. If the desert was not without such eucalypt monuments, its space and light evoked a spirituality which, to his mind, surpassed Streeton's Arcadian streams: 'I have seen it on calm days of crystalline purity when the eye could travel, as it were, to the end of the world, bringing with it that wonderful sense of infinity that a land of moist atmosphere could never give'. Heysen's sublime images of the central Australian desert returns Australia to an imagined *terra nullius* – a true sublime unable to be improved. Thus he 'found it difficult to believe in this [the desert's] extraordinary

recuperative power',[39] and when he visited the area after an exceptionally rainy period he refused to paint its verdant splendour, regretting that 'over it all was a mantle of green – which to me was most disconcerting and out of harmony'[40] – that is, too picturesque, too improved.

Heysen's vision of a land of 'wind, dust, and sand'[41] was widely applauded in record sales of his paintings, enthusiastic reviews, and in 1928 and 1932, the publication of special editions of *Art in Australia*, which featured his new desert iconography. Lionel Lindsay, comparing them to the best of contemporary work he had seen in Europe, claimed that they had struck a chord:

> here, before this nakedness of the Earth, I was conscious of a curious innocency of composition – a directness of approach ... This mountainous country gives the sensation of an unalterable landscape, old and young as Time – a landscape of fundamentals, austerely Biblical, and yet for us intimately associated with our aboriginal stone age ...
>
> They are his discovery and, I believe, the most important contribution to Australian landscape made in the last decade.[42]

Heysen's desert paintings fall squarely within the Judaic Christian tradition of the desert being a place of redemption. In its sublime emptiness and silence could be found God. While in the Australian desert there could also be found Aborigines, Heysen's desert paintings remain without Aborigines, and elide Aboriginality as completely, though not as effectively, as Streetonian pastoralism. At least the title of Heysen's *The Land of the Oratunga* (1932), unlike Streeton's *The Land of Golden Fleece* (1926), acknowledges whose land this is. Whatever, the emerging desert iconography pioneered by Heysen developed into a conscious Aboriginalism which became an essential component of the discourse of nationhood – if only because the central desert of Australia remained the domain of Aborigines. The descent of this shift in consciousness can be traced to discourses earlier than those of Lambert and Heysen – specifically to pre-war scientific texts, thus confirming Bernard Smith's thesis that science provided the radical impulse of European imagery in the South Pacific.

The desert is rich in symbolism, and full of ambivalence. Much like Ocean, it is a place of redemption, a figure of death and spiritual regeneration. At the turn of the century, and indeed throughout the twentieth century, the desert, along with the north, has remained Australia's last frontier. In the mid-nineteenth century it had defeated Edward Eyre and Charles Sturt and killed numerous others, including Leichhardt, Burke and Wills. Sturt claimed: 'A veil hung over Central Australia that could neither be pierced nor raised. Girt round by deserts, it almost appeared as if Nature had intentionally closed it upon civilised

man, that she might have one domain on earth's wide field over which the savage might roam in freedom'.[43]

While this image remained largely intact throughout the century, the rhetoric of late Victorian empire increasingly looked upon such places as sites where the empire might be rejuvenated. In Ernest Favenc's adventure story, *The Secret of the Australian Desert* (1895), for example, the desert is allegorised as a place of the other; it is mysterious, dangerous, hostile and inhabited by non-Europeans, but also redemptive. Baldwin Spencer's very influential anthropology of Aboriginal society discovered the desert to be an Eden, the genesis of mankind. Such an attitude was fully developed in *The Dead Heart of Australia* (1909), the story of an expedition to Lake Eyre in 1902 by the British geologist J. W. Gregory. Here the desert and the Aborigines are eulogised with an enthusiasm not seen before, even though Gregory was well aware of the writings of Sturt, the tragedy of Burke and Wills and the current attitude to Aborigines. 'It is difficult', he wrote, 'to express the charm of the desert, and perhaps impossible to make a town-dweller believe in it'. Gregory spiritualised the desert by orientalising it: 'the desert is the garden of Allah'. It had, he believed, its own holy calligraphy, at night transforming into a temple of oriental splendour which had the power to redeem:

> Instead of a waste of glaring yellow sand we look up at the noble expanse of dark blue sky, lighted by the glittering sky, and perhaps by a faint cone of zodiac light . . . Slowly the charms of the desert enters our soul, and drives away the demon dread of day . . .

Unlike Spencer, Gregory saw in primitivism the means of exceeding modernity, rather than a negative term which legitimised modernity. Thus, he valued Aboriginal knowledge, albeit within modernist primitivist tropes, and for the first time made Aboriginal experience part of modern Australia:

> The simplicity of the desert, the uniformity of its conditions, the merciless severity of its forces, awaken in us the primitive man, lying beneath the carefully built-up fabric of social obligations . . . for a moment, a man sums up in himself the long experience of his race. To retain the knowledge and thought of the twentieth century while meeting the conditions of prehistoric man . . . gives that stimulus to the imagination, which is one of the highest joys given to man to feel.[44]

Gregory was well aware that his opinion went against the grain; that 'there is a widespread belief that the Australian aborigines are the most degraded members of the human family', universally regarded as 'the zero, so to speak, of all anthropological analysis', and 'the lowest of savages'.[45] Gregory admitted coming to Australia 'sharing the popular

prejudice'. But 'instead of finding them degraded, lazy, selfish, savage, they were courteous and intelligent, generous even to the point of imprudence, and phenomenally honest; while in the field they proved to be born naturalists and superb bushmen'.

Gregory put down the cause for the prejudice against Aborigines to 'the inevitable hostility between them [Aborigines] and the early settlers'. His spiritual experience in the desert had not, however, suddenly thrown off the arrogant racism of empire. He admitted that the 'most irritating trait' of the Aborigines 'is that their notion of truth, though well above the average of coloured peoples, is not up to the exceptionally high standard of the Teutonic race'. What redeemed the Aborigines in Gregory's eyes was their race, which he insisted was Caucasian, not Negroid: 'The Australians must be included in the Caucasians, and belong to the same race-group as ourselves. The view of their affinities seems to be that now accepted by the majority of anthropologists'. 'With east African negroes', said Gregory:

> even the best of them, I had always the feeling that they were children, and had to be treated as such ... But after a few days with our Deiri and Tirari guides, I always felt towards them that they were men and brothers ... their humour and point of view with regard to things in general were like those of an intelligent but untrained European.[46]

After a survey of current scientific evidence, including Spencer's studies of the complex laws and rituals of Aboriginal tribes, Gregory concluded, against Spencer, that 'the Australian aborigine is further removed from the primitive ancestor of man than is the negro, and that he belongs to the highest primary division of mankind'.[47]

Gregory's writing presages the beginning of a new but ambivalent attitude to the desert. Prior to the First World War the desert was difficult to access, and so was largely absent from the everyday imagination of most Australians. However, when the development of roads, railways and aviation made the desert regions of Australia accessible to the general public (for example, the trans-Australia railway across the Nullarbor was completed in 1917), anxieties increased about the viability of the nation, forcing the populous regions living in the relatively rich agricultural land in the south-east of Australia to incorporate the desert into their imagining of the nation. 'For half a dozen years (1921–8) Sydney newspapers gave a large amount of space to the controversy on "the Australian desert"'.[48] Since the 1930s the desert has been a popular icon of Australian identity – rivalled only by the beach. Even the disastrous drought and dust storms, which paralleled the United States dust bowl experiences of the same time,[49] contributed to this change. If in the United States the dust bowl was experienced as a transgressive act, in Australia it

became an *Australian* disaster which, like those of fire and flood, is a perverse icon of national pride, as if it confirmed the antipodean character of the place.

By focusing the populous regions of south-east Australia on the desert, the increased travel opportunities revived what the national myths of the 1890s had worked hard to repress: the treatment of Aborigines. The train to Alice Springs opened the centre of Australia to a larger number of people, including artists and writers, many of whom quickly developed a life-long fascination and love for the country and its indigenous inhabitants. Typical was Robert Croll. He first travelled on the train to Alice Springs in 1929, and in 1937 published his impressions of this and several subsequent journeys to central Australia. While he still held to Spencer's evolutionism, believing that he 'had done well to travel in four days the twenty thousand, fifty thousand, one hundred thousand – who shall say how many? – years that separate modern civilised man from these people',[50] Croll judged Aborigines to be highly intelligent, beautiful and strong in appearance, kind and thoughtful. He admired their traditional ways and admonished non-Aboriginal Australians for their 'shocking' 'treatment of the original owners of the land we now possess'[51] – which he detailed in the final chapter of the book. His belief that Aborigines were a dying race was based on traditional notions of paradise lost, not the modern evolutionary paradigm of an anachronistic race heading for extinction. Croll wished that the missions and cattle stations had not come to central Australia and that the Aranda and Luritjas had been left in freedom. 'To the native the price of Christ, as of civilisation, is, far too often, death',[52] and contrasted the photographs of a proud, beautiful, naked Aborigine with another miserable-looking urchin dressed in mission clothes, each with the respective and deliberately ironic titles, 'uncivilised' and 'civilised'. He also rejected the fear of miscegnation, believing that 'half-castes' 'may grow into dependable and intelligent women and men'. Hence, he suggested that they be fully assimilated into 'the general population, with full citizenship rights'.[53]

Such ideas (unintentionally) Aboriginalised non-Aboriginal Australians as much as they (intentionally) Europeanised Aborigines. For example, after her journeys across Australia in the 1930s, Ernestine Hill wrote of the 'living heart': 'Two thousand miles due west and north of civilisation, where ... the silence is implacable as death, white men are living in the Great Australian Loneliness, and greeting it each morning as a friend'.[54] 'Many a time', she wrote, in this 'purely British country', 'I have unrolled the little swag by creek and sandhill in the silence and starlight with a white man and a black'. If many Australians still worried about the racial integrity of the nation, Hill celebrated a multicultural nation which she saw emerging from the desert: 'I have attended

Japanese Feasts of Lanterns, Chinese banquets, blackfellow burials and Greek weddings, and turned to the west with the Mussulmans when they knelt on their prayer-mats to Allah at the call of the *muezzin*'.[55]

The reformed Caucasian Aboriginal, no longer a figure of Africa, received an enthusiastic public reception during the 1940s. Aborigines had, since the nineteenth century, adorned postcards as emblems of a past primitivism, but now they appeared as a noble people who were emblems of a new Australian identity. This new image was found on Australian stamps, on the pages of the popular travel journal *Walkabout*, and in the numerous books by populist authors such as Ion Idriess and Charles Barrett. In a relatively quick reversal, signs of Aboriginality became important insignias of a non-Aboriginal Australian identity. For example, Charles Barrett's *White Blackfellows*[56] (1948) describes the adventures of Europeans who, in living with the indigenous peoples of Australia, became what he called 'white blackfellows'.

While it was still widely believed, as Grenfill Price wrote in 1950, that 'the full bloods are steadily declining ... [and that] the half-castes are increasing so much ... [that] they threaten to become a difficult problem',[57] this only guaranteed the figure of the 'full blood' being made an emblem of a lost primordial Australia. If non-Aboriginal Australians generally feared miscegenation like the plague, Barrett and others like him imagined a spiritual accord with a lost primitivism in which non-Aboriginal Australians, much like the ripping yarn heroes, achieved a higher spirituality than their decadent brothers in Europe and the cities. Such nationalism produced a less Eurocentric and more radical nativism than that developed by Lambert, Heysen and others such as Gruner, all of whom tended towards a modernist pastoralism but eschewed Aboriginalism and any suggestion of a non-European identity.

Aboriginalism: White Aborigines and Australian Nationalism

As in the previous world war, the Second World War produced an upsurge of nationalism, but one which, following the defeat of Singapore, sought a radical independence from Britain. The development of new iconographies of identity in the prevous two decades, and especially in the 1930s, provided much of the basis for the nationalisms of the 1940s and 1950s, and their strong Aboriginalist character. One of the first signs was the literary journal *Meanjin*, founded by Clem Christensen in Brisbane in 1940. While *Meanjin* was uninterested in Aboriginal culture, it adopted an Aboriginal name to advertise the Australian-ness of its criticism and writing.

In 1941 Christensen published a 'Nationality Number' which 'proclaimed the necessity of "developing here a distinctively-Australian

culture"'.[58] The achievement of this generation was to transform
nativism into a distinctly anti-imperial indigenous consciousness. Vance
Palmer saw in the war the chance for Australia to throw off its colonial
past:

> If Australia had no more character than could be seen on its surface, it would
> be annihilated as surely and swiftly as those colonial outposts white men built
> for their commercial profit in the East – pretentious facades of stucco that
> looked imposing as long as the wind kept from blowing. But there is in
> Australia a different spirit, submerged and not very articulate, that is quite
> different from these bubbles of old-world imperialism. Born of the lean
> loins of the country itself, of the dreams of men who came here to form a
> new society, of hard conflicts in many fields, it has developed a toughness
> all its own.[59]

Exemplary of such post-war anti-imperial nativism is Russel Ward's *The
Australian Legend* (1958), in which the origins of nativism are traced to
the early years of the colony in the ballads and oral histories of the
colonists, before flowering in journals, such as the *Bulletin*. Ward's
account follows the model established in the late nineteenth century by
the United States historian Frederick Jackson Turner, who proposed a
nativist ideology that flagrantly paraded its anti-colonialism. Ward was
particularly interested in Turner's psychological metaphors which
emphasised the new consciousness of the colonials, despite their
European habits. Ward quotes Turner:

> The wilderness masters the colonist ... at the frontier the environment is at
> first too strong for the [European] man. He must accept the conditions which
> it furnishes, or perish, and so he fits himself into the Indian clearings and
> follows the Indian trails. Little by little he transforms the wilderness, but the
> outcome is not the old Europe ... The fact is, that there is a new product that
> is American.

'Turner's achievement', claimed Ward:

> was to show that indigenous, and particularly 'frontier' influences, were not
> less important for a just understanding of American history. In so far as the
> American was not just a transplanted European but a different kind of man,
> the change could only have been brought about by influences met in the new
> land. And, as we have seen in Australian history, these indigenous influences,
> of necessity, were most potent on the expanding frontier of settlement.[60]

Ward's nativism is a type of Aboriginalism which, in the manner of the
day, displaces Aboriginality within a white indigenity. The convict
becomes the prototype of a *new* person, not the melancholy figure of
exile; his/her oceanic origins glossed with a promising future wrought

from the fringe of settlement. Not only did the convicts mainly congregate 'on the expanding edge of settlement', but this edge (frontier) redeemed them. 'There is convincing evidence', wrote Ward, 'that convicts and old hands were morally improved, if not entirely made over to the Lord, by up-country conditions'. The 'typical Australian' ethos was, said Ward, developed by the 'convict, working-class, Irish and native-born', as they 'coalesced "beyond the Great Divide" where remoteness and the peculiar geographical, economic and social conditions transmuted them into something new'.[61] Instead of an imperial history descending on Australia, there was a new frontier communality which worked 'upwards from the lowest strata of society and outwards from the interior' until, 'towards the end of the nineteenth century, when the occupation of the interior had been virtually completed ... Australians generally became actively conscious, not to say self-conscious, of the distinctive "bush" ethos, and of its value as an expression and symbol of nationalism'.

His new Australian was a white Aborigine sprung from the land itself – namely, 'the outback ethos' and the 'nomad tribe' of bushmen being formed by 'the struggle to assimilate' to 'the brute facts of Australian geography'.[62] While such a prescription could only be written on the presumed extinction of the Aborigines whose land it was, it also incorporated Aboriginality into the new national mythos, and so provided the opportunity for an appreciation of Aboriginal art and culture. In the same vein, Marjorie Barnard proposed a nativist historiology which evaded the historical experience of colonialism for a geographical one: 'If you would read history, and most particularly Australian history, study your atlas, for in the long run geography maketh man'. Against the shadow of empire, argued Barnard, a new local individual identity emerges from the land itself: 'the bush asks other qualities of men than does the English countryside'.[63]

> The white man with his possessions and his ignorance erupted into the close-knit patterns of the last waste and isolated continent in 1788. They had a great deal to learn, but they did not realise that. They believed that they came bearing gifts; in reality, as they adapted themselves, they were to receive ... his [the colonialist's] ways, particularly in the early days, fell into a rough copy of the aboriginal way of life. He became a nomad.[64]

The leading artist-advocate of Aboriginalism was Margaret Preston, the first artist to find in Aboriginal art the source for a distinctive Australian identity, and the first modernist to take up the cause of Aboriginal art.[65] What most distinguished her art was its joining of Aboriginalism and modernism. In this she consciously emulated, and allied herself to, cultural anthropology. The anthropologist A. P. Elkin and Preston, both

members of the Anthropological Society of New South Wales, were the most effective propagandists for this new Aboriginalism, and laid the groundwork for the reception of Aboriginal art in the 1940s and 1950s.

The alliance between art, anthropology, modernism and nationalism that marks Preston's aesthetic, echoes, as much as it departs from, Spencer's earlier interests. While Spencer's evolutionist paradigms disparaged Aboriginal art, the aesthetic imperatives of modernist primitivism found inspiration in tribal art. When Spencer was collecting his impressionist and Aboriginal art, the English critic Roger Fry, under the influence of the modernism of Gauguin, Matisse and Picasso, claimed 'that certain nameless savages have possessed this power [to create expressive plastic form] not only in a higher degree than we at this moment, but than we as a nation have ever possessed it'.[66]

With such ideas informing her own aesthetic concerns, Preston contributed four articles to *Art and Australia* between 1925 and 1941, urging that Aboriginal art become the foundation and inspiration of a modern, national Australian art. With other like-minded enthusiasts, such as Alfred Kenyon, Croll and Barrett, she joined with anthropologists to promote and organise several exhibitions of Aboriginal art. The first was at the National Museum of Victoria in 1929 – organised by Barrett, Croll, Kenyon and D. J. Mahony and opened by Elkin.[67] However, Daniel Thomas observed that not until the 1940s did 'Australian Aboriginal art became art, as far as the European–Australian art world was concerned'.[68] The Exhibition of Australian Aboriginal Art and its Application, organised by Preston's close friend, the anthropologist Frederick McCarthy (with Preston, Elkin and others acting as advisers), opened in the Sydney department store, David Jones, in 1941. At the same time, the first exhibition in which non-Aboriginal and Aboriginal paintings were hung together, travelled to North America.[69] Two years later, the National Gallery and National Museum of Victoria held their exhibition of Aboriginal art called Primitive Art. In the introduction to the catalogue Daryl Lindsay, director of the gallery, stressed its 'genuine artistic value' as opposed to its ethnographic interest.[70] During the 1940s the *Jindyworobak Review*, with the help of *Meanjin* and authors such as Xavier Herbert, Daisy Bates and Katharine Prichard, made Aboriginalism a literary movement. The Australian public had been largely won over by 1950: 'the David Jones Art Gallery exhibition in 1949', writes Philip Jones, 'was visited by large numbers of people, and according to Ronald Berndt it provided the turning point in the Australian public's attitude toward Aboriginal art'.[71]

While populist and amateur enthusiasts such as Croll, Kenyon, Barrett and Idriess, and to a certain extent Preston, were the evangelists of Aboriginalism and a desert pastoralism, it was the anthropologists who

gave professional credibility to the new attitude towards Aboriginal art. At the time, anthropology was undergoing a profound reassessment of its theoretical base. Spencer's evolutionism was rejected for cultural paradigms which not only paid close and sympathetic attention to the complexity and intelligence of traditional Aboriginal art, but also began accepting the cross-cultural cultures of many contemporary Aboriginal communities as worthy of study. Elkin, the most influential and energetic exponent of the new anthropology in Australia, promoted the exhibition of Aboriginal art, and lobbied governments for a radical overhaul of its attitude to Aborigines. His attention to detail included, from the late 1930s, the capitalising of the word 'Aborigine' – a practice only recently adopted in Australia, and not yet fully practised elsewhere. In the lower-case, *aborigines* are 'savage in respect to culture', 'primitive', 'simple', 'unsophisticated' (Funk & Wagnell, 1963) – a biological rather than cultural existence. Capitalised, *Aborigines* attain an ethnic status. In the same spirit, Elkin successfully lobbied for an assimilationist Aboriginal policy and the recognition of Aboriginal artefacts as art because, he wrote, 'a people possessing an art ... is much higher in the human scale than had previously been thought' (1938).[72] When this was publicly accepted, the basis for an Aboriginal art movement as a means of political empowerment was laid, and Australian art and culture was forever changed.

Radical Modernism

In the midst of the nationalist modernism advocated by Elkin and Preston there emerged a more radical strand of modernism. Inspired by surrealist and existentialist ideologies which developed in the ruins of European civilisation, the radical modernists finally brought to an end the search for a redemptive colonial art. They saw in Aborigines and the desert not a sublime ideology which might finally redeem Australia, but an emblem of the alienation and ugliness of Australia's colonialist history and identity. Such ideas received their first theoretical exposition in P. R. Stephensen's essay of the mid-1930s – written as a response to an article in the Melbourne *Age* (16 February 1935) by Professor G. H. Cowling, one of Australia's many professors imported from England, who had dismissed the very idea of an Australian culture. According to John Barnes, Stephensen's essay, *The Foundations of Culture in Australia*, is 'probably the most influential piece of critical writing in the period'.[73] In part, Stephensen's essay repeated many commonly held views at the time. Like the pastoralists, he believed that 'Race and Place are the two permanent elements in a culture', and that the 'work of Gruner, Hilder, Heysen, Streeton and others' had discovered a 'Spirit of a Place' that was

'an Australian contribution, to the art of the world'.[74] However, Stephensen was contemptuous of the ways in which 'Australia' had, to date, been imagined. While a fervent nationalist with fascist tendencies, he questioned the idea that Australia was yet a nation: 'we are something betwixt and between a colony and a nation'; and called for a fierce Australian independence: 'Australian nationalism with or without the idea of the British Empire, has a right to exist; and there can be no nation without a national place-idea; a national culture'.[75]

Even though Stephensen professed his admiration for the conservative pastoralism of Streeton and Gruner, his vision was very different to theirs and more attuned to D. H. Lawrence's *Kangaroo* – which had been written during a six-week residence outside Sydney in 1922. If Lawrence's descriptions of the bush recall Marcus Clarke's criticism, unlike Clarke, Lawrence had no premonition of redemption. To him, the bush was:

> so phantom-like, so ghostly ... so deathly still ... the tree trunks like naked pale aborigines among the dark-soaked foliage ... Not a sign of life – not a vestige. Yet something. Something big and aware and hidden! ... there was something among the trees ... a presence. He looked at the weird, white, dead trees, and into the hollow distances of the bush.

For Lawrence 'the spirit of the place' evoked 'the icy sensation of terror':

> He felt it was watching, and waiting. Following with certainty, just behind his back. It might have reached a long black arm and gripped him. But no, it wanted to wait. It was not tired of watching its victim. An alien people – a victim. It was biding its time with a terrible ageless watchfulness, waiting for a far-off end, watching the myriad intruding white men.[76]

Lawrence's reaction to the bush was not just that of a newcomer, it was also grounded by his comprehension of the psychological import of the Australian experience during the post-war period. The imperial vision which once had orientated newcomers was shattered by the war. On one level, the metaphors Lawrence uses are stereotypical colonial representations. As well as the precedent of Clarke, there is the tradition of what Joan Kirkby called the 'nature unleashed' theme which, in the post-war period, had gained a new lease of life – as in Joan Lindsay's *Picnic at Hanging Rock* and E. M. Forster's *A Passage to India*, both novels which evoke the supernatural forces of colonial spaces which the Old World cannot order.[77] However, in *Kangaroo* the demise of Europe is consciously foregrounded as that which stages the story. *Kangaroo* is a meditation on what a post-European and so post-colonial world might be: 'In [post-war] Europe, he had made up his mind that everything was done for, played

out, finished, and he must go to a new country. The newest country: young Australia!' But once there 'the vast, uninhabited land frightened him'. 'He understood now that the Romans had preferred death to exile. He could sympathise now with Ovid on the Danube, hungering for Rome and blind to the land around him, blind to the savages'.[78]

Through Somers, the autobiographical English writer and traveller whom the novel centres on, Lawrence shows how the limits of the colonialist vision, its tropes and prejudices, are exceeded at the periphery of empire. 'All this hoary space of bush between' garnered his imagination and his intuition for 'the strange, as it were, *invisible* beauty of Australia, which is undeniably there, but which seems to lurk just beyond the range of our white vision'.

> You feel you can't see – as if your eyes hadn't the vision in them to correspond with the outside landscape. For the landscape is so unimpressive, like a face with little or no features, a dark face. It is so aboriginal, out of our ken, and it hangs back so aloof. Somers always felt he looked at it through a cleft in the atmosphere; as one looks at one of the ugly-faced, distorted aborigines with his wonderful dark eyes that have such uncomprehensible ancient shine in them, across the gulf of unbridged centuries. And yet, when you don't have the feeling of ugliness or monotony, in landscape or in nigger, you get a sense of subtle, remote, formless beauty more poignant than anything ever experienced before.

To Lawrence the Australian landscape is a place of transgression, 'treated more like a woman they pick up on the streets than a bride'. It has not, says Somers' wife Harriet, been loved: 'England and Germany and Italy and Egypt and India – they've all been loved so passionately ... if I were an Australian, I should love the very earth of it – the very sand and dryness of it – more than anything'. And 'it seemed to Somers as if the people of Australia *ought* to be dusky'.[79]

Stephensen transformed Lawrence's premonition into a type of surrealist primitivism typical of modernist discourses at the time:

> Australia is a unique country ... Visitors such as D. H. Lawrence, have discerned a spiritual quality of ancient loveliness in our land itself. The flora and fauna are primitive, and for the most part harmless to man, but to the visitor there is another element, of terror, in the Spirit of the Place. The blossoming of the waratah, the song of the lyrebird, typify the spirit of primitive loveliness in our continent; but the wail of the dingo, the gauntness of our tall trees by silent moonlight, can provide a shiver of terror to a newcomer. Against a background of strangeness, of strange beasts and birds and plants, in a human emptiness of three million square miles, our six million white people, of immigrant stock, mainly from Europe, are becoming acclimatised in this environment new to them but geologically so old that Time seems to have stood still here for a million years.

If 'Race' was important to Stephensen, 'it is the spirit of a Place which ultimately gives any human culture its distinctiveness';[80] and his sense of place was imbued with an existential consciousness that rejected the redemptive imperatives of pastoralism. 'For the first hundred and fifty years of colonising, the immigrants have merely raped the land, or "settled" it, as we say, with unconscious irony in our choice of a word to describe the process of destroying its primitiveness.' But now, he said, 'a new nation, a new human type, is being formed'; and proudly proclaimed: 'We are Antipodeans'.[81]

To be Antipodean is to be out of place in one's place. For Stephensen, the alienation which constituted Australian-ness was due to the ways in which colonialism had constructed the experience of place in Australia. Unlike Rex Ingamells of the Jindyworobaks, whom Stephensen profoundly influenced, he did not eulogise the Aborigines as emblems of a timeless geographical Australia. While aspects of Stephensen's ideology sound in the Aboriginalism of Preston and Ingamells which found in the desert and Aboriginality a primeval genealogy for their nationalist discourses, Stephensen's legacy lies elsewhere. Australian 'culture' he wrote, 'if it ever develops *indigenously*, begins not from the Aborigines, who have been suppressed and exterminated, but from British culture' (my emphasis)[82] – that is, from a colonialist history of rape and pillage, from acts of alienation not nurturing. In this scheme Aborigines are emblems of alienation, not a primeval past – as is evident in the art and literature which most fully articulated Stephensen's ideas: Xavier Herbert's and Patrick White's novels, A. D. Hope's and John Thompson's poetry, and the paintings of Sidney Nolan, Arthur Boyd, Albert Tucker and Jon Molvig. In many ways, such writing and art recalled the themes of colonial art, except that these modernists did not conceive alienation as something to be disavowed. Indeed, the very alienation of Aborigines made them exemplary Australians, as if in Australia a new convergent culture was being formed from both traditional Aboriginal and Western practices. Such a future was first envisaged in Herbert's *Capricornia* (1938), which Stephensen edited.

If Coonardoo, the Aboriginal woman and main character in Katharine Susannah Prichard's *Coonardoo* (1929) is, in Aboriginalist fashion, an emblem of the earth's spiritual timelessness, the central character in *Capricornia* is Norman, a bastard 'half-caste'. Murdrooroo writes of Norman: 'Initially, he is shocked to discover that he does indeed belong to both races; but then he comes to the realisation that he is their heir'. Herbert 'is not describing the replacement of Aboriginal culture and society by the stronger British "civilisation"; but', says Murdrooroo, 'by a "new" society emerging from the amalgamation of the two'. The

Aboriginalist opposition of 'primitivism and civilisation', he continues, 'engages in an ironic dialectic, and the synthesis of the dialectic is the "new" race'. However, 'the potentialities of this "new" race are not "realised"'. There is no redemptive moment. The possibilities of convergence are only imagined; and when made into reality are, like many biological hybrids, a tragic impotent affair. If Herbert's hybrid characters are not without the hardiness of mongrel breeds, running through *Capricornia* is the metaphysical force of fate, the primordial mother, which leaves Australia a tragic Antipodean place. Australia's origin of exile (as a convict colony) haunts it at every turn. For this reason, Murdrooroo declares *Capricornia* typical of the 'great Australian yarn', and being 'about what makes Australians Australian'.[83] The same fatalistic 'ironic dialectic' runs through much Australian art in the 1940s and 1950s. In what have since become the most emblematic images of this period, Sidney Nolan's Ned Kelly series (1946), Kelly is a black iconic shape who, Aboriginal-like, haunts a landscape in which the British police are comic aliens. Kelly is part of the trees and land yet at the same time a hunted beast in it. In many ways, Nolan figures Kelly with the same grotesque tropes which colonial painters had figured Aborigines and the bush; except that Nolan makes Kelly, and later other legendary white Australians, emblems of an Australian-type. The same claims can be made for Russell Drysdale's paintings which, more consistently but less radically, picture the 'white blackfellow' that characterised mid twentieth-century Australian national identity, hence making his images the most emblematic of the so-called 'Australian-type'.

Nolan and Drysdale painted white Aborigines, but very different ones to Sydney Long's spirit of the plains; they were 'a symbol of desperate impotence' – as Terry Smith described Arthur Boyd's painting *Australian Scapegoat* (1987), which fused the Anzac digger with the Aborigine.[84] Even if, with Murdrooroo and Terry Smith, we judge the achievements of these radical modernists fatalistic and impotent, they did finally accept the failure of redemptive tropes in Australian discourses and picturings of identity, and attempted to rethink what it was to be an Australian from this failure.

Conclusion: Aboriginalism and Postcolonialism

On first sight Aboriginalism, be it Preston's more conservative modernism or the radical modernism of Nolan, appears to offer a radically different 'Australia' to the conservative pastoralism of previous times. Lionel Lindsay and J. S. MacDonald, for example, were contemptuous of Preston's Aboriginalism. Lindsay wrote to MacDonald:

> I don't think MP [Preston] will do any harm – as such pseudo writers as Croll
> on Abo art – you're right in saying they have no art since ritual signs are only
> magic formula – and that's where half baked ideas like Margaret's go all out
> ... such is the urge of novelty that it's the new hat that counts – I remember
> when she came back and talked of surrealism and those horrible Mexican
> 'murals' heavier than the walls they were painted on.[85]

To Lindsay and MacDonald, Aboriginalism seemed part of an inter-
national modernist primitivism which had overtaken modern art, and
had little to do with nationalist agendas. In one sense they were right.
Between the wars so-called 'Negroism' had penetrated the fashionable
bohemias of London, Paris, Berlin and New York. For the first time was
glimpsed the possibility of convergent cultural practices between
European, Asian, African and American cultures. The surrealists danced
to jazz and championed Afro-American artists, such as the dancer
Josephine Baker and the poet Aimé Césaire. In Australia, Aboriginal
motifs were incorporated into a Western aesthetic, and the Aboriginal
painter, Albert Namatjira, was widely acclaimed. The precepts of mod-
ernist primitivism had so penetrated the fabric of Australia by the 1950s
that its influence was evident across a wide range of competing art
practices, from kitsch to high art, from pastoralism to modernism. By this
time the significance of Aboriginal culture to an Australian identity was
incontestable. The future of Aboriginal and non-Aboriginal Australians
was linked to a common fate. Even many of the Australian abstract
expressionists (such as John Olsen, Tony Tuckson and Iain Fairweather)
who, in the 1950s, preferred an internationalist art to the impulse for
figurative nationalism of Nolan, Boyd and Drysdale, showed a close
interest in Aboriginal art. They saw it as an originary art that eclipsed its
anthropological impulse in the post-surrealist search for a universal
aesthetic epitomised by United States artists such as Jackson Pollock and
Adolph Gottlieb, and the European Cobra painters, all of whom had
turned to local non-Western and indigenous traditions for inspiration.
Despite the many stylistic and thematic contrasts between the figurative
art of Nolan, Boyd and Drysdale and the abstract art of Olsen, Tuckson
and Fairweather, each drew on Aboriginal themes to an extent not seen
since early colonial times.

From the perspective of 1980, Gary Catalano reflected: 'it now appears
that the most significant event in Australian art during the 1950s was the
"discovery" of primitive art, particularly that of the Australian
Aboriginals'.[86] During the 1950s Aboriginal art was exhibited more
regularly and widely than ever before, and for the first time state art
galleries began collecting Aboriginal art. The UNESCO publication of
the mid 1950s, *Australia Aboriginal Paintings: Arnhem Land*, for which
Preston helped select paintings for reproduction, outsold any other book

ever published on Australian art.[87] The *Sydney Morning Herald* reported
on the Aboriginal art boom,[88] and the Art Gallery of New South Wales
began collecting Aboriginal art with general public and (art) profes-
sional support, though with opposition from some quarters who refused
to accept it as art – or at least an art equal in quality and significance to
that of European art.[89] The Australian artist and critic, James Gleeson,
wrote of Melville Island grave posts donated to the Art Gallery of New
South Wales by the collector of modern art, Stuart Scougall: 'Whatever
their symbolic significance they represent an ensemble of abstract shapes
of considerable aesthetic appeal ... Even in the artificial atmosphere of
the gallery they are impressive'.[90]

Tuckson, who according to Daniel Thomas 'did most to bring
Aboriginal art into the art museums',[91] was appointed, by the Art Gallery
of New South Wales, the first curator of Aboriginal art. In that role he
sought to exhibit Aboriginal art 'as art', by which he meant a de-
contextualised hanging that allowed the art to be appreciated 'without
any knowledge of its ... original purpose'.[92] For the modernist observer,
such distancing guaranteed the uncluttered pure space necessary for
the critical consciousness, and in other ways, argued Nigel Lendon,
recontextualised the work as contemporary innovative art, rather than
anthropological artefact.[93] For the first time at an institutional level,
Spencer's ethnographic aesthetic had been reversed and Aboriginal art
was being appreciated like white art; that is, with the formal rigour of
an aestheticised gaze. Aboriginal art was no longer the artefact of an
anachronistic culture, but a modern art.

However, if in this respect Aboriginalism laid the ground for the
postcolonial imagining of 'Australia', today Aboriginalism seems more
the end than the beginning of something. In the wake of the Second
World War, the Cold War and the collapse of the old colonial empires,
traditional figurings of identity and redemption were overtaken by new
paradigms in which Aboriginal art played a significant role. The
harbinger of the future is not any of the artists discussed in this chapter,
but an Aboriginal artist, Albert Namatjira. Invested in him was the hope
for a redemptive ideology. Ironically, a black man carried this white
hope.

CHAPTER 6

The Aboriginal Renaissance

If during the 1960s and 1970s the Australian art scene changed dramatic-
ally for both Aboriginal and non-Aboriginal artists, these changes
appeared to be quite independent of each other. Not until the 1980s did
they begin to converge. This chapter considers the development of
Aboriginal art since the 1960s and then discusses its impact on non-
Aboriginal Australian art since that time.

Aboriginal Art since 1960

The grip of Aboriginalism on the reception of Aboriginality not only
loosened but virtually disappeared in the 1960s. Coincident with this was
the tragic death of the Aranda artist Albert Namatjira – tragic because his
achievements were also his undoing. Within a decade, and with no
training in Western art practices, Namatjira had risen from obscurity and
extreme underprivilege to being one of Australia's most famous artists
and citizens. This, combined with his subsequent death at the hands of
larger forces, gave his life and art mythical proportions which profoundly
affected Aboriginal and non-Aboriginal Australians.

The reception of Namatjira's art by the Australian academic and pro-
fessional community during his lifetime was primarily concerned with its
perceived aesthetic value within the context of Eurocentric traditions.
Aborigines however, were generally moved by the political import of his
art. Indeed, they claim him as the progenitor of the Aboriginal art move-
ment. The Koori artist Lin Onus observed that the embryonic urban
Aboriginal art movement which emerged in the late 1960s and 1970s was
largely 'inspired by the success of the famed *Arrernte* artist Albert
Namatjira in the 1950s.'[1] Galarrwuy Yunupingu, an elder from Yirrkala
and one of the delegates who handed over the bark painting petition to

the House of Representatives in 1963, also revered Namatjira for demonstrating the political value of art. Namatjira's paintings, said Yunupingu, showed 'to the rest of the world the living title held by his people to the[ir] lands'. Now, continued Yunupingu: 'Painting has become central to the conflict that has existed between Aboriginal and non-Aboriginal people ... we paint to show the rest of the world that we own this country, and that the land owns us. Our painting is a political act'.[2]

Namatjira learnt watercolour techniques from a Victorian painter, Rex Battarbee. Battarbee mixed in the circle of influential Melbourne writers who combined Aboriginalism with a pastoral aesthetic, such as Robert Croll, Charles Barrett and Alfred Kenyon. Their campaign for an Australian identity and culture forged by the experience of central Australia, not European modernism, included the organisation of the 1929 exhibition of Aboriginal art at the National Museum of Victoria, and after Battarbee's 'discovery', the promotion of Namatjira's paintings. Thus, Battarbee's trip to Hermannsburg in central Australia was not unusual for the time,[3] and should be considered in the context of a much larger movement and ideological battle for the hearts and minds of Australians (discussed in the previous chapter).

Battarbee first travelled to the centre in 1932, and met Namatjira in 1934. In 1936 they embarked on a two-month painting trip together. The next year Namatjira exhibited with Battarbee, and in 1938 had his first solo exhibition. Namatjira's exhibitions sold out, prints of his work were and still are to be found on many Australian suburban walls, and even Buckingham Palace gave its blessing with a purchase. Namatjira accomplished in a few years what no other Aborigine had done in a lifetime: he achieved fame and citizenship, and became an honorary white Australian.

In the context of the attitudes to, and treatment of, Aborigines during the previous 150 years of colonialism, Namatjira's popular success amongst non-Aboriginal Australians was phenomenal, and produced heated debate in anthropological and art circles. However, his popularity rested on his perceived disavowal of Aboriginality – he became the icon of an assimilationist ideology that legitimised the new nation. This, in itself, was a radical paradigm shift, as before the First World War race could not be disavowed. Tony Tuckson astutely commented that 'Namatjira gained greater recognition than any of the others [of the Hermannsburg group], because in Western eyes his work was the least Aboriginal'.[4] Namatjira's supporters and detractors agreed on the success of his assimilation, and judged him accordingly. Leslie Rees, a supporter of Namatjira, wrote: 'the achievements of the Aranda painter of Hermannsburg, Central Australia, is one outstanding example of the capacity of the full-blood to learn from the white man'.[5] C. P. Mountford

shared Rex Battarbee's wonder that 'a man, not one generation removed from his stone-age culture, could, in a matter of months, understand and utilise the fundamentals of art that had taken white men years to learn'.[6] If Mountford emphasised Namatjira's 'rich cultural background', 'it scarcely seemed possible' to Mountford 'that any man could have bridged that immense gap in artistic expression'[7] between Aboriginal and European art.

Namatjira's modernist critics also believed that he had disavowed his Aboriginality. Instead of being a genius they believed him to be a victim. While they also acknowledged Namatjira's talent, achievement and competence in Western traditions of art, it was exactly these traditions which modernists contested, and contested within a primitivist aesthetic that reified non-European and especially tribal art. Thus, Australian modernists generally spurned Namatjira as a turn-coat who had betrayed the 'sensibility, the pure expression of art' 'latent' in Aborigines, and which, claimed Paul Haefliger (in 1945), 'is superior to any white artist Australia has yet produced'. Haefliger regretted that Namatjira had been trained by Batterbee: 'It is perhaps his [Namatjira's] personal tragedy that he could not have been taught by a more spacious talent'.[8] The directors of the Victorian and New South Wales' State art galleries agreed and refused to purchase Namatjira's work, despite public protests.[9] In the opinion of Australian modernists, Namatjira's very success at mimicry confirmed his parochialism and lack of (ab)originality. According to Geoffrey Serle, Namatjira's art was insignificant because he followed Battarbee, one of the 'host of imitators [who] debased' the 'vision' of Hans Heysen – a vision already 'lacking in imagination and had almost nothing to say in social or intellectual terms' because it, in turn, was the late development of an aesthetic derived from European impressionism. Serle thus judged Namatjira the end-stock of an impotent hybrid of European thought that (in Heysen) had become stranded on the other side of the world in 'a largely German district of the Mt Lofty Range', South Australia.[10]

The modernist's disdain of mimicry never impressed the general public. 'To this day,' observed Sylvia Kleinert, 'Albert Namatjira remains a popular hero'. However, his popularity does more than 'confirm the egalitarian myths of an Australian ethos',[11] it touches a raw nerve in the Australian psyche. In the eyes of non-Aboriginal Australians at the time, whether they were his detractors or supporters, Namatjira's landscapes fulfilled the redemptive hopes of colonialism, and so legitimised European rule within the Aboriginalist tropes of mid twentieth-century nationalism. Before his death Namatjira appeared to many non-Aboriginal Australians to be the first of a new black Australian, a white Aborigine, and the herald of a future Australia in which black might

become white. Thus, his paintings were received as tokens of Aboriginal surrender and European supremacy, and it was implicit in most non-Aboriginal Australian attitudes towards Namatjira at the time. For example, T. G. H. Strehlow, then the foremost non-Aboriginal authority on the Aranda people, called his book of 1956 on the Namatjira school *Rex Battarbee: Artist and Founder of the Aboriginal Art Movement in Central Australia.* Strehlow argues that 'it was almost certainly Battarbee's sympathy for their old homeland that first induced his aboriginal followers to take up water-colour painting unasked as a serious and lifelong occupation'.[12] 'The new art of the foreign intruder ... was worth emulating' because the old art and culture 'is dead as far as the Central Australian natives are concerned'. Today, said Strehlow, 'the young Aranda native ... generally despises these things as trash belonging to a defunct age'. While Strehlow did not entirely discount the possibility 'that the old type of art could not in some form give added vigour to the designs of white Australian artists', or that 'in two or three generations' time ... young aboriginal artists may begin to use again spirals, lines, and circles in a new, geometrical form of *abstract* art', he believed that traditional Aboriginal art 'had become entirely fossilised even before the arrival of the first whites'.[13] Agreeing with Strehlow's rebuttal of the commonplace idea that Aborigines should only paint according to totemic traditions,[14] Rees concluded:

> the example of the 'white' art has allowed the present generation of native artists to escape from a traditional bird's-eye symbolic illustration that needed myth to explain it, that had become 'frozen' and sterile, that did not allow of extra creative enterprise ... surely we can agree that any artist must be free to choose his own material and method, and the colour of his skin is beside the point.[15]

Battarbee made a similar point, claiming that his art enabled Namatjira to 'perceive beauty which he had not noticed before'. According to Battarbee, Namatjira told him that 'in primitive times the tribesmen looked at the ground seeking tracks of living creatures to hunt and collect as food. So they had little time for examining the surrounding country and the mountains, and so did not develop an appreciation of light and atmosphere on the landscape and ranges'. Battarbee believed that 'tribal taboos limit the artistic expression by Aborigines', and he cited the example of Namatjira being ordered to tear up one of his paintings by an elder. The Aborigines, said Battarbee, 'do not have a great deal of originality, and in their tribal artforms are copyists and traditionalists'.[16]

Traditional Western conceptions of mimesis and originality were deployed to underwrite the surrender of Aboriginality to Western

culture. In Battarbee's mind, Namatjira's ability to copy was his genius and nemesis: 'Here was a man, a full-blooded member of a race considered the lowest type in the world, who had in two weeks absorbed my colour sense' and learnt 'a very difficult medium' which had taken Battarbee years of hard work to master. 'I have', said Battarbee, 'always believed that no ordinary white man could do what Albert did in such a short time'.[17] However, as with most modernist critics, these very powers of mimicry only confirmed, in Battarbee's eyes, Namatjira's dependence on white art and the eventual fate of Aboriginal culture. 'One could not', wrote Battarbee, 'have expected a man like Namatjira to create his own artistic style without assistance', but equally, Battarbee was disappointed that Namatjira's style was so close to his, and that Namatjira had lost 'his Aboriginal sense of decoration'.[18] Hence Battarbee, as if agreeing with his modernist critics, resolved that when other Aborigines asked him for help:

> I would ... educate each man to see the landscape for himself and paint for himself and paint it in his own style. Thus it happened that the young men developed a more natural approach; somewhat primitive, in fact, as befitted their tribal background ... and [the] ancient, primitive structure of the Central Australian landscape.[19]

The Aboriginal artist who Battarbee most admired was Edwin Pareroultja. In order to preserve his originality (and hence his modernism), Battarbee 'dared not interfere with one who had so much ability', and 'jealously tried to guard him from outside influences'.[20] Battarbee's paternalism is modernist. He wished to ensure that Pareroultja's individual genius was not compromised, not that his art would remain in the traditional Aboriginal style. According to Battarbee 'modern Aboriginal painting' was not a relic of past Aboriginality, but the promise of a new Australian culture. Hence, his vision was framed by the politics of assimilation which suppressed rather than articulated difference. Perhaps, mused Battarbee:

> we can learn something from our Aboriginal artists. At present there are several white artists trying to show us an Australian aboriginal form of art which is too forced to be of much value. The true primitive artist is too far removed from us to be of much assistance to present day art. The Arunta artists are painting in our medium ... [and] may be nearer [to] a real Australian art than anyone has ever been in the past.[21]

So much had been invested in Namatjira that his tragic death highlighted the inadequacies of the government's assimilation policy, and government officials moved quickly to distance the policy from the example of Namatjira. Paul Hasluck, the Minister for Territories at the

time of Namatjira's arrest, and responsible for (without precedent) en-
suring that his sentence was spent at Papunya and not in a gaol, insisted
that he was not an emblem of 'his race', and that the tragedy was not due
to the failure of his government's assimilation policy: 'A great part of
Albert's difficulties arose because of separation from his own people ...
The confusion he felt came from the pull on him of his own origin and
not because of rejection by the white community towards which he was
moving'.[22] Hasluck was, however, one of the few to believe this. If before
his arrest and death Namatjira had been symbolic of the success of
assimilation policies, he now became emblematic of its failure. Joyce
Batty noted that: 'the term "Wanderer Between Two Worlds" was used
anew, but now with deeper inference. Albert was described as rejected by
two races, his own and that of the White Australians; he was also referred
to as "a hapless victim of fate and humanity" '.[23]

Namatjira was not the first Aborigine to die for his enlightenment, but
he was the first whose progress and enlightenment was considered tragic
and not comic. With his death, Namatjira, who had once seemed to fulfil
the redemptive aspirations of colonialism, destroyed it. If, as I argued in
the previous chapter, writers and artists such as Herbert, Nolan and Boyd
had already given up on the very idea of redemptive discourses, they
spoke for only a few though nevertheless influential Australians.
Namatjira's death did not necessarily confirm their diagnosis, but it did
destroy the redemptive hopes of Aboriginalism and its accompanying
assimilationist ideology.

It might appear from the success of Namatjira that he did more than
any other single person at the time to change the white market in black
goods. In an editorial on Namatjira's death, the *Adelaide Advertiser* said:

> A significant aspect of Namatjira's life and work is that he helped make us
> more self critical, even censorious, of our attitude towards aborigines.
> Probably more than anyone he stirred the communities conscience in this
> matter ... [and] sharpened our awareness that the conditions of aborigines
> should be improved and their status raised.[24]

However, it was the imperatives of colonialism and postcolonial
nationalism, not the 'genius' of Namatjira, which set the pace of Aborigi-
nalism in the mid-twentieth century. The rights of white citizenship
conferred upon him, unusual as it was at that time, was in accord with
that rite of colonialism recognised by Frantz Fanon: 'the colonised is
elevated above its jungle status in proportion to its adoption of the other
country's cultural standards'.[25] The question which remains unanswered
to this day is whether Namatjira's mimicry was a surrender of his
Aboriginality or a negotiation, on his part, with Western ideology. The
answer probably lies in an assessment of the strategies developed by

Namatjira during his own struggle for identity as he mapped the rene-
gade territory between the Aboriginal and European worlds. Namatjira,
as Philip Jones argues, transgressed both his Aboriginal and European
heritages in the search for a third way.[26]

Rather than being 'a hapless victim' lost 'between two worlds', Namat-
jira's art testifies to his ability to make an ideology from the ambivalence
of Hermannsburg – to map the new coordinates of its third diasporic
space which was neither Aboriginal or European, but somewhere in
between. Mimicry may not, as both the Aboriginalist supporters and
modernist detractors of Namatjira believed, articulate the subservient
desire to be the same, but in its semiology, ironically encode difference.
In never quite being the same, the mimic parodies rather than repeats
its origin.[27] Mimicry is performative. Hence, to coin a phrase from
Adorno, its 'illusory character' is simultaneously its 'methexis in truth'.[28]
If this imputes a postcoloniality to Namatjira that seems to far exceed the
historical moment of his art and his place in mid twentieth-century
Aboriginalism, within a few years of his death was launched the modern
Aboriginal art movement. Its symbolic birth was the Yirrkala bark paint-
ing petition of 1963, which fully and consciously sought to realise the
political potential of art that Namatjira had instigated, according to
Yunupingu. From this point Aborigines began to take control of
Australian myths of Aboriginality.

Recalling his involvement in the making of the Yirrkala bark petition,
Yunupingu expressed the frustration that his people had in com-
municating to non-Aborigines the significance of the Aboriginal attach-
ment to the land, and the role which their art might play in this:

> Very few white people have even tried to learn our language, and English is
> incapable of describing our relationship to the land of our ancestors. We
> decided then to try and do it in a way we hoped non-Aboriginal people would
> understand; through pictures. If they wouldn't listen to our words, they may
> try and understand our paintings.[29]

By the late 1960s, in an atmosphere of highly organised and sustained
protest activities exemplified in the Aboriginal strike movements in
northern Australia during the 1940s, 1950s and 1960s, from the Pindan
movement to Wattie Creek, Aboriginal elders in the north had adopted
a decidedly cultural strategy. This conscious strategic shift also occurred
amongst southern urban Aborigines. Lin Onus, recalling the genesis of
the Koori art movement in which he played a significant role, wrote that
a 'new class' of Aborigines 'who had received access (in varying degrees)
to education and mobility . . . broke upon the political scene in the late
1960s. Many were young, many were articulate, but they were all angry. It

is against this background that the art movement in these regions has evolved'.[30]

The political nature of the Aboriginal art movement cannot be underestimated. From the beginning it was part of the Land Rights movement; both being simultaneously inaugurated by the 1963 bark petition. Within a decade Land Rights had, for the first time, galvanised all Aboriginal peoples, creating a pan-Aboriginal consciousness. This was exemplified by the Aboriginal Tent Embassy erected in Canberra in 1972 by Koori activists in their campaign for the Gurindji people, then in their sixth year of strike in pursuit of Land Rights. At this time, Harold Thomas designed the distinctive Aboriginal flag which, more than anything else, has become the emblem of a pan-Aboriginality.

From a global perspective the emergence of a pan-Aboriginality and the associated revival of Aboriginal cultures across Australia coincided with the escalation of Third World liberation struggles, including Black and Red Power groups in Northern America. In other words, Aboriginal groups were, for the first time, pro-actively participating in the international scene, and it was a scene in which cultural aspirations were a prime strategy for political empowerment. While American Indian liberation movements such as the American Indian Movement have, over the years, had the more sustained influence on Aboriginal communities, in the late 1960s Afro-American Black Power activism became the most important exemplar for Koori activists. Its impact, while short-lived, was far reaching, and irrevocably changed Aboriginal politics. In Brisbane, Dennis Walker founded an Aboriginal Black Panther organisation which emulated the rhetoric and posture of its United States model. When the Caribbean Black Power activist Dr Roosevelt Brown was invited to Melbourne in 1969 by Koori activists, it was clear that direct links had already been developed with the long established pan-African movement which, for decades, had been employing strategies of liberation through cultural ideologies expressed in slogans of Negroism and Africanism.

The 'pan-Aboriginalism' advocated by black activists such as Kevin Gilbert and Chris Mullard in the 1970s[31] descends directly from the ideology of pan-Africanism which, Fanon prophetically pointed out, 'will not stop at the limits of the [African] continent'.[32] At first sight the influence of radical Afro-Americans on Aboriginal activists might seem unlikely, for they have little in common except in the most general terms. However the global postcolonial scene of the 1950s and 1960s, which ranged from neo-colonial decolonisation to violent anti-colonial wars, had created a common cause between oppressed black groups across the world. Its more radical exponents received significant press, and few more than Fanon, whose influence on black activists in the United States, UK and Australia was unequalled.[33]

Inspired by his teacher, the surrealist poet Aimé Césaire, and by existentialist and structuralist theory emanating from the French circles that he mixed in, Fanon argued that power was an ideological, and so cultural, effect of language.[34] Fanon's first book, *Black Skin, White Masks* (1952) addressed the discourses which propelled one word, 'Negro'. He showed the effect of its invention by colonialist discourse, and how once an abusive slogan for white power, it could, by inverse appropriation, become a slogan for black power. Here the subversive potential of mimicry was fully realised. Fanon further elaborated on this theme a decade later (on his deathbed) in *Wretched of the Earth*: 'The Negro, never so much a Negro as since he has been dominated by the whites ... comes to realise that history points out a well-defined path to him: he must demonstrate that a Negro culture exists'.[35]

Fanon's inspiration was derived from Césaire's slogan of 'Negritude'. While well aware of its limitations, especially when it assumed the form of essentialist and nationalist chauvinisms, Fanon supported its strategic purpose. For him, Negritude was not rooted in African-ness or the ancestral memories of local affiliations, but in the historical experience of colonialism in which black was the colour of otherness. Further, he believed that the struggles of decolonisation were historical processes which fundamentally transformed the colonised into 'privileged actors, with the grandiose glare of history's floodlights upon them'. 'Decolonisation is the veritable creation of new men', a 'new language and a new humanity'.[36] His strategy of cultural empowerment through decolonisation and decolonisation through cultural empowerment, is clearly evident in the self-conscious attempt by Aborigines to create an Aboriginal renaissance through the deployment of ideological slogans of a black culture and language, not the essentialism of traditional ethnography.[37] By the end of the 1970s Aborigines had effectively won this battle for language; a victory which underpinned the success of Aboriginal art in the 1980s.

In 1972, between visiting the UK and participating in the North American Planning Committee meeting of the Sixth Pan-African Congress in Jamaica, Roberta (Bobbi) Sykes, a black activist from Townsville, argued that the word 'aborigine' should be rejected because it was imported here by the British colonists, had no definite Australian connotations, and excluded other oppressed groups in Australia such as the Kanakas who also receive 'racist treatment because of their skin colour'. Further, she urged the use of 'Black' because it elevated 'the broad Black struggle being undertaken here to a Third World level'. Echoing Fanon, Sykes concluded: 'Black is more than a colour, it is a state of mind'.[38] Sykes thus adopted the ironic strategy of Fanon and other black-power activists. With a similar intent, in the 1990s, Destiny Deacon adopted the

term 'Blak' to describe herself and her art.[39] If few Aborigines were so internationalist in outlook, Fanonism did triumph. The two labels which eventually enjoyed the most success were the home-grown ones of 'Koori' and 'Aboriginality'. The former aimed at enhancing the identity of urban Aborigines, the latter at creating a united ideology for all Aboriginal groups in their struggle for power. Together these two labels, and the strategies that they encapsulate, shifted the impression of Aborigines in non-Aboriginal Australian minds from a racial to a cultural one. A new cultural paradigm designed by Aborigines that was derived from their own experiences of colonialism radically changed the reception and power base of Aborigines in Australia.

In the late 1960s radical members of the Victorian Aboriginal Advancement League, agitating to make the League an all-black organisation, began using the traditional south-eastern Aboriginal word, 'Koorie' (now generally spelt 'Koori'), as a radical slogan of empowerment. They established the 'Koorie Club', and called its newspaper, edited by Bruce McGuinness, the *Koorier*. The label has since proved effective in creating a cultural and ideological focus for many urban Aborigines, and has been emulated by Aboriginal groups across Australia.

The emergence of the label 'Aboriginality' is not so clearly pinpointed. The term was initially appropriated by Koori activists from the colonial label 'aborigine', in order to inject a Fanonist ideology into their struggle. Pride in one's Aboriginality became a principle strategy of black power – a strategy which clearly echoes Fanon's and Césaire's ironic uses of the terms 'Negro-ism' and 'Negritude'. 'Aboriginality' was not a new word but it had been rarely used, even by anthropologists, and had not previously been employed as a label for black power – though in a prophetic article written in 1971 the anthropologist Ronald Berndt suggested an identity politics in which Aborigines might 'deliberately cultivate their Aboriginality as a device that is designed to express uniqueness in contrast to other Australians ... as an attempt to rectify a situation that previously relegated them to a position of inferiority, nonentity and general deprivation'.[40] By the mid-1970s the term was becoming fashionable amongst radical Aborigines who were highly conscious that the Aboriginal movement needed to articulate a distinct Australian-wide ideology.[41] In 1973 Kevin Gilbert observed: 'the northern full-bloods do not consider that the southern blacks are Aborigines'; but he argued, 'their burden is the same – the white man'.[42] To Gilbert, a single black culture (which the term 'Aboriginality' signifies) already existed as a negative formation of colonialism, formed by the 'cement which binds all blacks in unity': 'persecution by whites'. If the name 'Koori', in recalling the fullness of precolonial tribal times in south-east Australia, espoused the survival of Aboriginality in urban Australia, the

name 'Aboriginality' signified a self-conscious postcoloniality designed to exceed both tribal identities and the biologism of colonial racism which, in their very different ways, had historically divided rather than united Aborigines.

Not until 1980 did the term 'Aboriginality' enter the market of white academia as a label signifying an ideology of black power. Since then it has proved extraordinarily effective, and in the last decade has appeared in virtually every publication designed to sell the products of Aboriginal culture. Today First World collectors buy Aboriginal paintings because the label says 'Aboriginality'. Even if the term 'Aboriginality' does, in some minds, signify a cultural essentialism and traditionalism, the shift it effected from a racial to cultural paradigm has been paramount in the success of the Aboriginal art movement. The impact of the new paradigm of 'Aboriginality' not only created a new market, but also radically altered the attitudes of the original labellists, the anthropologists, who continue to play a significant role as 'middle-men'. As early as 1974 Ronald Berndt hoped that a '"new" anthropology' might articulate 'the real Aboriginal identity' which included both 'traditional Aboriginal', and 'the long and painful process of Aboriginal–European contact'.[43] Jeremy Beckett reflected:

> Younger anthropologists including the author, continued to use the term 'mixed blood' into the 1960s, no doubt in conformity with official usage, but nevertheless perpetuating a confusion between genetics and culture. Despite these survivals of racism, however, the operative definition of Aboriginality had shifted from the biological to the cultural.[44]

Aboriginal painters in Arnhem Land were the first to profit from the new cultural paradigm. They were not just well placed but also well prepared, for the same ideological move towards empowerment that had given Kooris so much press had also been occurring more quietly in 'traditional' communities since the late 1960s, though within the frame of indigenous practices, not Fanonism. Many of these communities had then resolved to develop the aesthetic aspects of traditional culture – their myths, song, dances, painting – as a means of empowerment.[45] The resulting increase in the production of paintings and their exhibition had direct political consequences. In the introduction to the catalogue of an exhibition of bark paintings by the Gunwinggu people from Oenpelli (1979), Wandjuk Marika advocated a cultural ideology in order to overcome the current problems of uranium mining and associated Land Rights issues.[46] The strategy has paid more than monetary dividends. The increasing market price of Aboriginal paintings, in which the Oenpelli painters played a significant early role, has been an accurate barometer of the Aborigines' enhanced legal position in land claims and other

political struggles across the nation. Gunwingguity no longer divided one Aboriginal group from another, but was transformed into an 'Aboriginality' that empowered not just the Gunwinggu people, but all Aborigines, including Kooris. More broadly, it has began to change the perception by non-Aboriginal Australians of not only Aborigines but of themselves as well, thus opening a space for an effective dialogue between the cultures which Aboriginal artists and activists have been keen to exploit. For example, the 'only wish' of Malangi, Bungawuy and Milpurrurr, the first Aboriginal artists included in an official exhibition of contemporary international art (the Third Biennale of Sydney, 1979), was 'that the Europeans who view their work to look far enough into the dreaming to find a starting point for real dialogue'.[47]

Many urban Aboriginal artists also followed the path of reconciliation, their art often dealing simultaneously with Aboriginal and non-Aboriginal Australian traditions, and thus self-consciously proffering a convergent space for articulating new identities. 'The great innovator of the '70s was Trevor Nickolls.[48] He began a trend amongst urban-based Aboriginal artists of marrying European modernism with Aboriginal traditions, thus surveying what Onus called the 'anguished' boundary between these categories.[49] Nickolls also spearheaded the move by many urban-based artists to visit, for a variety of reasons, Aboriginal communities in northern Australia. Equally, Aboriginal artists who remain close to their traditional styles have succeeded in functioning simultaneously and equally powerfully in the different cultures that they inhabit. In Aboriginal communities art was being made the broker for reconciliation – both between Aboriginal and non-Aboriginal values, and between tradition and change.

Since the Second World War Aborigines living in traditional communities and urban centres have demonstrated an enormous capacity to maintain aesthetic and ideological initiatives within the frame of colonialism and its institutions. While contemporary Aboriginal art often draws on traditional practices, the notion that these traditions are unhistorical, that they originate in the land rather than history, in the earth rather than the world, needs to be dispensed with. Aborigines have consistently sought to include colonial history within their traditions. It has, says Tony Swain, been happening since first contact.[50] If traditional 'Aboriginal art does not conform to the logic of historical development ... in white Australian art',[51] it engaged with this logic in aesthetic as well as political terms. From Bungaree's dandy bricolage to contemporary Western Desert painting, including the Namatjira school, is mapped a repeated attempt by Aborigines over the last 200 years to meet with white history and its mythologies. For example, the replication of traditional sand painting in art museum contexts, popular in the 1980s, was an

Aboriginal initiative which involved substantial negotiations between the imperatives of their tradition and the history of colonialism. This did not, in the opinion of the Aboriginal artists, mean abandoning Aboriginal traditions but was a means of maintaining and enriching them. The twelve members of the Warlpiri tribe who made the ground painting for the French exhibition of Australian art in 1983, From Another Continent: Australia the Dream and the Reality, issued the following statement through Lance Bennett: 'We ... want to show the world that our traditions have *never* collapsed ... that our culture is as modern as today ... and how strongly we feel about being allowed to remain ourselves'. Their problem was less the making of painting in Paris, far from their land, but the confrontation within their own practice between tradition and history. Aboriginal law or tradition insisted that the painting be erased on completion, which would have defeated the cultural strategy of contemporary Aboriginality. The Aboriginal community plotted a third course: 'We agreed among ourselves [to keep the painting 'intact for the period of the exhibition'] ... to make the point that our culture *is* modern, even though it is 40,000 years old'.[52] Such negotiations by Aborigines have given their traditions and mythologies the capacity to occupy a contemporary Western space.

Non-Aboriginal Australian Art since the 1960s

The success of the Aboriginal art movement cannot be underestimated. 'In world terms', Terry Smith said in 1992, 'the impact of contemporary Aboriginal painting matches [the impact of] Neo-Expressionism in Europe and Postmodernism in the USA'.[53] Even if Smith's euphoria overstates the case, it does signify the type of attention which the Aboriginal art movement was getting by the early 1990s – an attention which suggests that the reception of Aboriginal art by the white community also played a significant role in its success. Nevertheless, for Aboriginal art to be accepted as a contemporary Western practice, immense changes had to occur within Western notions of art. The sudden ascendancy during the 1980s of Aboriginal art as an acceptable contemporary art form was not only due to a tenacious and persistent campaign by Aborigines, but to complex shifts in Western culture following the Second World War. In this respect the global postcolonial events which pre-figured the emergence of the Aboriginal art movement were also responsible for the radical shift that occurred in white attitudes to Aboriginal art in the 1980s.

The development of Australian art in the 1960s and 1970s was primarily staged by the global unravelling of modernism rather than local or nationalist agendas. While the existentialist mood of the immediate

post-war period had created a discursive space for nationalist, Aboriginalist and regionalist ideologies, this space was effectively closed by the late 1950s with the dominance of United States late-modernism. Paradoxically, at a time when, for Aborigines, their culture was undergoing a dramatic revival, for non-Aboriginal Australians it had sunk back into a nether world of craft and curios.

The dramatic shift within Australian culture during the 1960s was due to the emergence of a new world order following the Second World War which disrupted Australia's sense of place in the world. The implications of the new world order for Australia, a colony long under the spell of an exaggerated sense of its Britishness, was enormous and baffling. On the one hand, Australia's traditional British genealogy was threatened, opening the possibility for a postcolonial nationalist culture; on the other hand, such a future was circumscribed by the new United States imperialism and associated globalising trends. In this climate Australian culture remained as divided as it had been in the colonial period. The divisions were starkly epitomised by 'The Antipodean Manifesto' (1959) and the commotion it caused.[54]

Even though the abstraction of United States late-modernism triumphed in the 1960s, Australian cultural production remained deeply ambivalent. On one level, avant-garde art in Australia fell under the spell of a powerful United States cultural imperialism. This was particularly evident in The Field exhibition, which opened the new National Gallery of Victoria in 1968. Gary Catalano, who judged The Field a low watermark 'in Australia's sense of confidence in the potential of its society', observed, somewhat simplistically, that the artists of The Field followed their politicians by rushing 'for cover beneath the umbrella of the United States'.[55] However, the ascendancy of a United States internationalist late-modernism did not necessarily mean that Australia's postcolonial aspirations had withered. Arguably, at a populist level the nationalism of the previous decades strengthened.[56] To begin with, for the first time Australian artists were not painting that hitherto predominant cipher of their coloniality, the landscape. Daniel Thomas even argued that the influence of late-modernism inaugurated a new maturity in Australia's national consciousness. Early signs, he said, were the publication of Bernard Smith's *Australian Painting* (1962),[57] the journal *Art and Australia* (since 1963) and Robert Hughes' *The Art of Australia* (1966). Before then, 'art students and others were taught little about Australian art ... for many Australians the work of Australian artists remained invisible even if they visited an art museum ... Since the 1960s we have reclaimed our past'.

Thomas argued that the late 1960s was a turning point which saw the world come to Australia, as much as Australians making their pilgrimages

to the world. The Field was followed by a crescendo of international art
events in Australia: the next year John Kaldor's Art Projects brought
Christo to Sydney, the Visual Art's Board of the Australia Council, set
up in 1973, began bringing international artists to Australia, and 'the
Biennale of Sydney got off the ground in 1976 with its second exhibi-
tion'.[58] In 1978, after a twenty years' absence, Australia was present at the
Venice Biennale. 'By the time of the third [Sydney] Biennale, in 1979',
wrote Thomas, 'the world's experts in contemporary art ... took it for
granted that Australia was a significant producer' of avant-gardist art.[59]
Terry Smith commented from New York in 1974: 'the stylistic diversity of
international art during the past 15 years reverberates throughout recent
Australian art'. By the end of the 1960s, he said, 'it seemed that the time
of a liberating "global village internationalism" had arrived'. However,
the 'coming of age' was ambivalent, its 'liberation' constrained by the
terms of its freedom. 'If within the last 20 years we have learned to do
what everybody else does in art, and do it as well as most', 'so has almost
everybody else'. 'The art fairs have been condemned to insufferable
dullness by their own success in promoting international sameness.'[60]
Smith eventually diagnosed the heightened exhilaration of the 1970s
as harbouring a profound crisis which shook Australian art 'to its roots'.[61]
In shaking it, it opened the possibility for new paradigms to emerge
– the most significant being the notion that Aboriginal art was a con-
temporary art.

If interest in Aboriginal art had withered with the emergence of late-
modernism in the 1960s, by the end of the decade late-modernism had
lost much of its credibility. The symptoms were evident in a widespread
cynicism towards Western values, especially those epitomised by the
'American Dream'. These included the technological sophistication of
the United States armed forces being stymied in Vietnam by a Third
World guerrilla army without a navy or air-force, an anti-colonial scenario
repeated in many Third World countries; Afro-Americans returning
to their so-called African roots; indigenous activists demanding Land
Rights and reclaiming their identity or Aboriginality; and feminists
foregrounding issues of sexuality and the body. Such events were favour-
able to the emergence of primitivist, essentialist and anthropological
tropes associated with 'identity politics'. These tropes, which dominated
aesthetic practices in the 1970s, provided a space for Aboriginal art as
well as for more nationalist agendas which opposed the internationalism
of late-modernism.

For Australians, the two events closest to home were the Vietnam war
and the rising tide of Aboriginal protest movements – both of which
galvanised a generation of young Australians and resulted, in the late
1960s and early 1970s, in the flowering of the New Left. A product of the

1960s, the Australian New Left was itself also derivative of the United States scene. However, what distinguished the New Left from the Old Left was its Third Worldism. The new heroes were not the Europeans Marx, Engels, Lenin and Trotsky, but Asians such as Mao Tse Tung, Ho Chi Minh, and Afro-Americans such as Fanon and Eldridge Cleaver. For the first time in Australia's history a generation of Australians rejected the mythology of a white Australia which had constituted Australian national identity since its inception. If this fundamental shift in consciousness eventually returned the non-Aboriginal Australian scene to Aboriginal culture, ironically, but not surprisingly, the shift was first evident in a switch of allegiance from United States to European art.

Left in ruins by the war, many European artists seemed uninterested in negotiating or managing the crisis of modernism. Instead they disclaimed their European heritage – though the disclaimers followed previous European disavowals, in particular German romanticism and expressionism. Many European artists eschewed the hyper-reality and spectacle of the media-saturated society and politics of so-called 'late capitalism', and instead sought alternative traditions in the 'Outsider art' championed by Jean Dubuffet, in the anthropological visions of Claude Lévi-Strauss and Georges Bataille, in the revolutionary alternativism of Asger Jorn and Guy Debord's Situationist International, and in the conceptual primitivist aesthetics of Art Povera and Joseph Beuys. The appeal to a primitivist ethic in which artists imagined themselves as shamans, magicians and alchemists was diametrically opposed to the overtly intellectual and hyper-modernist strategies of United States late-modernists. Anti-modernism, as I will call it, was the common property of European artists as diverse as the Cobra group, Dubuffet, Beuys, Hermann Nitsch, Arnulf Rainer, Gorg Baselitz, A. R. Penck, Anselm Keifer, Hamish Fulton, Richard Long – most of whom saw themselves as modern-day shamans intent on cleansing and healing the devastated world in which they grew up.

By the late 1970s anti-modernism had become a predominate trend in Western art. It received a strong showing in the 1979 Sydney Biennale *European Dialogue*,[62] which excluded United States artists, and for the first time included Aboriginal artists. Not only did regionalist issues again surface in Australian art and literature but, as in the mid-twentieth century, it was accompanied by an interest in Aboriginal culture not seen for twenty years. For example, in 1977 the Australian literary journal *Meanjin* published for the first time a specifically Aboriginal issue. The editor's comments applied equally to the visual arts: 'Apart from raiding it for a name, *Meanjin* has not hitherto paid much attention to Aboriginal culture; for many years it seemed a separate, a forbidding terrain of secret, ancient rites patrolled almost exclusively by anthropologists'.[63]

Bernard Smith, who had consistently opposed the influence of United States art in Australia, went even further three years later. In his influential Boyer lectures of 1980 a framework was sketched by which Aboriginality could be included in the history of Australian art with an equality never before imagined. Smith called for a 'cultural convergence', an idea and term that he borrowed 'quite unashamedly from the poet Les Murray' – whom he quoted: 'In Australian civilisation, I would contend, convergence between black and white is a fact, a subtle presence, hard to discern often, and hard to produce evidence for. Just now [1977], too, it lacks the force of fashion to drive it: the fashion is all for divisiveness now'.[64] For the first time the convergence of Aboriginal and Western cultures in Australia was being canvassed in an intellectual fashion that avoided Aboriginalism. While convergence between Aboriginal and non-Aboriginal cultures was difficult to conceive, let alone realise, the idea was enthusiastically practised by some artists – such as John Wolseley and Tim Johnson. It was also vigorously attacked by many others, especially those of postmodernist persuasions – to an extent that Smith's Boyer lectures arguably provided the main focus of debate in Australian visual arts in the early 1980s.

Postmodernism and Cultural Convergence

The 1980s art scene in Australia and elsewhere was dominated by debates emanating from the reform of late-modernist practices. This reform, usually known as postmodernism, is experienced by many non-United States artists and critics as a cultural imperialism little different to earlier forms of European modernism and United States late-modernism. The Cuban critic Gerardo Mosquero complained (in 1992) that 'the other is always us', the 'postmodern interest in alterity is once more, Eurocentric, a movement from the dominant to the dominated'.[65] Like modernism and late-modernism, postmodernism was perceived as a global style that incorporated others – as is implicit in Ronald Jones' comment in *Artforum* on the first major exhibition of Aboriginal art in New York, 1989:

> Post-modernist theory has seeped into our bones, so we're all pretty clear on the fact that if we don't dream our religion, we may have dreamed our own art. Considered in this light, . . . is it any wonder that we might feel justified in conjoining our Age of acrylic and the agelessness of aboriginal culture?[66]

However, if United States postmodernists mounted vigorous arguments against convergence and indigenity, they did not simply repeat the imperialisms of modernism and late-modernism. The major connection for European modernists with non-European art was the aesthetic practices of modernist primitivism – be it in Gauguinesque,

cubist, expressionist or surrealist forms. While postmodernist theorists such as Rosalind Krauss and Hal Foster objected to the return of earlier primitivist models by various anti-modernists, the postmodern interest in difference and irrational structures is also close to aspects of modernist primitivism, especially that espoused by certain surrealists. Against the romanticised identification with the primitive as primal and essentialist that characterised European anti-modernists in the 1970s, postmodernists advocate a transgressive primitivism. Here both feminised and colonised bodies became strategic sites of resistance to what was perceived as the Eurocentric and phallocentric discourses of modernism. For example, Foster attacked William Rubin's 1984 exhibition at the Museum of Modern Art, 'Primitivism' in Twentieth Century Art: Affinity of the Tribal and the Modern, claiming that it legitimised the 'neoprimitivist [anti-modernist] movement in contemporary art'. Foster objected to the claim by Rubin that the exhibition was a 'significant correction to the received history of modern art', because its exposition of the formal affinities between Western modernist art and the traditional art of Africa, Oceania and America merely reinscribed the project of Enlightenment in which 'the primitive' was 'constructive, not disruptive, of the binary ratio of the west'. Instead of assisting 'in the establishment of a western identity, centre, norm and name' by managing the other through dialectical incorporation, which, Foster claimed, the exhibition did according to a modernist and colonialist agenda, he proposed (after Bataille) a 'counterreading of the primitive ... as subversive' and transgressive. With postmodernity, wrote Foster, 'this "eclipsed" or sublated primitive re-emerges in western discourse as its scandal – where it links up genealogically with poststructuralist deconstruction and politically with feminist theory and practice' to provide a virtual 'eclipse of otherness' and the beginning 'of a potential break with the phallocentric order of the west'.[67]

If Foster's proposal for the 'eclipse of otherness' was a type of convergence, or at least a collapse of differences, it eschewed notions of affinity and assimilation. However, it was the possibility of cultural convergence producing assimilation which many Australian commentators, especially those sympathetic to aspects of postmodern theory, feared. Colin Symes and Bob Lingard claimed that Bernard Smith's notion of cultural convergence 'carries atavistic overtones of assimilation', and instead argued for a 'cultural divergence' which would see 'the proliferation of highly localised and culturally differential types of art production'.[68] Paul Taylor, who edited Art & Text, also rejected the idea of an aesthetic convergence between Aboriginal and non-Aboriginal artists but for reasons which promoted global not local agendas. The artists Taylor supported, he said, 'don't really have a lineage within

Australian art, they are just isolated instances'. Further, he continued, 'one looks at how other countries are using their local histories, and I refute the stupid notion that Australians are going to "naturally" use Aboriginal motifs and are going to draw on the cultures of South East Asia and this kind of rubbish'.[69]

Reviewing the exhibition Tall Poppies, curated by Taylor in 1983, Su Cramer wrote:

> Apart from the 'black' Aboriginal pieces appearing, as Taylor says, by 'default' in John Dunkley-Smith's *Interior No. 7 (University Gallery) Melbourne*, (1983), there is little specifically Australian subject matter in Tall Poppies. Notions of a regional or national identity, a truly 'aboriginal art' seem not to appear, viewed perhaps as an oversimplistic response to the questions of 'place' and territory when viewed from a lateral and relativist perspective. Here there is a contrast with the regionalist approach of the Trans Avant Garde.[70]

Imants Tillers, also associated with *Art & Text*, was equally disparaging of the 'attempt by some artists and curators to blend the exoticism of Aboriginal culture with certain manifestations of contemporary art'.[71] While he noted that 'the acceptance of Aboriginal art can in part be attributed to the promotional activities of the Aboriginal Arts Board of the Australia Council and ... the [Aboriginal co-operative] Papunya Tula Co.', 'the other more subtle and powerful reason for this acceptance', said Tillers, 'is that certain contemporary forms in recent art seem to be convergent with Aboriginal art (and even "life-style") to the extent that they have the atmosphere of "aboriginality"'. Such convergence, he believed, was a form of cultural colonialism; a fashionable and expedient way to absolve 'the deep guilt underlying Australian culture' without at first rectifying the 'political and economic inequalities'. According to Tillers:

> 'Cultural convergence' is attractive as an idea because it offers a painless way to expiate our collective guilt ... while simultaneously suggesting an easy solution to the more mundane but nevertheless pressing problem of finding a uniquely Australian content to our art in an international climate sympathetic to the notion of 'regional' art.[72]

Further, Tillers objected to the ways in which 'Aboriginality de-contextualised what he believed to be the real issues of contemporary society: 'the re-emergence of a strong urban-based art, orientated towards mimicry and deconstruction of the codes and signs of consumerism'.[73] Thus his target was not so-called traditional Aboriginal art or society, but events such as the 1979 Sydney Biennale. During the Biennale, said Tillers, 'Australian artists were often dismayed by the interest and knowledge shown by visiting artists and critics of Aboriginal

culture and the almost aggressive indifference they displayed to the Australian urban environment and its culture'.[74]

Tillers, along with like-minded artists and critics such as Taylor and Juan Davila, aimed to construct a radically new notion of subjectivity in the postmodern global village, where there was no centre and hence no periphery. The old differences had collapsed into a new universal globalism; and the local, liberated from its burden of peripherality, was no longer a site of transgression. In short, we had entered a postmodern, not postcolonial world. Tillers' point, argued Rex Butler:

> was that the specificity of Australian art was not to be found in anything actually within the country (its landscape, its light, its people), but in the fact that it is almost entirely mediated through other people's perceptions of it. There is no authentic Australia: the only original thing about it – if we can put it that way – is that there is nothing original about it.[75]

In Tillers' postmodern world all aboriginalities were, like all essentialisms and identity politics, anachronistic: the 'widespread though largely unstated hope (or even belief) in an "indigenous" Australian art ignores the contemporary understanding of the nature of the physical world' – a postmodern 'world in which "locality fails" is far more interesting than the one in which we are limited to our immediate circumstances and which we are suffered upon to reflect in our art'.[76]

Australian-born of Latvian refugees from the Second World War, Tillers embodies the modern diaspora which epitomises the postmodern scene. His migrant experience resulted in an aesthetic which, Bernice Murphy pointed out, prefigured the postmodernist appreciation of 'decentredness' and 'quotational strategies'.[77] For Tillers the concept of indigenity is anachronistic. 'Australia today', he said, 'is primarily an amalgamation of different diasporas from around the world – the Irish, the Jewish, the Anglo-Saxon, Greek, Italian, Chinese, Vietnamese etc.'[78] Here, the only place Aborigines have is as part of the modern diaspora, that is, as wanderers in a *terra nullius*. Thus, when he did include Aboriginal artists within his world view, he denied them an indigenity by making their art a simulacrum, an appropriated discourse of the second degree. For example, in paintings such as *The Nine Shots* (1985) and *Prisms* (1986), he explicitly joined appropriated Aboriginal and German new-expressionist paintings in an ironic collapse of such modernist binaries as the centre and periphery, the modern and the primitive, European and Aboriginal. The effect was to de-Aboriginalise and de-essentialise Aboriginal art. However, despite Tillers' objections to cultural convergence, he produced a type of convergence. The collapse of difference in the everyday experience of postmodern globalism even made Papunya painting a type of postmodernism. Thus, Tillers

compared the dot paintings from Papunya with the dot screen of photo-graphically reproduced images, arguing that the 'Papunya paintings have a very strong conceptual aspect ... [that] can be identified with the dematerialised aspects of the Australian conceptual art of the early 1970s'. Also, he pointed out, they shared 'exactly the same historical period in Australia as conceptual art. 'Papunya paintings', he declared, were not Aboriginal art, but 'post-conceptual':

> The 'dot-screen' in Papunya painting is thus in addition to any other significance, a sign of not just the radical and transcendent superficiality of this art but also of its *invisibility*.[79] There is a supreme irony in this since it is an attitude convergent with the art of 'White Aborigines' – Australian 'unexpresssionists' – those who embrace the 'dot-screen' of mechanical reproduction either directly or through its agent – photography.[80]

Tim Johnson also developed a style in which the use of dots produced a convergence of Aboriginal and Western styles – though Johnson's use of dots recalled impressionism rather than the dot screen. Other artists, however, resisted Tillers' postmodernist Aboriginalism. Juan Davila, the Chilean artist with a reputation for transgressive postmodernist appro-priations, attacked the specific content of Tillers' and Tim Johnson's appropriations, arguing that their soft primitivism was aesthetically and 'politically regressive'. Always an advocate of 'hard primitivism', Davila dismissed Johnson as naively seeking an 'intuitive primitivism', 'an affinity with the "savage mind"', and accused Tillers of 'taking a dominant role with regard to Aboriginal culture', his postmodernism merely 'repeating the strategies of modernism' and endorsing 'the "art of white aborigines"'. Instead, Davila called for the Bataillian 'counter-primitivism' advocated by Foster, in which Aboriginality is accorded a transgressive instrumentality. Aboriginality, he argued, should not be 'promoted from the centre': here it will, like all transgressive objects, sites and economies, be absorbed,[81] become another Aboriginalism, and its artists other white Aborigines. If this was so, it had little effect on the triumph of Aboriginal art.

If the slip between Western Desert dot painting and its mechanical reproduction through the 'dot-screen' had, 'ironically', produced an art of convergence, Tillers was less interested in actual Papunya paintings than in the way they had entered, via the media, the flat postmodern realm in which all differences are collapsed into the same layout. He was not appropriating actual paintings, let alone Aboriginal ceremonies, but their reproductions in contemporary art journals that he flicked through in his studio. However, this did not stop other postmodernists making an explicit ideology of aesthetic convergence, from what Tillers perceived

as irony. The anthropologist Eric Michaels was its most influential exponent. In 1989 he commented:

> you can pick up a Yuendumu canvas directly from its site of production (these politically grotesque, post-colonial, depressed, third world desert camps and settlements) and drop it straight into any contemporary New York, Cologne or Paris gallery and, without any explanation, documentation or apology, it will 'work' in these settings.[82]

Michaels read this positively, as evidence of the ability of Aborigines to critically engage with postmodernism rather than be incorporated by its agenda: 'Aboriginal painters now match the postmodern methodologies of appropriation with their own counter-appropriative strategies'. If, like Tillers, Michaels found a place for Aboriginal art within the internationalist logic of postmodernism and claimed 'startling correspondences ... between some contemporary Aboriginal work and aspects of postmodern aesthetic theories', he also asserted that the Western Desert painters were directly engaging with the postmodern scene. Not only are 'Western Desert acrylic paintings ... not exempted from the postmodern condition', but says Michaels, 'they respond to and comment on it every bit as much as Tillers, and [Tim] Johnson and others do, and the style has become attractive to us now for precisely this reason'.[83]

Whether Aboriginal artists were, as Michaels argued, critically engaging with postmodernism or merely being postmodernised, there is little doubt that the very resistance by postmodernists to essentialist discourses had paradoxically created a contemporary space for Aboriginal art. The very lengths which Tillers and other postmodernists went to dispel the myths of regional and Aboriginalist identities only showed the force of such myths in the contemporary arena. Even if 'the issue of Black culture versus White culture' was, in Philip Brophy's postmodernist view, generally being 'handled in appallingly "black and white" terms', there was, he said, no escaping the historical fact that 'in the domain of Arts and Culture, Australia is currently embroiled, or calmly participating, in the intersection of Aboriginal and White Australian (otherwise known as "non-Aboriginal") art practices'.[84] On every front Aboriginal art was emerging as the main focus of interest. Only Aboriginal art, it seemed, could position the Australian local in the global, and paradoxically, make an Australian art of global significance. Thus, the most significant new paradigm to emerge in Australian art since the late 1970s was not the new urbanism espoused by Tillers, but the contemporaneity of Aboriginal art. Tillers might claim that contemporary Aboriginal art is a new urbanism, and in a sense it is. However, the success of Aboriginal art has been to resist its incorporation into postmodernism without forgoing its contemporaneity.

CHAPTER 7

Aboriginality and Contemporary Australian Painting

The discourses of Aboriginality and their historical and ideological effects became a major narrative in the exhibitions of contemporary art in Australia during the 1980s. This narrative did not follow a smooth linear development from mid twentieth-century Aboriginalism, but erupted after a sustained period (more than two decades) of official indifference to Aboriginal discourses, including Aboriginal art. Today it is easy to forget how little Aboriginal art was appreciated even fifteen years ago.

If the inclusion of Aboriginal art in institutional exhibitions of contemporary art in the early 1980s signalled a radical shift in Australian culture, it initially was tentative, and reflected the prejudice of two decades of neglect and indifference. Indeed, even the impact of mid twentieth-century Aboriginalism had been peripheral on art institutions, despite the genuine interest in Aboriginal art by a broad range of artists and other people. In 1976 Daniel Thomas complained that Tony Tuckson's 'beautiful exhibition "Australian Aboriginal Art", which toured all State art galleries of Australia in 1960–1, is still the only serious show of its kind'.[1] Thus, the success of the Aboriginal art movement in the 1980s was experienced by art institutions as a disruption to their traditions. When Aboriginal art was exhibited in survey exhibitions of contemporary art, it sat awkwardly in the venue and in the catalogue essays. Vivien Johnson's comment on the 1986 Sydney Biennale was generally true of all such occasions: 'it was the radical incommensurability of artistic strategies with all the other exhibitors which most characterised the contemporary practice of Aboriginal art'.[2] However, while the reception of Aboriginal art by white institutions was a difficult exercise, it was experienced as a necessary and even fateful one because many hoped it might provide answers to the unfathomable questions of

identity which have resounded in non-Aboriginal Australian culture for 200 years, and which resurfaced with renewed vigour during the bicentenary year (1988).

The ideological imperatives of Australian culture in the 1970s were showcased in the collecting policies of Australia's art galleries, especially that of the National Gallery of Australia – or the Australian National Gallery, as it was then called. Under the directorship of James Mollison, it had the antithetical task of creating a *national* collection at a time when an international late-modernism was the dominant paradigm, and regionalist, nationalist and Aboriginalist discourses were considered anachronistic. Nevertheless, on officially opening the Gallery in 1982, Queen Elizabeth II stated the obvious: 'The establishment of a national collection is also the establishment of a national identity'.[3] What national identity, then, was articulated after nearly 200 years of occupation by her subjects of the southern continent?

Two things stand out – though then they seemed, to most, only natural. First, Aboriginal art was not included in the Australian art galleries in the opening hang of the Australian National Gallery. Second, the collection was structured around 'masterpieces' of European modernism and post-war United States art showcased in the enormous high ceilinged galleries on the main floor. Non-Aboriginal Australian art was relegated to a second but important place, followed by a third group of black art collected by the curator of the 'Arts of Oceania, Black Africa, Pre-Columbian American and Aboriginal Art'. While the values of late-modernism permeated every aspect of the opening hang, Aboriginal art was not entirely excluded. Daniel Thomas, the curator of Australian art and long-time admirer of Tuckson and his advocacy of Aboriginal art, took the innovative step of juxtaposing a contemporary bark painting by Djawa with his hanging of two Aboriginalist paintings by Margaret Preston. Thomas was not writing a convergent Aboriginal and non-Aboriginal Australian art history because, Nigel Lendon pointed out, the Djawa painting was 'merely a device to "frame" the Prestons'.[4] If the experiment signalled a desire to consider Aboriginal art part of Australian art, a desire also evident in exhibitions of contemporary art at the time, the experiment was not applied or tested elsewhere in the Gallery. For example, the one area where such a convergence might be more easily surveyed – in the so-called 'transitional' Aboriginal art of Albert Namatjira, the Western Desert painters and the like – was ignored. Ian Burn found this omission 'disturbing'.[5] Not many others did. The Gallery, after all, was only reflecting current opinion which, like Thomas, believed that Aboriginal art was tribal and unhistorical: 'a chronological display [of Australian Aboriginal art]', he wrote, 'is inappropriate, as it is for other tribal art'.[6] This lends weight to Lendon's reading of Thomas'

hanging of the paintings by Preston and Djawa as a 'triptych', 'an icon to the assumption that one tradition was progressive and innovative, the other conservative, static and essentially retrospective'.[7]

The anthropological reception of Aboriginal art, which discounted Aboriginal art as contemporary art, still prevailed into the 1980s. Even though private collectors in Australia and overseas had started to seriously collect Western Desert paintings, the public galleries and official response remained reticent. Michael O'Ferrall remarked that few believed 'such a structured controlled art [could] emerge un-announced from a largely unknown "illiterate" society', and that 'con-ditional similarities' with modernist art 'were insufficient'.[8] Not only had art historians and curators in public art galleries not paid serious attention to Aboriginal art, and had left the field to anthropologists, but they adopted unquestioningly the anthropological concept of authenticity. Thus, they considered 'real' Aboriginal art 'primitive' and judged it accordingly. Bernice Murphy commented in 1981: 'Aboriginal ground paintings in acrylic on canvas have long been excluded from the art museum context in Australia as a result of quite artificial strictures placed around the question of their "cultural authenticity". They have often been regarded as hybrid, because of their expression in non-traditional materials'.[9] For example, Ruth McNicoll, the 'Curator of the Arts of Oceania, Black Africa, Pre-Columbian American and Aboriginal Art' at the Australian National Gallery in 1982, believed that museums and art galleries should only purchase Aboriginal art which was 'wholly traditional in subject matter'.[10] In this scheme, Western Desert acrylic paintings, the flagship of contemporary Aboriginal art in the 1980s, lost both ways: they were neither 'authentically' primitive or authentic-ally modern. The same scepticism repeated itself when such paintings received their first large-scale exposure in New York in the 1988 exhi-bition curated by the anthropologist Peter Sutton, Dreamings: The Art of Aboriginal Australia. According to Nicholas Baume, 'viewers claimed that these desert artists were frauds, that they couldn't do such sophis-ticated paintings without having seen books on modern paintings'. 'Without exception', he said, Aboriginal acrylic paintings were under-stood in New York according 'to modernist precedents'.[11]

While the first 'official' survey exhibition of contemporary art which included Western Desert acrylic painting was in 1981,[12] Aboriginal art only gained its current exposure in the late 1980s. This was due more to the difficulty of the exercise than for want of trying. Even though the Sydney Biennale provided a lead in the exhibition of Aboriginal art in a contemporary and avant-garde context,[13] its curators remained limited by the traditional anthropological reception of Aboriginal art as authentic and primitive. For example, the 1979

Biennale, the first to include Aboriginal art, exhibited bark paintings only because, one suspects, the medium signified the 'authentic' primitiveness of the artists, for this is what the catalogue emphasised. According to it, 'none [of the artists] could read or write a European language'; 'each continues to live in a bush environment, hunting and providing food for his wives and children'; 'all three men ... are keepers of sacred knowledge'; and they were 'no strangers to warfare ... each has experienced the taking and restoring of human life'. Yet the very inclusion of Aboriginal art in such a venue signalled a new agenda in the reception of Australian contemporary art. Understandably, the curators of the 1979 Biennale were uncertain of how to relate Aboriginal art to non-Aboriginal art. However, they were convinced that 'their inclusion [of Aboriginal art] in a significant international Biennale represents a historic occasion, and parallels a growing awareness in political and economic spheres that the future of Aboriginal society is tied to the dominant Australian consciousness'.[14]

This thesis was first tested internationally in the 1983 exhibition at Musée d'Art Moderne de la Ville de Paris, From Another Continent: Australia the Dream and the Reality, (D'un autre continent l'Australie le rêve et le réel), which included work by contemporary Aboriginal and non-Aboriginal Australian artists. The results did not bode well. The French exhibition made Australia the site of alterity, with the curator, Suzanne Pagé, picturing Australia as a mythical place where the extremes of humanity meet. To her Australia represented 'a return to sources, the last frontier, the last place where adventure is still possible, the final refuge for a death-dealing civilisation haunted by the spectre of universal disator [sic]'. Non-Aboriginal Australians, she said, were 'a mass of contradictions, multifarious, unstable (post-War immigration brought people from many lands)', while 'at the centre' of this is 'Aboriginal society' which 'stands with serene permanence and timeless transcendance [sic]'. And Paris, with the reputation for being the modern site of all universal accomplishments, was bringing together these cosmic opposites – 'so that most of the artists exhibiting here will be meeting an Aboriginal tribe for the first time in Paris'. 'From an Australian point of view', said the French curator: 'this presentation involves the artifice of placing side by side two realities which are still foreign to each other. In fact this is the first time a museum outside Australia presents this double participation, including Aborigines'.[15]

The combination of Pagé's naivety and curatorial ambition, which was echoed in the general reception of the exhibition in France, touched a raw nerve amongst the more postmodernist Australian participants. Faced with such new-age romantic notions from the French, Richard Dunn (a participating artist) compared the theoretical rigour of the New

York scene to the 'mythical' presence of Paris which still indulges in anachronistic notions of Australia as a place of 'escape' and 'arcady'. To the French, said Dunn:

> white Australia was to be characterised as a dream, interlopers of other's imaginary space, colonisers of the Real place ... and as purloiners of European art. Forty thousand years of the Real in the form of the Warlpiri ground painting was to be set against the two hundred year dream. No contest!
> ... the 'white' culture if not seen as a poly-culture is far more heterogeneous than is admitted here, and it would be more accurate to speak of a plurality of aboriginal cultures. The pragmatism (demonstrated in Paris) of both tribal Aborigines (and also of urban blacks) is ignored as is the transitional nature of aspects of tribal culture.[16]

The non-Aboriginal artists had hoped that the French would be interested in non-Aboriginal Australian art. However, the French were preoccupied with their own identity crisis: 'Something unique is afoot in Europe, in what is still called Europe even if we no longer know very well *what* or *who* goes by this name'.[17] Jacques Derrida here argued against those who saw the postcolonial crisis as merely a strategic retreat, and insisted that Europeans were being forced back to the difference which constitutes their 'culture' and identity. In this 'crisis of the spirit', said Derrida, it is timely to 'recall ourselves not only to the *other heading*, but also perhaps to the *heading of the other*, and especially to the *other of the heading*'.[18] In From Another Continent 'Australia' was yet again made into a European emblem of alterity, the 'other' continent. Thus, complained Philip Brophy, whatever we do, 'it all goes for naught, for overseas this is interpreted as the one search for identity'.[19]

The postmodernist viewpoints of Philip Brophy and Dunn were not unrepresented in the exhibition. Leon Paroissien, an Australian adviser to the French organisers and a curator who responded positively to the ascendant current of postmodernism, stressed that the muse of contemporary 'Australia's visual culture' was no longer the landscape, but an 'urban society unhampered by tradition and unburdened by history'. No longer 'susceptible to the periodic tides of European and American styles', Australian artists 'more often see their geographical remove from the greatest sources of cultural imagery ... as providing a positive process of filtration. The all-pervading, cultural imagery of publications, television and film generates a profoundly rich source for reconstruction'.[21] The French, however, were not so convinced, and generally saw only another colonial culture. The non-Aboriginal Australian artists, said one French critic, '"hungrily" assimilate and emulate the ideas and trends which have originated in Europe and the USA'. To the French, Australia

remained a colony, a site of transgression. Thus, for them, the work of the non-Aboriginal Australians paled into insignificance beside 'the discovery of Aboriginal Australia'[22] – the other half of the exhibition which Paroissien's remarks unintentionally disparaged for their anachronistic attachment to the land.

The frustration felt by the participating Australian postmodernists to the French attitude was strongly felt and publicly articulated. Juan Davila blamed it on the 'international return to the aesthetic of the picture', by which he meant the new-expressionism of the anti-modernists, and accused the French, as well as the more expressionist Australian artists in the exhibition, of 'following the international trend' which disparages discourse, overvalues the object, and abandons 'theoretical and political concerns' for 'a position of indifference'. The exhibition, he argued, was constructed as a simple set of differences, 'Aboriginal Art versus white urban Art, painting-painting [sic] versus Art practices with a theoretical concern', which, while easy to read, eschewed any dialogue. Moreover, little empathy was felt by the postmodernist artists towards the Aboriginal artists. The Aboriginal art, said Davila, 'reflected the passivity that characterised the Aboriginal intervention in Paris'; it did not 'have a word for the problems of other tribes or Urban Aborigines, and even less about the possibility of contacting white artists'.[23] Brophy added that 'he found no interest in any of' the discussion surrounding Aboriginal art. Nevertheless, his criticism of the exhibition centred entirely on this discussion, and he concluded: 'my views are determined not so much from lack of care as they are from a lack of relevance ... I'm much more offended by the New Wave advertising of denim jeans than I am by bastardised aboriginal culture in white galleries'.[24]

Australian postmodernist reaction against the French reaction to Australian art, and against the new Aboriginality making inroads into contemporary art, was widely canvassed in Australia's art journals the following year (1984). Christopher Pearson, for example, accused the idealism of 'sympathetic representations of Aborigines' as 'usually' being the 'worst'. He singled out a popular song by Shane Howard played by the band Goanna (1982), Peter Weir's film *The Last Wave*, and several Aboriginal writers who eulogised the pre-contact time as a paradise since lost due to the rapacious greed and violence of 'White man – White law – White gun' (Shane Howard). Better, he said, are the grotesque images of Aborigines produced by colonialist artists such as the 'Port Jackson Painter'. Pearson's desire for an 'authentic account of their [Aboriginal] history' as the only 'potent weapon'[25] in their struggle is commendable. However, as I have argued in previous chapters, grotesque and utopian tropes are implicated in the same colonialist history – neither is more or less 'authentic', more or less desirable than the other.

The more postmodernists disavowed identity politics, the more they seemed drawn into its arena. For example, seeing in advance the sorts of questions which might be raised by the French in the exhibition From Another Continent, Meaghan Morris wrote in the catalogue of the exhibition that 'the only serious response today to the question of an Australian "identity" might be: there isn't one ... and there may never be one'.[26] If Pagé had crudely canvassed a colonialist and essentialist identity politics, Morris' postmodern resistance to the ontology of such a politics was, like the art of Imants Tillers, couched within a return to issues of identity, not as original essences but as comprising the improvised and appropriated discourses of migrant texts. This only left a space for diasporic identities without indigenity, but it was, as Tillers realised, a very interesting space from a postmodernist perspective. For this reason, as if by default, Tillers found himself engaging in the very convergence with Aboriginal art that he was so critical of, for contemporary Aboriginality had become a site of the postmodern diaspora.

The reaction to the French exhibition confirmed that Aboriginal art had become part of the postmodern global urban environment which Tillers and other postmodernists were committed to traverse and appropriate to their own ends. Tillers' criticism in 1982 of the 'atmosphere of aboriginality' in much recent art had admitted as much. By describing an aesthetic environment in which 'more and more contemporary advantages are extracted from an association with "aboriginality"', 'in defiance of the dictionary definition' of the term, Tillers concluded that 'aboriginality' has become 'an ubiquitous quality which is no longer the exclusive domain of "black" aborigines'.[27] This convergence was most apparent in what Morris called 'one of the privileged figures of postmodern rhetoric in Australian art writing', 'the white Aborigine'.[28] In 1983 Paul Taylor used the term to characterise postmodernist artists as nomads of a transgressive terrain. He called the artists included in his exhibition Popism, 'white Aborigines', because 'Popism, like the aboriginal nomad, can ... find a metaphor for itself in its existence on the surface and the edges of the existing land-scape'.[29] Instead of the shaman figure offered by anti-modernists, such as Joseph Beuys, is the Deleuzean postmodern nomad.[30] To Taylor, Aborigines are exemplary postmodernists and postmodernists are exemplary Aborigines, because both are nomads who inhabit the borders of state institutions. Taylor's position was more fully theorised the next year by Stephen Muecke, who directly applied Gilles Deleuze and Felix Guattari's concept of the nomad to traditional Aborigines. For Aboriginal nomads, said Muecke, 'Australia is not divided into eight "states" or territories, it is criss-crossed with tracks. The smooth space (*épace lisse*) of these invisible and secret tracks has been violently assaulted by the public checker-board grid

(*épace strié*) of the states'. Muecke thus distinguishes between the nomad who is autochthonous, aboriginal, indigenous, and the migrant who is alienated, modern, imperialistic. 'The nomads live in these places, remain in these places, and make them grow themselves in the sense that one notices that they make the desert no less than they are made by it.' Hence 'the nomad is in fact the one who *doesn't* leave the country. The migrant might leave a country embittered, never to return, and then try to appropriate the nomadic spaces of another country'.[31]

Taylor and Muecke unintentionally revived a primitivist trope that returns Aborigines to 'nature' and a pre-modern state, effectively reiterating the colonialist concept of *terra nullius*. Instead of being the subversive discourse that he imagines, Muecke pictures Aboriginality as pre-historical and pre-lingual in the Rousseauean sense. 'It was', said Muecke, 'the country ... which slowly produced the nomadism of the Aboriginal people'.[32] Not only do Muecke and Taylor follow Deleuze and Guattari by inventing a postmodernist primitivism which appropriates Aboriginal practices as effectively as any previous colonialism, including modernist primitivism, but they reinvent in the guise of a postmodernist nomadology the very modernist frontier metaphors which Tillers had criticised in his article, 'Locality fails'. In direct contrast to Taylor's and Muecke's 'nomad', Tillers' 'white Aborigine' is an agent of the 'State apparatus' and its language of mechanical reproduction. For Tillers, postmodernism is not an aesthetic of resistance but of reproduction; it exemplifies rather than resists the postmodern condition. In Tillers' diaspora all binaries collapse, Aborigines are white and whites Aborigines. However, no matter how differently the 'white Aborigine' was theorised in the 1980s, there had emerged an Aboriginalism which rivalled that of the 1940s and 1950s. It even had a populist manifestation – as Vivien Johnson suggests: 'Haven't Crocodile Dundee's aspirations to the status of white Aborigine, pretending to the wisdom of indigenous bushcraft, earned him a place in American box office history?'[33]

Despite its imperial overtones, the concept of the 'white Aborigine' does figure a desire for some form of reconciliation, or even a threshold beyond which difference might be reinscribed into the double genealogy of the text 'Australia'. The white Aborigine is, whatever its particular form, a hybrid figure, in Australia at least; and it is one which impacts on Aborigines as much as it does on whites. Thus, the absence of Aboriginal art in the 1984 Fifth Biennale of Sydney did not signal the decline of interest in Aboriginal art, but the difficulty of engaging with a debate which was far from resolved, and one overloaded with other agendas. Arguably, the absence of Aboriginal art was strangely present in the atmosphere of Aboriginality pervading the new-expressionism which dominated this Biennale, as it did in all such international events in

the mid-1980s. The absent presence also lurked in the director's introduction:

> all artists in this exhibition, whether they come from Europe, from former European colonies, or from countries where there has been more recent economic colonisation, either work within a tradition that has been shaped by Western art or are concerned to resuscitate and reshape characteristics of regional cultures that have been swamped by Western modernism.[34]

Evidently this theme excluded Aboriginal culture from the Biennale; not so the next one. In 1986 several Aboriginal artists conclusively proved their contemporaneity, decisively announcing, said Vivien Johnson, 'Aboriginal art's escape from the ethnographic context of natural history museums and "Primitive Art" sections of public galleries'.[35]

During the latter half of the 1980s even the most Eurocentred of Australia's critics and curators were being won over to the Aboriginal art movement. In 1986 Patrick McCaughey asserted that 'Aboriginal art was now perceived as being central and essential to the body politic of Australian art as a whole', rather than being the 'preserve of those patient and devoted souls who had sought to understand it in its time of oblivion'.[36] Indeed, it even had its 'Masters'. Sandra McGrath had already discovered the 'Picasso of Arnhem Land', and the Art Gallery of South Australia had dubbed Clifford Possum Tjapaltjarra the 'Leonardo of the desert'.[37]

The official success of Aboriginal art was cemented in 1988, largely because the Australian bicentenary year induced prolonged reflections by Australians on their identity, its past history and future possibilities. However, the gap between practice and desire remained difficult to negotiate. Nick Waterlow, the director of the 1988 Sydney Biennale, could only 'come to terms with crucial problems of [Australian] identity and creativity', by comparing non-Aboriginal Australian artists with ones from Europe and the United States. Waterlow's world view of art seemingly remained very Eurocentric, its art being the benchmark of quality. 'We must', urged Waterlow, 'learn from our history rather than repeatedly trying to rewrite it'.[38] And in accord with not rewriting it, he trotted out several European 'Masters', even Matisse and Picasso. Aboriginal art was represented by only one piece – the 200 burial poles from the Ramingining community in north-eastern Arnhem Land, curated by the then art adviser, John Mundine. It has since become a major icon of Australian art, being permanently located in the most prominent space of the National Gallery of Australia.

However, the 1988 Biennale did attempt to rethink the colonial relationship between Australian, European and United States cultures.

In the catalogue, Ian Burn argued that Australian modernism had always been in a resistant mode, and did not just reflect and confirm international (post)modernism. European and United States (post)modernists, he claimed, appropriated 'qualities … characteristic of peripheral cultures', which are then 'quoted back to us' 'in forms integrated into the practice and critical vocabulary of the centre'. He had in mind the claims of United States postmodernists for a decentred hybrid mediating art which their apostles then spread as the good 'news' when, claimed Burn, it was here in Australia, that 'complex hybrids and transgressions of "pure" styles have [long] been self-consciously developed'.[39] Here, Burn was addressing the work of non-Aboriginal Australian modernists such as Drysdale and Nolan, not Aboriginal artists.

Despite the under-representation of Aboriginal art in the 1988 Biennale (many Aborigines were reluctant to participate in official events during the bicentenary year), it was the first time that Aboriginal art was made, in the mind of the curator at least, the centre of the Biennale. Aboriginal art might have only been represented by one piece, but it was, said Waterlow, 'the single most important statement in this Biennale'. And, he continued, 'the Aboriginal presence is the most civilising and creatively challenging element in our world'. Hence, this under-representation of Aboriginal artists was less a case of tokenism than the result of not knowing how to proceed with it.

Waterlow's musing in his catalogue essay that 'it is the Aboriginal spirit which [today] nourishes our [Australian] spirit',[40] reflected widespread opinion engendered by the bicentenary, and marked a turning point in the reception of Aboriginal art in the community at large. Aboriginal art, pronounced Mundine, 'has now come of age'.[41] Daniel Thomas was equally enthusiastic, if over-simplistic: 'The Aboriginal people are reconquering the minds of their invaders, as the Greek reconquered the ancient Romans'.[42]

By the late 1980s Aboriginal art had achieved an unprecedented popularity and exposure in commercial and State public galleries, culminating in the Dreamings exhibition which opened in 1988. Significantly, Dreamings was not organised by art curators, critics, theorists or historians, but by the anthropology division of the South Australia Museum which, under Peter Sutton, effortlessly presented Aboriginal art as a continuity of traditional and contemporary practices that engaged with Aboriginal relations to land in religious, colonial and postcolonial contexts. The impact of the Dreamings exhibition and its excellent catalogue was profound. Before 1988 Aboriginal art had barely penetrated New York; by 1989 it was clear to most commentators that 'the acrylic movement [Papunya painting] has revolutionised the way we see Aboriginal art',[43] both in Australia and overseas.

However, this shift should not be exaggerated. Though real gains have been made they remain ambivalent. First, while for the first time Australia's major galleries and museums are collecting Aboriginal art, they are yet to give it the same critical attention accorded non-Aboriginal art. Aboriginal artists are yet to receive representation in contemporary survey shows commensurate with their production and influence on the Australian imagination today. Not one traditional Aboriginal acrylic or bark painter has been given a place in the Sydney Biennale since 1986. The Museum of Contemporary Art in Sydney has put together a large collection of art from Arnhem Land but Vivien Johnson observed in 1993 that it 'has yet to acknowledge the presence of Western Desert acrylic painting in contemporary Australian art'.[44] Equally, contemporary Koori artists are very under-represented. John McDonald's criticism of 1988 is a sobering analysis:

> With overseas visitors to Australia, one of the most common requests is to see the Museum of Aboriginal Art. To the best of my knowledge there is no such place. In Sydney, there is now the lurid spectacle of the Powerhouse Museum, celebrating a couple of hundred years of cultural importation and there is the Art Gallery of New South Wales, which is usually preoccupied with an overseas blockbuster exhibition ... Aboriginal art has little more than a toehold in our public institutions.[45]

Even today, no national or State Australian art gallery presents a history of Aboriginal art with the same care and depth it accords non-Aboriginal art in Australia. Yet art curators have done more than any others in the art profession to write the histories of Aboriginal art by which a new history of Australian art might be imagined.

Second, by 1990 Aboriginal artists from the Western Desert had left an indelible mark upon the Australian consciousness, but urban Aboriginal artists still remained largely invisible. Despite its groundbreaking agenda, the Dreamings exhibition did not include art by urban Aborigines, though a few examples were illustrated in the catalogue. While urban Aboriginal art had been officially baptised in 1984 in an exhibition called Koori Art '84 at Artspace in Sydney (instigated by Tim and Vivien Johnson, and defined as non-traditional styles by urban and tribal Aborigines), not until 1990 were there signs of an institutional shift towards the inclusion of urban Aboriginal artists – such as the special supplement in Art Monthly (May 1990) titled 'The emergence of urban Aboriginal art', the special issue of Artlink on 'Contemporary Aboriginal art' (Autumn 1990), which profiled many urban artists, the winning by Gordon Bennett of the prestigious Moët & Chandon Australian Art Fellowship in 1991, and the next year, the inclusion for the first time in the Sydney Biennale, of a significant number of urban Aboriginal artists.

Finally, if urban Aboriginal artists have benefited from the influx of postcolonial theory into art practice, many Aboriginal artists, along with critics from around the world, are sceptical, and see in postcolonial theory only the incorporation of Aboriginality into a postmodern neo-colonialism. 'In the name of postcolonialism', wrote Stan Anson:

> the types and categories of the metropolis are once again projected onto the periphery, only this time it is the postmodern rather than Enlightenment verities ... Postmodernism seizes on aspects of the neocolonial experience – hybridity, simulation, marginality, rootlessness – and universalises them. The entire planet is crawling with composites, mimics, borderlines and nomads.

Anson concluded: 'To deny the command structure of neocolonialism in the name of postmodern indeterminacy and postcolonial diversity is to collude with imperialism'. His solution is to reinstate the realism and nationalism of indigenous ideologies. The realism of the Australian 'black writers', concludes Anson in a prophetic note, 'may well inherit the task of demonstrating that postcolonialism, like the new world order [of Bush], is just another ideological disguise of imperialism'.[46] Similarly, Ella Shohat warned that 'post-colonial theory's celebration of hybridity risks an anti-essentialist condescension toward those [invariably Fourth World indigenous] communities obliged by circumstances to assert, for their very survival, a lost and irretrievable past' as 'a crucial contemporary site for forging a resistant collective identity'. Thus, the 'celebration of syncretism and hybridity per se ... runs the risk of appearing to sanctify the *fait accompli* of colonial violence'.[47] It is a view which has wide support amongst indigenous groups.

Paradoxically, the gains made by urban Aboriginal artists through postcolonial paradigms have been at the expense of so-called 'traditional' Aboriginal artists. Even though 'there can be few Australian artists who have more effectively tested and breached the boundaries of contemporary art practice than the contemporary acrylic painters of the Central and Western Deserts – and, lately, the bark painters of the North',[48] the explicitly postcolonial Ninth Sydney Biennale, The Boundary Rider (1992), could not accommodate art from traditional Aboriginal communities. On the other hand, if indigenous practices were neglected by the Biennale, the more postmodern practices of several urban Aboriginal artists received a showing not seen before in such events. This was only the second time that there was a substantial Aboriginal presence at the Biennale, the first time that this presence focused on urban rather than traditional Aboriginal artists, and the first time that the 'artistic strategies' of the Aborigines were 'broadly identical to those of their contemporaries from post-colonial cultures around the globe'.[49] The convergence of postmodernism and

Aboriginality was, it seemed, coming as much from the Aboriginal as non-Aboriginal side.

The internationalisation of what previously seemed the local and provincial practices of indigenous art practices is the most significant development of contemporary art practices in the 1990s. Further, theories (of postmodernism), which previously were the preserve of ivory-tower Western academics, have become irretrievably entangled in the imagining of indigenity. This has, in part, been due to shifts within the academy, which have seen the emergence of leading Third World postmodernist theorists, such as Gayatri Spivak, Homi Bhabha, Trinh Minh-ha. The result has been a profound critique of the essentialist identity politics which, until now, staged the most radical ideologies of indigenity, resulting in a rethinking of the borders which previously separated the coloniser and colonised, Aboriginal and non-Aboriginal, First and Third Worlds. While postcolonial critics such as Spivak do acknowledge the strategic usefulness of indigenist essentialism, they also warn against it. For Spivak, essentialism is always contingent on its strategic value, and hence is not essentialist.[50] The staging of identity by colonised groups, argued Spivak, must exceed the decentring of colonialism without 'leading to the sort of obsession with one's proper identity as property that is both self-duping and the oppressive power of humanism'.[51]

If many urban Aboriginal artists have adopted a postmodernist aesthetic, it has not been without problems. Probably the most contentious aesthetic strategy of postmodernism from an indigenous perspective is appropriation. It smells too much of imperialism. Even Vivien Johnson, who is generally sympathetic to the hybridity of much Koori and Western Desert art, admonished the practice of 'High Art' which 'still defiantly presses its right to stand outside the requirements of the legal system [in regard to copyright] when artistic inspiration dictates'. But, she insists, 'not the "death of the author" or any of the other metafictions with which contemporary High Art appropriators seek to rationalise the mining of Aboriginal culture for imagery ... can allay our anxiety'.[52]

Many Aboriginal artists and critics intent on defending an indigenous ideology have consistently spoken against practices of appropriation. For example, Fiona Foley accused Tim Johnson and Tillers (in particular) of 'stealing from Aboriginal culture ... they were for postmodernism – a universal thing where you can borrow from different cultures. I was questioning that whenever I got the chance'.[53] On the other hand, Gordon Bennett, an urban artist of Aboriginal descent, has made appropriation the cornerstone of his aesthetic. However, when indigenous and Third World artists have adopted postmodernist strategies, their uses of

these strategies have been generally cautious and often critical. As early as 1981 Spivak outlined why:

> French theorists such as Derrida, Lyotard, Deleuze, and the like, have at one time or another been interested in reaching out to all that is not the West, because they have, in one way or another, questioned the millennially cherished excellences of Western metaphysics ...
> ... [However] in spite of their occasional interest in touching the *other* of the West, of metaphysics, of capitalism, their repeated question is obsessively self-centred: if we are not what official history and history say we are, who then are we (not), how are we (not)?

The answer incessantly heard was that *we* were 'postmodern'. However, Spivak cautioned, it was an identity which did not escape its own 'First World' 'inbuilt colonialism toward the Third'.[54] The question of identity is doubly felt by the colonised who, already decentred by colonialism, find no solace in that which has displaced them. Thus, Spivak's answer to the question of who *she* is (not), was that she is 'postcolonial'.[55] In 1984, while in Australia for a conference on postmodernism, she described the 'postcolonial critic' as someone caught between 'East' and 'West':

> since there is now a longing once again for the pure Other of the West, we post-colonial intellectuals are told [by Western intellectuals] that we are too Western, and what goes completely unnoticed is that our turn to the West was [initially] in a response to a command ... To an extent I want to say that I am caught within the desire of the European consciousness to turn towards the East.[56]

Even though the strategies used by contemporary Aboriginal artists are so crossed-over with white discourses that they are difficult to distinguish from the other, Aboriginal and non-Aboriginal art cannot be uncritically collapsed into a shared postmodern/postcolonial discourse, as if today we are all white Aborigines. When urban Aboriginal artists, such as Gordon Bennett, Destiny Deacon, Fiona Foley, Tracey Moffatt and Rea, adopt postmodernist strategies their work remains informed by issues of indigenity in ways that Tillers' work, for example, does not. What Tillers said in 1982 remains true today: if 'Aboriginality ... is no longer the exclusive domain of "black" Aborigines', 'we do not yet [either then or now] have a *white* artist who can declare with conviction: "I am Aboriginal"'.[57] While many urban Aboriginal artists also struggle with this declaration, they live every day of their lives in the anxious space between Aboriginal and non-Aboriginal cultures, and know the incommensurable differences which 200 years of colonialism has etched into the fabric of their subjectivities. For the great majority of Australians, Aboriginal Australia remains a *terra incognita*.

CHAPTER 8

Painting for a New Republic

Australia is still a colonial culture because it remains two worlds: Aboriginal and non-Aboriginal. The accumulating generations of non-Aboriginal native-born Australians and the recent refigurings of multi-culturalism have not altered this. Nor has the ever-increasing hetero-geneity of each sphere. The policies and institutions of government, the rhetoric of officials on both sides and the more general structures of everyday life – for example, the way Australian art is bought, sold, exhibited, taught and written about – are evidence of Australia being a split economy. However, while this two-nation paradigm (henceforth called the colonial paradigm) is still dominant, it is no longer secure. Increasingly, the focus of national affairs is on reconciliation. The most interesting and difficult questions being asked today are not what goes on in the separate realms of Aboriginal and non-Aboriginal economies, but what happens between them.

If most Australians still do find a place for themselves in the colonial paradigm, an increasing number cannot. While many have always fallen between the Aboriginal and non-Aboriginal spheres, they were quickly pushed by the paradigmatic power of the binary into one or the other. This does not happen so readily these days. Gordon Bennett, for example, does not easily find a place in either Aboriginal or non-Aboriginal Australia. In finding a way of being between the two, he exceeds the binary logic of the colonial paradigm.

Growing up in the suburbs as a white Australian, the discovery at about the age of eleven of his Aboriginal heritage was a shock from which Bennett never fully recovered. It plunged him into a nether world of uncertainty and ambiguity. I am, he said (to me) half seriously, half jokingly, a Libran: destined to balance the scales, conciliate the op-posites. His life has been a quest to reconcile his suburban roots with his

once unspoken and largely invisible Aboriginal genealogy – a genealogy that, for many years, hung tenuously in the memories of his mother and a few old photographs.

Gordon Bennett's Mirror World

Colonialism is an epistemological as well as political space. The colonial paradigm empowers the non-Aboriginal sphere by giving it a voice and the Aboriginal none. The presence of the one is made from the absence of the other. Hence, for Bennett the problem is not just who is allowed to speak, but how the very structures of the language which is spoken, written and pictured in cultural practices can be undone and rearranged.

Bennett's quest to understand how language determines meaning, and in particular, the ways in which the specular codes of traditional Western knowledge in the arts and sciences obscure as much as they reveal, has primarily been within a deconstructive mode. For Bennett the mirror, the traditional device of identity-politics, came to represent this deconstructive space because, to him, it is an emblem of the way Western knowledge is organised, and also has an impressive pedigree as the metaphor of an imaginative space. If the mirror is where we inspect ourselves, the inspection is not a passive survey of the self but a dynamic means to reconstruct and imagine ourselves differently. Before the mirror we make ourselves up. Hence, the mirror is a metaphor for an imaginary space. Because the mirror image is a reversed figure, it is also often conceived as a doorway to another inverted fantastic world, an antipodes. Bennett put a mirror rather than a microscope to Australia, because the reflective surface of the mirror upturns (inverts) the generally accepted history of colonialism. Here the discourses of colonialism might be exceeded, the past and future renegotiated, and history rewritten.

While Bennett is interested in the multiple meanings that mirrors have had in Western cultures, he has been particularly drawn to the symbolic role of mirror images in the Narcissus myth. His interest was first signalled in his painting *Echo and Narcissus*, completed in July 1988, his final year at art school. Ovid's tale of Narcissus is a founding myth of Western notions of identity, and plays a prominent role in modern psychoanalytical theories. According to Ovid, many fell in love with the beautiful Narcissus, including the nymph Echo. All of them he spurned. His punishment was to fall in love with his own reflection in a clear pool. Transfixed by his own beauty, he became what he was not – a fate shared with that of Echo. Narcissus turned into a narcotic narcissus flower, while Echo, unfulfilled by her love for Narcissus, metamorphosed into the stone and rocks of the mountain, her presence only a *trace*, an echo.

More useful in reading Bennett's paintings is the interpretation of
the Narcissus story by the Roman philosopher Plotinus, and the various
uses to which this interpretation was put during the colonial period –
a time when the symbolic meaning of the mirror shifted from medieval
notions of purity and divinity, to Renaissance ideas of vanity and the
Socratic dictum, 'know thyself'. In an age fascinated with melancholy,
the story of Narcissus assumed a new significance. Plotinus believed that
our everyday life is a mirror world because it easily deludes us. Narcissus,
in mistaking himself for his own shadow, confuses beauty with truth.
Plotinus altered Ovid's version of the story. Instead of transforming into
the narcissus flower, Narcissus attempts to embrace his own shadow,
falls into the pool and drowns.[1] In the colonial period Ovid's and
Plotinus's versions are combined with Renaissance pastoral themes to
give Echo a greater prominence in the story. She is variously allegorised
as the voice of God which Narcissus fails to heed, as a well nymph who
seduces Narcissus, and as a wood nymph whose powers over nature
eventually destroy Narcissus. In 1736 the orientalist Hermann von der
Hardt interpreted the Narcissus story as an allegory of colonisation, with
Narcissus representing a new people colonising those signified by Echo.[2]

If von der Hardt's theory was ignored by later commentators, Bennett
also makes the Narcissus myth into an allegory of colonialism. As well,
he crosses it with modern psychoanalytical theories of identity. Such a
modern interpretation of Narcissus might go like this. By remaining
entrapped in the 'mirror phase' (Lacan), unable to repress his own
narcissism, Narcissus is condemned to a type of disappearance, to a
virtual drowning. Echo's fate was similar – losing her own voice and even-
tually her own body and identity, she could only repeat or echo another's
shout. Unseen, she became part of the earth, her invisible presence
evident as an uncanny echo of another. Unable to articulate her own
desires, she is reduced to mimicking the words of others. Like the
Uroborus serpents in the Aboriginal motifs along the bottom of
Bennett's painting of *Echo and Narcissus,* both are entwined in the same
circle of desire and the same genealogy. According to Robert Graves,
'Echo ... [represents] the mocking ghost of his [Narcissus's] mother'.[3]

Bennett's particular intent is inescapable. His Narcissus is transfixed
by a reflection which is Echo, as if she is a Jungian shadow of Narcissus'
desire. For Jung, not only do each of us have an *alter ego,* unconscious or
shadow which projects our fears onto others, but each society has a
collective shadow which is expressed in the mythologies of that society,
usually as grotesque forms. As with Jungian analysis, the object of
Bennett's work is not to expel these shadows, but to know them.[4]
Bennett's intent is obvious when we realise that Echo is an Aborigine and
Narcissus European.

Alternatively, *Echo and Narcissus* might be the self-portrait of a man irrevocably divided by the ideology of his upbringing and of his place; a man who is both Echo and Narcissus, Aboriginal and European. Such a split image also represents the dilemma of being an Australian. In casting the Australian coloniser as Narcissus, Bennett set the stage for a new understanding of the relationship between Aboriginal and non-Aboriginal Australians. If non-Aboriginal Australians repeat the story of Narcissus, Bennett adds a subtle twist. The reflection which they see in the mirror surface of the stream is not that of a white Briton which most Anglo-Australians have generally imagined, but a black Echo who reaches up to stroke his face. Here the mirror is a metaphor for a place of reconciliation, the waterhole becoming a place of purification, a place of dreaming, identity and law making – as it is in Aboriginal mythology. This is underscored by the use of dot painting around the edge of the pool, the reference to traditional Aboriginal mythology in the depiction of a snake which encircles the pond, and the deployment of Western Desert emblems of waterholes and meeting places in the bottom frame and top right-hand corner of the painting.

However, for Bennett the mirror is more than a specific symbol of reconciliation, of identity politics or whatever; it represents a way of thinking about and being in the world which organises or structures both colonial and postcolonial subjectivities. In the colonial period its most pervasive 'aesthetic effect' is evident in the organisation of space by perspective[5] which, on one level, is a diagrammatic representation of the narcissistic space of the mirror. When perspective was invented at the beginning of the colonial period, the mirror was instrumental in unlocking the secrets of visuality. Heinrich Schwarz reminds us that for Alberti, 'Narcissus, who saw his reflection in the water, and trembled at the beauty of his own face, was the real inventor of painting', and hence claimed that the mirror was the best means of determining the success of art. Likewise, Leonardo proclaimed: 'the mirror – above all, the mirror is our teacher'.[6] The mirror also played an important role in Brunelleschi's pioneering demonstration of perspective. However, Bennett is interested in the symbolic not scientific means of perspective which, to him, do not escape the ideological effects of its construction around the eye of the (white male) viewer. As well as constructing images, perspective, says Bennett, constructs 'histories'.[7] According to Bob Lingard and Fazal Rizvi, in Bennett's work perspective is an iconographical paradigm or visual trope of that 'linear rationality' which has ideologically framed 'colonialist discourses'.[8] Perspective is the organising principle of colonial spatiality.

When Brunelleschi held a mirror to the world, his mimicry was not a pale Platonic copy because its perspectival space, in being organised by

the gaze of the viewer, empowered his or her subjectivity. Perspectival space is, like the 'mirror', a field of 'identification, in the full sense which psychoanalysis gives to the term: namely the transformation which takes place in the subject when he assumes an image' (Lacan). For this reason, Lacan named the decisive coming into being of subjectivity, at about six months of age, the 'mirror-stage'.[9] Relating this Lacanian notion of subjectivity to colonialism, Homi Bhabha argued that mimicry, in being the theatre of otherness and the precondition of subjectivity, is a deconstructive discourse that has the potential to reconstruct a postcolonial subjectivity.[10]

Because perspective maps a mirror space, it is both the axis and Achilles heel of colonial spatiality. When the perspective lines and vanishing points that hide just below the plastic space of the painting are retraced, as Bennett does in his paintings, the ideological function of perspective is revealed. The vanishing point, simultaneously the eye of the viewer in front of the painting and the point of infinity on the pictorial horizon, marks, at the same time, the central organising point of the pictorial space and its most extreme margin. Perspective does not expel the periphery to the ends of the world, as it might seem, but brings these ends into the centre of both the picture's space and the subjectivity of the viewer.

In retracing the surface of the mirror in colonial spatiality, Bennett exceeds but does not transgress the laws of colonialism, for his strategy is to follow its laws diligently, indeed to mirror them. Here he asks the same questions as Derrida: 'How to conceive what is outside a text? ... what is other than the text of Western metaphysics?' The problem is that the other, even the Aboriginal other of colonial regimes, does not stand alone. 'Difference cannot appear as such ... There is no essence of *difference*'.[11] Because the subject 'is inscribed in language', it 'becomes a speaking subject only by making its speech conform – even in so-called "creation", or in so-called "transgression" – to the system of the rules of language' which, in Bennett's case, is the perspectival mirror language of colonialism.

Bennett refuses both the transcendental domain of the ego as it stares into the mirror, and the imaginary domain on the other side of the mirror. Instead, he inhabits the threshold between the two, a strategic location from where he can rearticulate but not withdraw from the law. His is a project of deconstruction in the strict Derridean sense of the term. 'Deconstruction', said Derrida, 'is not a movement of transgression, of liberation'. Even if, 'in a given situation',[12] it has some of these effects its subject is language, which is always in the realm of the law. Thus, Bennett is primarily interested in the dilemma of Echo: the problem of language; how can the colonised speak? The issues of identity

and power are one of language and its theatre. And this is why appropriation became, at this time, a central strategy of Bennett's aesthetic. Like Echo, Bennett can only speak through mimicry; and it is this which differentiates his articulated echoes from the narcissistic simulacra of much postmodernist appropriation.

Bennett's deconstructive turn is signalled in his use of appropriation. By the end of 1988, the year he finished art school, he had settled on what has since become a trademark of his art: the simultaneous submission of an appropriated image to both Aboriginal and Western language systems. For example, the first of such paintings, *Landscape Painting* (October 1988), juxtaposes the codes of Aboriginal and European art with an appropriated image from Hans Heysen. Heysen was the first Australian artist to make the desert an icon of non-Aboriginal Australia, yet he never showed Aborigines in this landscape. He depicted a *terra nullius*. However, like a mirror, *terra nullius* looks us back in the eye, as if the old river gums depicted by Heysen are the traces or fingerprints of the original owners which cannot be erased. Hence, Heysen's paintings, icons of Australian identity, proclaim the theft of Aboriginal land. Bennett repeated the same message in numerous paintings of the time, employing appropriated images from social studies books and Australian paintings to repicture the history of Australian colonialism as a story that never exceeds its motive of invasion and genocide.

During 1989 and 1990 Bennett's interest in the symbolic space of mirrors appeared to wane as he concentrated on postmodernist strategies of appropriation. However for Bennett appropriation was itself a mirror regime. Hence, it is not surprising that when he did consciously return to the image of the mirror in *Abstract Mirror* (1991), it was through appropriation – specifically, an appropriation of Roy Lichtenstein's *Mirror No. 6* (1971). Since then the mirror has remained a major theme in his work.

In *Mirror Line*, an installation constructed at Ian Potter Gallery (University of Melbourne) in September 1993, Bennett made the mirror the central organising symbol of the work. Facing each other on opposite walls, like mirrors to the other, were a suite of bark paintings and several nineteenth-century colonial lithographs of Australian landscapes. In front of the bark paintings stood copies of Michelangelo's *David*. Guarding the lithographs was a row of grotesque black-boy money boxes. In between, on the floor, was a grid of mirrors. The paintings and objects were displayed with such a strong narrative structure and cross-referencing that the viewer was forcibly centred around the stark binary of the colonial paradigm. The mirror's position on the floor as a line dividing the installation in half served as a hinge for the binary

displacements that occurred on many levels throughout the work. Bennett had not manufactured a postmodern simulacrum, but staged a field of deconstruction; the mirror on the floor proclaiming an inverted space in which a new subject becomes possible. Literally an illusionary well (narcissistic pool) in the ground (foundation) upon which 'Australia' (the gallery) is built, the mirror line (hinge) opens up a panorama of grotesque events (of colonialism) – what Bennett called a 'Mirrorama' of continuously unfolding reflections in which images are momentarily suspended rather than fixed in time and space. This cinema unfolds a mercurial subject to its prehistory – here, artefacts of a colonial past inserted into our living present. This is as much a recentring as decentring process. Bennett not only retained the iconic remnants of colonialist discourses (for example, the nineteenth-century lithographs), he polished them to give them their full effect, so that when he opened each to its other, juxtaposing them according to their acute binary formations, the mirror line shimmered with a third presence, a double reflection, a palimpsest of coloniser and colonised – the postcolonial subject. Put simply, Bennett's critical purpose is to recirculate repressed memories until the postcolonial subject becomes a possibility.

Throughout 1994 Bennett continued to work with appropriations from Lichtenstein's *Mirror No. 6*. However, whereas Lichtenstein's mirror is always empty, Bennett took this absence to signify what is occluded in Western art. Bennett populates his Lichtenstein mirrors with the ghosts of colonialism that look back at us. In the large monumental painting of this series, *Painting for a New Republic (the Inland Sea)* (August 1994), Bennett revisits many of his earlier themes to provide the most comprehensive statement of his aesthetic as it has developed in the previous five years.

On its most superficial level, *Painting for a New Republic (the Inland Sea)* (reproduced on the front cover of this book) mirrors the Australian flag, with the Union Jack in the top left corner and the Southern Cross in the bottom right. On a deeper level, it transposes the Australian flag into a story of colonialism. On the left side are the relics of colonialism: the British flag, memories of exploration and massacres, even a white obelisk, as if a monument to the White mythology of colonialism,[13] all of which float on a Pollock-like ground. On the other side is the spiral pattern of what appears to be the remnants of a Western Desert ground painting. The right-hand side of the painting is, in fact, taken from Georg Baselitz's painting *The Poet* (1965), also previously appropriated by Tillers. Between these two worlds is the mirror of colonialism. While the mirror is not actually depicted here, it is in earlier paintings which follow a similar structure, such as *Terra nullius (Teaching aid), as far as the eye can*

Gordon Bennett, *Terra nullius (Teaching aid), as far as the eye can see,* 1993. Acrylic. 174 by 414 cm. Private collection.

see (1993), and *Men with Weapons (Corridor)* (1994). So, as if a mirror, each side is haunted by the other.

Painting for a New Republic (the Inland Sea) also appears to have an inside and outside. The outside is the ordered world of Western reason and Enlightenment, here consisting of a mirror in which is reflected a face, a table with a book by Kant, and, in the distance, a symmetrical tree marking the vanishing point of a centred perspectival space. This outside promises a golden dawn, like the sunlit enlightenment of neo-classical republican virtue which Plato and his followers assure us is outside the cave. However, for Bennett this promise is just another mirror world. It is haunted by the inland sea, that is, by the scene of Echo and Narcissus. The haunting is exemplified by the mysterious red and yellow heads which lie like lovers at the top of the picture, each the reflection of the other. This mirror ontology is the navel of the picture; the Lichtenstein mirror being an emblem of the oval-shaped eye from which flows the mythical inland sea. The republic for which all patriotic Australians dream is made from mirrors.

If, on one level, Bennett exposes the narcissism of colonialism, on another level he appropriates its visual regimes for his own politics of identity. The metaphor of the mirror allows Bennett to implicate the one in the other without reducing one to the other. Rather than being totally separate laws, two opposed systems, non-Aboriginal and Aboriginal Australians become figures of each other, but figures in which their differences are not foreclosed in a mythology of colonialism. Here the tain of the mirror is that mesmerising frontier between absence and presence which gives the mirror its iconic power, and the images held

within their alluring palpability. The mirror is Bennett's window of opportunity by which to deconstruct the semiology of colonialism and, at the same time, refigure the differences which have sustained its power for so long. For when we look into the mirror, it looks back at us – we become caught in the gaze of the other.

Postcolonialism versus Postmodernism

Whatever his achievements, Bennett's blatant use of postmodernist aesthetic strategies, in particular appropriation and deconstruction, along with his engagement with the pre-eminent postmodernist artist, Imants Tillers (no matter how oppositional and critical this engagement might be), makes his art seem a type of postmodernism and, by inference, part of the culture of neo-colonialism that he intends to deconstruct. The outstanding success of Bennett and other urban Aboriginal artists seems to confirm this. The favourable institutional reception of so-called postcolonial art, be it Bennett's work, Western Desert Aboriginal paintings or art from the Third World, does not signify 'a fundamental rethinking' of 'founding principles' by the Eurocentric West and its institutions, but is, argues Nikos Papastergiadis, an instrumental restaging of colonialism, an aesthetic neo-colonialism.[14]

The mechanisms of this aesthetic neo-colonialism are evident in the incorporation of the tropes of postcolonialism into the projects of modernism and postmodernism. For example, in the Ninth Biennale of Sydney, *The Boundary Rider* (1992), which included the work of Bennett and other identifiably postcolonial artists, the 'border art' of postcolonialism, the avant-gardism of modernism and the decentring practices of postmodernism were deliberately conflated into that icon of colonialist frontier ideology, the boundary rider. The director of the Biennale, Anthony Bond, argued that 'recently, the image of a cultural avant-garde as an arrow pointing down a single "progressive" path towards the future has been replaced by theories of borders where conceptual territories must be constantly negotiated'. The resulting cultural hybridisations 'now being applied by artists everywhere, including within the perceived cultural centres',[15] were the common form of the new postcolonial art. However, Fay Brauer observed:

> Although hybridisation was one of the most dominant issues in this biennale, it was initially difficult to distinguish postcolonial from neocolonial strategies deployed by some artists ... The Belgium artist Wim Delvoye exhibited traffic barricades, warning lamps and wheel barrows carved like Dutch East Indian colonial furniture. Yet these objects were produced by Indonesian artisans from instructions faxed from Ghent.[16]

Bond did not mount a specifically postcolonial exhibit, but incorporated (post)modernist tropes of liminality and borders into contemporary global practices, which he then framed through the frontier metaphor of 'the boundary rider'. The metaphor is rich, and the twists it inserts into notions of Australian identity profound. Stephen Muecke pointed out in 1984 that the 'boundary rider' is the figure of pastoralism and the 'state apparatus' which dispossessed traditional Aborigines.[17] The boundary rider, with whip and gun, patrols and repairs rather than contests boundaries. With the image of the boundary rider, Bond collapses postcolonialism and postmodernism into the avant-garde ideology of aesthetic modernism, and at the same time revives the Australian legend and its frontier myth as a modernism whose continuity he traces in the postmodern and postcolonial practices of today.

Appropriately then, John Welchman's essay in the catalogue argues for the theoretical continuity of Western avant-gardism in contemporary postcolonial art. Employing Deleuze and Guattari's cosmology as a model for contemporary art, Welchman locates the 'return of understandings of the border' in a genealogy which descends directly from 'the modernist trope of the border-as-frame and the thematic of the border-contestation of the visual avant-garde'. 'Border ideas', he writes, 'have always been significant, definitional tropes or devices conditioning the development of our visual modernity'. Locating the history of Western modernism in a contest between conservative forces 'of formalist criticism' intent on 'fortifying its boundaries', and a progressive 'avant-gardism' whose 'determining concept' is 'a border that has been dissolved, transgressed, or otherwise dissipated', Welchman argues that the 'mixed genealogy of border transgression (modernist/avant-garde) is ... explicitly foregrounded in the "appropriation art" of the late 1970s and 1980s'. Today, he said:

> we are situated at the end of a third phase of avant-garde embordering. The first was configured in the transgressive unconscious of the secessionist avant-gardes of the late nineteenth and early twentieth centuries. The second was subsumed in the explicitly radical heterogeneity and deterritorialisation of the Dadaists and others in the 1910s and early 1920s. And the third was played out in the conscious transgressivism of the 1960s and 1970s in which counter-centrism, counter-aestheticism, counter-objectism (and so on) became the obsessive content of the 'expanded field' [Krauss] of visual practice.

Welchman's analysis, which argues that this 'third phase of border-busting' extends to 'feminist and non-Western re-appropriation of the power of visual enframement', so that today there is a 'crisis, not of objects, but of borders',[18] draws postcolonialism into the long Western project of avant-gardism.

While Welchman's thesis seems to confirm Papastergiadis' Marcusian pessimism, I believe that the very vigour of the recent restagings of postcolonialism by the institutions of the state is testimony to the effectiveness of postcolonial art as much as its assimilation. However, Papastergiadis' point remains, for the institutions and ideologies of modernity have a proven uncanny ability to incorporate difference; the history of modernist art being the absorption of avant-gardisms (frontier-isms), that is, the transformation of frontiers into centres. Here, borders are made sites of redemption for a centre decentred by its own inner breakdown/mutation. The mimicking of postcolonial strategies by the institutions of (post)modernism which Papastergiadis complains of, is a type of identity transformation which refuses to acknowledge its own psycho-politics, repressing it into substitute figures (white Aborigines, boundary riders) which have become all too familiar in the assimi-lationist policies of the post-war Australian governments. Hence, Papastergiadis is ultimately right to insist on the differences between the (post)modernist ideology of contemporary Western institutions and the ambitions of the decolonised.

Nevertheless, the institutional reception of colonial art as a type of (post)modernism is not to be conflated with the actual practices of all postcolonial artists and critics (and Papastergiadis does not do this). While both First World postmodern and Third World postcolonial critics generally start from the premise of a crisis in Western power which hinges on a politics of difference, their analysis has been quite dif-ferent. Postcolonial critics join postmodern theory to an historical view which situates the so-called crisis of the West and of modernism within colonial history. In this history, postmodernist practices are not the aesthetic manifestation of late-capitalism or an historical reaction against modernism, but follow in the wake of colonialism. For example, Ashis Nandy believed that it was in the colonies that the nineteenth-century dream of a benign universal humanism, since transformed into the nightmare of 'a fully homogenised' postmodern world, 'was first tried out' – its emissaries the 'hard working, middle-class missionaries, liberals, modernists, and believers in science, equality and progress'. It was not the initial bandits of capital who, though they 'robbed, maimed and killed', were the most effective colonists, but the liberal middle-class modernists. According to Nandy, they colonised bodies as well as minds, releasing 'forces within the colonised societies to alter their cultural priorities once and for all', and transforming the colonial process 'from a geographical and temporal entity to a psychological category'. Further, it was a colonisation which 'survived the demise of empires'. 'The West', wrote Nandy, 'is now everywhere, within the West and outside it; in structures and in minds'.[19] Following much the same line of argument,

the Australian postcolonial critics, Bill Ashcroft, Gareth Griffiths and Helen Tiffin, observed that 'the impetus towards decentring and pluralism ... in post-structuralism ... are implicit in post-colonial texts from the imperial period to the present day'.[20]

To understand the specificity of the postcolonial art of urban Aboriginal artists such as Bennett, the differences between it and the border aesthetics of modernism and particularly postmodernism need to be vigorously pursued. In Bennett's case, it must be emphasised that if his work refuses the essentialist positions generally associated with identity politics and, in easily sliding across boundaries, provides few assurances, it is still pre-eminently about negotiating a subject position, an identity. Thus, Bennett spoke approvingly of the 'passion for identification' being 'a central issue'.[21] His is an aesthetic of production, not negation or simulacrum.

Bennett's quest to negotiate a subjectivity from within difference marks his artworks as exemplary icons of reconciliation. No matter how much Bennett has been influenced by postmodernism, the context of his work in the aesthetic practices of colonised peoples seeking more centred lives needs to be emphasised. Postmodernism is a legacy of the disillusionment and disenchantment with the redemption promised by the historical project of Enlightenment and progress. Bennett, too, is sceptical of such redemptive histories. For example, if he is fond of representing history by the redemptive figure of an angel, it is a black angel which lives outside the guarantees of God's realm. Nevertheless, Bennett pictures an angelic space, a space of mediation between two worlds – in fact, one world split by the history of colonialism. In *Contemplation* (1993), Bennett's black angel pays homage to Malevich's mysterious black square – which for Bennett is emblematic of the black absence repressed in white mythology.[22] The mediation Bennett seeks is within a divided subject, and not, as has been usual in non-Aboriginal Australian culture, between a fallen Australia and a European origin. Australia is traditionally regarded, by imperial critics at least, as a place without culture, a cemetery. Australian postmodernist artists such as Tillers continue this tradition, viewing Australia as a land of reproductions, of second-hand images. Tillers called Australia 'The Island of the Dead', its discourses matching 'the dot-screen of mechanical reproduction' which, he says, is also 'a form of death', 'like disembodied souls ... waiting to be reborn'. Thus, for Tillers, 'Australia' is beyond history. If Bennett has some sympathy for Tillers' diagnosis, he contests his prognosis, especially since Tillers' paintings and writings often address issues of Aboriginality and identity (if only to disavow both), and have, in the process, become contemporary icons of Australian art.

Tillers pictures an Australia, and indeed a world, without a centre; an homogenised world where everything is, as in death, 'equivalent, inter-changeable, scale-less and surface-less'.[23] Here all subjects are colonised – appropriated beings without a centre. In *The Recentred Self* (1994), an appropriation of Tillers' *The Decentred Self* (1985), Bennett proposes an optimistic 'healing' of the colonised mind. Instead of Tillers' grey world is one of colour; and instead of Tillers' white decentred body is a black hand reaching out. The healing, said Bennett, is exemplified by the black angel, who loosely refers to the 'recentring' engendered by the 'Aboriginal Renaissance'.[24] Four years earlier, in 1990, in his first depiction of black angels, he had painted *Resurrection (Bloom)*, in which two black cupids remove the arrows from their chest underneath the blooming of a giant yellow flower/sun of the Aboriginal flag. However, typical of Bennett's deconstructive rather than redemptive mode, the recentring remains a promise, a distant vision, perhaps a mirage.

Bennett's difference with postmodernism is most apparent in the strategic aims of his appropriations. If he uses appropriation as a strategy to deconstruct the history of colonialism, he also uses it as a means of refiguring his identity. Postmodernist appropriation is primarily a tactic which breaks codes of representation so that all identities are reduced to a commodity, or fetishistic objects of exchange. Philip Brophy, for example, characterised the postmodern subject articulated by Maria Kozic as 'a sensibility of *being lost* inside the terrain of mass images'. Her 'desire', said Brophy, was not to address 'something in her subject matter' but to '*become* it'. 'To use this kind of imagery, you have to lose your identity.'[25] Bennett's dilemma is very different. Already lost, already a fetishised object, his intent is to re-enter or reclaim his history.

Bennett's art alerts us to what should be an obvious point: post-modernism does not hold a copyright on appropriation. Not only was collage and appropriation liberally used in the syncretic cultures of colonised peoples well before it found a place in Western art, but there is an essential strategic difference between syncretic and postmodernist appropriations. Postmodernists aim to decentre the subject, in particular those subjects which have been centred by the binaries of modernism. However, in the syncretic traditions of the colonised these binaries are already collapsed and subject positions already decentred. Bennett commented on his own experience:

> I was socialised to believe that the [Eurocentric] 'I' ... included me, totally. When I discovered my Aboriginal descent I first denied it and repressed it. When the repression became unbearable, and that was a true decentring, not a matter of 'failed locality' [Tillers] but almost of my entire system of belief – I mean a psychic rupturing.[26]

In the diaspora of the colonised, appropriation is an everyday means of survival which helps centre, not decentre subject positions. Here, appropriation is literally a means of pasting together an identity, of manufacturing a symbolic realm. Paul Carter argues that in 'post-colonial' societies 'collage is the *normal* mode of constructing meaning', and it is a collage in which fragments are seized upon 'not "at the expense of the whole" but in its absence'.[27] If European modernist collage was a means of subverting eloquent (complete) discourses, postcolonial collage is a means of 'constructing meaning' from within loss. Bennett's appropriations might seem close to a postmodern aesthetic, but they are closer to what the Caribbean writer Wilson Harris called the 'cross-cultural imagination'.[28]

Bennett is not the only Australian artist picturing a postcolonial subject in terms of a cross-cultural imagination. For example, Tracey Moffatt, of the same generation as Bennett, also proposes a postcolonial palimpsest of past and present in her filmic and photographic essays. Her films consistently juxtapose the present with the past in ways which do not redeem or essentialise Aboriginality. As different as Bennett's and Moffatt's art is, they each problematise essentialist notions of Aboriginal and non-Aboriginal identities in order to make a new cross-cultural space, and even home. In Moffatt's films and photographs, this is realised within the *frisson* she creates by heightening the artificiality of her art. The theatricality of her work, for example, the tense gaps between soundtrack and image in the opening sequence of *Night Cries – A Rural Tragedy* (1989), map a hybrid space in which a trace, or something more than is immediately apparent, is impressed upon the viewer. Like Bennett, her frequent appropriations are always a means of exceeding a dominant semiology to make other hybrid histories. To achieve this, she combines an eye for Australiana with a narrative structure interrupted by memories dredged from a shared cultural heritage. In *Nice Coloured Girls*, text from William Bradley's journal *A Voyage to New South Wales*, is historically re-engaged and recontextualised into contemporary history rather than merely appropriated or reified (dehistoricised) from its original context. If here fate undergoes Chaplinesque twists, in *Night Cries* it assumes more tragic proportions when an adopted Aborigine finds a strange tortuous alliance with her dying white foster-mother. Set against a highly stylised Namatjira-like background, and with references to Chauvel's 1950s film *Jedda*, it articulates a genealogy for contemporary Aboriginality in the Aboriginalism of the mid-twentieth century. The same issues are addressed in more comic fashion in the three-part *Bedevil* (1993), in which 'Australia' emerges as a quintessentially bedevilled place – haunted not just with Aboriginal ghosts, but by the complexity and multiculturalism of its history.

Living, like all of us, in a postmodern world, Bennett finds himself in an endlessly repeating mirrorama rather than gazing out the panoramic window of essentialist identities. In a similar fashion, Moffatt displaces the clear vistas of essentialist ideologies with flaring memories, ghosts, histories. Like the swamp haunted by the ghost of a United States soldier in *Bedevil*, they ooze and bubble beneath the pristine screen of her cinema. Instead of losing themselves in the discursive practices erupting around them, Bennett and Moffatt each fashion an echoing voice of reflected otherednesses, creating an Australia of multi-centred identities which is something more than its constitutive parts. In some respects, this is an effect of the broken mirror which they hold up to our narcissistic desires. Its reflections are fractured, but vague outlines can be discerned. Bennett and Moffatt hold up the broken mirror of coloniality to show that the other is there, that 'she' is looking at us, and that we are all implicated in 'her' gaze. In this respect, their experiences as Aboriginal Australians are exemplary Australian ones, except that what Aborigines have suffered as a naked oppression non-Aboriginal Australians have experienced as an entrancing repression. From this conundrum Bennett and Moffatt negotiate a type of convergence which, like the proverbial train-tracks in perspective diagrams, only meet in the mind and the distance. However, this distant point, the eye of the other, holds us firmly in its gaze.

The Wandering Islands[1]

Sir John Kirwan, conservative politician, friend of Empire and admirer of Benito Mussolini, described Australia in 1934 as a 'great empty land – one of the last of the world's fertile spaces that remain to be filled'. His metaphor of emptiness belied his enormous fascination with every aspect of the life and geography of outback Australia, including its Aboriginal inhabitants. However, he regarded Aborigines as 'a Stone Age people. We and they, as people, are far apart. The mystery of the dead past ages is about them'.[2] This goes some way towards explaining why so many books about Australia that were published in the mid-twentieth century included phrases in their titles such as an Empty Land, a Dead Heart, a Timeless Land. Because they enclose both Aborigines and the land in the same metaphors of entropy, the place is acknowledged as being both Aboriginal land and a *terra nullius*. This contradiction is due to speaking about an other who is in 'our' midst, and about an other place that is also 'our' place – a metaphysical *difference* which structures Australian cultural identity.

Metaphysical difference is not a political relation between centre and periphery, but an internal relation – what Theodor Adorno called the 'non-identical' that 'my thought is driven to it by its own inevitable insufficiency', its own exclusions, limits and contradictions.[3] No culture or individual is single or complete in itself; each is broken and run through with internal differences and repressed histories. In other words, cultures behave like individuals. They have an unconscious; their identity is structured like a language and regulated by the self-effacing work of the uncanny – what Derrida called the 'radical trembling' of the other. Derrida named this 'ef-*face*ment' in Western cultures, a 'white mythology'. It is a mythology because, while reassembling and reflecting 'the culture of the West', it simultaneously represses its origin in 'the

violent relationship of the whole of the West to its other'.[4] In Derrida's
words, white mythology erases 'within itself the fabulous scene that has
produced it, the scene that nevertheless remains [like the uncanny]
active and stirring, inscribed in white ink, an invisible design'. Hence
'difference cannot appear as such';[5] it is the ghost in the text – just as the
Empty Land and the Dark Continent are not actual sites but the
reverberations of otherness in Western thought.

No matter how often and how insistently Western texts figure the other
in external, or more exactly, foreign forms, such as an exotic landscape,
a noble or ignoble savage, it is the product of an interior effacement
which can be recovered, even if only in vague lines. This recovery, the
project of postcolonial art and criticism, has all the hallmarks of an
Oedipal drama. Australia is a young nation which, despite every effort,
cannot efface its origins. Australia's nationhood is not staged by the first
settlement in 1788, or even by Federation, or by a revolution of independ-
ence that might have graduated it into the republican age of modernity,
but by the invasion of the cradle of classical civilisation in which Aus-
tralians suffered severe losses and the empire a crushing defeat. Gallipoli
has taken on such significance because it was a classic tragedy to which
Australia was propelled as if by some strange fate. Its significance lies not
on the shores of the Agean but in colonial ideology. At last Australian
colonials could demonstrate, as Donald Macdonald hoped after
returning from the Boer War (as a correspondent), that 'the patriotism
and pride of race ... has made Australasia a fighting unit of the British
Empire'.[6] In short, the father was appeased.

The Australian hunger for redemption and constant worry about
identity suggests a failed or incomplete Oedipal scene that is charac-
teristic of migrant communities. In settler societies it is even worse. Not
only is the subject far from home, but the indigenous culture which
might offer shelter is made abject, the non-identical, and hence is des-
troyed yet preserved (repressed) in the psyche of the nation. In Australia
this sense of loss was further compounded by its convict origins. The free
settlers who came to Australia had to fit into a local culture which was
founded by slaves. Psychoanalytically, the slave is stolen from the Oedipal
circle. If, like the migrant, the slave is plunged into a type of exile, not all
exiles are equal. Kristeva, an expatriate from eastern Europe living in
Paris, saw her exile as 'a form of dissidence' and as a way of both escaping
and surviving the law of the father.[7] Her exile was like the salvation
sought by the puritans and other religious communities who migrated to
America. However, redemption in the convict colony of Australia was
never this straightforward.

Considered from a long rather than short perspective, the plan for
Botany Bay is the culmination of England's long association with slavery.

In ancient times England was a type of Africa, exporting her own people as slaves to Mediterranean societies. The practice continued in the post-Roman period. Jack Lindsay reminds us that 'in the dark ages ecclesiastics took part in the slave trade', and that a 'large exportation of slaves from Bristol went on', with slaves being 'bred for the market like cattle'. 'In the seventeenth century many thousands of Irish, men, women and children, were sold under Government licence for slaves in the West Indies'.[8] So too were Africans. Thus, in more modern times, the African slave and the British convict are each psychically the same figure. Indeed, in the nineteenth century transported convicts were commonly known as 'slaves', and the Abolitionists successfully fought for both the end of slavery and transportation. Likewise, it is not surprising that Hegel defined the slave as being like a prisoner – a person deprived of freedom or identity. Further, he recognised that Africa was itself the sign of the slave – even though most Africans were not slaves. 'The only essential connection that has existed between the Negroes and the Europeans', said Hegel, 'is that of slavery'. 'Bad as this may be', 'their lot in their own land is even worse, since there slavery quite as absolutely exists; for it is the essential principle of slavery, that man has not yet attained a consciousness of his freedom, and consequently sinks down to a mere Thing – an object of no value'.

The reason seemed obvious then: 'the Negro ... exhibits the natural man in his completely wild and untamed state'. Hence, Hegel called Africa the space of the 'Unhistorical', 'the land of childhood' 'shut up' from the 'rest of the World', 'for it is no historical part of the World, it has no movement or development to exhibit' except that which properly belongs to 'the Asiatic or European World'. Here 'Africa' is figured as an abject fatherless geography 'still involved in the condition of mere nature'. Lying beyond the day of self-conscious history, [it] is enveloped in the dark mantle of night.' Indeed, for Hegel, Africa's abjectness was due to its geography – an interior isolated by mountain ranges and 'a girdle of marsh land with the most luxuriant vegetation, the especial home of ravenous beasts, snakes of all kinds – a border tract whose atmosphere is poisonous to Europeans'. Its people mirrored its spatial or natural history. 'Cannibalism', 'tyranny', injustice, immorality and 'carnage' are, said Hegel, commonplace. He cited stories of a kingdom of female 'furies ... driven to constant plunder'. It was ruled by a murderous Queen who 'had the blood of pounded children at hand', and had 'driven away or put to death all the males, and commanded the death of all male children'.[9]

Africa was not another country with which to exchange goods, it was not even imagined in terms of a centre/periphery model; rather, it was the other of Europe, the non-identical: 'that which limits it [Europe],

and from which it derives its essence, its definition, its production'.[10] Thus, to eighteenth-century English law-makers, Africa seemed the 'natural' destiny for its own wasted offspring, especially when the revolt in the American colonies, along with a growing demand for prison reform, put great pressure on the Pitt government to find a new dumping ground. 'The convicts could go out "in Slave ships which could then proceed up the coast in pursuit of their usual traffic"'. In 1785 Gambia was considered but ruled out. A ship was sent to survey the 'Caffire' coast of (east) Africa, but that too was abandoned.[11] 'Botany Bay', the final option when all else had failed, was a substitute 'Africa'.

Further, the convict question taxed English minds at the same time as did that of the recently emancipated African slaves in England. Due to an unexpected court ruling in 1772, the 14 000 black slaves in Britain had been freed. The decision for the 'Botany Bay' adventure was made at the same time as it was decided to transport Britain's ex-slaves to a colony along the Sierre Leone coast (Africa).[12] With the help of the British government, transportation began in 1787 – the same year that Phillip departed as commander of the First Fleet. By 1792, the year that Phillip returned from his successful mission to expel the worst elements of Britain's criminal class to New South Wales, Britain had also lanced its 'Black Poor'.

Convicts, slavery and 'Africa' were such adjacent tropes in the eighteenth-century English mind that, at the time, they were one figure. Thus, the sizeable proportion of Afro-American convicts transported to Australia was not commented on at the time because then it seemed only natural that these former slaves would be present – or that convicts would be intermingled with blacks.[13] After all, 'Australia' and 'Africa' were each the arse end of the world. Well into the twentieth century Africa was depicted as a deep dark interior laced with intestinal rivers coursing to their anus: the 'monster mouth of the Congo, yawning seven miles wide, and vomiting its dirty contents into the blue Atlantic'; Africa the great despoiler, where 'all things European degenerate ... European provisions go bad, European fruits, European dogs degenerate. So, too, European men and women'.[14] It should, then, be no surprise that even Tasmania's benevolent climes would be Africanised when made the site of Britain's most notorious prisons. John Mitchel, the educated Irish political prisoner who escaped from Tasmania in 1853, found the 'affable' and 'mild-mannered' (white) Tasmanians to have 'the same languor that is said to characterise all the Creole races of America and the West Indies – that soft, luxurious, voluptuous languor which becomes girls rather than men.'[15] With this metaphor, which includes in its field notions of colonialism, race, decadence and gender, Mitchel defined the colonial subject as one which is deprived of its place and subjecthood.

The key phrase is 'girls rather than men', for as Luce Irigaray argues, the feminine is experienced as space, but often with connotations of 'abyss and night'; it 'lacks: a "proper" place.'[16] In a word, it is 'Africa'.

Today this 'lack' has become an excess which makes possible the postcolonial subject. The move was first made in existentialist texts by Frantz Fanon and Jean-Paul Sartre – though contemporary postcolonial critics generally follow the lead of post-Lacanian theorisations of the feminine subject. Feminine spatiality, argues Irigaray, is 'the pre-sentiment of the first dwelling place'. Elizabeth Grosz names it the ground of ground, 'the space in which place is made possible'. Kristeva characterises it as an abject site which returns the subject to 'the foundations of the symbolic construct' – a space so 'archaic' and a-symbolic (without language) that it is a 'border' rather than a place. She diagnoses abjection as the inhabitation of an other in the body of the subject: 'I experience abjection only if an Other has settled in place and stead of what will be "me" ... an Other who precedes and possesses me, and through such possession causes me to be'.[17]

Australia has seemed such a 'natural' site of the abject that it has shaped irrevocably both the Australian subject and the Australian sense of place in the eyes of the British colonisers, the anti-colonial Australian nationalists and more recent postcolonial critics. To the eighteenth- and the nineteenth-century British governments, wrote Robert Hughes, 'Australia's eventual fate as a community of free citizens mattered infinitely less than its expedient role as England's sewer'. Australia was, said the Abolitionist-controlled Molesworth Committee's (1838) inquiry into 'the System of Transportation, its Efficacy as a Punishment, Its Influence on the Moral State of Society in the Penal Colonies ...', a 'Sodom and Gomorrah'.[18] Closer to home, women novelists such as Barbara Baynton, Henry Handel Richardson and Katharine Susannah Prichard located the Australian abject in the feminine. If, as Kay Schaffer remarked, their novels 'depict the land as an enduring, maternal presence',[19] this presence was conceived in terms of the abject. In 1917 Richardson described the Australian land as 'lying stretched like some primeval monster in the sun, her breasts freely bared, she watched, with a malignant eye, the efforts made by these puny mortals to tear their lips away'.[20]

In the mid-twentieth century Marjorie Barnard and Manning Clark used similar tropes in their historiographies. Barnard, who believed the Australian landscape to be sublime 'perfection' 'with no provision for man', described its spatiality and the story of colonialism with implicit gendered and sexual metaphors:

> When a man wandered into the bush it closed over him like water and he was lost in its vast anonymity ... He needed all the force of civilisation to break his

way through the mysterious resistance of a continent, and having conquered,
it he has had to be conquered by it to make the new world of white Australia.[21]

Manning Clark was more explicit. Australian mateship, he said, was the
strut of conquerors and adventurers, not lovers; it represented the
ideology of 'the queer relationship between [white] man and earth in
Australia', which 'treated her like a harlot, frenziedly raped her ... no
wonder his conscience was uneasy, no wonder he was restless'. 'So', he
concluded, we 'must ask the dreadful question: do we belong here?'[22]
The 'horrid howl' of 'aboriginal women' 'on first seeing the white man at
Botany Bay in April 1770' was, he believed, a 'howl [that] contained in it
a prophecy of doom'. This spectre of the phallic mother produced a
chilling castrating thought: the Australian continent, 'on which man so
far had scarcely scratched his presence, had,' he wrote, 'a strength of its
own with which to adapt itself to the invader'.[23] If the Aborigines had not
repelled the invaders, the land would.

Clark's historiography has been very influential on Australian critics.
For example, Graeme Turner argued (1986) that representations of
nature in Australian literature and film, provided a metaphysical
compensation for the loss of exile by naturalising a 'grim and static view
of the powerlessness of the individual within the Australian context'. The
pre-eminent landscape tradition in Australian culture is, then, 'an alibi
for impotence' – a view which more or less reiterates Clark's view. Turner
conjectured that Australia's convict origins 'inhibited the development
of a consoling mythology', and compared the pessimism of Australian
fiction to the 'enabling' myths of United States narratives, which are 'a
mission of hope' designed 'to escape from the perceived inequalities of
life in Europe'. By contrast, Australia's myths are an 'ordeal of exile' that
'accommodates us [Australians] to the inevitability of subjection'. They
are 'arrested at a "pre-existential moment" ', halting 'just before the
feeling of absurdity, without fully accepting it'. 'Instead of responding to
an existential vision' ... , the narratives tend to admit defeat. Our
fictional heroes often have to be destroyed because there is nothing else
for them.[24]

Postcolonial critics generally see in Clark's diagnosis an end-game
which might exceed the limits of Western subjectivity and its colonial-
isms. Against Hegel's African dystopia, they posit the abjection of
colonial spatiality as utopic. For example, Joan Kirkby welcomes the
abject, arguing that it makes possible 'the first authentic step in the
[re]constitution of the self'.[25] Drawing an affinity between the terrain of
colonialism and Kristeva's psychoanalytical understanding of abjection,
Kirkby praises the turn of the century Australian writer, Barbara Baynton,

for 'confronting the abject' and thus 'preparing the ground for what Kristeva refers to as "the first great demystification of Power (religious, moral, political, verbal) that mankind has ever witnessed"'.[26] In a different fashion, but to a similar effect, Ross Gibson diagnosed positive signs in the 'sublime structural void' and 'homelessness' of Australian texts that were akin to postmodern identities – even if the indigenous are made migrants in their own home.

> Australian artists are adept at this 'postmodernism' precisely because such 'mongrel aesthetics' derive from the survival strategies developed in colonial dominions wherein all 'matter' found at the site of exile must be *acculturated*, or rendered meaningful and useful. In this respect, white Australian culture has always been 'wildstyle'; it exists because of its ability to redefine and work whatever it finds to be nature.[27]

An example he gives is cruising through the suburbs of Sydney, where cultural differences collapse at such a rate that home becomes the diaspora:

> across the Spanish strip of southern Liverpool Street and through a large and expanding Chinatown ... up to Leichhardt and Sydney's largest Italian community ... into Newtown – traditionally Greek, Lebanese, and Anglo-Saxon proletarian, but more recently under the newer influences of three-tiered Vietnamese families and yuppie refurbishment ... down Newtown's fabled King Street ... and to Redfern, where the most visible people ... are Koori ... and on to the Princes Highway.

Here, where the open plains have given way to 'Falcons parked outside Fijian supermarkets run by Indian retailers',[28] the road movie of frontierism has a new hero: Mad Max screaming 'wild style' down the highway,[29] not in alienation but as if at home in his oblivion. It provides, observed Gibson, 'one of the most enduring local myths: that of the transcendent failure'.[30]

Notions of an abject space not secured by empire resound in post-colonial picturings of Australia because such a space seems a perversion of imperial values through which the subject can both evade and exceed the empire. Thus, even today Australia remains a fabulous rather than real place – something it has been in the European imagination since ancient times. Its current master mythographer is Paul Carter – hence the appropriateness of the oxymoron name that he gave to his task of uncovering the pre-history of place in Australia, 'spatial history', as if here an emptiness existed where time can be folded back and the culture of the place, its words and pictures, returned to an original plenitude.

Paul Carter's Migrantology

Carter's accounts of imperialism do not round up the usual suspects –
triumphant explorers, heroic settlers, colonial terrorists of indigenous
populations – because his concern is neither that of celebrating the
coming of 'civilisation' or admonishing it for its colonial barbarisms.
Rather, he wants to make from the irrevocable terror of colonialism a
new future, a redemption. 'If nothing from the events of first contact can
be redeemed, what cultural genealogy will our historians invoke to
explain their own ambiguity? ... to fail to recognise that first contact is not
simply a preliminary to invasion and massacre but contains within it
antithetical possibilities.'31

Carter's subject is the 'psychic' rather than historical occupation of the
country. Like many contemporary postcolonial critics, he reads the myth-
ography of colonialism as emblems of desire, and not as lies to justify
conquest. However, Carter does not analyse its libidinous impulses,32 but
outlines its structures of repetition and deferral in which he glimpses 'a
mode of being in the world'33 – a mode that necessarily embraces
strategies of translation, collage and hybridity, and is anti-imperial. More
recently, Carter approvingly cited Edward Said's notions of 'travelling
theory' and 'contrapuntal perspectives' which, claimed Carter:

> subverts cultural imperialism without retreating into the other fundamental-
> ism of 'difference'. It is out of an oscillation between positions and
> perspectives that contemporary, post-colonial cultures must weave the fabric
> of their identity; anything less than the 'counter-energy' of a consciously
> hybridising 'internationalism' condemns us to recapitulate the disastrous
> 'them and us' demonologies of imperialism.34

The metaphor Carter favours is that of echoing (*echos*) which, to him,
structures the 'chiaroscuro' of space. If his notion of Echos recalls the
myth of Narcissus, Carter rewrites it from the perspective of Echo: 'Echos
is not to be understood as a degradation of the original. For echos takes
in what we call the primordial world, as it sounds and swells, all about us
and within us'.35 He suggests that 'the migrant's new world is, like Echo,
heard not seen'.36 Second, he distinguishes between the echos of the
'first journey', and the narcissism of the settlers who followed. The
travelling narratives of the '*first journey*', said Carter, 'occupied a pre-
visual realm, one in which ... lookouts (the *sine qua non* of picturesque
touring) had still to be found',37 and in which, therefore, the explorer
remained 'rooted phenomenologically in our most primitive sensations
of earth and water and of their common heritage in the wind-filled sky'.
The gift of exploration is that it, momentarily at least, restores the pre-
eminence of the ground over ideology, of the earth over the world, of

space over place, of nature over language. Thus, the 'essence' of Cook's 'texts', wrote Carter, 'was that they did not sum up a journey, but preserved the trace of passage'; 'the sense in which places are means, not of settling, but of travelling on'. 'Cook's un-cumulative, un-centred maps and travelling journal retained the possibility of multiple futures, endless journeys, arrivals and departures.' Not only did Cook's *first journey* inaugurate 'Australia's spatial history', it stands 'at odds with the aims of imperialism'.[38]

The way to avoid the reaffirmation of colonialism in contemporary practices, Carter argues, is to reconceive the very concept of ground 'in ways that avoid the usual Western associations of foundedness, stasis and origin'.[39] Carter yearns for a non-phallic order which he envisages as a return to the sort of primordial existential truths that Kristeva theorises in the abject, and Irigaray in the sex that is not one. This is, he argues, most evident during what he calls the 'first journey' of exploration and in moment of first contact, when the failures of the explorers to satisfy their singular imperial desires resulted in crossing-overs, deferrals and repetitions which momentarily stop the semiotic of Empire. 'Far from marking a neurotic retreat from life and its pleasurable dangers', exploration is, argues Carter, 'both a source of pleasure and a means of getting on ... The explorer sublimates his desire of arrival and finds satisfaction in the certainty of disappointent ... here travelling itself is the assurance of satisfaction'.[40] He concludes:

> The world of exploration is characterised by a return to an earlier state ... Its dangers represent a way of avoiding that deviation into adult responsibility. The true danger that confronts the explorer lies in the false 'home' of social life: his psychic ambition is to come home by another route or, better, to defer homecoming as long as possible.[41]

On the other hand, the scientific instruments used by the surveyors and settlers plot and fence the contours of this originary space in order to make it a home, as if the earth was a mirror to their own narcissism. Carter contrasts the first journeys of the explorers Cook, Eyre and Sturt, who confined themselves to a 'metaphorically constituted track', with that of Mitchell, whose survey was a 'strategy of invasion' by which Australia was made the object of imperial desire. Mitchell's survey renders 'the country habitable' – a 'grander project which distinguished the surveyor from the explorer and which justified Mitchell in taking his historical role so seriously'. The prospect of the survey locked the country in a trigonometric grip so that 'history could not be distinguished from geography', nor science from conquest.[42] Mitchell's triangulations provided more than an innocent survey of the land; they staged the

triangular rule of Oedipus, the triumph of language over nature, and the
art of landscape and civilisation in colonial places such as Australia.

Carter's prime concern is the relationship between colonial language
and the landscape it describes. In his first book, *The Road to Botany Bay*
(1987), Carter showed that the origin of spatial history is naming. Since
then he has increasingly become interested in the breakdown of
language, and the failure of narrative conventions to represent Aus-
tralian space, to make it into a place. The major themes of his work are
the folding of first contact experiences into language, and the unfolding
and fracturing of European language systems at the frontier. Hence, he
is less interested in the aesthetics of settlement, taking it for granted that
their picturesque representations in colonial art provided this place of
an other with a ready-made English unconscious that possessed the
country for England:

> The agents of that conceptual transformation [of colonialism] are not only
> the surveyors and road-gangs despatched to measure and clear, but the artists
> and poets who attempt to see and gloss what the rulers have in mind. To paint
> a colonial landscape of smiling fields, of hazed hill heads and glinting brooks
> was not to represent the lie of the land but to articulate the logic of a cultural
> dream and its spatial *mise-en-scène*.[43]

For this reason Carter returns to precolonial moments before the
artists of high art have woven their tales of place, to resurrect a spatial
history which, he believes, has been repressed into the unconscious of
colonial representations. These 'first' moments, which exhibit the
ambivalent structures of the unconscious, momentarily articulate the
voice of the other. An example he gives is Sir George Grey's 'discovery' of
Aboriginal Wandjina paintings in 1837. Surprised by monstrous heads
'staring grimly down at me'[44] which unsettled his sense of place, Grey
quickly transforms them into more familiar images, effectively colonising
the space of these former Gods. 'At first', writes Carter, 'Grey is the
observed, not the observer ... What follows [in Grey's journal] is in effect
a narrative of Grey's neutralisation and assimilation of their gaze to his
own point of view' – but one in which the unsettling experience of the
other looking back is not entirely evaded. According to Carter, this
process is one of projection in which a double, with all its uncanny
attributes, displaces former ghosts with new ones. While he admits that
Grey's double was as likely a 'mimic puppet of his own ideological pro-
jection', Carter is interested in what he calls the 'performative' potential
of such encounters to dissolve 'the unified viewpoint' of European
ideologies. The 'theatrical' projection of European ideology in the
colonies is not just the one-way street of an imperial gesture, but in its
structure returns, however momentarily, to the uncanny field of the

unconscious, to 'the blindness at the heart of our culture's tradition of seeing'.[45] This return, argues Carter, is a return to the rudiments of spatiality, not the artifice of place and culture. Thus, he argues, the fragmentary, doubled anti-narratives of explorer texts, like 'anastomos-ing narratives that fan out inconclusively as they proceed, ... strangely resemble the country they describe'.

Using the same metaphors favoured by Irigaray and Kristeva, Carter revels in the ways that Australian explorers sail 'from absence to absence without ever reaching home'. 'Advancing against the tide of narrative logic', their journals reveal 'the nostalgia for a more primitive state at the heart of the civilising process'.[46] Carter especially privileges those explorers' texts in which language, unable to describe the land, falters. Here Australian myths of place become a shifting ground, a drifting 'mirror world' where 'there is no beyond, no interior', and 'no origin-ating place or time ... when the world, was, as it were, named naturally'.[47] Despite his wish to deconstruct colonial spatiality, Carter is curiously prone to repeating its tropes of an Empty Timeless Land in his post-colonial imagining of Australia. This is particularly evident in his dis-cussions of 'postcolonial collage' – by which he means the stilted exchanges and mimicries of migrants and first contact experiences. According to Carter, they enact a radical Rousseauean subversion of language that returns us to a 'latent' 'deeper poetics' that he believes are 'suppressed' 'within the ritualised performances of language'. Post-colonial collage is an ur-language which 'refuses to lie down and become a semiotic system ... Instead it disrupts the linear exchange of ideas, insisting on the confusion of sound, the independent logic or illogic of purely phonetic contrasts and coincidences'.[48]

Carter's claims parallel the strategy of feminine discovery and libera-tion outlined by Irigaray: '*What remains to be done, then, is to work at "destroy-ing" the discursive mechanism* ... [through] *mimicry*'. Irigaray considered mimicry a type of feminine language which exceeded 'masculine logic' by making 'visible', through 'playful repetition, what was supposed to remain invisible: the cover-up of a possible operation of the feminine in language'. Like Carter, Irigaray insisted that mimics are not simply 'resorbed in this function', as if they lack their own egos and pleasures; '*they also remain elsewhere*' – what Irigaray called the ' *"elsewhere" of female pleasure*'. In this respect, mimicry was a means of enacting a 'playful crossing, and an unsettling one, which would allow woman to rediscover the place of her "self-affection". Of her "god"'.[49]

While Carter acknowledges that his 'attempt to give mimicry a respectable meaning' can be counted as the 'achievement of a post-colonial identity', like Irigaray, his ambition has wider horizons than the 'historical or political'. 'In the end', he argues, his aesthetic 'implies a

poetics' which, in turn, 'implies the world we would like to inhabit' –
what he describes as 'a post-colonial history on grounds other than those
of ideology'.[50]

Any assessment of Carter's migrantology must ask if its claims of
redemption do exceed the ideology of colonialism, and indeed, as
Carter claims, all ideology? While Carter is strong on phenomenology,
he is weak on history. If, on the one hand, he welcomes colonialism's
migratory habits, its vigorous going out into the world, on the other
hand, he complains about its ideological closures which act as a brake on
this movement. The 'first journey' of exploration which he believes
opens up a non-ideological space is, despite his disclaimers, also invari-
ably the first historical step towards the ideological closures of colonis-
ation he so regrets. Further, his desire for a non-ideological space, in
effect a paradise in which one can be reborn, is an old and familiar one.
Perhaps it irrevocably marks his texts as Western. Dante's image of an
antipodean Eden seems to have forever motivated the imagining of
exploration and colonialism as acts of redemption. Carter continues this
hunt for an ideology-free ground in the blind gropings of first contact.
Carter's utopianism is motivated by the Heideggerean notion that the
world is never completely objectified, never completely made into mat-
ter. 'Even as man seeks to rise higher and higher', writes Irigaray, 'so the
ground fractures more and more beneath his feet. "Nature" is forever
dodging his projects of representation, of reproduction. And his grasp'.[51]
Carter too has this faith, his aim being to forestall the objectifying gaze of
the coloniser by returning to the threshold between the coloniser and his
other, to those 'first' moments when the land and its inhabitants looked
back:

> Our carefully enclosed and ornamented places, with their artillery of hedges,
> views, roads, boundaries and horizons, grow out of the sacrifice of the ground
> and are, in this sense, non places ...
> Let the ground rise up to resist us, let it prove porous, spongy, irregular –
> let it assert its native title, its right to maintain its traditional surfaces'.[52]

Compare this to Irigaray: 'If the earth turned and especially turned upon
itself, the erection of the subject might ... risk losing its elevation and
penetration. For what would there be to rise up from and exercise his
power over?'[53]

Carter's metaphors of sacrifice and salvation, freedom and denial,
delivered within a morality which favours touch and aurality over sight,
movement over stasis, revelation over memory, is, I suggest, a type of
spirituality. His prescription for salvation is leaving home, for then we are
plunged into a foreign environment which diminishes the aura of
ideology, leaving us with no choice but to move on, to mimic our new

environment, to touch it intimately, as when we make our way in darkness. The epistemology which Carter seeks is conceived as an alternative 'to the Western identification of truth with visual representations', and one which can map 'the ontological possibilities of an interior which has no outside – the kind of world inhabited, say, by the blind'.[54] In particular, Carter's notion of a spatiality made from 'the duality of being', and 'as an oscillation, a contract across difference',[55] recalls Irigaray's concept of the 'fecund caress', 'where crossing the threshold is ... an entrance into another, more secret, space ... where the gaze is still innocent of the limits set by reason ...' Such 'abandon', said Irigaray, 'is inspired by the most absolute trust in the transcendence of life'. What Gayatri Spivak said of Irigaray is also true of Carter: it is 'not just philosophical or literary talk, but Christian talk, of incarnation'.[56]

Carter's writings show how deeply utopianism and imperialism are entwined. His 'pre-semiotic' realm, which remembers the maternal sojourn that precedes all discourse, what Freud characterised as 'pre-Oedipus',[57] also enacts the originary desire of imperialism. Here the mother's body is an 'uninscribed territory', a *terra nullius* which, said Spivak, the 'imperialist project' had to imagine in order to fulfil its desire to inscribe, map, possess.[58] When Carter elevates the epistemologies of exploration and first contact to a spiritual dimension, he forgets that they are the first necessary step of colonisation. No matter how stuttering their beginnings, they begin the rubbing out of ideology, in fact, of indigenous ideologies, in order to provide a blank sheet on which the colonial powers reinscribe their mythologies. The value of Carter's work is to show that this sheet is never blank, that it is a palimpsest which speaks back. However, for Carter, it is invariably the land, and not the indigenous populations, that speak back.[59] In this way he finds an innocence which, like the surrealists' dream-states, offers the redemption of a free unconscious, a new beginning without the memory of colonial wars and the guilt of our generations. The explorer narratives, suggests Carter, 'lack an unconscious', and 'offer a way of avoiding deviation into adult responsibility'.[60] However, in Freud's scheme, they exhibit all the characteristics of the unconscious: they plot the repressions of the father's rule. As the pre-texts of empire, they were its psychic foundation, not its undoing.

The danger of diagnosing Australia as a sublime space is that it replays rather than transforms imperialism; for, on one level, it merely confirms age-old European views of Australia as the Antipodes. Indeed, it might be argued that Carter's project comes close to reinvesting in the Victorian and Edwardian ethic of empire which sought to rejuvenate tired Englishmen through imperial adventures. This begs the question: do Carter's redemptive politics escape the imperial imperative, or do they

merely refashion the late Victorian and Edwardian penchant for ripping yarns into a Kiplingesque salvation?[61] While ripping yarn has the potential to be a classic Carteresque metaphor, Carter does not, of course, write ripping yarns. His frontiers are elsewhere, and he prefers a slower meditative life to the melodrama of boys' own adventures. His sensibility is more like that of Adrian Stokes who, in Venice, found a salvation in the aesthetic contemplation of light, water and melting stones, in the 'richness of an identity in difference, images of interchange, of transformation and of metamorphosis' which recall 'the feats of Giorgione', and act as a 'potent symbol of the mother'.[62] No wonder Carter found in Stokes' writings evidence that 'living in a new country refers less to a place than to the manner of arriving there' – quite literally, said Carter, 'a second birth' via 'another birth canal, the Mont Cenis tunnel'. The desire to preserve or repeat this rebirthing, argued Carter, resulted in Stokes' championing of Venetian art against 'Florentine grace'. 'It may be that there is a connection between Venetian art, unfinished, asymmetrical, its perspectives reversed so as to confront the contingencies of life in the historical world, and life in a new world, where the novelty is abiding and habits remain improvised, provisional and superficial.'[63] 'Venice' is itself a metaphor for journey, always having 'been a point of departure and arrival', the West's gateway to the East, and 'the historical queen of those "wine-dark seas" that the Greeks crossed a thousand years before the winged lion of St Mark alighted on its lagoon'.[64] However, Carter sought 'Venice', not in Italy, 'a world where names belong, where words are washed clean and restored to their original place in the world', but in 'new countries in which entry depends on giving up one's former name and tongue and where the light does not illuminate the countryside but specifies its emptiness, its lack of names'.[65] Carter idealises this condition of emptiness and namelessness into a way of being, a migrantology. His 'migrant poetics' not only generalises the experience of migration, and conflates exploration and the Grand Tour with migration, like the ripping yarn, it mistakes the complex anthropology of making a new home for a diasporic spiritualism. Both can be classed as a travelling pharmacopoeia for melancholy souls.

What Carter finds redemptive in 'first contact' is not the voice and face of the indigenous other, but the free empty space that imperial explorers so often presume their first journeys uncover. Carter wants to retain the alterity of a free space as an empowering site for an individual's spirituality rather than as a place of social contract between others. Indeed, Carter's writing is peripatetic.[66] It is grounded in a phenomenology which walks about in a *terra nullius*, or at least in an imaginary land whose inhabitants have either not imposed their rule on it, or their

former rule has long since been foreclosed by new travellers. Indeed, his work remains more in the mould of phenomenology than feminism. Whereas the threshold about which Irigaray's feminine subjecthood is located in the internal 'circumvolutions upon herself', upon 'this sex which is not one', Carter's threshold is between himself and an other. His is not Irigaray's feminine subject which is in itself 'restless and unstable ... never exactly the same', but a masculine subjectivity which must make this difference by going out into the world. Exploration and imperialism are the mechanisms of masculine subjectivity. Hence, argues Irigaray, 'Man moves away in order to preserve his stake in the value of his representation'. Although Carter desires a transcendence which culture or language cannot secure, his migrantology repeats the masculine quest for subjecthood that requires an other 'upon which', writes Irigaray, 'he will ever and again return to plant his foot in order to spring farther, leap higher'. This other, which Carter locates in the (feminine) earth itself, is 'a benchmark that is ultimately more crucial than the subject, for he [the masculine subject] can sustain himself only by bouncing back off some objectiveness, some objective.[67] Hence, Carter cannot find satisfaction in the plurality of his own divided self, but must continuously move on to ever new thresholds.

Carter's return to the intrauterine meanderings of the first journey is not a rejection of the father's home but a regressive refusal to face its law. He seeks a respite from an Imperium Oedipus by evading the trap of language and returning to the open ground, where, without the dictatorship of the unconscious, the world is without order, a space not a place. Thus, Carter does not seek a new father in the land itself. The beat to which he walks is not an amplitude sounding from the land, but the rhythm of his own footsteps. Carter does not simplistically replace the symbology of language with the stuff of dirt and rock. He rejects the view that 'it is the country ... which slowly produced the nomadism of the Aboriginal peoples'. The ironic subtext to his title, the *lie* of the land, suggests that it is not the land which interests him but his phenomenological relationship with it. The value of Carter's phenomenology depends largely on the ways in which he occupies these border zones, what he called the 'quality' of 'travelling'.[68] However, the land remains the other to which he surrenders.

Carter's cure is radical. In turning away from 'the distorting mirror of the parental gaze',[69] he comes dangerously close to staging the nativism he disclaims. His arabesques may elude the vocabulary of colonialism and come at 'Australia' from new angles, but the rhythms he composes do not escape the nostalgia of colonial melancholy. There is no guarantee that Cook's more arabesque scenography is less logocentric than the linear specular regime of Mitchell's imperial gaze. They each

participated in the same imperial endeavour. The baroque sensibility which Carter champions was, after all, the invention of an imperial age. In the end, Carter's nostalgia for 'a form of emplacement', for 'a mode of being at home in the world' does not teach us how to settle. Because Carter's prescription of always moving on only delays settlement, his cure is an ever-retreating mirage in the middle-distance.

Carter has not faced up to the ideological and historical import of spatial historiography being a symptom of a colonised mind. To invoke migrantology as a pre-semiotic space enacts the desire for another Oceania, for the foreclosure of European texts which always animated the most radical of nativist texts. Worse, he risks what Alain Corbin called 'psychological anachronism'. If Carter fulfils Corbin's recipe for avoiding such anachronisms – 'map the boundaries of what the mind can imagine, identify the mechanisms driving new emotions, trace the origins of desires and the way in which suffering or pleasure was experienced at a given time, describe habitus, and reconstitute logic behind systems of vision and evaluation'[70] – in mythologising rather than historicising the coenaesthetic pleasures of encounters with the landscape, Carter's 'pre-semiotic' 'spatial history' inadvertently reproduces the 'Australia' which it deconstructs.

Carter's mapping of the structure of migrant texts provides a framework for analysing Australian art. However, this structure needs to be more finely tuned to the specific historical and ideological conditions of colonialism in Australia. While colonialism is a type of migration, it is a particularly extreme kind. Here the ambivalent emotion of the migrant engendered by the difficulties of translating one place to another is amplified by the particular psychoanalytical content of colonisation – to the extent that a successful translation of one culture into another seems impossible. Leaving one modern community for another, in Carter's case flying from England to Australia, is a relatively straightforward task compared to colonisation which, in its oceanic baptism, effaces the dialogical space that nurtures translation.

Like many Australians before him, Carter discovered in Australia an oceanic space without bearings. His taking to it like a fish to water, like a *flâneur* of the bush lapping up its redemptive and medicinal powers, is, ironically, also the very cause of the anxiety felt by so many non-Aboriginal Australians. Australians, it seems, are condemned to wandering, to a perpetual walkabout, of not arriving. In his poem 'The Traveller', John Thompson asked the perennial Australian question which has no answer, 'Is it now true that I am home in Australia?' The question has no answer because, for these Australians, their home is nowhere, unless it is the timeless, disorganised and fragmented space of a dream, the grotesque space of the abject.

Hot rock-knuckles amid this breathless bracken
Jut to the light that glints unwinkingly
From every slack leaf, every crook and jag
Of silvery deadwood. Glare, not colour, hangs
Like Gauze around me, irregularly scrawled
Grey-green and umber, with abrupt interruptions
Of blackness: I can feel the heat in my guts,
The light in my bones. But it is very strange
Not to be still in Venice ...[71]

'This is', Thompson wrote, 'the naked and aboriginal feel/of Nobody's Land'.

So how does an Australian make his or her subjecthood in the presence of the father's refusal? Claude Lévasque, writing from Quebec about a similar problem, observes that:

Several Quebecois poets ... have tirelessly and tragically stated their distance from the maternal tongue, their nomadism and discomfort in the language. Others have gone so far as to deny the very presence of a maternal tongue, as if the Quebecois writer (as well as the Quebecois people themselves) spoke ... only from a position of exile in a foreign language that is irreducibly other ... as if they spoke only out of ... [the] emptiness of a translation language. Thus ... the Quebecois continues to cherish a nostalgia for a language that is his, a properly Quebecois language, a maternal tongue that will refashion an identity for him and reappropriate him to himself.

While Lévasque believes that there is 'a chance: the possibility ... of reinventing language as if from the beginning', he admits that it remains 'a dream of fusion with the figure of the mother'[72] – that is, an Oedipal dream under the spell of the father. This perhaps, is the real significance of Gallipoli. The submission to the father was the action of a hopeful prodigal son. It was a submission repeated again in Vietnam; but no fatted calves were prepared. Perhaps this sacrifice without victory in faraway places was, in its very defeat, a kind of liberation from the imperial father. If so, Gallipoli *is* a founding event, a birth, because in its very submission it inaugurated an undoing, a deconstruction of empire from which a new cultural order might be made. Yuri Lotman has provided a way of theorising border wars (though for Australians the unanswerable question of where the borders are, is as anxious as it is perennial), arguing that the conflicts, exchanges and often violent wars which occur at the borders of cultural systems 'inevitably lead to cultural equalisation and to the creation of a new semiosphere [or cultural order] of more elevated order in which both parties can be included as equals'.[73]

In describing the history of Australian painting in terms of such exchanges, I too am inevitably driven by an Hegelian hope for redemption, for an elevated order based on cultural equalisation and reconciliation.

However, the story I have told teaches a more Adornoesque lesson in which redemption is forever stalled as one imperial semiosphere refuses to give ground. Here there has been a failure of 'the dialogical situation' necessary for the success of Lotman's project. Such failure, which Lotman saw as running through Russian history, results from the lack of 'mutual attraction' between the two sides.[74] This persistent failure was not a total loss. While the Australian colonists resisted any mutual exchange with the indigenous populations, they were at the same time caught in a situation where their psychic constitution depended upon such exchange. If this is the lesson of the history of Australian art – that is all it is. Like most lessons, little seems to be learned. The same mistakes, which are born of refusals not ignorance, are being repeated with increasing regularity. Hope vanishes like a mirage, as if we are determined to accept our inheritance from Europe as the Antipodes. This is the real lesson of Australian art, for in it, we hear as A. D. Hope heard '... in the huge monotonous voices/of wave and wind: "The Rescue will not take place".

Notes

1 Ocean and the Antipodes

1 James S. Romm, *The Edges of the Earth in Ancient Thought*, Princeton University Press, Princeton, 1992, p. 12.

2 Ibid., p. 17.

3 'Plato was the first writer whom we know to have thought seriously about the worlds beyond the *oikoumene*, though there is every evidence that here, as elsewhere, he owes much to the Pythagoreans' (Romm, p. 124).

4 Yuri Lotman, *The Universe of the Mind: A semiotic theory of culture*, trans. Ann Shukman, I. B. Tauris, London, 1990, p. 131; p. 140.

5 See Romm, pp. 1–23.

6 Luce Irigaray, *An Ethics of Sexual Difference*, trans. Carolyn Burke and Gillian C. Gill, Athlone Press, London, 1993, p. 215; Jacques Derrida, *Margins of Philosophy*, trans. Alan Bass, Harvester Wheatsheaf, New York, 1982, p. 134.

7 Irigaray, *An Ethics of Sexual Difference*, p. 185.

8 See Romm, pp. 160–70; pp. 181–2.

9 As Christos G. Doumas described the Aegean sea in 'Aegean Thalassocracy', Giovanni Pugliese Curratelli (ed.), *The Western Greeks*, Bompiani, Venezia, 1996, p. 25.

10 Quoted in William Eisler, *The Furthest Shore: Images of Terra Australis from the Middle Ages to Captain Cook*, Cambridge University Press, Cambridge, 1995, p. 15.

11 Romm, p. 222.

12 Quoted in Glyndwr Williams and Alan Frost, '*Terra Australis*: Theory and speculation' in Glyndwr Williams and Alan Frost (eds), *Terra Australis to Australia*, Oxford University Press, Melbourne, 1988, p. 13.

13 See Bernard Smith, *European Vision and the South Pacific*, Oxford University Press, Oxford, 1960.

14 Jean Baudrillard, *America*, trans. Chris Turner, Verso, London, 1988, p. 82; p. 125; pp. 76–7; p. 71.

15 Edward Colless, 'At the edge of the world', *Art and Australia*, 30, 4, Winter 1993, p. 462.

16 Robert Hughes, *The Fatal Shore: A history of the transportation of convicts to Australia 1787–1868*, Pan Books, London, 1988, p. 1.

17 A. Dalrymple, 'Objections to Botany Bay', C. M. H. Clark (ed.), *Select Documents in Australian History, 1788–1850*, Angus & Robertson, Sydney, 1966, p. 38.
18 See C. M. H. Clark, *A History of Australia*, vol. 1, Melbourne University Press, Carlton, 1962, p. 71.
19 Peter Cunningham, *Two Years in New South Wales*, vol. 2, 2nd edn, Henry Colburn, London, 1827, p. 48, p. 47.
20 See Sigmund Freud, *Civilisation and its Discontents*, trans. Joan Riviere, rev. and ed. James Stratchey, Hogarth Press, London, 1979, pp. 1–10.
21 Elizabeth Grosz, *Volatile Bodies: Toward a corporeal feminism*, Allen & Unwin, Sydney, 1994, p. 104.
22 'Phillip's views on the conduct of the expedition. 1787', Clark (ed.), *Select Documents*, p. 42.
23 Charles Darwin, 29 January 1836, *Journal of Reserches into the Natural History and Geology of the Countries visited during the Voyage of H.M.S. Beagle round the World*, 2nd edn, John Murray, London, 1845, pp. 445–6.
24 'England', wrote Ross Gibson, 'simply *is*, in contrast to the colonial society, which *becomes*' (*South of the West: Postcolonialism and the narrative construction of Australia*, Indiana University Press, Bloomington, 1992, p. 65).
25 See Jacques Derrida, *Points Interviews, 1974–1994*, ed. Elisabeth Weber, trans. Peggy Kamuf and others, Stanford University Press, Stanford, 1995, pp. 339–41.
26 Sandy Nairne, 'European fusion', *Frieze*, 11, Summer 1993, p. 20.
27 Michel Foucault, *The Order of Things: An archeology of the human sciences*, Vintage Books, New York, 1973, pp. 304–7.
28 Lotman, pp. 136–42.
29 See Paul Carter, *The Road to Botany Bay*, Faber & Faber, London, 1987, p. 309.
30 Ibid., pp. 317, 319, 309, 320.
31 Charles Barrett, *Coast of Adventure*, Robertson & Mullens, Melbourne, 1946, pp. 13–14.
32 Arnold Wood, *The Discovery of Australia*, Macmillan, London, 1922, pp. 1–2.
33 J. W. Johnson, 'The utopian impulse and southern lands', Ian Donaldson (ed.), *Australia and the European Imagination*, Humanities Research Centre, Australian National University, Canberra, 1982, pp. 43–4.
34 See Frank E. and Fritzie P. Manuel, *Utopian Thought in the Western World*, Belknap Press, Cambridge, 1979, pp. 83–5.
35 Ibid., pp. 83–4.
36 See Romm, pp. 127–34.
37 Neither Megasthenes who first reported people with inverted feet (towards the end of the fourth century BC), nor Pliny who reported Megasthenes' discovery (in the first century AD), named them the Antipodes: on 'the mountain named Nulus' are people with 'their feet turned backwards', and with 'eight toes on each foot' (*aversis plantis octonos digitos*) (*Natural History*, VII, 2, 23); and in 'a certain large valley in the Himalayas' 'are many people who have their feet turned backward behind their legs (*homines aversis post crura plantis*) (*Natural History*, VII, 1, 11).
38 See E. H. Bunbury, *A History of Ancient Geography*, vol. 1, John Murray, London, 1879, pp. 123–4.
39 See Romm, pp. 45–81.
40 Quoted in Romm, p. 128.
41 'Of the false wisdom of philosophers', *Works of Lactantius*, vol. 1, trans. William Fletcher, T. & T. Clark, Edinburgh, 1871, p. 196. There is no

conclusive evidence that Lactantius invented the term. For an alternative explanation, see Romm, pp. 124–33.

42 Rudolf Wittkower, 'Marvels of the East: a study in the history of monsters', *Journal of the Warburg and Courtauld Institutes*, 5, 1942, p. 182.
43 However, he was not sure if they existed, or if they did, that they were human – that is, descendants of Adam (Augustine, *City of God*, 16, 8 pp. 531–2).
44 See Romm, p. 131.
45 Hayden White, *Tropics of Discourse: Essays in Cultural Criticism*, Johns Hopkins University Press, Baltimore, 1978, p. 173.
46 See Ruth Cowhig, 'Blacks in English Renaissance drama and the role of Shakespeare's *Othello*' in Advise Dabydeen (ed.), *The Black Presence in English Literature*, Manchester University Press, Manchester, 1985, p. 8.
47 All of which Helen Gardner invokes in her short study, *The Noble Moor*, Oxford University Press, Oxford, 1955.
48 See Albert Gerard, ' "Egregiously an Ass": the dark side of the moor. A view of Othello's mind' in Kenneth Muir and Philip Edwards (eds), *Aspects of Othello*, Cambridge University Press, Cambridge, 1977, pp. 12–20.
49 Cowhig in Dabydeen (ed.), p. 12.
50 Ian Donaldson, *The World Upside-Down: Comedy from Jonson to Fielding*, Clarendon Press, Oxford, 1970, p. 51, see also pp. 14–16; p. 81.
51 See May McKisack, *The Fourteenth Century, 1307–1399*, Clarendon Press, Oxford, 1959, p. 487.
52 See Pieter Spierenburg, 'The body and the State: early modern Europe' in Norval Morris and David J. Rothman (eds), *The Oxford History of the Prison*, Oxford University Press, Oxford, 1995, pp. 62, 64.
53 See Michael R. Weisser, *Crime and Punishment in Early Modern Europe*, Harvester Press, Hassocks, 1979, p. 63.
54 See Spierenburg in Morris and Rothman (eds), pp. 64–7.
55 See Weisser, pp. 100–5.
56 See William Andrews, *Bygone Punishments*, William Andrews, London, 1899, p. 210.
57 Marjorie Barnard, *A History of Australia*, Angus & Robertson, Sydney, 1978, p. 207.
58 Spierenburg in Morris and Rothman (eds), p. 76.
59 See A. G. L. Shaw, *Convicts and the Colonies*, Faber & Faber, London, 1966, p. 25; Spierenburg in Morris and Rothman (eds), p. 76.
60 See John Bender, *Imagining the Penitentiary: Fiction and the Architecture of Mind in Eighteenth-Century England*, University of Chicago Press, Chicago, 1987, p. 26.
61 Daniel Defoe, *Moll Flanders*, Penguin Books, Harmondsworth, 1982, pp. 258–9.
62 Ibid., pp. 28–32.
63 See John Hirst, 'The Australian experience: the convict colony' in Morris and Rothman (eds), pp. 263–74.

2 Artful Killings

1 Hughes, *The Fatal Shore*, p. 127; p. 108.
2 John Black, 'King George commands – and we obey over the hills and far away. The New South Wales Corps 1789–1810: a reassessment', BASA conference paper, University of Stirling, Stirling, 1996.
3 Quoted in Hughes, *The Fatal Shore*, p. 281.

4 See White, *Tropics of Discourse*, p. 1.
5 See Julia Kristeva, *Black Sun: Depression and Melancholia*, trans. Leon S. Roudiez, Columbia University Press, New York, 1989, pp. 3–10.
6 Smith, *European Vision*, p. 172; p. 176.
7 See Jurgis Baltrusaitis, *Aberrations*, trans. Richard Miller, MIT Press, Cambridge, 1989, p. 5.
8 Hayden White, 'Foucault decoded: notes from underground', *History and Theory*, 12, 1, 1973, p. 48.
9 I owe this observation to Nicholas Thomas.
10 See Raymond Klibansky, Erwin Panofsky and Fritz Saxl, *Saturn and Melancholy*, Nelson, London, 1964.
11 Friedrich Nietzsche, 'The birth of tragedy', *Basic Writings of Nietzsche*, trans. Walter Kaufmann, Modern Library, New York, 1968, pp. 43–6.
12 Klibansky *et al.*, pp. 312, 333.
13 Jack Lindsay, *A Short History of Culture from Prehistory to the Renaissance*, Studio Books, London, 1962, p. 381.
14 Louis Martin, 'The frontiers of Utopia' in Krishan Kumar and Stephen Bann (eds), *Utopias and the Millennium*, Reaktion Books, 1993, pp. 7–16.
15 Richard Burton, *The Anatomy of Melancholy*, ed. T. Faulkner, N. Kiessling and R. Blair, Clarendon Press, Oxford, 1989, p. 7.
16 Ibid., pp. 74–86.
17 *The Damoiselle* (1637), quoted in Martin Butler, *Theatre and Crisis, 1632–1642*, Cambridge University Press, Cambridge, 1984, p. 211.
18 Burton, p. 81.
19 Quoted in Shaw, *Convicts and Colonies*, p. 49.
20 Clark, *A History of Australia*, vol. 1, p. 84.
21 See Smith, *European Vision*, p. 1.
22 Smith, *European Vision*, p. 58.
23 Ibid., pp. 42–3.
24 I owe this observation to Jane Stewart from the University of Stirling.
25 Alexis de Tocqueville, *Journey to America*, trans. George Lawrence, Anchor Books, New York, 1971, pp. 377–8; pp. 398–9.
26 Smith, *European Vision*, p. 120.
27 Bernard Smith, *Imagining the Pacific in the Wake of the Cook Voyages*, Melbourne University Press, Carlton, 1992, p. 132.
28 Kirk Varnedoe, 'Gauguin', William Rubin (ed.), *Primitivism in Twentieth Century Art: Affinity of the Tribal and the Modern*, vol. 1, Museum of Modern Art, New York, 1984, p. 189. Varnedoe was quoting Smith, *European Vision*, p. 31.
29 David Collins, *An Account of the English Colony in New South Wales*, T. Cadell Jun. and W. Davies, 1798, London, vol. 1, January 1788, p. 5.
30 Thomas Watling, 'Letters from an Exile at Botany-Bay to his Aunt in Dumfries …', quoted in Ross Gibson, 'This prison this language: Thomas Watling's *Letters from an Exile at Botany Bay* (1794)', in Paul Foss (ed.), *Island in the Stream: Myths of Place in Australian Culture*, Pluto Press, Leichhardt, 1988, pp. 11–12.
31 Ibid., p. 8.
32 Ibid., pp. 4, 28.
33 Ibid. pp. 11, 13.
34 Ibid., p. 10.
35 Collins, p. 4 (January 1788); p. 69 f (May 1789).
36 Watkin Tench, *A Complete Account of the Settlement at Port Jackson in New South Wales*, G. Nicol, London, 1793, p. 160.

37 Cited in Keith Willey, *When the Sky Fell Down*, Collins, Sydney, 1979, p. 214.
38 John West, *The History of Tasmania*, vol. 1, Henry Dowling, Launceston, 1852, p. 32.
39 Bartolomé de Las Casas, *A Short Account of the Destruction of the Indies*, trans. Nigel Griffin, Penguin Books, Harmondsworth, 1992, p. 6.
40 West, pp. 95–6.
41 Ibid., p. 35.
42 Rosario Assunto, 'Monstrous and imaginary subjects' in Massimo Pallottino (ed. in chief), *World Encyclopedia of Art*, vol. 10, McGraw–Hill, New York, 1972, p. 264.
43 Harold Osborne (ed.), *The Oxford Companion to Art*, Oxford University Press, Oxford, 1970, p. 516.
44 Indeed, in the eighteenth century the grotesque paraded as a self-conscious redemptive discourse in the guise of the sublime.
45 See Geoffrey Harpham, 'The grotesque: first principles', *Journal of Aesthetics and Art Criticism*, 34, 4, Summer 1976, p. 465.
46 Cunningham, vol. 2, pp. 39–40.
47 Wolfgang Kayser, *The Grotesque in Art and Literature*, trans. Ulrich Weisstein, Indiana University Press, Bloomington, 1963, p. 188.
48 Mikhail Bakhtin, *Rabelais and his World*, trans. Helene Iswolsky, Indiana University Press, Bloomington, 1988, p. 91.
49 Candice Bruce and Anita Callaway, '"Dancing in the dark": black corroboree or white spectacle?', *Australian Journal of Art*, IX, 1991, pp. 84–5.
50 Cunningham, vol. 2, pp. 16–17.
51 Ibid., p. 8.
52 See Cunningham, vol. 1, pp. 41–2.
53 Jean-Paul Sartre, 'Introduction' in Frantz Fanon, *Wretched of the Earth*, trans. Constance Farrington, Penguin Books, Harmondsworth, (1961) 1973, p. 22.
54 Quoted in Ross Gibson, *The Diminishing Paradise: Changing Literary Perceptions of Australia*, Sirius Books, Sydney, 1984, p. 148.
55 Anthony Trollope, *Australia*, ed. O. D. Edwards and R. B. Joyce, University of Queensland Press, St Lucia, 1967, pp. 100, 103, 107, 113.
56 Quoted in Paul Hasluck, *Black Australians: A Survey of Native Policy in Western Australia, 1829–1897*, 2nd edn, Melbourne University Press, Carlton, 1970, p. 52.
57 James Bonwick, *The Last Tasmanians*, Sampson Low, Son and Marston, London, 1870, p. 99.
58 *Sydney Gazette*, 19 May 1805, quoted in Willey, p. 167.
59 Quoted in Willey, p. 164.
60 See Bonwick, p. 92; p. 94.
61 Bonwick, p. 217.

3 The Art of Settlement

1 Robert Dixon, *The Course of Empire and Neo-classical Culture in New South Wales, 1788–1860*, Oxford University Press, Melbourne, 1986, p. 25.
2 Hirst in Morris and Rothman (eds), *The Oxford History of the Prison*, p. 268.
3 Coral Lansbury, *Arcady in Australia: The Evocation of Australia in Nineteenth-Century English Literature*, Melbourne University Press, Carlton, 1970, p. 43.
4 Nigel Everet, *The Tory View of Landscape*, Yale University Press, New Haven, 1994.
5 See Baltrusaitis, *Aberrations*, pp. 142–58.

6 Ibid., p. 147.
7 See Gordon Bull, 'Taking place: panorama and panopticon in the colonis-
 ation of New South Wales', *Australian Journal of Art*, 12, 1994–5, pp. 75–95.
8 See Dixon, *The Course of Empire*, pp. 51–3.
9 Ibid., p. 93.
10 Quoted by Dixon, *The Course of Empire*, p. 97.
11 Major T. L. Mitchell, *Three Expeditions into the Interior of Eastern Australia*,
 2nd edn, vol. 1, T. & W. Boone, London, 1839, p. 126.
12 Dixon, *The Course of Empire*, p. 114.
13 Mitchell, vol. 1, p. 303.
14 Illustrated in Mitchell, vol. 1, pp. 262 and 155 respectively.
15 Ibid., vol. 1, p. 1.
16 Ibid., vol. 2, p. 171.
17 See Tim Bonyhady, *Images in Opposition: Australian Landscape Painting
 1801–1890*, Oxford University Press, Melbourne, 1985, pp. 30–4.
18 Glover's copies of Price's books are now held in the Queen Victoria Museum
 and Art Gallery, Launceston.
19 Smith, *European Vision*, p. 199.
20 Of the sixty-eight paintings exhibited by Glover in London in June 1835,
 sixty-three were painted in Tasmania. Of these twenty-three were English
 and European scenes painted from his sketchbooks, six were depic-
 tions of Tasmanian natives, and the rest were of Tasmanian scenes (see
 John McPhee, *The Art of John Glover*, Macmillan, South Melbourne, 1980,
 pp. 32–5).
21 Robert Hughes, *Art of Australia*, Penguin, Harmondsworth, 1970, pp. 41–2.
22 Bonyhady, p. 47.
23 Baltrusaitis, p. 175.
24 As John McPhee did (McPhee, p. 35).
25 Smith, *European Vision*, p. 201.
26 Hughes, *Art of Australia*, p. 42.
27 Bonyhady, p. 30.
28 See Baltrusaitis, pp. 33–55.
29 Quoted in Albert Boime, *The Magisterial Gaze: Manifest Destiny and American
 Landscape Painting c. 1830–1865*, Smithsonian Institute Press, Washington,
 1991, p. 7.
30 Stephen Daniels, *Fields of Vision*, Polity Press, Cambridge, 1993, p. 146.
31 Letter from Sturt to George Macleay, A4099, July 1845, quoted in Stephen
 Martin, *A New Land: European Perceptions of Australia, 1788–1850*, Allen &
 Unwin, Sydney, 1993, p. 43.
32 Gail Ching-Liang Low, 'White skins/black masks: the pleasures and politics
 of imperialism', *New Formations*, 9, Winter 1989, p. 91.
33 See J. P. R. Wallis, *Thomas Baines: His Life and Explorations in South Africa,
 Rhodesia and Australia*, A. A. Balkema, Cape Town, 1976, pp. 1–3.
34 See Georg W. F. Hegel, *The Philosophy of History*, trans. J. Sibree, Dover
 Publications, New York, 1956, pp. 93–9.
35 Quoted by Robert Dixon, *Writing the Colonial Adventure*, Cambridge University
 Press, Cambridge, 1995, p. 4.
36 Letter to Margaret Burne-Jones, 1886, quoted in Low, pp. 93–4.
37 Eric Hobsbawn and Terence Ranger (eds), *The Invention of Tradition*,
 Cambridge University Press, Cambridge, (1983) 1996, p. 226.
38 See Bruce and Callaway, '"Dancing in the dark": black corroboree or white
 spectacle?', pp. 86–90.

39 See Dixon, *Writing the Colonial Adventure*, pp. 64–5.
40 Marcus Clarke, 'Waterpool near Coleraine' in Bernard Smith (ed.), *Documents on Art and Taste in Australia, 1770–1941*, Oxford University Press, Melbourne, 1990, p. 135.
41 See Bernard Smith, 'The Interpretation of Australian Nature During the Nineteenth Century', unpublished BA (Hons) thesis (English), University of Sydney, 1952, pp. 38–40.
42 Clarke, 'Waterpool near Coleraine' in Smith (ed.), pp. 134–6.
43 Joan Kirkby, 'Old orders, new lands: the earth spirit in *Picnic at Hanging Rock*', *Australian Literary Studies*, 8, 3, May 1978, p. 255.
44 Clarke, 'Waterpool near Coleraine' in Smith (ed.), p. 135.
45 Clarke, 'The Buffalo Ranges' in Smith (ed.), p. 135.

4 The Bad Conscience of Impressionism

1 Frederick McCubbin, 'Some remarks on the history of Australian art' in *The Art of Frederick McCubbin*, Boolarong Publications, 1986, pp. 83–9.
2 Robert Hughes, *Art of Australia*, Penguin, Harmondsworth, 1970, p. 51.
3 Kerryn Goldsworthy, 'Short fiction', Laurie Hergenhan (ed.), *The Penguin New Literary History of Australia*, Penguin Books, Ringwood, 1988, p. 538.
4 Leigh Astbury, *Sunlight and Shadow: Australian Impressionist Painters, 1880–1900*, Bay Books, Sydney, 1989, p. 9.
5 Quoted in Geoffrey Smith, *Arthur Streeton*, National Gallery of Victoria, Melbourne, 1996, p. 130.
6 Thomas Griffiths, *Hunters and Collectors*, Cambridge University Press, Cambridge, 1996, p. 127.
7 Letter to Tom Roberts, early 1890s, quoted Geoffrey Smith, p. 69.
8 Bernard Smith with Terry Smith, *Australian Painting 1788–1990*, Oxford University Press, Melbourne, 1992, p. 82.
9 See Griffiths, p. 134.
10 Quoted by Griffiths, p. 119.
11 *Sydney Morning Herald*, 21 October 1895, p. 3, col. 7.
12 Xavier Pons, *Out of Eden: Henry Lawson's Life and Works, A Psychoanalytical View*, Sirius Books, Sydney, 1984, p. 3.
13 Ibid., p. 141.
14 Quoted in ibid., p. 136.
15 See Astbury, *Sunlight and Shadow*, p. 100.
16 Ibid., p. 178.
17 Smith with Smith, *Australian Painting*, p. 94.
18 Ruth Zubans, *E. Phillips Fox: His Life and Art*, Miegunyah Press, Carlton, 1995, p. 71.
19 Astbury, *Sunlight and Shadow*, p. 139.
20 Quoted by Zubans, p. 71 (*Table Talk*, 21 April 1893, p. 5).
21 Ian Burn, *National Life and Landscapes*, Bay Books, Sydney, 1990, p. 38.
22 Ibid., p. 27.
23 See Astbury, *Sunlight and Shadow*, pp. 177–80.
24 Bonyhady, *Images in Opposition*, p. 134.
25 See Ian Burn, *Dialogue*, Allen & Unwin, Sydney, 1991, pp. 19–20.
26 See Michael Fried, *Absorption and Theatricality: Painting and the Beholder in the Age of Diderot*, University of California Press, Berkeley, 1980. See also Norman Bryson, *Tradition and Desire from David to Delacroix*, Cambridge University Press, Cambridge, 1984, pp. 46–50.

27 See Ann Bermingham, 'System, order, and abstraction: the politics of English landscape drawing around 1795', W. J. T. Mitchell (ed.), *Landscape and Power*, University of Chicago Press, Chicago, 1994.

28 See Michael Charlesworth, 'Thomas Sandby climbs the Hoober Stand: the politics of panoramic drawing in eighteenth-century Britain', *Art History*, 19, 2, June 1996, pp. 247–66.

29 See, for example, John Barrell, 'Public prospect and private view', J. C. Eade (ed.), *Projecting the Landscape*, Humanities Research Centre, Australian National University, Canberra, 1987, pp. 15–35.

30 J. S. MacDonald, 'Arthur Streeton', *Art in Australia*, 3, 40, 15 October 1931, p. 19.

31 Burn, *National Life and Landscape*, p. 14.

32 Burn, *Dialogue*, p. 34.

33 Deborah Edwards, *Stampede of the Lower Gods: Classical Mythology in Australian Art*, Art Gallery of New South Wales, Sydney, 1989, p. 9.

34 Burn, *National Life and Landscape*, p. 14.

35 Burn, *Dialogue*, pp. 31–4.

36 See Bernard Smith, *The Spectre of Truganini*, Australian Broadcasting Commission, Sydney, 1980, pp. 17–30.

37 See Zubans, p. 99.

38 *Herald*, 4 December 1902, quoted in Astbury, *Sunlight and Shadow*, p. 209.

39 Three paintings were commissioned, the third being Roberts' *Opening of the First Commonwealth Parliament* (1901).

40 Smith with Smith, *Australian Painting*, p. 139.

41 Including some portraits by Tom Roberts in the early 1890s which, wrote Astbury, in their troubled expression 'appear to foretell the Aborigine's fate' (Astbury, *Sunlight and Shadow*, p. 198). See Helen Topliss, 'Tom Robert's Aboriginal portraits', Ian Donaldson and Tamsin Donald-son (eds), *Seeing the First Australians*, Allen & Unwin, Sydney, 1985, pp. 110–36.

42 Barbara Baynton, 'Squeaker's Mate' in Barbara Baynton, *Bush Studies*, Angus & Robertson, Sydney, 1965, pp. 54–71.

43 Kay Schaffer, *Women and the Bush*, Cambridge University Press, Cambridge, 1988, p. 148.

44 Burn, *National Life and Landscape*, p. 48.

45 Tom Roberts to the editor, *Argus*, 4 July 1890. Quoted in Jane Clark and Bridget Whitelaw, *Golden Summers: Heidelberg and Beyond*, rev. edn, International Cultural Corporation of Australia, Sydney, 1986, p. 132.

46 See C. D. Rowley, *The Destruction of the Aboriginal Society*, Penguin, Ringwood, 1983, pp. 190–1.

47 I thank Joanna Sassoon, librarian, Pictorial Collection, J. S. Battye Library of West Australian History, for drawing my attention to this photograph.

48 Leigh Astbury, *City Bushmen: The Heidelberg School and the Rural Mythology*, Oxford University Press, Melbourne, 1985, pp. 15–42.

49 See Albie Thoms in Linda Slutzkin and Barry Pearce (eds), *Bohemians in the Bush: The Artists' Camps of Mosman*, Art Gallery of New South Wales, Sydney, 1991; and Helen Topliss, *The Artists' Camps: Plein Air Painting in Melbourne, 1885–1898*, Monash University Gallery, Clayton, 1984.

50 Smith with Smith, *Australian Painting*, p. 99.

51 Ibid.

52 See Thoms in Slutzkin and Pearce (eds), p. 31.

53 Frederick Jackson Turner, *The Frontier in American History*, Holt, Rinehart & Winston, New York, 1962, p. 5.

54 Sigmund Freud, 'Totem and taboo', *The Basic Writings of Sigmund Freud*, trans and ed. Dr A. A. Brill, Modern Library, New York, 1966, p. 807.

55 Quoted in John Mulvaney, 'Introduction', Ron Vanderwal (ed.), *The Aboriginal Photographs of Baldwin Spencer*, National Museum of Victoria, Melbourne, 1982, p. x.

56 See D. J. Mulvaney and J. H. Calaby, *So Much that is New*, Melbourne University Press, Carlton, 1985, pp. 335–59.

57 Baldwin Spencer and Frank Gillen, *The Native Tribes of Central Australia*, Dover Publications, New York, n.d., p. vii.

58 Ibid., p. 105.

59 Edward B. Tylor, 'Preface' in H. Ling Roth, *The Aborigines of Tasmania*, F. King & Sons, Halifax, 1899, p. v.

60 Edward B. Tylor, *Anthropology*, London, 1881, p. 25.

61 Baldwin Spencer and Frank Gillen, *The Northern Tribes of Central Australia*, Anthropological Publications, Oosterhout, 1969, p. xiv.

62 Sir Frank Fox, *Australia*, 2nd edn, A. & C. Black, London, 1927, pp. 133–4; p. 142.

63 See Terry Smith, in Smith with Smith, *Australian Painting*, p. 498.

64 See Mulvaney and Calaby, pp. 217–19.

65 *Australian Aboriginal Art*, Public Library, Museum and National Gallery of Victoria, Melbourne, 1929, p. 15.

66 A. W. Grieg, 'Aboriginal art', *Lone Hand*, 5, 25, May 1909, p. 42.

67 See the *Boomerang*, 4 January 1890, p. 11.

68 See Pons, pp. 49–53, 181–6.

69 Sigmund Freud, 'Wit and its relation to the unconscious', *Basic Writings*, pp. 634–5.

70 See the *Boomerang*, 18 January 1890.

71 *Bulletin*, 18 March 1909.

72 Ibid., 3 January 1918, p. 18.

73 Ibid., 3 June 1909, p. 21.

74 Ray Norman, my colleague at the University of Tasmania, drew my attention to this.

75 Sydney Long, 'The trend of Australian art considered and discussed' in Bernard Smith (ed.), *Documents on Art and Taste in Australia, 1770–1941*, Oxford University Press, Melbourne, 1990, pp. 263–7.

76 Edwards, p. 11.

5 Aboriginalism and Australian Nationalism

1 Geoffrey Serle, *From Desert the Prophets Come: The Creative Spirit in Australia, 1788–1972*, Heinemann, Melbourne, 1973, p. 90.

2 Russel Ward, *A Nation for a Continent: The History of Australia, 1901–1975*, Heinemann Educational, Richmond, 1977, p. 127.

3 Burn, *National Life and Landscapes*, pp. 61–2.

4 Dixon, *Writing the Colonial Adventure*, p. 190.

5 See W. K. Hancock, *Australia*, Ernest Benn, London, 1930, pp. 58, 46, 57.

6 Arthur Mee, 'Introduction *Kabbarli*' in Daisy Bates, *The Passing of the Aborigines*, John Murray, London, 1947, p. xi.

7 See Dennis Judd, *Empire the British Imperial Experience, from 1765 to the Present*, Harper Collins, London, 1996, pp. 8, 11–12.

8 C. J. Dennis, 'The Moods of Ginger Mick', *The Sentimental Bloke and Other Verse*, Angus & Robertson, Sydney, 1963.

9 A. G. Stephens, 'Introduction to the *Bulletin* story', John Barnes (ed.), *The Writer in Australia: A Collection of Literary Documents, 1856–1964*, Oxford University Press, Melbourne, 1969, pp. 106–7.

10 Vance Palmer, 'An Australian national art', in Barnes (ed.), pp. 168–9.

11 See Vance Palmer, *The Legend of the Nineties*, Melbourne University Press, Carlton, 1963, p. 14.

12 See Smith with Smith, *Australian Painting*, p. 195.

13 Ward, *A Nation for a Continent*, p. 30.

14 Humphrey McQueen, *Gallipoli to Petrov: Arguing with Australian History*, George Allen & Unwin, Sydney, 1984, p. 5.

15 Lionel Lindsay, 'Arthur Streeton's Australian work', *The Art of Arthur Streeton*, Angus & Robertson, Sydney, 1919, p. 5.

16 Lionel Lindsay, 'Arthur Streeton', *Art in Australia*, October 1931, pp. 11 and 16.

17 J. S. MacDonald, 'Arthur Streeton', pp. 12–60.

18 Lansbury, *Arcady in Australia*, p. 61.

19 Ibid., p. 163.

20 See Christopher Wray, *Arthur Streeton: Painter of Light*, Jacaranda, Brisbane, 1993, p. 98.

21 Reported by Grace Joel (1906), quoted in Wray, p. 101.

22 Letter from Lionel Lindsay to Hans Heysen, June 1932, quoted in Colin Thiele, *Heysen of Hahndorf*, Rigby, Adelaide, 1968, p. 22.

23 Edwards, *Stampede of the Lower Gods*, p. 40.

24 MacDonald, 'Arthur Streeton', p. 22.

25 See Burn, *National Life and Landscapes*, p. 110.

26 Ibid., pp. 79–81.

27 *Sydney Morning Herald*, 6 March 1928, p. 9, quoted in Geoffrey Smith, *Arthur Streeton*, National Gallery of Victoria, Melbourne, 1996, p. 174.

28 W.S., *Art in Australia*, August 1940, pp. 30–1, quoted in Geoffrey Smith, p. 190.

29 *Age*, 16 March 1920, p. 7, quoted in Geoffrey Smith, p. 158.

30 Quoted by Mary Eagle, *Australian Modern Painting Between the Wars, 1914–1939*, Bay Books, Sydney, 1989, p. 72.

31 Burn, *National Life and Landscapes*, p. 72.

32 Eagle, p. 74.

33 Burn, *National Life and Landscapes*, pp. 189, 192.

34 See Thiele, p. 201.

35 William Moore, *The Story of Australian Art from the Earliest Known Art of the Continent to the Art of Today*, vol. 1, Angus & Robertson, London, 1934, p. xx.

36 Letter to Lionel Lindsay, 25 April 1927, quoted in Thiele, p. 196.

37 Hans Heysen, 'Some notes on art', *Art in Australia*, 3, 44, June 1932, p. 18.

38 Letter to Lionel Lindsay, quoted in Thiele, p. 207.

39 Heysen, 'Some notes on art', p. 20.

40 Letter to Lionel Lindsay, 23 August 1928, quoted in Thiele, p. 205.

41 Letter to Sydney Ure Smith, 27 March 1928, quoted in ibid.

42 Lionel Lindsay, quoted in Thiele, pp. 203–4.

43 Charles Sturt, *Narrative of an Expedition into Central Australia*, vol. 2, T. & W. Boone, London, 1849, p. 2.

44 J. W. Gregory, *The Dead Heart of Australia*, John Murray, London, 1909, pp. 159–64.

45 Ibid., pp. 165–6.

46 Ibid., pp. 171–80.

47 Ibid., p. 207.
48 Griffith Taylor, *Australia*, 6th edn, Methuen, London, 1951, pp. 102–3.
49 I thank Tom Griffiths of the Australian National University for drawing my attention to this parallel.
50 Robert Henderson Croll, *Wide Horizons*, Angus & Robertson, Sydney, 1937, p. 129.
51 Ibid., p. 147.
52 Ibid., p. 134.
53 Ibid., p. 146.
54 Ernestine Hill, *The Great Australian Loneliness*, Robertson & Mullens, Melbourne, 1943, p. 336.
55 Hill, p. 7.
56 Charles Barrett, *White Blackfellows*, Hallcraft, Melbourne, 1948.
57 A. Grenfill Price, *White Settlers and Native Peoples*, Greenwood Press, Westport, 1972, p. 101.
58 Jenny Lee, Philip Mead and Gerald Murnane (eds), *The Temperament of Generations: Fifty Years of Writing in* Meanjin, Melbourne University Press, Carlton, 1990, p. 6.
59 Vance Palmer, 'Battle', in Lee, Mead and Murnane (eds), p. 8.
60 Russel Ward, *The Australian Legend*, Oxford University Press, Melbourne, (1958) 1977, pp. 285–6.
61 Ibid., pp. 93, 105 and 136.
62 Ibid., pp. 32–4.
63 Barnard, *A History of Australia*, pp. 668–9.
64 Ibid., p. 650.
65 See Philip Jones, 'Perceptions of Aboriginal art: a history', Peter Sutton (ed.), *Dreamings: the Art of Aboriginal Australia*, Viking, Ringwood, 1988, p. 165.
66 Roger Fry, 'Negro sculpture' in R. Fry (ed.), *Vision and Design*, Meridian, New York, 1974, p. 100.
67 See Griffiths, *Hunters and Collectors*, pp. 181–3.
68 Daniel Thomas, 'Aboriginal art as art', Robert Edwards (ed.), *Aboriginal Art in Australia*, Ure Smith, Sydney, 1978, p. 29.
69 See Sydney Ure Smith (ed.), *Art of Australia*, Museum of Modern Art, New York, 1941. The exhibition was sponsored through the Carnegie Corporation for the Museum of Modern Art (New York). Bernard Smith believes that the inclusion of Aboriginal art was at the instigation of Theodore Sizer, rather than being due to any Australian political agenda (conversation with author, December, 1993).
70 Daryl Lindsay, 'Foreword', *Primitive Art Exhibition*, Public Library, Museum and National Gallery of Victoria, Melbourne, 1943, p. iii.
71 Jones in Sutton (ed.), p. 174.
72 A. P. Elkin, 'Foreword', *Australian Aboriginal Decorative Art*, Frederick McCarthy, Australian Museum, Sydney, 1974, p. 10.
73 John Barnes, 'The years between commentary' in Barnes (ed.), *The Writer in Australia,* p. 165.
74 P. R. Stephensen, *The Foundations of Culture in Australia: An Essay toward National Self Respect*, Allen & Unwin, Sydney, (1936) 1986, p. 15 and 73.
75 Ibid., pp. 18–19.
76 D. H. Lawrence, *Kangaroo*, Heinemann, London, (1923) 1966, pp. 8–9.
77 See Kirkby, 'Old orders, new lands', pp. 255–68.
78 Lawrence, pp. 8 and 15.
79 Ibid., pp. 73–4 and 100.

80 Ibid., p. 15.
81 Stephensen, pp. 11–13.
82 Ibid., p. 12.
83 Mudrooroo Nyoongah, 'Introduction', *Capricornia*, Xavier Herbert, Angus & Robertson, Sydney, (1938) 1990, pp. vii–xiv.
84 Terry Smith, in Smith with Smith, p. 459.
85 National Library of Australia MS 430 Box 2.
86 Gary Catalano, *The Years of Hope: Australian Art and Criticism, 1959–1968*, Oxford University Press, Melbourne, 1981, p. 75.
87 See Roger Butler, *The Prints of Margaret Preston*, Oxford University Press, Melbourne, 1987, p. 27.
88 'Aboriginal art is booming', *Sydney Morning Herald*, 30 June 1956, p. 14.
89 See *Bulletin*, 1 July 1959, p. 25.
90 James Gleeson, *Sun*, 18 July 1959.
91 Thomas in Edwards (ed.), p. 29.
92 Tony Tuckson, 'Aboriginal art in the Western world' in Ronald M. Berndt (ed.), *Australian Aboriginal Art*, Ure Smith, Sydney, 1964, p. 63.
93 See Nigel Lendon, 'The meaning of innovation: David Malangi and the bark painting tradition of Central Arnhem Land', unpublished draft for paper presented at Reimagining the Pacific: a Conference on Art History and Anthropology in Honour of Bernard Smith, Australian National University, 1996.

6 The Aboriginal Renaissance

1 Lin Onus, 'Southwest, southeast Australia and Tasmania', Bernhard Lüthi and Gary Lee (eds), *Aratjara Art of the First Australians*, Kunstsammlung Nordrheim-Westfalen, Düsseldorf, 1993, p. 290.
2 Galarrwuy Yunupingu (1987), 'The black/white conflict' in Lüthi and Lee (eds), pp. 64–6.
3 See Jane Hardy, 'Visitors to Hermannsburg: an essay on cross-cultural learning', Jane Hardy, J. V. S. Megaw and M. Ruth Megaw (eds), *The Heritage of Namatjira: The Watercolourists of Central Australia*, Heinemann, Melbourne, 1992, pp. 137–75; and Griffiths, *Hunters and Collectors*, pp. 176–86.
4 Tuckson in Berndt (ed.), *Australian Aboriginal Art*, p. 68.
5 Leslie Rees, 'Modern Australian Aboriginal art', *Australian Quarterly*, December 1951, p. 90.
6 C. P. Mountford, *The Art of Namatjira*, Bread and Cheese Club, Melbourne, 1944, p. 55.
7 Ibid., pp. 23, 74–9.
8 Haefliger in the *Sydney Morning Herald* 15 March 1945, quoted in Sylvia Kleinert, 'The critical reaction to the Hermannsburg School' in Hardy, Megaw and Megaw (eds), p. 229.
9 See Kleinert in Hardy, Megaw and Megaw (eds), p. 242.
10 Serle, *From Desert the Prophets Come*, pp. 71 and 95.
11 Kleinert in Hardy, Megaw and Megaw (eds), p. 219.
12 T. G. H. Strehlow, *Rex Battarbee: Artist and Founder of the Aboriginal Art Movement in Central Australia*, Legend Press, Sydney, 1956, p. 41.
13 Ibid., pp. 17 and 20–1.
14 See T. G. H. Strehlow, 'Introduction' in Rex Battarbee, *Modern Australian Aboriginal Art*, Angus & Robertson, Sydney, 1951.
15 Rees, p. 91.

16 Rex Battarbee, 'A summary' in Rex and Bernice Battarbee, *Modern Aboriginal Paintings*, Rigby, Adelaide, 1971, n.p.
17 Battarbee, *Modern Australian Aboriginal Art*, pp. 11–12.
18 Ibid., p. 19.
19 Battarbee in Battarbee and Battarbee, 'A summary', n.p.
20 Battarbee, pp. 22–3.
21 Ibid., p. 19.
22 Paul Hasluck, 'Foreword' in Joyce D. Batty, *Namatjira: Wanderer Between Two Worlds*, Hodder & Stoughton, Melbourne, 1963, pp. 9–10.
23 Batty, p. 144.
24 Quoted in Batty, p. 158.
25 Frantz Fanon, *Black Skin, White Masks*, trans. Charles Lam Markmann, Grove Press, New York, (1952) 1967, p. 18.
26 See Philip Jones, 'Namatjira: traveller between two worlds' in Hardy, Megaw and Megaw (eds), pp. 97–136.
27 For the application of such Bhabhaian ideas to Namatjira, see Ian Burn and Ann Stephen, 'Namatjira's white mask: a partial interpretation' in Hardy, Megaw and Megaw (eds), pp. 249–82.
28 Theodor Adorno, *Aesthetic Theory*, trans. C. Lenhardt, Routledge & Kegan Paul, London, 1984, p. 159.
29 Yunupingu in Lüthi and Lee (eds), pp. 64–6.
30 Onus in Lüthi and Lee (eds), p. 290.
31 Mullard, a black activist working in London, visited Australia in 1974 at the invitation of the National Aboriginal Forum. See Chris Mullard, *Aborigines in Australia Today*, Summit Press, ACT, 1976.
32 Fanon, *Wretched of the Earth*, p. 171.
33 See Emmanuel Hansen, *Frantz Fanon: Social and Political Thought*, Ohio State University Press, Ohio, 1977, pp. 4–6. Conversation between author and Lin Onus (January 1991) also confirmed that Fanon was widely read by Victorian activists in the late 1960s and early 1970s.
34 See Fanon, *Black Skin, White Masks*, p. 17.
35 Fanon, *Wretched of the Earth*, p. 170.
36 Ibid., p. 28.
37 For an example see Ross Watson in Kevin Gilbert, *Living Black Talk to Kevin Gilbert*, Penguin, Ringwood, 1977, pp. 184–5.
38 Ann Turner (ed.), *Neville Bonner Versus Bobbi Sykes*, Heinemann Educational, South Yarra, 1975, pp. 10–12.
39 See Clare Williamson and Hetti Perkins, *Blakness Blak City Culture*, Australian Centre for Contemporary Art, South Yarra, 1994, p. 20.
40 Ronald M. Berndt, 'Introduction', Ronald M. Berndt (ed.), *A Question of Choice: an Australian Aboriginal Dilemma*, University of Western Australia Press, Perth, 1971, pp. xviii–xix.
41 It first appeared as a label amongst the writing of black activists in the 1970s, where it signified pride in Aboriginal culture. For example, see *Farrago*, 12 July 1974, p. 5; Mullard, pp. 61–3; Gilbert, *Living Blacks*, pp. 299–305, 184.
42 Kevin J. Gilbert, *Because a White Man'll Never Do It*, Angus & Robertson, Sydney, 1973, p. 7.
43 Ronald M. Berndt, 'Aboriginal identity: reality or mirage' in R. Berndt (ed.), *Aborigines and Change*, Humanities Press, New Jersey, 1977, pp. 11–12.
44 Jeremy Beckett, 'The past in the present; the present in the past; constructing a national Aboriginality', *Past and Present: the Construction of Aboriginality*, Aboriginal Studies Press, Canberra, 1988, p. 200.

45 See G. Armstrong, 'Current developments amongst Arnhem Land Aborigines' in Berndt (ed.), *A Question of Choice*, pp. 53–60.

46 Wandjuk Marika, 'Introduction', in H. C. Coombs *et al.*, *Oenpelli Bark Painting*, Ure Smith, Sydney, 1979, pp. 10–11.

47 'Aboriginal artists from Arnhem Land', *Third Biennale of Sydney*, Art Gallery of New South Wales, Sydney, 1979, n.p.

48 Lin Onus, 'Language and lasers', *Art Monthly*, Aboriginal art supplement, 30, May 1990, p. 14.

49 Onus in Lüthi and Lee (eds), p. 292.

50 See Tony Swain, *A Place for Strangers: Towards a History of Australian Aboriginal Being*, Cambridge University Press, Cambridge, 1993.

51 Terry Smith in Smith with Smith, *Australian Painting*, pp. 495–6.

52 Lance Bennett, 'Aboriginal participation', *D'un autre continent l'Australie le rêve et le réel*, ARC/Musée d'art Moderne de la Ville de Paris, Paris, 1983, pp. 48–50.

53 Terry Smith in Smith with Smith, p. 495.

54 See Bernard Smith, 'The Antipodean Manifesto', and 'The Truth about the Antipodeans', *The Death of the Artist as Hero*, Oxford University Press, Melbourne, 1988, pp. 194–213.

55 Catalano, *The Years of Hope*, pp. 11 and 194.

56 See Griffiths, *Hunters and Collectors*, p. 220.

57 Republished in the 1990s with three additional chapters by Terry Smith.

58 See Daniel Thomas, 'The margins strike back: Australian art since the sixties', *Art and Australia*, 26, 1, Spring 1988, pp. 62–3.

59 Daniel Thomas, 'The Biennale: how Australian art escaped provincial internationalism and joined the world in its own right', Australian Biennale, *From the Southern Cross: A View of World Art*, c. *1940–88*, ABC Enterprises, Crows Nest, 1988, p. 18.

60 Terry Smith, 'The provincialism problem', *Art Forum*, 13, 1, September 1974, pp. 56–7.

61 Terry Smith in Smith with Smith, p. 458.

62 Including the work of Hamish Fulton, Joseph Beuys (his film *I Like America and America Likes Me*), Tom Arthur, Rosalie Gascoigne (her piece Feathered Fence), Nikolaus Lang and Hermann Nitsch.

63 Jim Davidson (ed.), 'Introduction', *Meanjin* Aboriginal Issue, 36, 4, December 1977, p. 419.

64 Smith, *The Spectre of Truganini*, p. 50.

65 Gerardo Mosquera, 'Modernity and Africanía: Wilfredo Lam in his island', *Third Text*, 20, Autumn 1992, p. 46.

66 Ronald Jones, 'Lifesaving in the Acrylic Age', *Artforum*, February 1989, p. 114.

67 See Hal Foster, 'The "primitive" unconscious of modern art, or white skin, black masks', *Recodings*, Bay Press, Seattle, 1985, pp. 190, 196, 198, 203.

68 Colin Symes and Bob Lingard, 'From the ethnographic to the aesthetic: an examination of the relationship between Aboriginal and European culture in Australian art 1788–1988', in Foss (ed.), *Island in the Stream*, p. 190.

69 Christina Davidson, 'Interview: Paul Taylor', *Art Network*, 10, Winter 1983, p. 47.

70 Su Cramer, '"Masterpieces" out of the seventies and "Tall Poppies"', *Art Network*, 10, Winter 1983, p. 45.

71 Imants Tillers, 'In perpetual mourning', *Imants Tillers Venice Biennale 1986*, Visual Arts Board of the Australia Council, Sydney, and Art Gallery of South Australia, Adelaide, 1986, pp. 17–18.

72 Imants Tillers, 'Locality fails', *Art & Text*, 6, 1982, p. 53.
73 Tillers, 'In perpetual mourning', pp. 17–18.
74 Tillers, 'Locality fails', p. 54.
75 Rex Butler, 'Two readings of Gordon Bennett's The Nine Ricochets', *Eyeline*, Winter/Spring, 1992, p. 19.
76 Tillers, 'Locality fails', pp. 54, 60.
77 Bernice Murphy, 'Scenes and journeys', Imants Tillers (ed.), *Diaspora*, Museum of Contemporary Art, Sydney, 1993, p. 47.
78 Imants Tillers and Jennifer Slatyer, 'Diaspora: an interview with Imants Tillers' in Tillers (ed.), p. 36.
79 Tillers is here referring to the use of the dots to conceal secret meanings from the uninitiated audience. He also considered invisibility to be an aesthetic of one of his favourite artists, Giorgio de Chirico (see Imants Tillers, 'Fear of texture', *Art & Text*, 10, 1983, p. 17, and p. 18(f20)).
80 Tillers, 'Fear of texture', p. 18.
81 Juan Davila, 'Aboriginality: a lugubrious game', *Art & Text*, 23/24, 1987, pp. 53–6.
82 Eric Michaels, 'Postmodernism, appropriation and Western Desert acrylics', Su Cramer (ed.), *Postmodernism: A Consideration of the Appropriation of Aboriginal Imagery*, Institute of Modern Art, Brisbane, 1989, p. 28.
83 See Michaels in Cramer (ed.), pp. 27–33, particularly p. 27.
84 Philip Brophy, 'Not the black & white artist show', *Art Network*, 13, Spring 1984, p. 53.

7 Aboriginality and Contemporary Australian Painting

1 Thomas (1976), 'Aboriginal Art as Art' in Edwards (ed.), p. 29.
2 Vivien Johnson, 'The unbounded Biennale: contemporary Aboriginal art', *Art and Australia*, 31, 1, Spring 1993, p. 50.
3 Quoted in Ian Burn, 'The Australian National Gallery: populism or a new cultural federalism?', *Art Network*, 8, Summer 1983, p. 39.
4 Lendon, 'The meaning of innovation', p. 5.
5 Burn, 'The Australian National Gallery', p. 41.
6 Daniel Thomas, 'Australian art' in James Mollison and Laura Murray (eds), *Australian National Gallery: an Introduction*, Australian National Gallery, Canberra, 1982, p. 194.
7 Lendon, 'The meaning of innovation', p. 5.
8 Michael O'Ferrall, *On the Edge: Five Contemporary Aboriginal Artists*, Art Gallery of Western Australia, 1989, p. 7.
9 Bernice Murphy, 'Introduction', *Australian Perspecta 1981*, Art Gallery of New South Wales, Sydney, 1981, p. 15.
10 Ruth McNicoll, 'Aboriginal art' in Mollison and Murray (eds), p. 188.
11 Nicholas Baume, 'The interpretation of Dreamings: the Australian Aboriginal acrylic movement', *Art & Text*, 33, Winter 1989, pp. 111–12.
12 Three paintings, two by Clifford Possum Tjapaltjarri and Tim Leura Tjapaltjarra, and one by Charlie Tjapangati, were included in the inaugural 1981 Australian Perspecta, a survey exhibition of contemporary Australian art organised by the Art Gallery of New South Wales.
13 Three Arnhem Land bark painters had been included in the 1979 Sydney Biennale, and in the 1982 Biennale a sand painting by Warlpiri artists from Lajamanu was created.
14 'Aboriginal artists from Arnhem Land', *Third Biennale* of Sydney, *European Dialogue*, Art Gallery of New South Wales, Sydney, 1979, n.p.

15 Suzanne Pagé, *D'un autre continent*, pp. 10–13.
16 Richard Dunn, 'Other than what', *Art Network*, 13, Spring 1984, p. 52.
17 Jacques Derrida, *The Other Heading: Reflections on Today's Europe*, trans. Pascale-Anne Brault and Michael B. Naas, Indiana University Press, Bloomington, 1992, p. 5.
18 Ibid., p. 15.
19 Philip Brophy, 'A face without a place: identity in Australian contemporary art since 1980', *Art & Text*, 16, 1988, p. 75.
20 Tillers, 'In perpetual mourning', *Imants Tillers Venice Biennale 1986*, pp. 17–18.
21 Leon Paroissien, *D'un autre continent*, pp. 26, 30.
22 Reported by Jill Montgomery, 'Australia – the French discovery of 1983', *Art & Text*, 12 and 13, 1984, pp. 13–14.
23 Juan Davila, 'On eclecticism', *Art Network*, 13, Spring 1984, p. 51.
24 Brophy, 'Not the black & white artist show', p. 53.
25 See Christopher Pearson, 'Aboriginal identity and kitsch', *Art & Text*, 14, 1984, pp. 42–9.
26 Meaghan Morris, *D'un autre continent*, p. 38.
27 Tillers, 'Locality fails', p. 51.
28 Meaghan Morris, 'Tooth and claw: tales of survival, and *Crocodile Dundee*', *Art & Text*, 25, 1987, pp. 58 f. However, the notion of 'white Aborigines' has been questioned by some postmodernists, most notably by Tim Johnson and Juan Davila. For a discussion of this, see Bob Lingard, 'Appropriation of Aboriginal Imagery: Tim Johnson and Imants Tillers', Cramer (ed.), *Postmodernism: A Consideration of the Appropriation of Aboriginal Imagery*, p. 20.
29 Paul Taylor, 'Popism – the art of white Aborigines', *Flash Art*, 112, May 1983, p. 50.
30 See Gilles Deleuze and Félix Guattari, *A Thousand Plateaus: Capitalism and Schizophrenia*, trans. Brian Massumi, University of Minnesota Press, Minneapolis, 1991.
31 Stephen Muecke 'The discourse of nomadology: phylums in flux', *Art & Text*, 14, 1984, pp. 25, 34.
32 Quoted in Paul Carter, *Road to Botany Bay*, Faber & Faber, London, 1987, p. 349.
33 Vivien Johnson, 'A whiter shade of Palaeolithic' in Cramer (ed.), p. 17.
34 Leon Paroissien, 'Director's Introduction', Fifth Biennale of Sydney *Private Symbol: Social Metaphor*, Art Gallery of New South Wales, Sydney, 1984, n.p.
35 Johnson, 'The unbounded Biennale', p. 50.
36 Patrick McCaughey, 'The transition from "Field" to Court', *Field to Figuration, Australian Art, 1960–1986*, National Gallery of Victoria, Melbourne, 1986, p. 14.
37 See Adrian Marrie, 'Killing me softly: Aboriginal art and Western critics', *Art Network*, Spring 1984, p. 19.
38 Nick Waterlow, 'A view of world art, *c.* 1940–88', Australian Biennale, *From the Southern Cross: A View of World Art c. 1940–88*, p. 9.
39 Burn, *Dialogue*, pp. 47–8.
40 Waterlow, 'A view of world art' in Australian Biennale, pp. 11–2.
41 John Mundine, 'Aboriginal Art Gallery of New South Wales', *Art and Australia*, 26, 1, Spring 1988, p. 94.
42 Thomas, 'The margins strike back', p. 71.
43 Baume, 'The interpretation of Dreamings', p. 120.
44 Johnson, 'The unbounded Biennale', p. 56.

45 John McDonald, 'Issues in contemporary Australian art', *Art and Australia*, 26, 1, Spring 1988, p. 89.

46 Stan Anson, 'The postcolonial fiction', *Arena*, 96, 1991, pp. 64–6.

47 Ella Shohat, 'Notes on the "post-colonial"', *Social Text*, 31/32, 1992, pp. 109–10.

48 Johnson, 'The unboundeded Biennale', p. 52.

49 Ibid., p. 50.

50 See Gayatri Chakravorty Spivak, *Outside in the Teaching Machine*, Routledge, New York, 1993, pp. 1–24.

51 Gayatri Chakravorty Spivak, *In Other Worlds: Essays in Cultural Politics*, Methuen, New York, 1987, p. 148.

52 Vivien Johnson, 'A whiter shade of the Palaeolithic', p. 16.

53 Interview by Jeffrey Samuels and Chris Watson, 'Three urban views: Fiona Foley, Ray Meeks and Avril Quaill' in Jeffrey Samuels and Chris Watson (eds), *Aboriginal Australian Views in Print and Posters*, Print Council of Australia, Melbourne, 1987 p. 38.

54 Spivak, *In Other Worlds*, pp. 136–7, 153.

55 Spivak had formally introduced the term 'postcolonial' to the Western academy in a conference session titled 'Colonialist and postcolonialist discourse' (which included a paper by Bhabha) which she organised for the Modern Language Association Convention in New York in December 1983. Thereafter she called herself a 'postcolonial critic'. 'Before you know what's what', she said, 'it becomes a buzzword to talk about anything that involves the Third World' (Gayatri Spivak with Nikos Papastergiadis, 'Identity and alterity: an interview', *Arena*, 97, 1991, p. 74). It was not surprising, then, that it was announced when she presented her paper at Documenta X (Kassell, 24 July 1997) that her forthcoming book would be titled *Don't Call Me Postcolonial*.

56 Gayatri Spivak, in Sarah Harasym (ed.), *The Post-colonial Critic*, Routledge, New York, 1990, p. 8.

57 Tillers, 'Locality fails', p. 60.

8 Painting for a New Republic

1 See Louise Vinge, *The Narcissus Theme in Western European Literature up to the Early Nineteenth Century*, trans. Robert Dewsnap, Gleerups, 1967, pp. 37–8.

2 Ibid., pp. 148–51, 197–8, 219, 268–9.

3 Robert Graves, *The Greek Myths*, Penguin Books, Harmondsworth, 1980, 85.1.

4 See Gordon Bennett, *On Shadows (of My Former Self)*, which accompanied his September 1995 exhibition at Sutton Galleries, Melbourne.

5 See Gordon Bennett, 'Aesthetics and iconography: an artist's approach', Lüthi and Lee (eds), *Aratjara Art of the First Australians*, pp. 86–9.

6 Heinrich Schwarz, 'The mirror in art', *Art Quarterly*, 15, 1952, pp. 110–11.

7 Bob Lingard, interview with Gordon Bennett, 'A kind of history painting', *Tension*, 17, August 1989, p. 40.

8 Bob Lingard and Fazal Rizvi, '(Re)membering, (dis)membering: "Aboriginality" and the art of Gordon Bennett', *Third Text*, 26, Spring 1994, p. 79.

9 See Jacques Lacan, 'The mirror-phase as formative of the function of the I', trans. Jean Roussel, *New Left Review*, 51, September–October, 1968, pp. 71–7.

10 See Homi Bhabha, 'Of mimicry and man: the ambivalence of colonial discourse', *October*, 28, 1984, pp. 125–33.

11 Derrida, *Margins of Philosophy*, pp. 25, 15.

12 Jacques Derrida, 'Women in the beehive: a seminar by Jacques Derrida' in Russell Ferguson *et al.* (eds), *Discourses: Conversations in Postmodern Art and Culture*, MIT Press, Cambridge, 1992, p. 122.
13 This black area of the painting quotes from Sigmar Polke's *White Obelisk* (1968).
14 See Nikos Papastergiadis, *The Complicities of Culture: Hybridity and 'New Internationalism'*, Cornerhouse, Manchester, 1994, pp. 5–8.
15 Anthony Bond, 'Notes on the catalogue and exhibition', Ninth Biennale of Sydney, *The Boundary Rider*, Art Gallery of New South Wales, Sydney, 1992, p. 15.
16 Fay Brauer, 'The bricoleur – the borderico – the postcolonial boundary rider', *Agenda*, 29, March 1993, p. 6.
17 Muecke, 'The discourse of nomadology', p. 25.
18 John Welchman, 'Bordering on' in Ninth Biennale of Sydney catalogue, pp. 34–42.
19 Ashis Nandy, *The Intimate Enemy: Loss and Recovery of Self under Colonialism*, Oxford University Press, Delhi, 1983, pp. x–xi.
20 Bill Ashcroft, Gareth Griffiths and Helen Tiffin, *The Empire Writes Back: Theory and Practice in Post-colonial Literatures*, Routledge, London, 1989, p. 12; see also pp. 172–173.
21 See Bennett in Lüthi and Lee (eds), p. 87.
22 Bennett's first use of a black square is in *Untitled* (1989).
23 Tillers, 'In perpetual mourning', p. 19.
24 Letter to the author from Gordon Bennett, 6 April 1994, p. 2.
25 Philip Brophy, 'A face without a place', p. 80.
26 Letter to the author from Gordon Bennett, 6 April 1994, p. 2.
27 Paul Carter, *Living in a New Country*, Faber & Faber, London, 1992, pp. 187, 193.
28 For example, see Wilson Harris, *The Womb of Space: The Cross-Cultural Imagination*, Greenwood Press, Westport, 1983.

Postscript: The Wandering Islands

1 'The Wandering Islands', poem by A. D. Hope, *Selected Poems*, Angus & Robertson, Sydney, 1963, p. 45.
2 Sir John Kirwan, *An Empty Land*, Eyre & Spottiswoode, London, 1934, pp. 312, 194.
3 See Theodor Adorno, *Negative Dialectics*, trans. E. B. Ashton, Seabury Press, New York, 1973, pp. 5–6.
4 Derrida, *Margins of Philosophy*, p. 134.
5 Ibid., pp. 211–13, 24–5.
6 Quoted in Griffiths, *Hunters and Collectors*, p. 137.
7 Julia Kristeva, 'A new type of intellectual: the dissident', *The Kristeva Reader*, trans. Seán Hand, T. Moi (ed.), Basil Blackwell, Oxford, 1987, p. 298.
8 Jack Lindsay, *A Short History of Culture from Prehistory to the Renaissance*, Studio Books, London, 1962, p. 316.
9 See Hegel, *The Philosophy of History*, pp. 91–9.
10 Derrida, *Margins of Philosophy*, p. x.
11 See Shaw, *Convicts and the Colonies*, pp. 45–48.
12 For an account of the Sierre Leone expedition, see George Padmore, *Pan–Africanism or Communism? The Coming Struggle for Africa*, Dennis Dobson, London, 1956, pp. 26–30.

13 See, Ian Duffield, 'Alexander Harris's *The Emigrant Family* and Afro–Black people in colonial Australia' in Dabydeen (ed.), *The Black Presence in English*, p. 77.

14 D. Crawford, *Thinking Black: 22 Years without a Break in the Long Grass of Central Africa*, Morgan & Scott, London, 1914, pp. xiv–xv.

15 John Mitchel, *Jail Journal*, R. & T. Washbourne, London, n.d., p. 263.

16 Luce Irigaray, *An Ethics of Sexual Difference*, pp. 7, 11.

17 Ibid., p. 188; Elizabeth Grosz, *Space, Time and Perversion*, Allen & Unwin, Sydney, 1995, p. 116; Julia Kristeva, *Powers of Horror: An Essay on Abjection*, trans. Leon S. Roudiez, Columbia University Press, New York, 1982, pp. 18, 9–10.

18 Hughes, *The Fatal Shore*, pp. 427, 493–4.

19 Schaffer, *Women and the Bush*, p. 107.

20 Henry Handel Richardson, *Australia Felix*, Heinemann, Melbourne, (1917) 1970, p. 13. See also Schaffer, p. 104.

21 Marjorie Barnard, 'This Australia' in Sydney Ure Smith (ed.), *Art of Australia*, Museum of Modern Art, New York, 1941, pp. 10–11.

22 C. M. H. Clark, 'Mateship' in Lee, Mead and Murnane (eds), *The Temperament of Generations: Fifty Years of Writing in* Meanjin, pp. 37–8 (*Meanjin, 3, 1943*).

23 Clark, *A History of Australia*, vol. 1, p. 110.

24 Graeme Turner, *National Fictions*, 2nd edn, Allen & Unwin, Sydney, 1993, pp. 125, 143, 74, and 80.

25 Joan Kirkby, 'Fetishizing the father', *Meridian*, 10, 1, May 1991, p. 41.

26 Joan Kirkby, 'Barbara Baynton: an Australian jocasta', *Westerly*, 34, 4, December 1989, pp. 123–4.

27 Gibson, *South of the West*, pp. 65 and 200.

28 Ibid., pp. 231–2.

29 See Gibson's review of the movie *Mad Max, Beyond the Thunderdome*, in ibid., pp. 158–77.

30 Ibid., p. 173.

31 Paul Carter, *The Sounds In-Between, Voice, Space, Performance*, New South Wales University Press, Kensington, 1992, p. 14.

32 As, for example, Robert Dixon and Gail Ching-Liang Low do: Dixon, *Writing the Colonial Adventure*; Gail Ching-Liang Low, *White Skins, Black Masks: Representation and Colonialism*, Routledge, London, 1996.

33 Carter, *Living in a New Country*, pp. 100–1.

34 Paul Carter, 'Contrapuntal perspectives', *Art and Asia Pacific*, 1, 3, 1994, p. 109.

35 Paul Carter, *The Lie of the Land*, Faber & Faber, London, 1996, p. 177.

36 Paul Carter, *The Sounds In-Between*, p. 18.

37 Carter, *Living in a New Country*, p. 35.

38 Carter, *Road to Botany Bay*, pp. 92, 31–3.

39 Paul Carter, 'Turning the tables – or, grounding postcolonialism' in Kate Darian-Smith, Liz Gunner and Sarah Nuttall (eds), *Text, Theory, Space: Land, Literature and History in South Africa and Australia*, Routledge, London, 1996, p. 34 (fn26).

40 Ibid., p. 18.

41 Ibid., p. 20.

42 Carter, *The Road to Botany Bay*, pp. 108, 116.

43 Paul Carter, 'Second sight: looking back as colonial vision', *Australian Journal of Art*, vol. xiii, 1996, pp. 12–13.

44 Quoted by Paul Carter, *Living in a New Country*, p. 52.
45 Carter, 'Second sight', pp. 27–8.
46 See Carter, *Living in a New Country*, pp. 14, 27.
47 Paul Carter, 'Migrant meditations', *Agenda*, 22, March/April 1992, pp. 9–11.
48 Carter, *Living in a New Country*, pp. 196, 198.
49 Luce Irigaray, *This Sex Which Is Not One*, trans. Catherine Porter, Cornell University Press, Ithaca, 1985, pp. 76–7.
50 Carter, *The Sounds In-Between*, p. 22; Carter, *The Lie of the Land*, p. 287.
51 Luce Irigaray, *Speculum of the Other Woman*, trans. Gillian C. Gill, Cornell University Press, Ithaca, 1992, p. 134.
52 See Carter, *The Lie of the Land*, p. 2.
53 Irigaray, *Speculum of the Other Woman*, p. 133.
54 Paul Carter, 'Events of today or, an end of writing', *Agenda*, 39/40, November 1994–February 1995, p. 5.
55 Carter, *The Lie of the Land*, p. 84.
56 See Irigaray, *An Ethics of Sexual Difference*, pp. 197–201; Spivak, *Outside in the Teaching Machine*, p. 168.
57 For a discussion of the pre-Oedipal, see Madelon Sprengnether, *The Spectral Mother*, Cornell University Press, Cornell, 1990, pp. 1–13.
58 Spivak in Harasym, S. (ed.), *The Post-colonial Critic*, p. 1.
59 While I have, in this respect, somewhat simplified Carter's argument, he does not sufficiently open up the irony of his phrase and title of his latest book, *The Lie of the Land*, and, when he does address the voice of indigenous cultures, often with great sympathy and insight, he tends to fetishise the relationship of Aborigines to the land so that their culture becomes a too transparent figure of the land.
60 Carter, *Living in a New Country*, pp. 18, 20.
61 See Dixon, *Writing the Colonial Adventure*, pp. 3–11.
62 Adrian Stokes, *The Image in Form*, Richard Wollheim (ed.), Penguin Books, Harmondsworth, 1972, pp. 276–7.
63 Carter, *Living in a New Country*, pp. 1–3. Carter develops this idea extensively in chapter two of *The Lie of the Land*.
64 Antonio Paolucci, 'Foreword' in G. P. Curratelli (ed.), *The Western Greeks*, Bompiani, Venezia, 1996, p. 12.
65 Carter, *Living in a New Country*, p. 3.
66 See Carter, 'Events of today', p. 6.
67 Irigaray, *Speculum of the Other Woman*, pp. 133–5.
68 Carter, *The Road to Botany Bay*, pp. 349, 103.
69 Carter, *Living in a New Country*, pp. 50–1.
70 Alain Corbin, *The Lure of the Sea: The Discovery of the Seaside, 1750–1840*, trans. Jocelyn Phelps, Penguin Books, Harmondsworth, 1995, p. vii.
71 John Thompson, 'The Traveller' in John Thompson, Kenneth Slessor and R. G. Howarth (eds), *Penguin Book of Modern Australian Verse*, Penguin Books, Harmondsworth, 1961, p. 127.
72 Claude Lévasque, in Jacques Derrida, *The Ear of the Other*, Christie McDonald (ed.), trans. Peggy Kamuf, University of Nebraska Press, Lincoln, 1985, pp. 143–4.
73 Lotman, *The Universe of the Mind*, p. 141.
74 Ibid., pp. 142–3.

Bibliography

Unpublished Papers

Black, J., 'King George commands – and we obey over the hills and far away. The New South Wales Corps 1789–1810 a re-assessment', BASA conference paper, University of Stirling, Stirling, 1996.

Lendon, N., 'The meaning of innovation: David Malangi and the bark painting tradition of Central Arnhem Land', unpublished draft for paper presented at Reimagining the Pacific: a Conference on Art History and Anthropology in Honour of Bernard Smith, Australian National University, 1996.

Smith, B., 'The Interpretation of Australian Nature During the Nineteenth Century', unpublished BA (Hons) thesis (English), University of Sydney, 1952.

Books and Catalogues

The Art of Frederick McCubbin, Boolarong Publications, 1986.

Adorno, T., *Aesthetic Theory*, trans. C. Lenhardt, Routledge & Kegan Paul, London, 1984.

Adorno, T., *Minima Moralia*, trans. E. P. N. Jephcott, NLB, London, (1951) 1974.

Adorno, T., *Negative Dialectics*, trans. E. B. Ashton, Seabury Press, New York, 1973.

Andrews, W., *Bygone Punishments*, William Andrews, London, 1899.

Ashcroft, B., Griffiths, G. and Tiffin, H., *The Empire Writes Back: Theory and Practice in Post-colonial Literatures*, Routledge, London, 1989.

Astbury, L., *City Bushmen: The Heidelberg School and the Rural Mythology*, Oxford University Press, Melbourne, 1985.

Astbury, L., *Sunlight and Shadow: Australian Impressionist Painters, 1880–1900*, Bay Books, Sydney, 1989.

Augustine, *City of God*, trans. Marcus Dods, Modern Library, New York, n.d.

Australian Aboriginal Art, Public Library, Museum and National Gallery of Victoria, Melbourne, 1929.

Australian Aboriginal Paintings – Arnhem Land, New York Graphic Society by arrangement with UNESCO, New York, 1954.

Australian Biennale, *From the Southern Cross: A View of World Art* c. *1940–88*, ABC Enterprises, Crows Nest, 1988.

Australian Perspecta 1981, Art Gallery of New South Wales, Sydney, 1981.

Bakhtin, M., *Rabelais and his World,* trans. Helene Iswolsky, Indiana University Press, Bloomington, 1988.

Baltrusaitis, J., *Aberrations*, trans. Richard Miller, MIT Press, Cambridge, 1989.

Barnard, M., *A History of Australia*, Angus & Robertson, Sydney, 1978.

Barnes, J. (ed.), *The Writer in Australia: A Collection of Literary Documents, 1856–1964*, Oxford University Press, Melbourne, 1969.

Barrett, C., *Coast of Adventure*, Robertson & Mullens, Melbourne, (1941) 1946.

Barrett, C., *White Blackfellows*, Hallcraft, Melbourne, 1948.

Bates, D., *The Passing of the Aborigines*, John Murray, London, 1947.

Battarbee, R. and B., *Modern Aboriginal Paintings*, Rigby, Adelaide, 1971.

Battarbee, R., *Modern Australian Aboriginal Art*, Angus & Robertson, Sydney, 1951.

Batty, J. D., *Namatjira: Wanderer Between Two Worlds*, Hodder & Stoughton, Melbourne, 1963.

Baudrillard, J., *America*, trans. Chris Turner, Verso, London, 1988.

Baynton, B., *Bush Studies*, Angus & Robertson, Sydney, 1965.

Beckett, J., *Past and Present: the Construction of Aboriginality*, Aboriginal Studies Press, Canberra, 1988.

Bender, J., *Imagining the Penitentiary: Fiction and the Architecture of Mind in Eighteenth-Century England*, University of Chicago Press, Chicago, 1987.

Benjamin, W., *Illuminations*, trans. Harry Zohn, Fontana, Bungay, 1982.

Bennett, G., *On Shadows (of My Former Self)*, Sutton Galleries, Melbourne, 1995.

Berndt, R. M. (ed.), *Aborigines and Change*, Humanities Press, New Jersey, 1977.

Berndt, R. M. (ed.), *A Question of Choice: an Australian Aboriginal Dilemma*, University of Western Australia Press, Perth, 1971.

Berndt, R. M.(ed.), *Australian Aboriginal Art*, Ure Smith, Sydney, 1964.

Boime, A., *The Magisterial Gaze: Manifest Destiny and American Landscape Painting, c. 1830–1865*, Smithsonian Institute Press, Washington, 1991.

Bonwick, J., *The Last Tasmanians*, Sampson Low, Son and Marston, London, 1870.

Bonyhady, T., *Images in Opposition: Australian Landscape Painting, 1801–1890*, Oxford University Press, Melbourne, 1985.

Brehaut, E., *An Encyclopedist of the Dark Ages: Isidore of Seville*, Burt Franklin, New York, 1912.

Bryson, N., *Tradition and Desire from David to Delacroix*, Cambridge University Press, Cambridge, 1984.

Bunbury, E. H., *A History of Ancient Geography,* John Murray, London, 1879.

Burn, I., *Dialogue*, Allen & Unwin, Sydney, 1991.

Burn, I., *National Life and Landscapes*, Bay Books, Sydney, 1990.

Burton, R., *The Anatomy of Melancholy*, ed. T. Faulkner, N. Kiessling and R. Blair, Clarendon Press, Oxford, 1989.

Butler, M., *Theatre and Crisis, 1632–1642*, Cambridge University Press, Cambridge, 1984.

Butler, R.,*The Prints of Margaret Preston*, Oxford University Press, Melbourne, 1987.

Carter, P., *Living in a New Country*, Faber & Faber, London, 1992.

Carter, P., *The Lie of the Land*, Faber & Faber, London, 1996.

Carter, P., *The Road to Botany Bay*, Faber & Faber, London, 1987.

Carter, P., *The Sounds In-Between, Voice, Space, Performance*, New South Wales University Press, Kensington, 1992.

Catalano, G., *The Years of Hope: Australian Art and Criticism, 1959–1968*, Oxford University Press, Melbourne, 1981.

Clark, J. and Whitelaw, B., *Golden Summers: Heidelberg and Beyond*, rev. edn., International Cultural Corporation of Australia, Sydney, 1986.

Clark, C. M. H., *A History of Australia*, Melbourne University Press, 6 vols, Carlton, 1962–84.

Clark, C. M. H. (ed.), *Select Documents in Australian History, 1788–1850*, Angus & Robertson, Sydney, 1966.

Collins, D., *An Account of the English Colony in New South Wales*, 2 vols, T. Cadell Jun. and W. Davies, London, 1798.

Coombs, H. C. *et al.*, *Oenpelli Bark Painting*, Ure Smith, Sydney, 1979.

Corbin, A., *The Lure of the Sea: The Discovery of the Seaside, 1750–1840*, trans. Jocelyn Phelps, Penguin Books, Harmondsworth, 1995.

Cramer, S. (ed.), *Postmodernism: A Consideration of the Appropriation of Aboriginal Imagery*, Institute of Modern Art, Brisbane, 1989.

Crawford, D., *Thinking Black: 22 Years without a Break in the Long Grass of Central Africa*, Morgan & Scott, London, 1914.

Croll, R. H., *Wide Horizons*, Angus & Robertson, Sydney, 1937.

Cunningham, P., *Two Years in New South Wales*, 2nd edn, 2 vols, Henry Colburn, London, 1827.

Curratelli, G. P. (ed.), *The Western Greeks*, Bompiani, Venezia, 1996.

Dabydeen, A. (ed.), *The Black Presence in English Literature*, Manchester University Press, Manchester, 1985.

Daniels, S., *Fields of Vision*, Polity Press, Cambridge, 1993.

Darian-Smith, K., Gunner, L. and Nuttall, S., *Text, Theory, Space: Land, Literature and History in South Africa and Australia*, Routledge, London, 1996.

Darwin, C., *Journal of Reserches into the Natural History and Geology of the Countries visited during the Voyage of H.M.S. Beagle round the World*, 2nd edn, John Murray, London, 1845.

de Las Casas, B,. *A Short Account of the Destruction of the Indies*, trans. Nigel Griffin, Penguin Books, Harmondsworth, 1992.

de Tocqueville, A., *Journey to America*, trans. George Lawrence, Anchor Books, New York, 1971.

Defoe, D., *Moll Flanders*, Penguin Books, Harmondsworth, 1982.

Deleuze, G. and Guattari, F., *A Thousand Plateaus: Capitalism and Schizophrenia*, trans. Brian Massumi, University of Minnesota Press, Minneapolis, 1991.

Dennis, C. J., *The Sentimental Bloke and Other Verse*, Angus & Robertson, Sydney, 1963.

Derrida, J., *Points Interviews, 1974–1994*, ed. Elisabeth Weber, trans. Peggy Kamuf and others, Stanford University Press, Stanford, 1995.

Derrida, J., *The Other Heading: Reflections on Today's Europe*, trans. Pascale-Anne Brault and Michael B. Naas, Indiana University Press, Bloomington, 1992.

Derrida, J., *Margins of Philosophy*, trans. Alan Bass, Harvester Wheatsheaf, New York, 1982.

Derrida, J., *The Ear of the Other*, ed. Christie McDonald, trans. Peggy Kamuf, University of Nebraska Press, Lincoln, 1985.

Dixon, R., *The Course of Empire and Neo-Classical Culture in New South Wales, 1788–1860*, Oxford University Press, Melbourne, 1986.

Dixon, R., *Writing the Colonial Adventure*, Cambridge University Press, Cambridge, 1995.

Donaldson I. and Donaldson, T. (eds), *Seeing the First Australians*, Allen & Unwin, Sydney, 1985.

Donaldson, I. (ed.), *Australia and the European Imagination*, Humanities Research Centre, Australian National University, Canberra, 1982.

Donaldson, I., *The World Upside-Down: Comedy from Jonson to Fielding*, Clarendon Press, Oxford, 1970.

D'un autre continent l'Australie le rêve et le réel, ARC/Musée d'art Moderne de la Ville de Paris, Paris, 1983.

Eade, J. C. (ed.), *Projecting the Landscape*, Humanities Research Centre, Australian National University, Canberra, 1987.

Eagle, M., *Australian Modern Painting Between the Wars, 1914–1939*, Bay Books, Sydney, 1989.

Edwards, D., *Stampede of the Lower Gods: Classical Mythology in Australian Art*, Art Gallery of New South Wales, Sydney, 1989.

Edwards, R. (ed.), *Aboriginal Art in Australia*, Ure Smith, Sydney, 1978.

Eisler, W., *The Furthest Shore: Images of Terra Australis from the Middle Ages to Captain Cook*, Cambridge University Press, Cambridge, 1995.

Everet, N., *The Tory View of Landscape*, Yale University Press, New Haven, 1994.

Fanon, F., *Black Skin, White Masks*, trans. Charles Lam Markmann, Grove Press, New York, (1952) 1967.

Fanon, F., *Wretched of the Earth*, trans. Constance Farrington, Penguin Books, Harmondsworth, (1961) 1973.

Favenc, E., *The Secret of the Australian Desert*, Blackie, London, 1895.

Ferguson, R., Olander, W., Tucker, M. and Fiss, K., *Discourses: Conversations in Postmodern Art and Culture*, MIT Press, Cambridge, 1992.

Field to Figuration, Australian Art, 1960–1986, National Gallery of Victoria, Melbourne, 1986.

Fifth Biennale of Sydney, *Private Symbol: Social Metaphor*, Art Gallery of New South Wales, Sydney, 1984.

Foss, P. (ed.), *Island in the Stream: Myths of Place in Australian Culture*, Pluto Press, Leichhardt, 1988.

Foster, H., *Recodings*, Bay Press, Seattle, 1985.

Foucault, M., *The Order of Things: An Archeology of the Human Sciences*, Vintage Books, New York, 1973.

Fox, F., *Australia*, 2nd edn, A. & C. Black, London, 1927.

Freud, S., *The Basic Writings of Sigmund Freud*, trans. and ed. Dr A. A. Brill, Modern Library, New York, 1966.

Freud, S., *Civilisation and its Discontents*, trans. Joan Riviere, rev. and ed. James Stratchey, Hogarth Press, London, 1979.

Freud, S., *The Standard Edition of the Complete Psychological Works of Sigmund Freud*, vol. XVII, trans. James Stratchey, Hogarth Press, London, 1955.

Fried, M., *Absorption and Theatricality: Painting and the Beholder in the Age of Diderot*, University of California Press, Berkeley, 1980.

Fry, R. (ed.), *Vision and Design*, Meridian, New York, 1974.

Gardner, H., *The Noble Moor*, Oxford University Press, Oxford, 1955.

Gendzier, I. L., *Frantz Fanon: A Critical Study*, Wilswood House, London, 1973.

Gibson, R., *South of the West: Postcolonialism and the Narrative Construction of Australia*, Indiana University Press, Bloomington, 1992.

Gibson, R., *The Diminishing Paradise: Changing Literary Perceptions of Australia*, Sirius Books, Sydney, 1984.

Gilbert, K. J. *Because a White Man'll Never Do It*, Angus & Robertson, Sydney, 1973.

Gilbert, K., *Living Black Talk to Kevin Gilbert*, Penguin, Ringwood, 1977.

Graves, R., *The Greek Myths*, Penguin Books, Harmondsworth, 1980.

Gregory, J. W., *The Dead Heart of Australia*, John Murray, London, 1909.

Griffiths, T., *Hunters and Collectors*, Cambridge University Press, Cambridge, 1996.

Grosz, E., *Space, Time and Perversion*, Allen & Unwin, Sydney, 1995.

Grosz, E., *Volatile Bodies: Toward a Corporeal Feminism*, Allen & Unwin, Sydney, 1994.

Hancock, W. K., *Australia*, Ernest Benn, London, 1930.

Hansen, E., *Frantz Fanon: Social and Political Thought*, Ohio State University Press, Ohio, 1977.

Harasym, S. (ed.), *The Post-colonial Critic*, Routledge, New York, 1990.

Hardy, J., Megaw, J. V. S. and M. R. (eds), *The Heritage of Namatjira: The Watercolourists of Central Australia*, Heinemann, Melbourne, 1992.

Harris, W., *The Womb of Space: The Cross-Cultural Imagination*, Greenwood Press, Westport, 1983.

Hasluck P., *Black Australians: A Survey of Native Policy in Western Australia, 1829–1897*, 2nd edn, Melbourne University Press, Carlton, 1970.

Hegel, G. W. F., *The Philosophy of History*, trans. J. Sibree, Dover Publications, New York, 1956.

Herbert, X., *Capricornia*, Angus & Robertson, Sydney, (1938) 1990.

Hergenhan, L. (ed.), *The Penguin New Literary History of Australia*, Penguin Books, Ringwood, 1988.

Hill, E., *The Great Australian Loneliness*, Robertson & Mullens, Melbourne, 1943.

Hobsbawn, E. and Ranger, T. (eds), *The Invention of Tradition*, Cambridge University Press, Cambridge, (1983) 1996.

Hope, A. D., *Selected Poems*, Angus & Robertson, Sydney, 1963.

Hughes, R., *The Art of Australia*, Penguin, Harmondsworth, (1966) 1970.

Hughes, R., *The Fatal Shore: A History of the Transportation of Convicts to Australia, 1787–1868*, Pan Books, London, 1988.

Imants Tillers Venice Biennale 1986, Visual Arts Board of the Australia Council, Sydney, and Art Gallery of South Australia, Adelaide, 1986.

Irigaray, L., *An Ethics of Sexual Difference*, trans. Carolyn Burke and Gillian C. Gill, Athlone Press, London, 1993.

Irigaray, L., *Speculum of the Other Woman*, trans. Gillian C. Gill, Cornell University Press, Ithaca, 1992.

Irigaray, L., *This Sex Which Is Not One*, trans. Catherine Porter, Cornell University Press, Ithaca, 1985.

Judd, D., *Empire the British Imperial Experience, from 1765 to the Present*, Harper Collins, London, 1996.

Kayser, W., *The Grotesque in Art and Literature*, trans. Ulrich Weisstein, Indiana University Press, Bloomington, 1963.

Kirwan, J., *An Empty Land*, Eyre & Spottiswoode, London, 1934.

Klibansky, R., Panofsky, E. and Saxl, F., *Saturn and Melancholy*, Nelson, London, 1964.

Kosuth, J., *Art After Philosophy and After, Collected Writings, 1966–1990*, ed. Gabriele Guercio, MIT Press, Cambridge, 1993, p. 124.

Kristeva, J., *Black Sun: Depression and Melancholia*, trans. Leon S. Roudiez, Columbia University Press, New York, 1989.

Kristeva, J., *Powers of Horror: An Essay on Abjection*, trans. Leon S. Roudiez, Columbia University Press, New York, 1982.

Kristeva, J., *The Kristeva Reader*, ed. T. Moi, Basil Blackwell, Oxford, 1987.

Kumar K. and Bann, S. (eds), *Utopias and the Millennium*, Reaktion Books, London, 1993.

Lactantius, *Works of Lactantius*, trans. William Fletcher, T. & T. Clark, Edinburgh, 1871.

Lansbury, C., *Arcady in Australia: The Evocation of Australia in Nineteenth-Century English Literature*, Melbourne University Press, Carlton, 1970.

Lawrence, D. H., *Kangaroo*, Heinemann, London, (1923) 1966.

Lee, J., Mead, P. and Murnan, G. (eds), *The Temperament of Generations: Fifty Years of Writing in* Meanjin, Melbourne University Press, Carlton, 1990.

Lindsay, D., *Primitive Art Exhibition,* Public Library, Museum and National Gallery of Victoria, Melbourne, 1943.

Lindsay, J., *A Short History of Culture from Prehistory to the Renaissance,* Studio Books, London, 1962.

Lindsay, L., *The Art of Arthur Streeton,* Angus & Robertson, Sydney, 1919.

Lotman, Y., *The Universe of the Mind: A Semiotic Theory of Culture,* trans. Ann Shukman, I. B. Tauris, London, 1990.

Low, G. C.-L., *White Skins, Black Masks: Representation and Colonialism,* Routledge, London, 1996.

Lüthi, B. and Lee, G. (eds), *Aratjara Art of the First Australians,* Kunstsammlung Nordrheim-Westfalen, Düsseldorf, 1993.

Manuel, F. E. & F. P., *Utopian Thought in the Western World,* Belknap Press, Cambridge, 1979.

Martin, S., *A New Land: European Perceptions of Australia, 1788–1850,* Allen & Unwin, Sydney, 1993.

McCarthy, F., *Australian Aboriginal Decorative Art,* Australian Museum, Sydney, 1974.

McKisack, M., *The Fourteenth Century, 1307–1399,* Clarendon Press, Oxford, 1959.

McPhee, J., *The Art of John Glover,* Macmillan, South Melbourne, 1980.

McQueen, H., *Gallipoli to Petrov: Arguing with Australian History,* George Allen & Unwin, Sydney, 1984.

Mitchel, J., *Jail Journal,* R. & T. Washbourne, London, n.d.

Mitchell, Major T. L., *Three Expeditions into the Interior of Eastern Australia,* 2nd edn, vol. 1, T. & W. Boone, London, 1839.

Mitchell, W. J. T. (ed.), *Landscape and Power,* University of Chicago Press, Chicago, 1994.

Mollison, J., and Murray, L., *Australian National Gallery: an Introduction,* Australian National Gallery, Canberra, 1982.

Moore, W., *The Story of Australian Art from the Earliest Known Art of the Continent to the Art of To-day,* 2 vols, Angus & Robertson, London, 1934.

Morgan, S., *My Place,* Fremantle Arts Centre Press, Fremantle, 1987.

Morris, N. and Rothman, D. J. (eds), *The Oxford History of the Prison: The Practice of Punishment in Western Society,* Oxford University Press, Oxford, New York, 1995.

Mountford, C. P., *The Art of Namatjira,* Bread and Cheese Club, Melbourne, 1944.

Muir, K., and Edwards, P. (eds), *Aspects of Othello,* Cambridge University Press, Cambridge, 1977.

Mullard, C., *Aborigines in Australia Today,* Summit Press, ACT, 1976.

Mulvaney D. J. and Calaby, J. H., *So Much that is New,* Melbourne University Press, Carlton, 1985.

Nandy, A., *The Intimate Enemy: Loss and Recovery of Self under Colonialism,* Oxford University Press, Delhi, 1983.

Nietzsche, F., *Basic Writings of Nietzsche,* trans. Walter Kaufmann, Modern Library, New York, 1968.

Ninth Biennale of Sydney, *The Boundary Rider,* Art Gallery of New South Wales, Sydney, 1992.

O'Ferrall, M., *On the Edge: Five Contemporary Aboriginal Artists,* Art Gallery of Western Australia, 1989.

Osborne, H. (ed.), *The Oxford Companion to Art*, Oxford University Press, Oxford, 1970.

Padmore, G., *Pan-Africanism or Communism? The Coming Struggle for Africa*, Dennis Dobson, London, 1956.

Pallottino, M. (ed. in chief), *World Encyclopedia of Art*, vols 1–16, McGraw Hill, London, 1960–83.

Palmer, V., *The Legend of the Nineties*, Melbourne University Press, Carlton, 1963.

Papastergiadis, N., *The Complicities of Culture: Hybridity and 'New Internationalism'*, Cornerhouse, Manchester, 1994.

Pons, X., *Out of Eden: Henry Lawson's Life and Works, A Psychoanalytical View*, Sirius Books, Sydney, 1984.

Price, A. G., *White Settlers and Native Peoples*, Greenwood Press, Westport, 1972.

Richardson, H. H., *Australia Felix*, Heinemann, Melbourne, (1917) 1970.

Romm, J. S., *The Edges of the Earth in Ancient Thought*, Princeton University Press, Princeton, 1992.

Roth, H. L., *The Aborigines of Tasmania*, F. King & Sons, Halifax, 1899.

Rowley, C. D., *The Destruction of the Aboriginal Society*, Penguin, Ringwood, 1983.

Rubin, W. (ed.), *Primitivism in Twentieth Century Art: Affinity of the Tribal and the Modern*, 2 vols, Museum of Modern Art, New York, 1984.

Samuels, J. and Watson, C. (eds), *Aboriginal Australian Views in Print and Posters*, Print Council of Australia, Melbourne, 1987.

Schaffer, K., *Women and the Bush*, Cambridge University Press, Cambridge, 1988.

Serle, G., *From Desert the Prophets Come: The Creative Spirit in Australia 1788–1972*, Heinemann, Melbourne, 1973.

Shaw, A. G. L., *Convicts and the Colonies*, Faber & Faber, London, 1966.

Slutzkin, L. and Pearce, B. (eds), *Bohemians in the Bush: The Artists' Camps of Mosman*, Art Gallery of New South Wales, Sydney, 1991.

Smith B., with Smith T., *Australian Painting 1788–1990*, Oxford University Press, Melbourne, 1992.

Smith, B. (ed.), *Documents on Art and Taste in Australia, 1770–1941*, Oxford University Press, Melbourne, 1990.

Smith, B., *European Vision and the South Pacific*, Oxford University Press, Oxford, 1960.

Smith, B., *Imagining the Pacific in the Wake of the Cook Voyages*, Melbourne University Press, Carlton, 1992.

Smith, B., *The Death of the Artist as Hero*, Oxford University Press, Melbourne, 1988.

Smith, B., *The Spectre of Truganini*, Australian Broadcasting Commission, Sydney, 1980.

Smith, G., *Arthur Streeton*, National Gallery of Victoria, Melbourne, 1996.

Smith, S. U. (ed.), *Art of Australia*, Museum of Modern Art, New York, 1941.

Spencer, B. and Gillen, F., *The Native Tribes of Central Australia*, Dover Publications, New York, n.d.

Spencer, B. and Gillen, F., *The Northern Tribes of Central Australia*, Anthropological Publications, Oosterhout, 1969.

Spivak, G., *In Other Worlds: Essays in Cultural Politics*, Methuen, New York, 1987.

Spivak, G., *Outside in the Teaching Machine*, Routledge, New York, 1993.

Sprengnether, M., *The Spectral Mother*, Cornell University Press, Cornell, 1990.

Stephensen, P. R., *The Foundations of Culture in Australia: An Essay toward National Self Respect*, Allen & Unwin, Sydney, (1936) 1986.

Stokes, A., *The Image in Form*, ed. Richard Wollheim, Penguin Books, Harmonds-worth, 1972.

Strehlow, T. G. H., *Rex Battarbee: Artist and Founder of the Aboriginal Art Movement in Central Australia*, Legend Press, Sydney, 1956.

Sturt, C., *Narrative of an Expedition into Central Australia*, 2 vols, T. & W. Boone, London, 1849.

Sutton, P. (ed.), *Dreamings: the Art of Aboriginal Australia*, Viking, Ringwood, 1988.

Swain, T., *A Place for Strangers: Towards a History of Australian Aboriginal Being*, Cambridge University Press, Cambridge, 1993.

Taylor, G., *Australia*, 6th edn, Methuen, London, 1951.

Tench, W., *A Complete Account of the Settlement at Port Jackson in New South Wales*, G. Nicol, London, 1793.

Thiele, C., *Heysen of Hahndorf*, Rigby, Adelaide, 1968.

Third Biennale of Sydney, *European Dialogue*, Art Gallery of New South Wales, Sydney, 1979.

Tillers, I. (ed.), *Diaspora*, Museum of Contemporary Art, Sydney, 1993.

Topliss, H., *The Artists' Camps: Plein Air Painting in Melbourne, 1885–1898*, Monash University Gallery, Clayton, 1984.

Tracey, D., *Patrick White: Fiction and the Unconscious*, Oxford University Press, Melbourne, 1988.

Trollope, A., *Australia*, ed. O. D Edwards and R. B. Joyce, University of Queensland Press, St Lucia, 1967.

Turner. A. (ed.), *Neville Bonner Versus Bobbi Sykes*, Heinemann Educational, South Yarra, 1975.

Turner, F. J., *The Frontier in American History*, Holt, Rinehart & Winston, New York, 1962.

Turner, G., *National Fictions*, 2nd edn, Allen & Unwin, Sydney, (1986) 1993.

Tylor, E. B., *Anthropology*, London, 1881.

Vanderwal, R. (ed.), *The Aboriginal Photographs of Baldwin Spencer*, National Museum of Victoria, Melbourne, 1982.

Vinge, L., *The Narcissus Theme in Western European Literature up to the Early Nineteenth Century*, trans. Robert Dewsnap, Gleerups, 1967.

Wallis, J. P. R., *Thomas Baines: His Life and Explorations in South Africa, Rhodesia and Australia*, A. A. Balkema, Cape Town, 1976.

Ward, R., *A Nation for a Continent: The History of Australia, 1901–1975*, Heinemann Educational, Richmond, 1977.

Ward, R., *The Australian Legend*, Oxford University Press, Melbourne, (1958) 1977.

Weisser, M. R., *Crime and Punishment in Early Modern Europe*, Harvester Press, Hassocks, 1979.

West, J., *The History of Tasmania*, Henry Dowling, Launceston, 1852.

White, H., *Tropics of Discourse: Essays in Cultural Criticism*, Johns Hopkins University Press, Baltimore, 1978.

Willey, K., *When the Sky Fell Down*, Collins, Sydney, 1979.

Williams, G. and Frost, A. (eds), *Terra Australis to Australia*, Oxford University Press, Melbourne, 1988.

Williamson, C. and Perkins, H., *Blakness Blak City Culture*, Australian Centre for Contemporary Art, South Yarra, 1994.

Wood, A., *The Discovery of Australia*, Macmillan, London, 1922.

Wray, C., *Arthur Streeton: Painter of Light*, Jacaranda, Brisbane, 1993.

Zubans, R., *E. Phillips Fox: His Life and Art*, Miegunyah Press, Carlton, 1995.

Articles

Anson, S., 'The postcolonial fiction', *Arena*, 96, 1991, pp. 64–6.

Baume, N., 'The interpretation of Dreamings: the Australian Aboriginal acrylic movement', *Art & Text*, 33, Winter 1989, pp. 110–20.

Bhabha, H., 'Of mimicry and man: the ambivalence of colonial discourse', *October*, 28, 1984, pp. 125–33.

Brauer, F., 'The bricoleur – the borderico – the postcolonial boundary rider', *Agenda*, 29, March 1993, pp. 5–6.

Brophy, P., 'A face without a place: identity in Australian contemporary art since 1980', *Art & Text*, 16, 1988, pp. 69–80.

Brophy, P., 'Not the black & white artist show', *Art Network*, 13, Spring 1984, p. 53.

Bruce, C., and Callaway, A., '"Dancing in the dark": black corroboree or white spectacle?', *Australian Journal of Art*, IX, 1991, pp. 79–104.

Bull, G., 'Taking place: panorama and panopticon in the colonisation of New South Wales', *Australian Journal of Art*, 12, 1994–5, pp. 75–95.

Burn, I., 'The Australian National Gallery: populism or a new cultural federalism?', *Art Network*, 8, Summer 1983, pp. 39–43.

Butler, R., 'Two readings of Gordon Bennett's *The Nine Ricochets*', *Eyeline*, Winter/Spring, 1992, pp. 19–23.

Carter, P., 'Contrapuntal perspectives', *Art and Asia Pacific*, 1, 3, 1994, pp. 108–9.

Carter, P., 'Events of today or, an end of writing', *Agenda*, 39/40, November 1994–February 1995, pp. 5–7.

Carter, P., 'Migrant meditations', *Agenda*, 22, March/April 1992, pp. 9–11.

Carter, P., 'Second sight: looking back as colonial vision', *Australian Journal of Art*, vol. XIII, 1996, pp. 9–35.

Charlesworth, M., 'Thomas Sandby climbs the Hoober Stand: the politics of panoramic drawing in eighteenth-century Britain', *Art History*, 19, 2, June 1996, pp. 247–66.

Colless, E., 'At the edge of the world', *Art and Australia*, 30, 4, Winter 1993, pp. 462–5.

Cramer, S., '"Masterpieces" out of the seventies and "Tall Poppies"', *Art Network*, 10, Winter 1983, pp. 42–5.

Davidson, C., 'Interview: Paul Taylor', *Art Network*, 10, Winter 1983, pp. 46–7.

Davidson, J. (ed.), 'Introduction', *Meanjin*, 36, 4, December 1977, pp. 419–27.

Davila, J., 'Aboriginality: a lugubrious game', *Art & Text*, 23/24, 1987, pp. 53–6.

Davila, J., 'On eclecticism', *Art Network*, 13, Spring 1984, pp. 50–1.

Dunn, R., 'Other than what', *Art Network*, 13, Spring 1984, pp. 51–3.

Ewington, J., 'Whence do we come? What are we? Where are we going? International collections at the ANG', *Art Network*, 8, Summer 1983, pp. 34–8.

Foster, H., 'Obscene, abject, traumatic', *October*, 78, Fall, 1996, pp. 107–24.

Grieg, A. W., 'Aboriginal art', *Lone Hand*, 5, 25, May 1909, pp. 42–8.

Harpham, G., 'The grotesque: first principles', *Journal of Aesthetics and Art Criticism*, 34, 4, Summer 1976, pp. 461–8.

Heysen, H., 'Some notes on art', *Art in Australia*, 3, 44, June 1932, pp. 7–20.

Johnson, V., 'The unbounded Biennale: contemporary Aboriginal art', *Art and Australia*, 31, 1, Spring 1993, pp. 49–56.

Jones, R., 'Lifesaving in the Acrylic Age', *Artforum*, February 1989, pp. 114–15.

Kirkby, J., 'Barbara Baynton: an Australian jocasta', *Westerly*, 34, 4, December 1989, pp. 114–24.

Kirkby, J., 'Fetishizing the father', *Meridian*, 10, 1, May 1991, pp. 35–44.

Kirkby, J., 'Old orders, new lands: the earth spirit in *Picnic at Hanging Rock*', *Australian Literary Studies*, 8, 3, May 1978, pp. 255–68.

Kirkby, J., 'The call of the mother in the fiction of Elizabeth Jolley', *Span*, 26, April 1988, pp. 46–63.

Lacan, J., 'The mirror-phase as formative of the function of the I', trans. Jean Roussel, *New Left Review*, 51, September–October, 1968, pp. 71–7.

Lindsay, L., 'Arthur Streeton', *Art in Australia*, October 1931, p. 11.

Lingard B. and Rizvi, F., '(Re)membering, (dis)membering "Aboriginality" and the art of Gordon Bennett', *Third Text*, 26, Spring 1994, pp. 75–89.

Lingard, B., interview with Gordon Bennett, 'A kind of history painting', *Tension*, 17, August 1989, pp. 40–2.

Low, G. C., White skins/black masks: the pleasures and politics of imperialism', *New Formations*, 9, Winter 1989, pp. 83–103.

MacDonald, J. S., 'Arthur Streeton', *Art in Australia*, 3, 40, 15 October 1931, pp. 12–60.

McDonald, J., 'Issues in contemporary Australian art', *Art and Australia*, 26, 1, Spring 1988, pp. 85–93.

Marrie, A., 'Killing me softly: Aboriginal art and Western critics', *Art Network*, Spring 1984, pp. 17–21.

Montgomery, J., 'Australia – the French discovery of 1983', *Art & Text*, 12 and 13, 1984, pp. 3–15.

Morris, M., 'Tooth and claw: tales of survival, and *Crocodile Dundee*', *Art & Text*, 25, 1987, pp. 36–68.

Mosquera, G., 'Modernity and Africanía: Wilfredo Lam in his island', *Third Text*, 20, Autumn 1992, pp. 43–68.

Muecke, S., 'The discourse of nomadology: phylums in flux', *Art & Text*, 14, 1984, pp. 25–40.

Mundine, J., 'Aboriginal Art Gallery of New South Wales', *Art and Australia*, 26, 1, Spring 1988, pp. 94–9.

Nairne, S., 'European fusion', *Frieze*, 11, Summer 1993, pp. 19–20.

Onus, L., 'Language and lasers', *Art Monthly*, Aboriginal art supplement, 30, May 1990, pp. 14–19.

Pearson, C., 'Aboriginal identity and kitsch', *Art & Text*, 14, 1984, pp. 41–50.

Rees, L., 'Modern Australian Aboriginal art', *Australian Quarterly*, December 1951, pp. 90–2.

Schwarz, H., 'The mirror in art', *Art Quarterly*, 15, 1952, pp. 96–118.

Shohat, E., 'Notes on the "post-colonial"', *Social Text*, 31/32, 1992, pp. 109–13.

Smith, T., 'The provincialism problem', *Art Forum*, 13, 1, September 1974, pp. 54–9.

Spivak, G. with Papastergiadis, N., 'Identity and alterity: an interview', *Arena*, 97, 1991, pp. 65–75.

Taylor, P., 'Popism – the art of white Aborigines', *Flash Art*, 112, May 1983, pp. 48–50.

Thomas, D., 'The margins strike back: Australian art since the sixties', *Art and Australia*, 26, 1, Spring 1988, pp. 60–71.

Tillers, I., 'Fear of texture', *Art & Text*, 10, 1983, pp. 8–18.

Tillers, I., 'Locality fails', *Art & Text*, 6, 1982, pp. 51–60.

White, H., 'Foucault decoded: notes from underground', *History and Theory*, 12, 1, 1973, pp. 23–54.

Wittkower, R., 'Marvels of the East: a study in the history of monsters', *Journal of the Warburg and Courtauld Institutes*, 5, 1942, pp. 159–97.

Index

Bennett, Gordon *cont.*
Landscape Painting 139; *Men with Weapons* (Corridor) 141; *Mirror Line* 139; *Painting for a New Republic (the Inland Sea)* 140–1; *The Recentred Self* 146; *Resurrection (Bloom)* 146; *Terra nullius (Teaching aid), as far as the eye can see* 140–1
Bennett, Lance 110
Bentham, Jeremy 16, 36
Berndt, Ronald M. 90, 108
Beuys, Joseph 113
Bhabha, Homi 132, 138
Bidjee 30
Black, John 17
Boime, Albert 44
Bond, Anthony 142, 143
Bonwick, James 31, 32–3
Bonyhady, Tim 40–2, 57
Boomerang 53, 64, 69–70, 77
Botany Bay 4–5, 7–8, 16, 17, 22, 59, 150, 152, 154
Boyd, Arthur 94, 95, 96, 103; *Australian Scapegoat* 95
Bradley, William 147
Brauer, Fay 142
Brome, Richard 21–2
Brophy, Philip 119, 124, 125, 146
Brown, Dr Roosevelt 105
Bruce, Candice 29
Brunelleschi, Fillipo 137
Bull, Gordon 36
Bulldog 32
Bulletin 53, 64, 69–70, 75, 77, 88
Bungaree 30, 109
Bungawuy 109
Burke and Wills 45, 60, 83, 84
Burn, Ian 56, 59, 61, 74, 75, 80, 81, 121, 129
Burton, Richard 21–2
bush, the 23, 44, 45, 48–51, 53–64, 76–82, 88–9, 92–5
Butler, Rex 117
Buvelot, Louis 41, 45, 49, 50, 51, 57; *Waterpool Near Coleraine* 50

Callaway, Anita 29
Campanella 20; *City of the Sun* 20
Camper, Petrus 43
Carter, Paul 7–8, 147, 155–64; *The Road to Botany Bay* 158

Catalano, Gary 96, 111
Centennial Magazine 68
Césaire, Aimé 96, 106, 107
Chauvel, Claude 147; *Jedda* 147
Chevalier, Nicholas 45, 49, 57
Christensen, Clem 87
Clark, Manning 153–4
Clarke, Marcus 49–51, 54, 55, 56, 57, 58, 59, 60, 61
Claude, Lorrain 23, 38, 40, 44, 56
Cleaver, Eldridge 113
Clifford Possum Tjapaltjarra *see* Tjapaltjarra
Cole, Thomas 19, 44–5; *The Course of Empire* 19; *The Oxbow* 44
Colless, Edward 4
Collins, David 24, 27, 64
Columbus, Christopher 2, 20, 38
conceptual art 113, 118
Condor, Charles 57, 61, 64; *Mirage* 57; *Spring-time* 57; *Under a Southern Sky* 61; *Yarding Sheep* 57; *The Yarra, Heidelberg* 64
Constable, John 26, 58
convergence, cultural 72, 95–8, 114–19, 121, 126, 148
convicts 14–16, 17, 21, 25–7, 34, 58, 88–9, 94, 150–3
Cook, Captain James 3, 10, 22, 59–60, 68, 157, 163
Corbin, Alain 164
corroborees 29
Corruna Downs 62
Cowling, Professor G.H. 91
Cramer, Su 116
Crocodile Dundee 127
Croll, Robert 86, 90, 96, 99
Cunningham, Peter 5, 29–30, 50

Dalrymple, Alexander 4
Daniels, Stephen 45
Dante 160
Darwin, Charles 6; Darwinisms 42, 50, 59, 66–9, 76
Davila, Juan 117, 118, 125
Deacon, Destiny 106–10, 133
de Balboa, Vasco Nunez 3
DeBord, Guy 113
de Brosses, Charles 22
de Mendonça, Cristóvao 3
de Tocqueville, Alexis 23
decolonisation 106